ON THE EDGE

RANDOM HOUSE
NEW YORK

ON THE EDGE

Introduction by Kennedy Fraser

IMAGES FROM 100 YEARS OF VOGUE

ALEXANDER LIBERMAN
Editorial Director

ANNA WINTOUR
Editor in Chief

RAÚL MARTINEZ
Art Director

ERIC PRYOR
Designer

POLLY ALLEN MELLEN
Fashion Director

DIANA EDKINS
Curator of Photographs

LESLEY JANE NONKIN
Writer

The exhibition
"On the Edge: Photographs from 100 Years of *Vogue*"
appeared at The New York Public Library,
April 4 – August 1, 1992

Copyright ©1992 The Condé Nast Publications Inc.
Introduction copyright ©1992 by Kennedy Fraser

Printed by Amilcare Pizzi, Milan, Italy

Library of Congress Cataloging-in-Publication Data
On the edge: images from 100 years of *Vogue*

p. cm.
Includes index.
ISBN 0-679-41161-5
1. Fashion photography. I. Vogue.
TR679.05 1992
779'.9391—dc20 91-40176
2 4 6 8 9 7 5 3
First Edition

CONTENTS

A fashion photograph is not
a photograph of a dress;
it is a photograph of a woman.

— ALEXANDER LIBERMAN

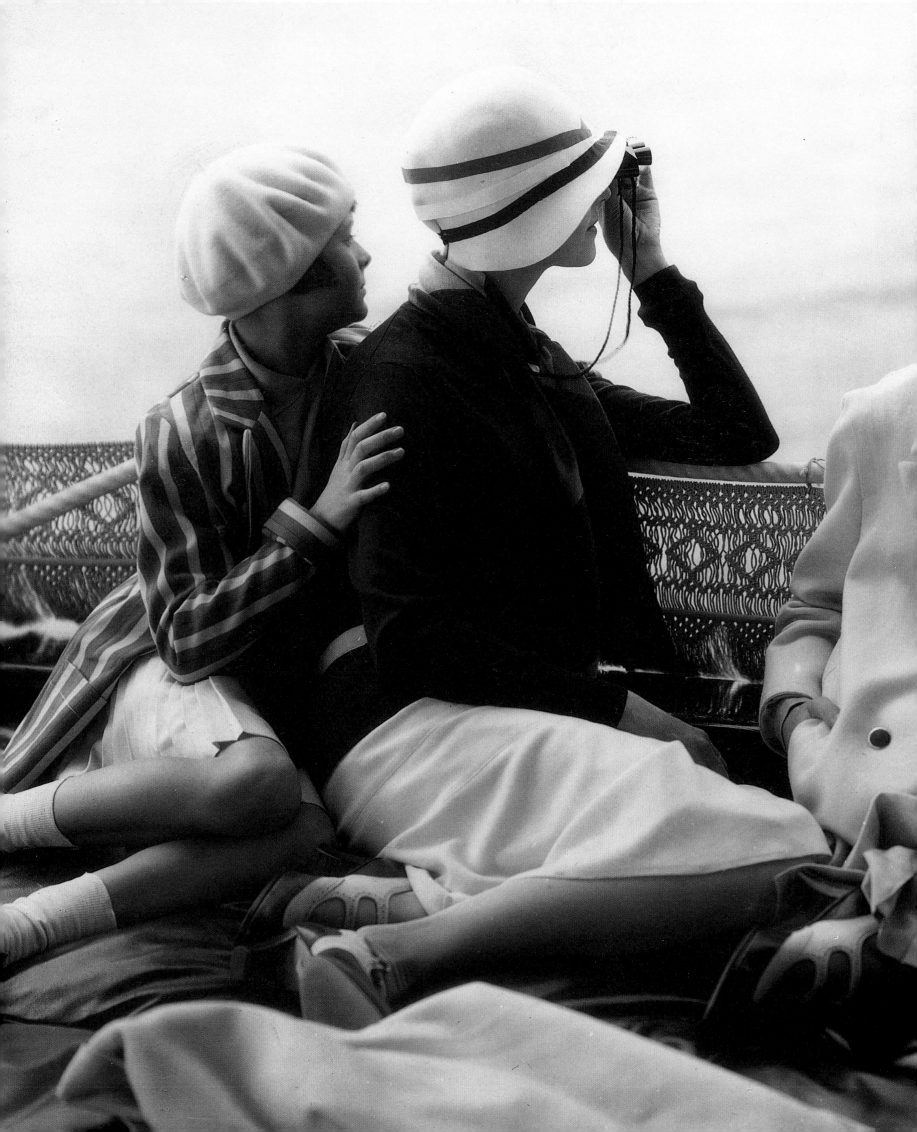

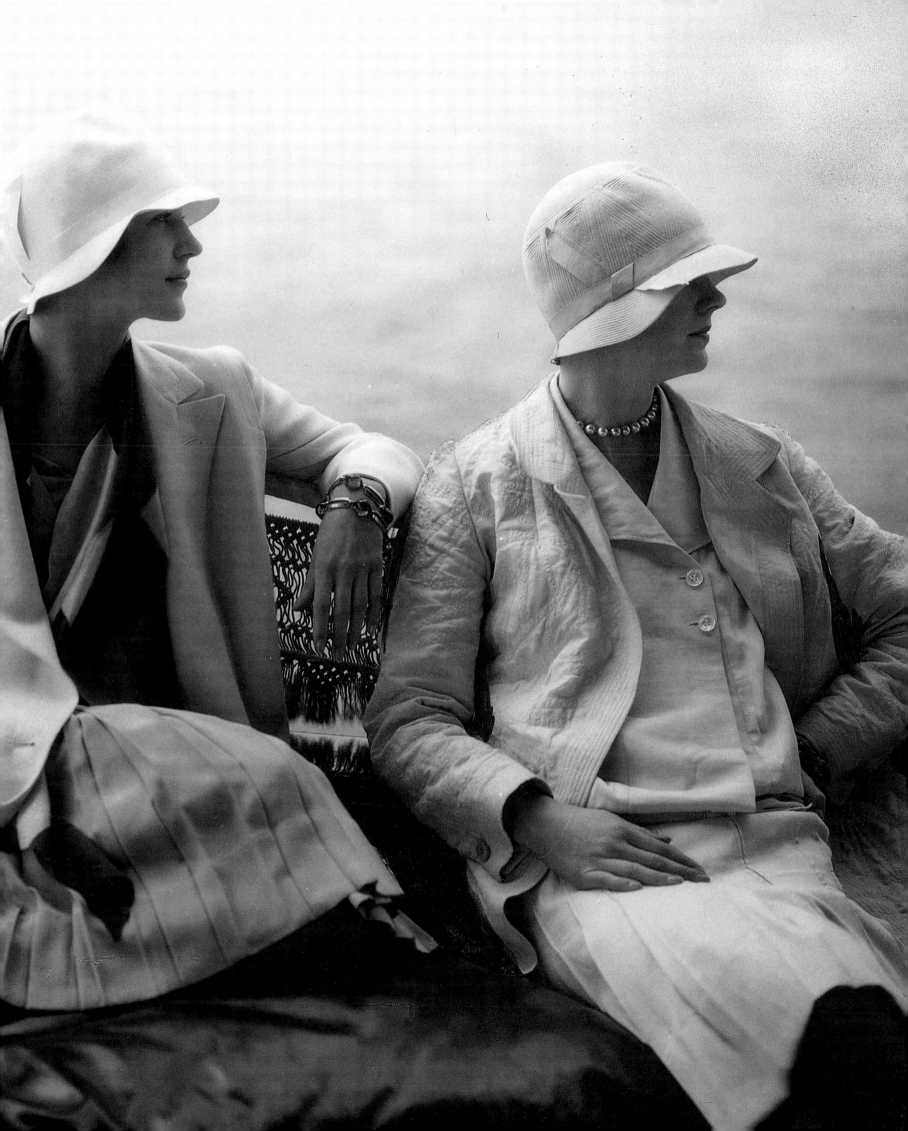

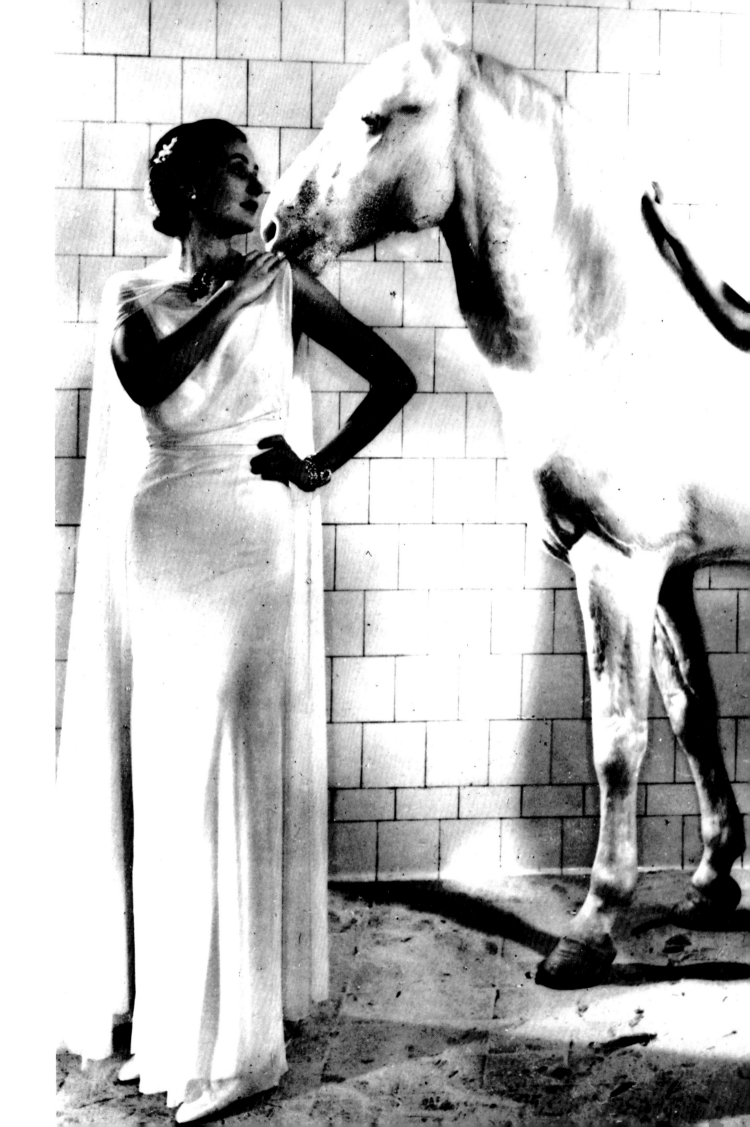

preceding pages
Edward Steichen
Summer sportswear
July 15, 1928

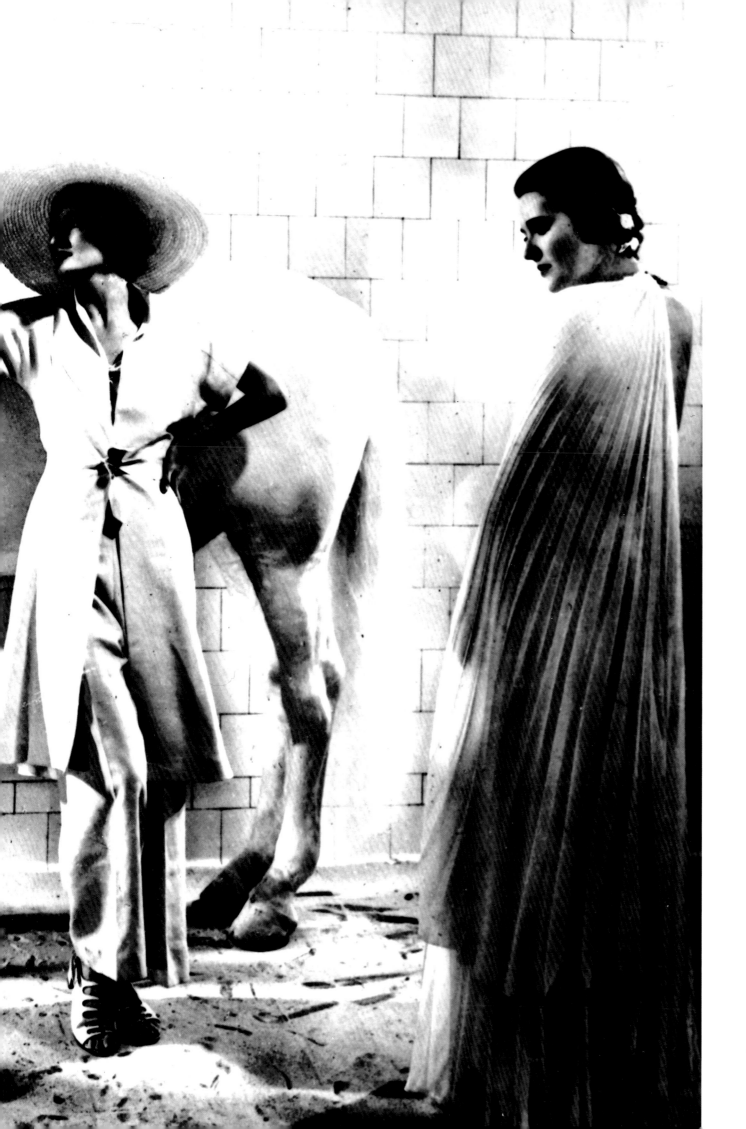

Edward Steichen
White resort clothes
January 1, 1936

following pages

Irving Penn
The twelve top models
of the forties
May 1, 1947

Nick de Margoli
Three "American beauties":
Ann Woodward, Brenda Frazier,
Daphne Bedford
February 1, 1952

XI

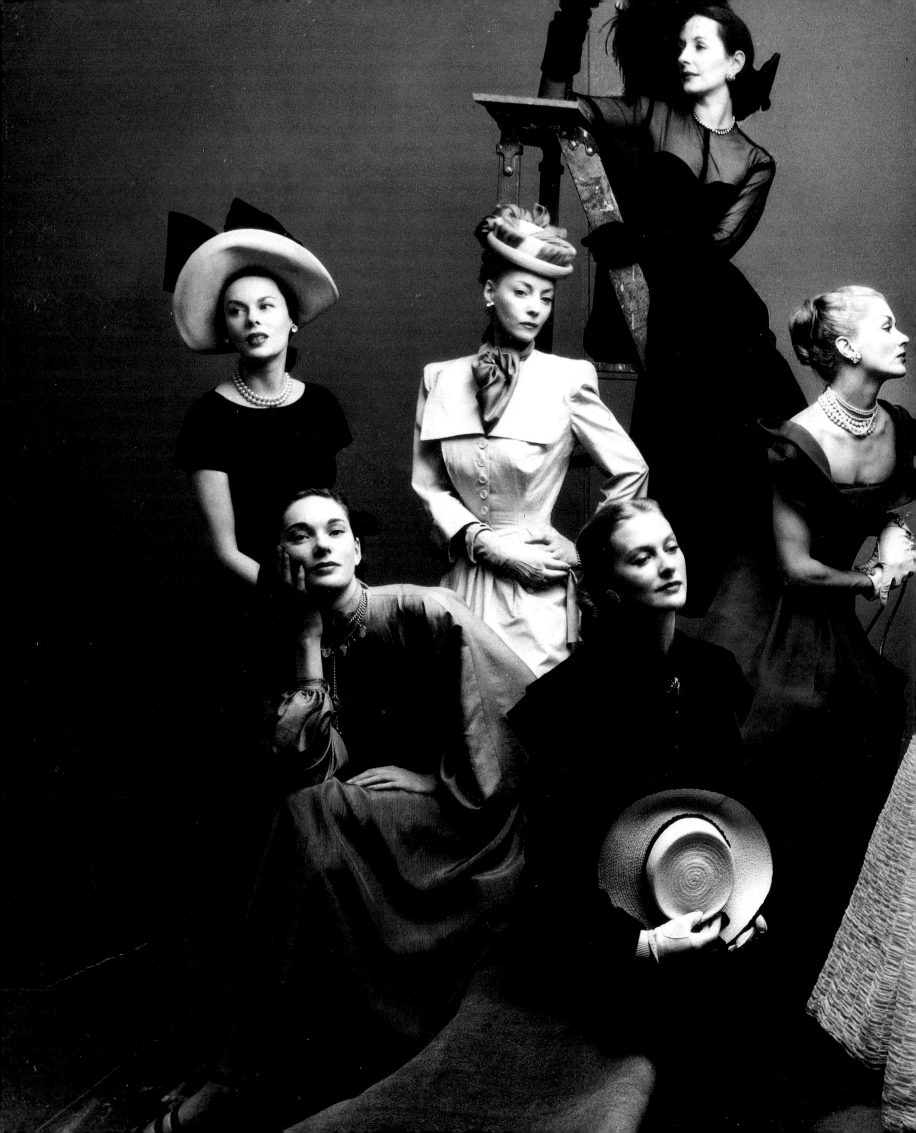

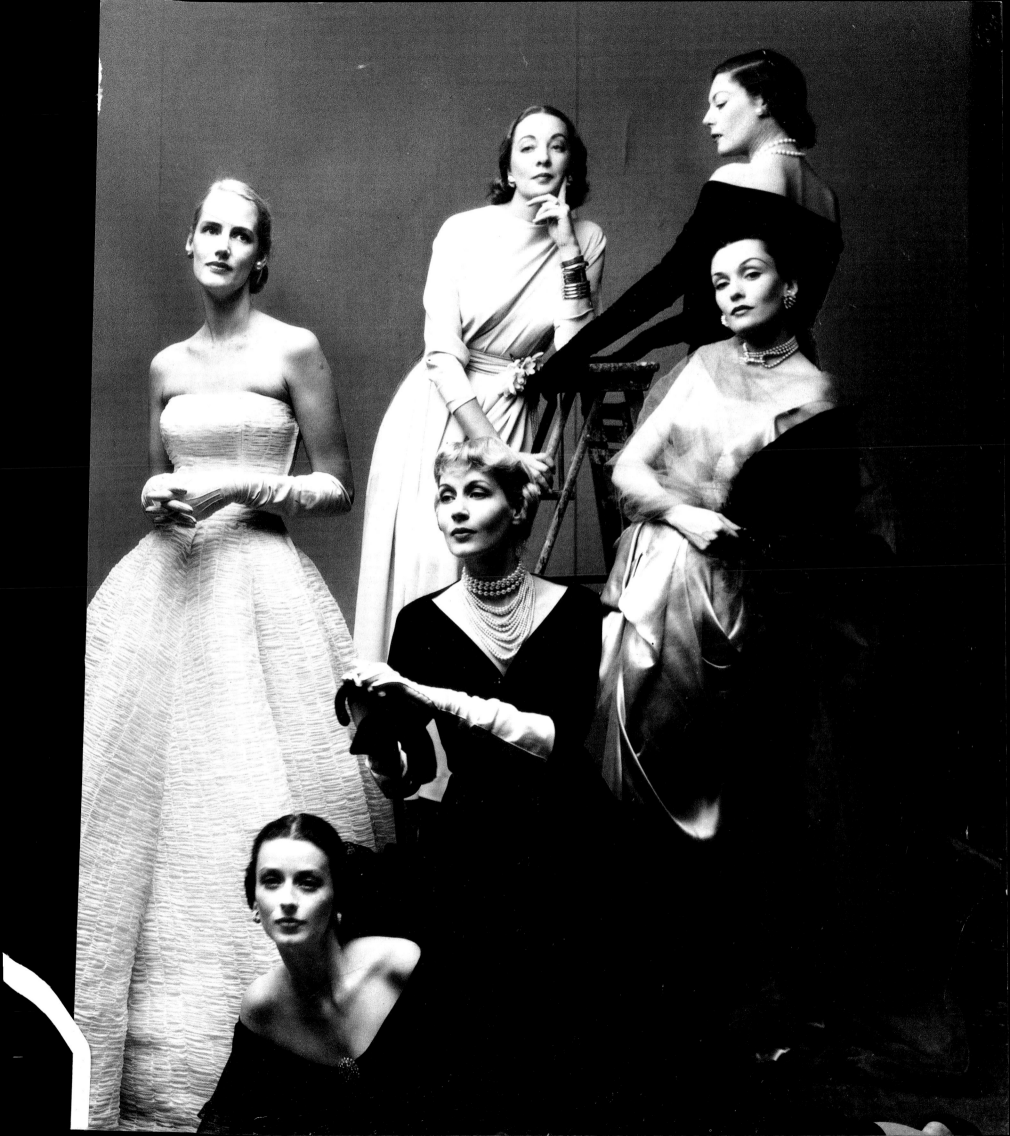

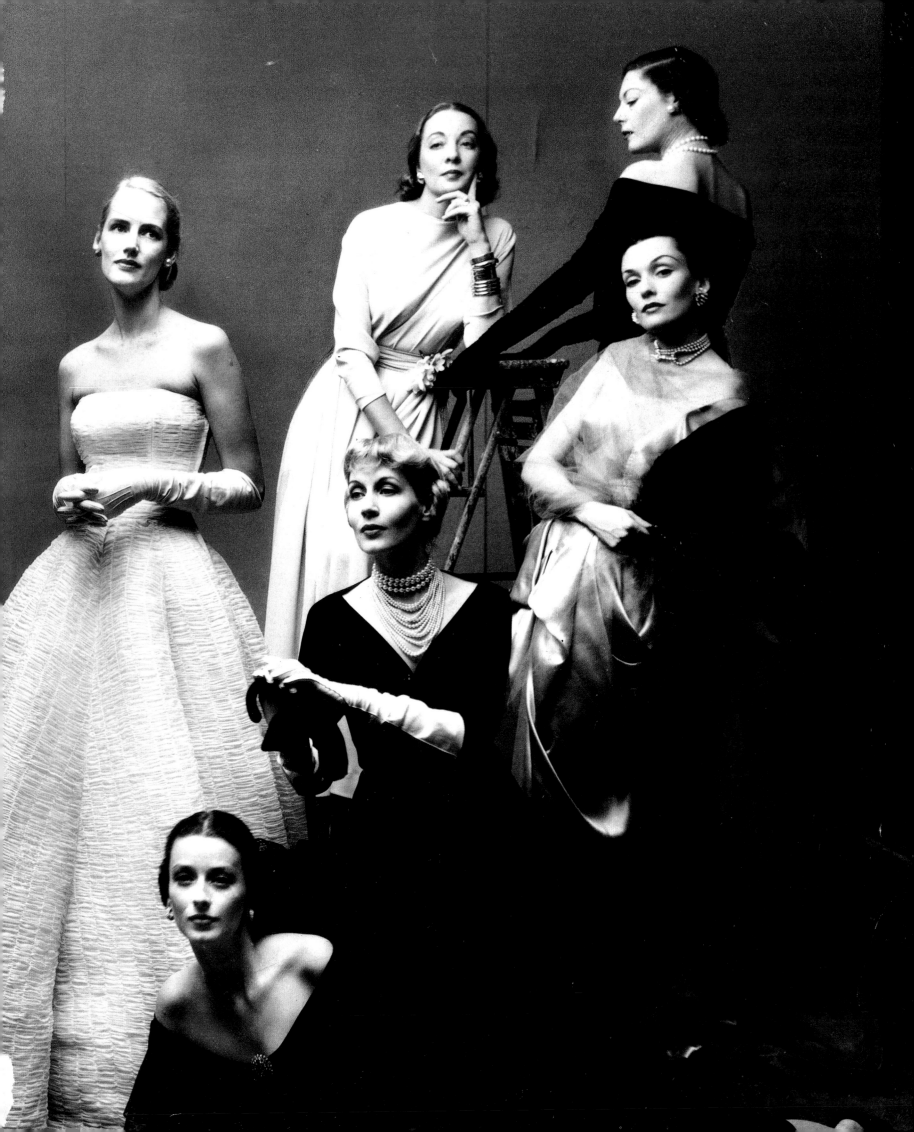

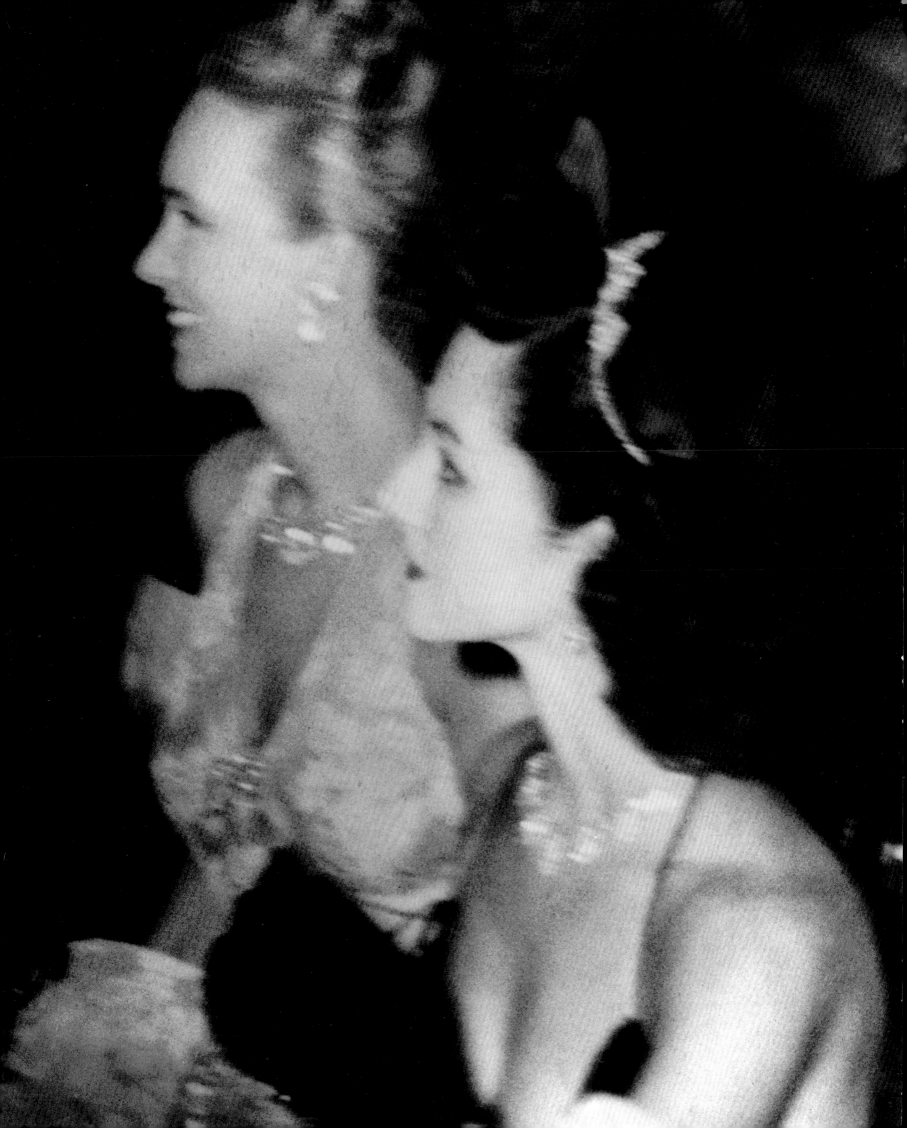

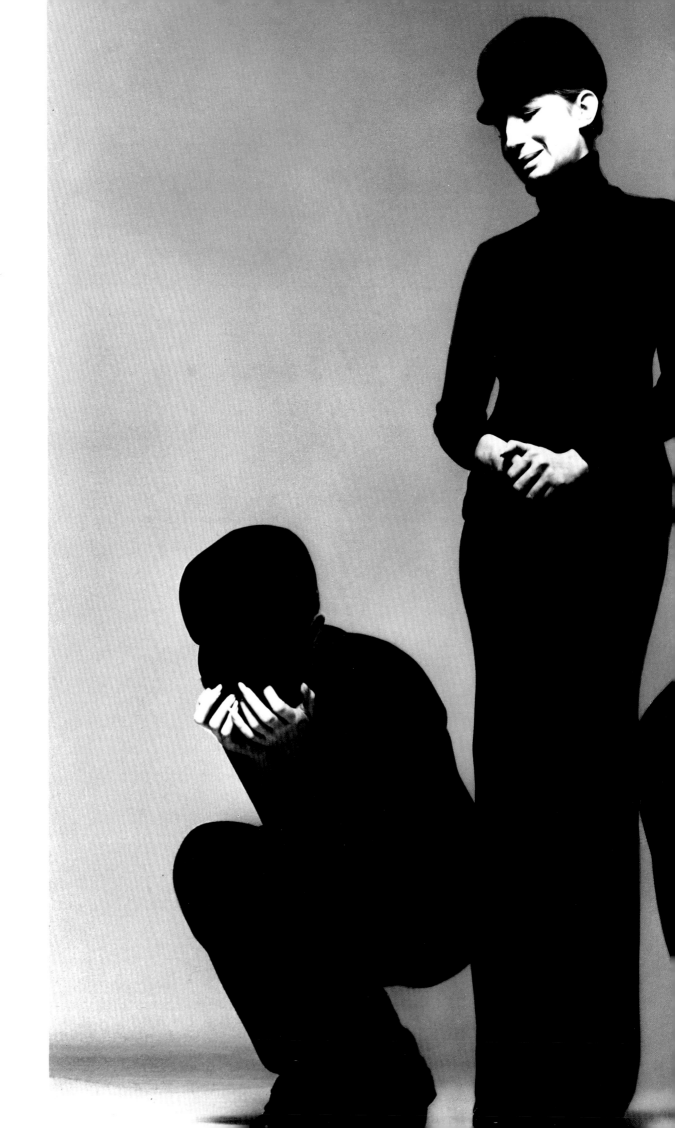

Richard Avedon
Barbra Streisand
June 1970

following pages

Deborah Turbeville
Models in public
bathhouse in New York
May 1975

Peter Lindbergh
White cotton shirts
August 1988

Peter Lindbergh
Helena Christensen, Stephanie Seymour,
Karen Mulder, Naomi Campbell,
Claudia Schiffer, and Cindy Crawford
in Chanel skirts and
leather motorcycle jackets
September 1991

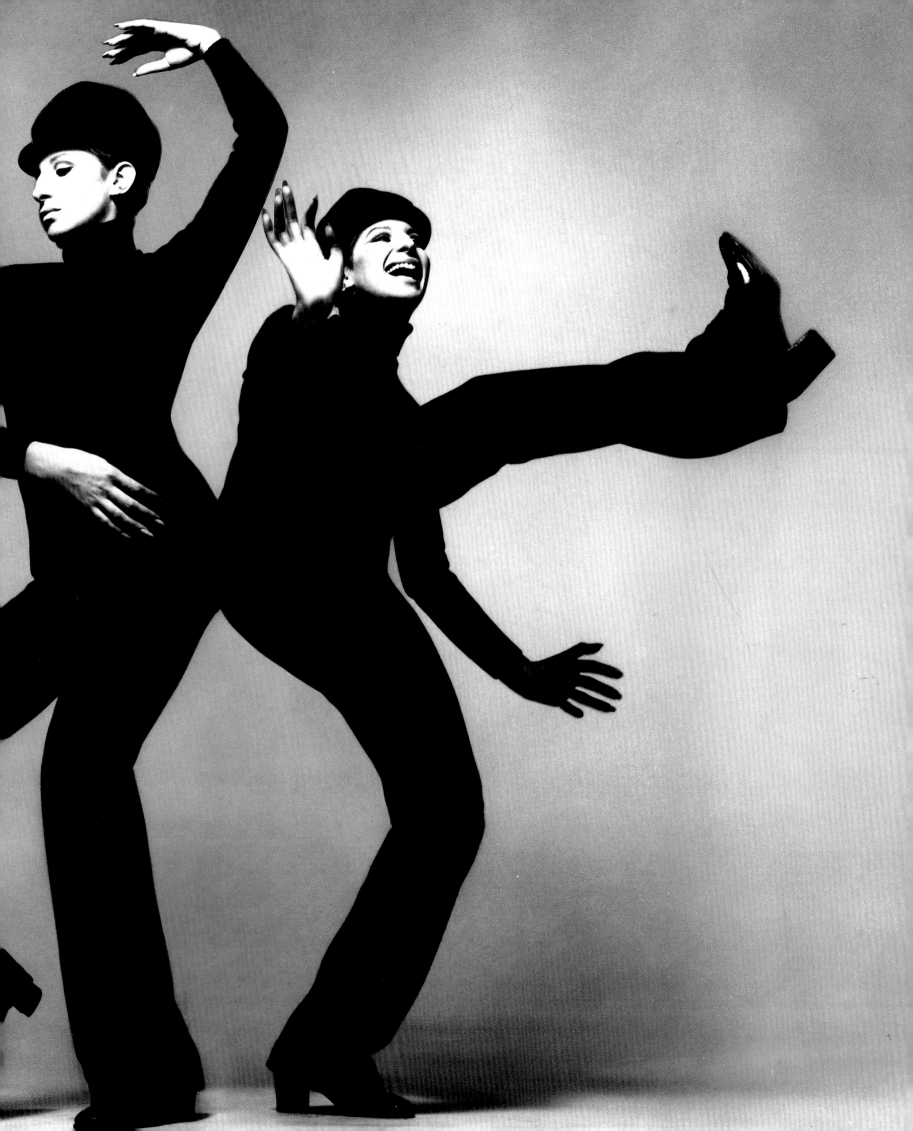

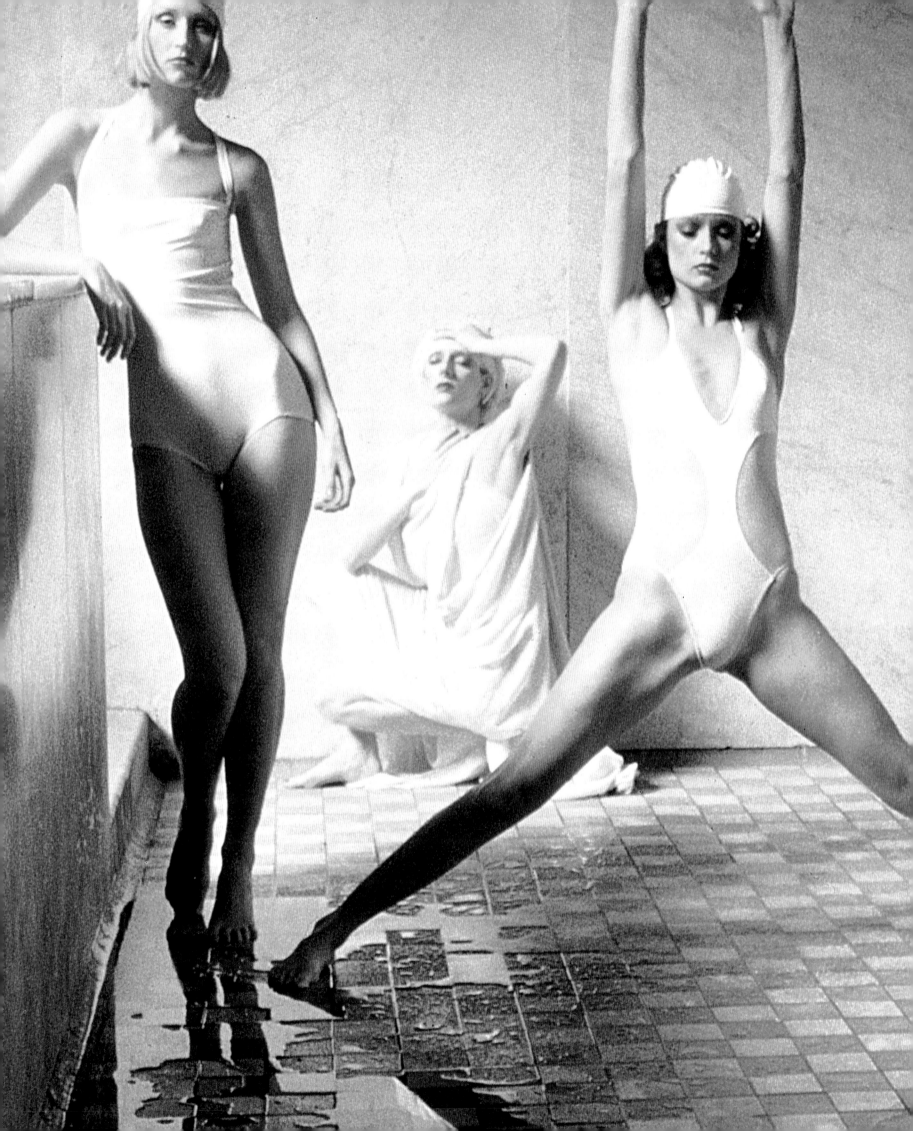

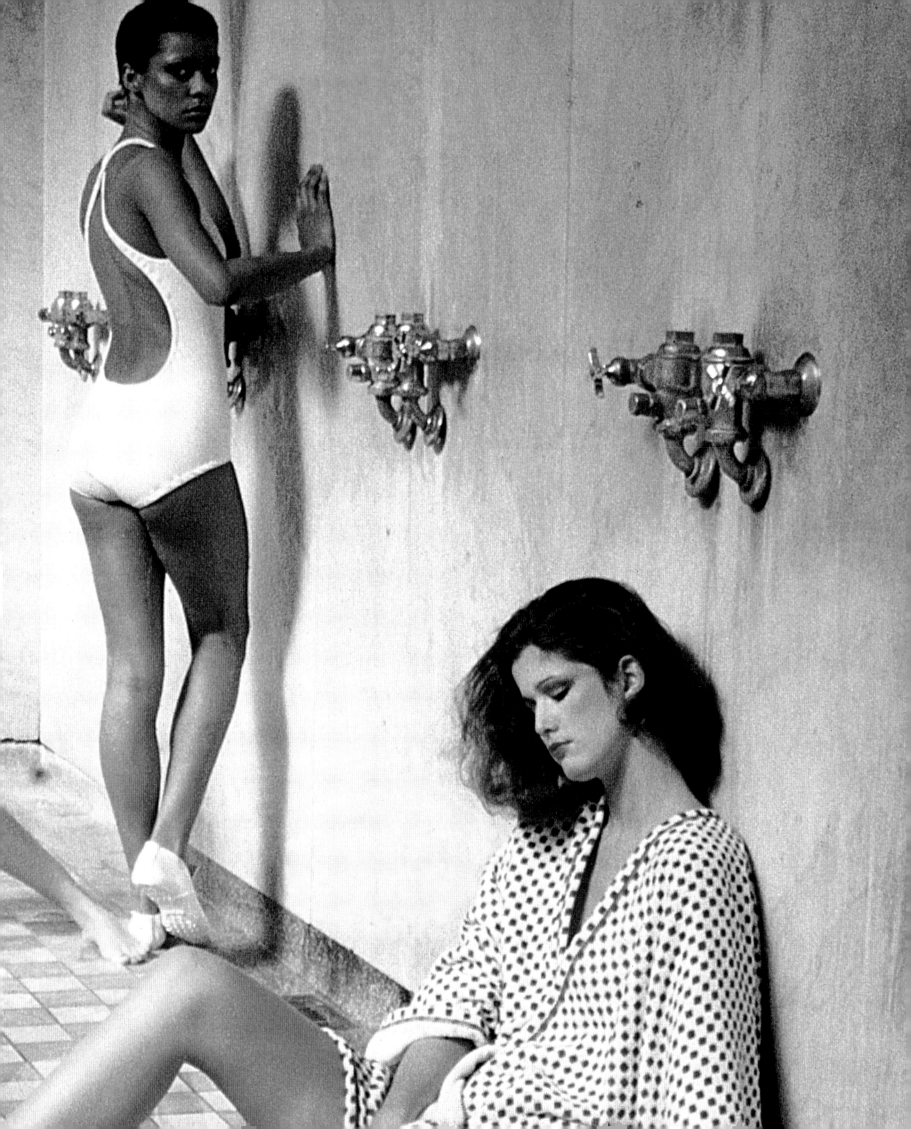

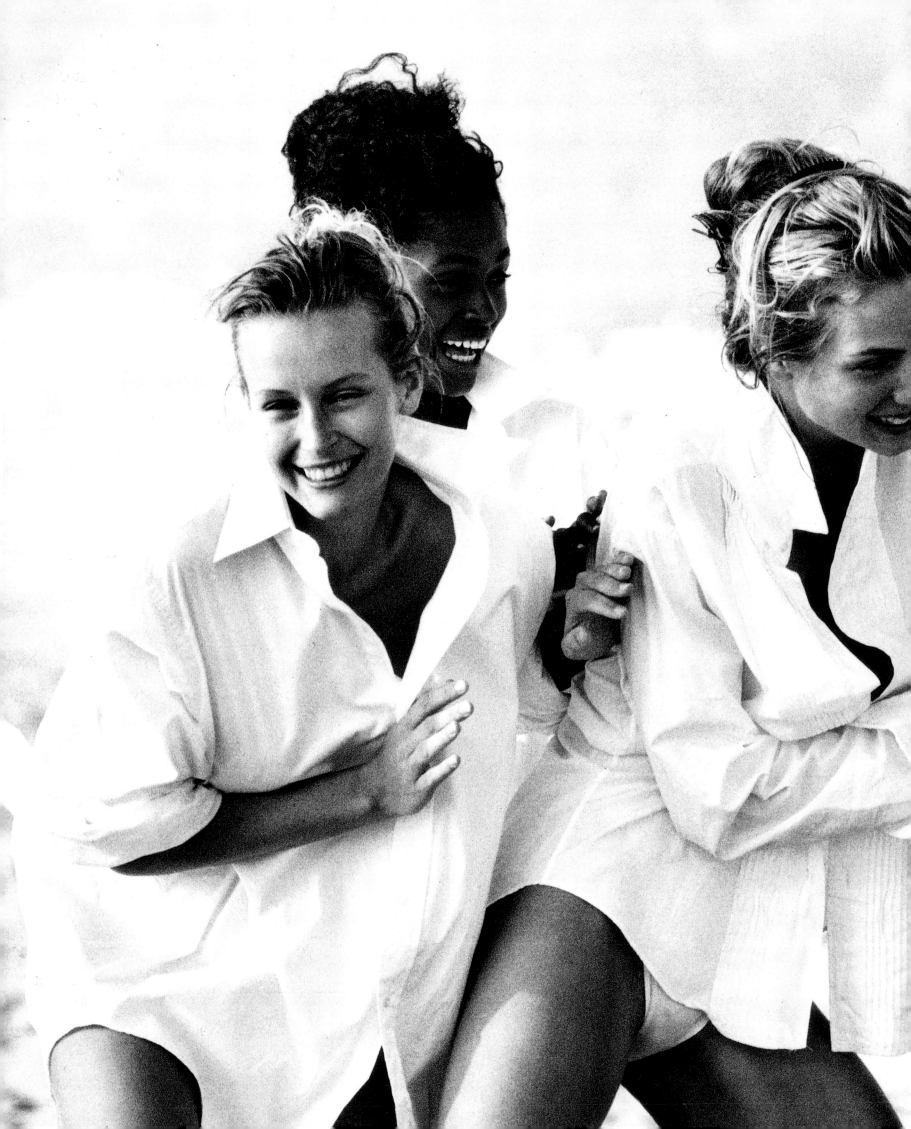

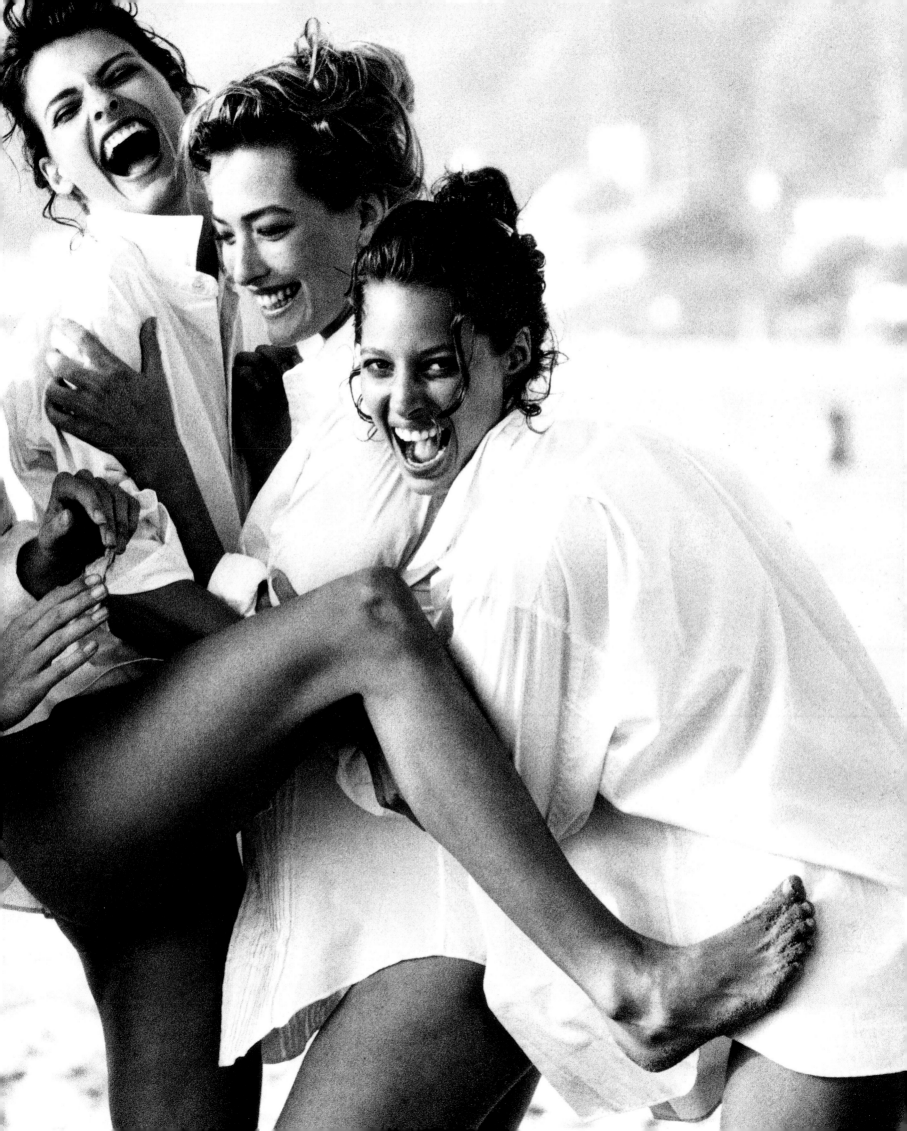

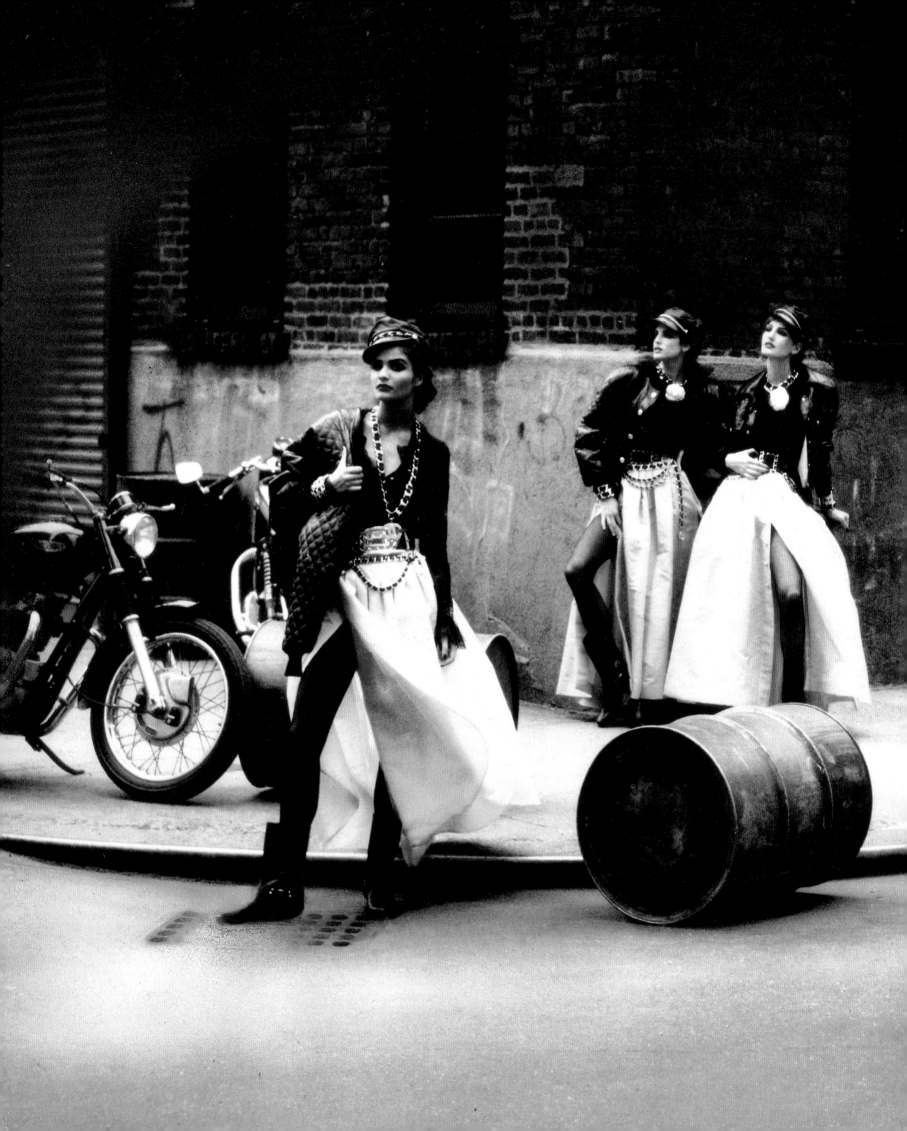

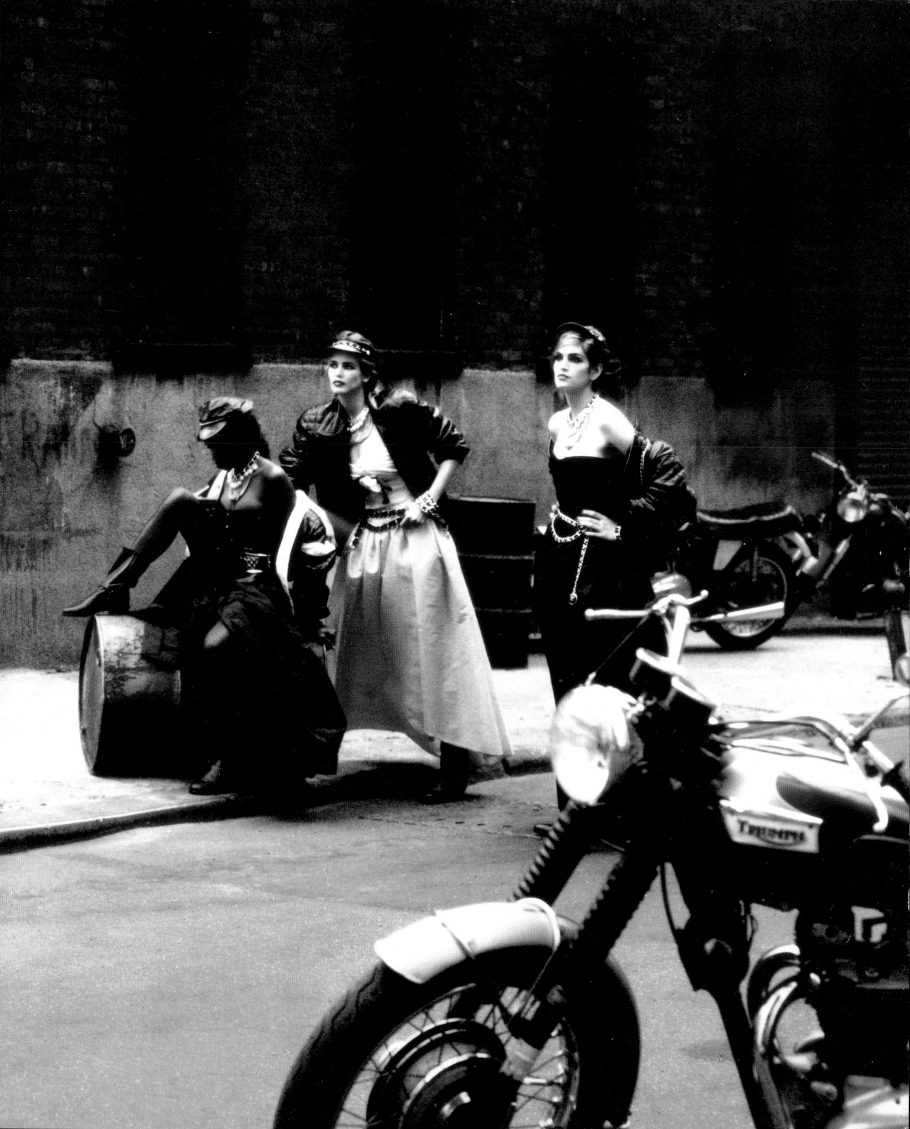

In the 1940s, about halfway into the remark-
able, now century-long history of *Vogue*, the
magazine published one of its many thousands
of portraits of creative artists: Henri Matisse, in
old age. He is sitting up in bed at home in Pro-
vence, tranquilly using a big pair of scissors to
make those paper collages that were given to
him as a coda—a late blooming of shape and
color—at the end of his life. With his neatly
trimmed gray goatee and his wire spectacles, he
looks like some respectable professional man in
Freud's Vienna. Although his legs are under the

bedclothes, his top half looks very proper in a starched white collar and a carefully tied four-in-hand. There is something endearing about that tie. ("Go for the details!" Diana Vreeland, the dramatic *Vogue* editor, would say to the photographer Horst P. Horst.) The formal touch serves to keep us at a distance as we spy on Matisse bobbing down the years on his magic bed—wise as any Prospero, innocent as a child—and also to make us intimates of his household, to draw us in. For he must have chosen and knotted his tie with particular care, on that vanished sunlit morning, knowing the man from *Vogue* was to come and take his photograph.

I'm glad Matisse is here. Anchored, harmonious, this old chap with his tie and his scissors. He's reassuring, somehow. So much, beneath the perfect surface of these pictures *Vogue* has collected from its archive—fetched up from the image-stream of the twentieth century—seems to quiver with jaggedness and pain. When I first saw the photographs together, I felt quite sad. So many forgotten faces looking back at me; so much spirit, power, and beauty; so much struggle between the pure and the corrupt. I remember understanding in a flash, years back, that "fashion" could have this spiritual dimension, a kind of fieriness. I was talking to the photographer Richard Avedon, in his kitchen, and he was telling me about Gloria Vanderbilt, when she was barely more than a girl and married to Stokowski still. Presenting me with the memory as if it were a museum-quality print, Avedon told how he had called at her house on Gracie Square, after midnight one New Year's Eve. As the door was opened, he had looked up to where she came to greet him from the head of the stair. She wore a Charles James, with a tracery of silk lilacs over her bosom. Her black, black hair fell to her waist; the light shone on her in a particular way. "I have never forgotten it," Avedon said. I knew then—knew, from the way he looked as he spoke, that *he* knew—the danger, the terror in seeing things like this. "An aberration, a burden, a mystery," was how Diane Arbus spoke of Beauty. Naturally, if you've seen it even once, you want to push a button and try to make it happen over and over again. And then, around all this, especially in America, there's a lot of money to be made.

Condé Nast, who created *Vogue* (in partnership with his editor, Edna Woolman Chase), knew all about the radiant moment, and how to make it pay. He was well versed in yearning and understood the perpetual pebble of dissatisfaction even in expensive, handmade shoes. He grew up in St. Louis, quite poor, but with a grandparental mansion that he would be taken to visit as if to a castle in a fairy tale. He became an innovative publisher, first of *Vogue* and then of the famous *Vanity Fair*. He was one of the great early-twentieth-century American merchants of dream. His father, although a scamp and a runaway, came from a family of prominent Methodists; on his mother's side, Condé's people were Catholic. Mrs. Chase, for her part, was raised by Quaker grandparents in Asbury Park, New Jersey. "Between us . . . we showed America the meaning of style," Nast said with satisfaction before his death in 1942. A Victorian in many ways, he was puritanical in his working habits, and liked nothing better than talking business with Edna over dinner at the Automat. He loved statistics of all kinds, and firing off memos. He invented the idea of "class" publications—drawing a line around his magazines and convincing advertisers that his readers formed an exclusive circle of taste, now to be reached directly. Like others who have sustained long careers around the ephemeral idea of fashion, he was a perfectionist who demanded absolute control. He also loved beautiful women, well-born people, and European objets d'art. In the twenties and thirties, he threw amazing parties in the thirty-room Park Avenue apartment that his friend, the famous decorator Elsie de Wolfe (later Lady Mendl), had done over for him in the grand style. People liked to think it was Nast who had invented "Café Society" by seating George Gershwin next to Mrs. Cornelius Vanderbilt.

Now the twentieth century is at the cusp. Time is rushing, smashing, snipping off the historic high culture, all the time. The ocean turns over, as they say. Who knows what comes next? *Vogue* was born in 1892, in what was still Edith Wharton's New York. The magazine was launched by and for people whose names were in the Social Register, the city's elitist "Four Hundred" families. (Four hundred would fit in Mrs.

Astor's ballroom at one go.) Condé Nast acquired the "dignified authentic journal of society, fashion, and the ceremonial side of life" in 1909. A hundred years on, it is the world of Nast, the onetime outsider, that seems to prevail: a more permeable, rootless, and democratic elite of looks, talent, image, money, and success. Nast may not have created the shift, but he certainly grasped its consequence, standing at the center of his world (a correct, bookkeeperly figure in pince-nez, never entirely at ease at his own parties) and guiding the flow of people who contributed to and appeared in his magazines and who moved between his office, photographic studios, and the Versailles-like rooms on Park Avenue.

The camera changed everything. Morally, politically, culturally, the critic Harold Rosenberg once observed, we are affected. "The camera has thrust us into a man-made world composed of fictions beheld by the eye and facts about which we are in the dark," he wrote. At any given moment, we know more about the present—its sufferings, its entertainments—and forget history faster than ever before. *Vogue*'s long, distinguished, copious contribution to the image-stream (mostly photographs of attractive women wearing the latest fashions, portraits of prominent people, and still lifes) has, unlike reports of wars or famines, license to be "fiction." A fashion photograph is not expected to *mean* a great deal. Not for nothing does Surrealism recur so often in the history of fashion photography. Salvador Dali crops up several times in this book. "A Surrealist is a man who likes to dress like a fencer, but doesn't fence, . . . to wear a diving suit but does not dive," *Vogue* explained to its readers when Dali's portrait appeared. Deborah Turbeville, whose photograph of five skeletal and profoundly isolated-looking women (one of them apparently masturbating) in a run-down public bathhouse shocked *Vogue*'s readers in 1975, professed to have been surprised by the meaning people read into the work. "People started talking about Auschwitz and lesbians and drugs," she said. "And all I was doing was trying to design five figures in space."

If fashion is licensed to divorce itself from meaning, it is also in an ambivalent, if not openly hostile, relationship to its past. In order to protect its power in the present, fashion will ruthlessly cold-shoulder yesterday's talent, yesterday's look. (Until the look is ripe for appropriation, at least.) Each original fashion idea, if compelling, is copied a thousandfold, and our perception of the original is changed. That's just the way it is, with fashion. The previous can never quite compete with the moment when the skin of the present bursts open to reveal the new. Perhaps that's why the history of dress, however brilliantly presented, always retains an odor of mustiness. Against this background of meaninglessness and ahistoricism, then, the most powerful women's-fashion magazine in the world celebrates its century in pictures, bold as brass. And a wealth of meaning emerges, a poignant essay on Time. Severed from their original moment (the lights, the pose, the shutter-click), these photographs rearrange themselves in a new collage—each suddenly equal to its neighbor and interrogating it. Brigitte Bardot and Winston Churchill; young Mick Jagger, old Colette; naked Charlotte Rampling meets the eye of Gertrude Vanderbilt Whitney, with her Edwardian monobosom and her frock by Léon Bakst.

These images have slipped their erstwhile moorings in the back issues of *Vogue*. Old commercial tags and credits no longer weigh them down. The lipstick shades are discontinued; the hat designers' names are forgotten; the once-exclusive stores have closed their doors. Gone are the texts that used to accompany the pictures—mitigating or chuckling at the visual messages, unreeling across them like eccentrically translated subtitles in a foreign film. ("The secret of looking great in a maillot . . . is knowing which one to choose," read the copy adjoining Turbeville's bathhouse, as if reassuring, calmly clicking its knitting needles in the shadow of the avant-garde.) That delirious, perfumed prose of the old *Vogues*—exclamatory, triple-dottily telegraphic, like a note dashed off on one of the transatlantic liners so central to photographers' and readers' imaginations between the First and Second World Wars—is stilled. Absent, too, are the sometimes quite feminist essays of recent decades, the urgent call for women to cultivate their independence and integrity. (A call sometimes contradicted

by photographs of objectified, vulnerable, scantily clad women in an atmosphere of urban violence and sexual pain.)

The former frame falls away, then, leaving us with this collection that is something like a family album—ours, the culture's, *Vogue*'s. A dazzling number of talented people have been affiliated with *Vogue* down the years, and some have sustained long careers there. As befits a flamboyant and creative enterprise—"a journal of the ceremonial side of life"—*Vogue*'s history is full of ambitious, impossible romantics; of empresses, kings, and courtiers; of tantrums, betrayals, and abrupt beheadings. (Virginia Woolf was troubled by the fate of her friend Dorothy Todd, sacked from the editorship of the British edition, in the twenties. Mr. Nast was more interested in Fashion, Society, and his profits than in acting as patron to Bloomsbury and Gertrude Stein.) In spite of—because of—its emotional intensity, *Vogue* has been able to inspire great loyalty and to sustain successive generations of photographers and editors, even while goading them along the dizzying edge of shock and risk. Edna Chase served *Vogue* for fifty-seven out of the eighty years she was alive. Alexander Liberman, currently editorial director of Condé Nast Publications (owned, for the past thirty years, by the family of S. I. Newhouse), joined *Vogue* in 1941, a Russian emigré from Paris. A formidable artist in his own right, Liberman took over as art director from Dr. Mehemed Agha in 1943, the year the photographer Irving Penn also arrived at *Vogue*. Leo Lerman, who as *Vogue* features editor commissioned many remarkable portraits of artists and writers, is a long-standing Condé Nast family member, as is Polly Allen Mellen, probably the last of the grand, ladylike American fashion editors in the tradition of Mrs. Chase and Mrs. Vreeland. For Mr. Liberman, Mr. Penn, Mr. Lerman, and Mrs. Mellen this book is truly a family album. Between them, they have known—or known others who knew—everyone in this book, no doubt. There is no substitute for living memory.

"The complete falsehood, the artifice intrigued me," Cecil Beaton once said of fashion photography. The power of the present collection comes from the contrast between that "falsehood" and the truth—between the repeated attempt (heroic, hopeless, human) to lock in the moment of perfect beauty and arrest the impassive movement of Time. All these women at the height of their beauty are in silent confrontation with the portraits of "real" people, palpably gripped by mortality. All the artifice in the world, these pictures cry, is powerless in the end. The Parisian Jean Cocteau, that master of style and friend to sailors, is seen here in a chilling portrait by Irving Penn, who was at the time an idealistic young man not long in New York from Philadelphia. Cocteau is said to have rehearsed a bon mot to use on his deathbed ("I want my money back. I didn't understand a thing"), but in the end said simply, "Mother." So many pairs of eyes gaze out here, at us or is it at the camera? Or slide away. Look! Look, you Blumenfeld girls with arrogant mouths and cold, hard eyes. Draw back the veil and see what became of chipper little Mrs. Dorothy Parker. Ingmar Bergman can see, hides what he knows from the casual and prying, sees what the future will bring, on the screen inside his lids. Roll backward, Time, and freeze. Give back Jack, an unsullied, sunlit boy in espadrilles (Details! Go for the details!) in that far-off garden, with his sisters. Stop! Young Mrs. Richard Burton, in your comfy old fleece robe, don't play that card. And Marilyn. There is another way. To live. Get out of bed and wash your face. Don't trust that guy with his case of booze and his sneakers.

The fashion world's a dangerous place. The most vulnerable don't survive it. "An uneasy mix of art and commerce," *Vogue*'s current editor in chief, Anna Wintour, once called it. Over this hundred years, many of the artists who have been drawn to the radiance have singed their wings or crashed. The love of physical beauty and of finery is a grand and innocent thing, as natural to the human race as the urge to have sex or to worship. Penn's New Guinea brides tell us this, so feathery and trusting. Gently, they rebuke our culture for mechanically pushing the beauty button, for exploiting the sacred. Beyond the gorgeous tableaux, we may find many warnings. Insiders always know the tales behind the photographs. "If only I were free to tell you what really went on," the hairdresser who worked on the shoot will say, with a sigh.

The Baron de Meyer, revered and rewarded by Nast for those romantically lit Society ladies shimmering like "Whistlerian nocturnes," wandered into the night-dark of opium and cocaine and ended a broken man, begging Mrs. Chase for a handout. Charles James, the impossible American Balenciaga, died penniless and hating. Poor Halston made a sweet little hat for the girl who married the sunlit boy (the same Miss Bouvier who won *Vogue*'s essay prize in 1951) and some tender, woman-friendly clothes before he jumped the tracks and lost hold even of his right to call himself "Halston."

Condé Nast himself came to learn the strain of living by panache alone after he lost control of his company in the crash of 1929. His debt was passed from hand to hand between the money men, who couldn't understand why he refused to lower standards of printing and production, why he went on giving the amazing parties. As the end of his life approached, he kept more and more statistics, fired off salvos of memos in a kind of frenzy. To a woman who visited him at home he showed his scrapbooks filled with famous faces, some already forgotten. He waved at the European objets—the paintings, the mirrors, the ormolu, the boulle, the priceless things around him. "I used to own all this," he said.

Irving Penn and Richard Avedon, the giants of this collection, have most consistently—in two quite individual ways—expressed in their work the mixed feelings of any true artist around the worlds of style and fashion. Fashion magazines made them both. ("A photographer without a magazine behind him is like a farmer without fields," Norman Parkinson once said.) These two large, tenacious, productive talents are linked by generation—as young men, they started at *Harper's Bazaar* (Avedon) and *Vogue* (Penn) in the dynamic postwar New York artistic moment—and by having made room for the shadow side of style, as well as the light. Avedon was probably the most inventive fashion photographer ever, a skillful negotiator in the "uneasy mix" and the minefield between photographic risk-taking and the magazine's need to "report the dress." As his career advanced, his work deepened and darkened through his studies of "real" people, some of them seen here.

Irving Penn has been continuously connected with *Vogue* for almost half its century, and we may see in this collection an overview of his life's work: the fashion photographs; the compassionate, consolatory portraits; the ethnographic studies; the still lifes. His shots of the Paris couture in 1950 and 1951, often modeled by his wife, Lisa Fonssagrives, are cultural icons. They convey a knowledge of art history, composition, and form; a respect for the beauty of women and the expressive quality of dress that has rarely been matched. There's a feel for the moment that's almost too intense to bear. Before the gloved wrist, the cascade of tucks, the chef's-toque gathers on a coat sleeve. Penn is like a Zen monk meditating before a flame. As a safety valve, perhaps, he turned to different ways of being, different kinds of style. He went from his first (and last) location fashion shoot in Lima to photograph the mountain people of a remoter Peru, including the two dignified, raggedy children seen here—two miniature adults, like a Velázquez prince and princess in a Spanish court. Then he took his portable studio and contemplated other far-flung members of the human family: women in remote Morocco and masked mud men in New Guinea, as well as those feathered brides. The fashion world, which prides itself on being knowing, is sometimes shut off by vanity from knowing vital things. Penn's small, impoverished Peruvians connect us with the other kind of knowledge, as do his wary old codger in Crete, his platinum-print cigarette butts, his then-and-now poppies, and his ancient-looking mouse.

We don't demand of a family album that it document the outside world. We pick up the great events of *Vogue*'s epoch largely through hints and clues. The First World War appears as a social disruption ("There does not promise to be as much yachting at Bar Harbor during the summer") and of slightly less importance than the Ballets Russes. We deduce that women have got the Vote by Steichen's modern, best-foot-forward creature (unmarried, unchaperoned, perhaps) out on the town with a man. The hardships of the Depression and the menace in Europe are felt by their absence, by the energy high fashion (and Hollywood, a great influence on fashion) seemed to be

expending on opulent surface, on trying to escape. In 1933, *Vogue*'s correspondent went to Rome ("the Fascisti black shirt is starched for evening") and in 1936 she paid a visit to Mr. Hitler's country retreat ("a cosy podge of clocks, dwarves, and swastika cushions").

The chatter went on round Lady Mendl's lunch table to the last, Elsa Schiaparelli saying she "just knew by instinct" that there would be no war. War came. Paris fashion was cut off from New York. (*Vogue*'s French edition was shut down until after the Liberation.) The *Vogue* photographers did their bit. Cecil Beaton, in the North African theater, treated it as just that—contriving to make soldiers and matériel look very like his shots of "Schiap" in her suit, and a landscape by Dali. Steichen (who had left *Vogue* in 1937, sickened by the way sex was being used to sell face creams in the advertisements) formed a special photographic unit of the U.S. Navy and made high-clarity eight-by-ten plates of young sailors and airmen in images of innocently muscular male bonding that would make Bruce Weber weep. And Lee Miller—*Vogue*'s own Miss Miller, part of the family...such a charming model for Hoyningen-Huene, the dear baron...who'd taken herself off to Paris to live with Man Ray and learn the secrets of taking pictures—got herself accredited as a war photographer. From the defeated Germany she radioed back artless images straight out of Hieronymus Bosch. For *Vogue* to have published them then was remarkable, and for the editors of this book to reproduce them here can have been no simple decision. In a collage like this, everything gets pulled toward the center to a morally neutral terrain of look and style. Penn's mud men, Avedon's Charles Ludlam, Kristine Larsen's street people are less about tribal ritual, theater, or homelessness than they are about the community of style. But the Holocaust is separate. Beside the corpses of Buchenwald, there is no other "edge" the human race can know.

In the main, *Vogue* has been a good friend to women. Many women have made their careers there, beginning with Mrs. Chase. And the student of women's history will find much to learn from the pages of *Vogue*, although much of the evidence is in code and not all the news is reassuring. "Fashion photography has played an extremely important role in the emancipation of women," Alexander Liberman has written. As women stepped out of the boundaries of home and a small social circle, the move was mirrored by the style and layout of *Vogue*. Where, at the outset, well-born matrons stared in black and white from oval photographs framed by a trim known as "spinach," at the end of the era very young, mind-bogglingly rich professional models "bleed" to the edge of the page in brilliant color. Between the two, like an always-humming tension wire, stretches the story of modern woman, trapped and free. Beautiful, vulnerable, in the intimacy of the studio, with a photographer as protector; or out in the world in a thousand risky ways—under water in an evening dress, mummified in Monument Valley, or with a cyclamen-colored coat and a Great Dane in the the rush-hour traffic of New York. Here are women draped in pearls, but confined to quarters like Schéhérazade, or loaded with diamonds and in a spiritual hell disguised as Monte Carlo. The image of a solitary young woman surrounded by exotic territory and charming natives—an image with which *Vogue* was familiar from the days when teams would set off on shoots that lasted weeks, like colonial safaris—was what came to mind when it tried to cope with the idea of Vietnam, running photographic features on the correspondents Gloria Emerson and Frances FitzGerald.

In exchange for providing a record of women's enormous progress, the camera exacted a price: that women look young and thin, the way they could best serve its requirements. "Slice the hips! That sag must go!" Beaton would yell at his retouchers as they revamped the portraits of his ladies. As we approach the end of the twentieth century, the fashion in women's faces is, as it has long been, for unwrinkled smoothness. And in women's bodies, the fashion is now for a combination of hard, muscular stomach and shapely breasts. Increasingly, women are willing to regard their bodies as photographic images, unpublishable until retouched and perfected at the hands of surgeons. Although many of the most significant women of our age have been heavy-set, middle-aged, or even elderly, these types are underrepre-

sented in the present visual record. And it has often been observed that the two explosive moments of female emancipation—the twenties, when women got the Vote, and the sixties, when they got the Pill—immediately produced a feminine ideal (the flapper, Twiggy, Penelope Tree) that was childlike, androgynous, and unthreatening.

From the abundant, idealistic, generous, and violent moment of the sixties (which ended somewhere around the mid-seventies) *Vogue* was left with nakedness. Small boys who had once searched the *National Geographic* now looked to mother's fashion magazines for information. To some extent, fashion photography has always been about sexuality—with the odd twist that these sometimes voyeuristic images of women in "private" moments are created (by male photographers, often) for consumption by other women. In the 1970s, in the increasingly fierce competition for the reader's sated eye, fashion photography began to explore previously taboo images of sexuality, including sadomasochism, transvestism, and lesbianism. The photographer Helmut Newton, in particular, regularly upped the ante in *Vogue* with his obsessive, dark observations of the place where eroticism meets domination, submission, money, and power.

Long before American *Vogue* was publishing Newton, who had grown up in prewar Berlin and who lives in Europe, the magazine was mirroring its homegrown versions of one of his favorite themes: the power relations between the clothed and the unclothed. Clifford Coffin's wonderfully evocative 1950 photo of the primly dressed Jean Patchett and the semidressed Ernest Hemingway probably provoked little or no outcry from contemporary readers. Newton's 1975 image of Lisa Taylor giving a faceless, shirtless male sex object a predatory eye as she sits in an unladylike posture (in an outfit as prim as Miss Patchett's) provoked tremendous response when it appeared in *Vogue*. Yet the Newton version feels much less "real" than the scene between the governessy Miss Patchett (like Lisa Taylor, a top model of her day) and the hirsute, big-bellied, barefoot American literary man. That she senses herself to be in dangerous territory (one that many women will recognize, seeing the photograph)

may be deduced from the way she clutches the small furry animal in her lap. Miss Monroe, both in the scene with the fully clothed Bert Stern, and all "alone" behind the famous smeary cross by which she indicated to Mr. Stern that she did not wish him to publish this image, seems to me, most clearly, a sexual victim, even if she opened the door to him.

Outwardly, for most of the time, American *Vogue* seems to believe in a sort of feminine Utopia of ever healthier, more flat-bellied, and thoroughly fulfilled young professionals. Much of the agony of modern urban life is glimpsed only out of the corner of the eye, or is as invisible as the breadlines of the thirties below the weightless flight of Fred Astaire. But fashion is a weather vane. In the end, there is no dissembling. In recent fashion images, *Vogue* has shown a face of female rage and fear unimaginable even ten years ago. Should we side with Mr. Dali, and find no meaning in those young women dressed in so much studded black leather? In the suffering age of AIDS, gay-bashing, and "wilding," what must we think of this gang of women in some dark alley with their Harleys, dressed in the costumes of hard-core pornography or a homosexual subcult or the violent, antifeminist Hell's Angels? Perhaps, out there shoulder-to-shoulder in their men's jackets and women's skirts, they are fighting back against some nameless enemy.

Top models make unprecedented amounts of money these days—almost up there with the boxer Mike Tyson, ten times more than the president. Yet there's a haunting Helmut Newton image of a model with long blond hair seen from the back as she sits on the edge of the bed in a hotel room. Beside her, making her look more lonely, somehow, stand the big black trunks with the clothes she will wear for her shoot. It's Newton showing one of his disquieting truths and also a rare compassion. The young woman is skimpily clad in a spangled dress—a dress for seduction. She waits tensely in this slightly seedy hotel room, a generic working girl, no face. On television, a middle-aged man in a necktie runs the world. Outside, there's the city of Nowhere, and it's dark. She's a beautiful young woman, at the end of the twentieth century. Marginal, in spite of all, and more vulnerable than ever. Out—way out—on the edge.

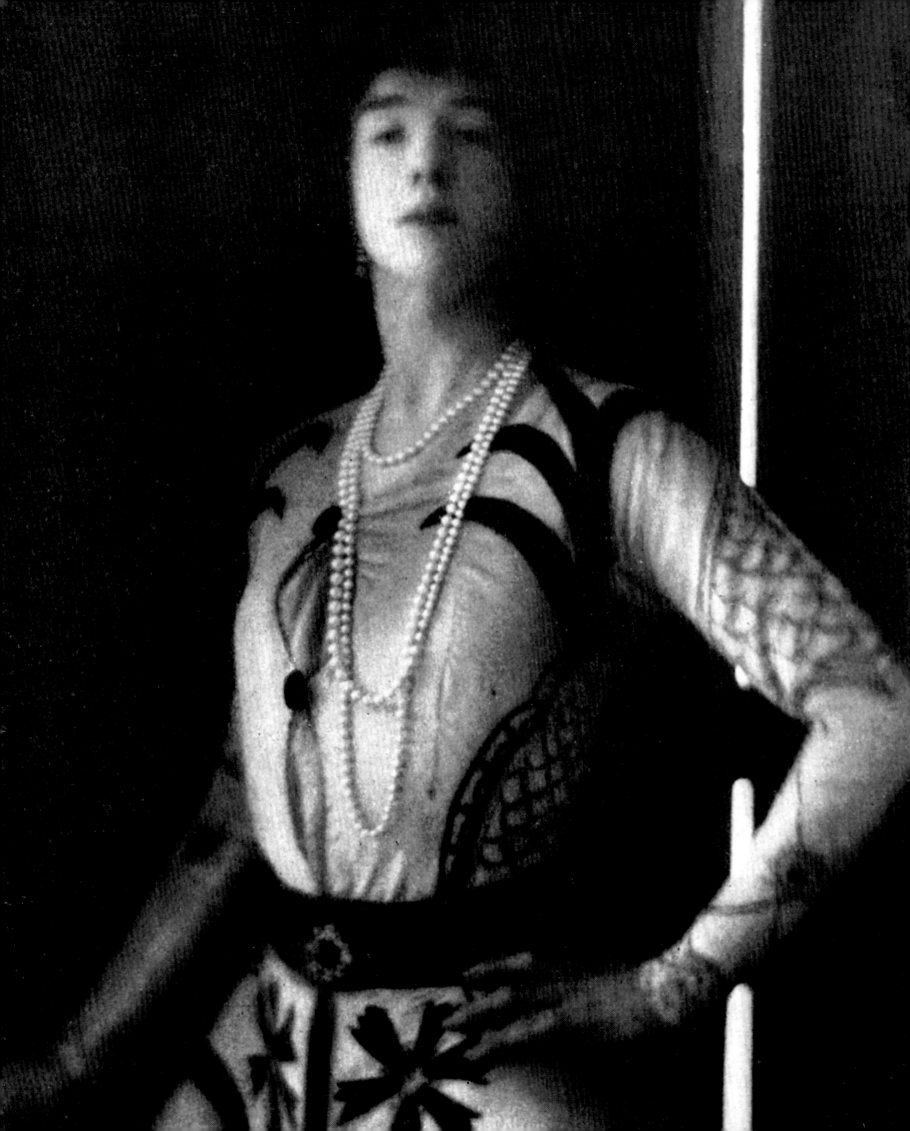

Fashion is general; style is individual Some people have it Some haven't

EDNA WOOLMAN CHASE, Vogue Editor in Chief, 1914–1952

"He was a great snob," Cecil Beaton noted of Baron Adolphe de Meyer, *Vogue*'s first regular photographer. And De Meyer's first photograph for *Vogue*, in the January 15, 1913 issue, exemplifies perfectly that fusion of class and chic and art that *Vogue* aspired to in its early years *(page 8)*. Gertrude Vanderbilt Whitney, "one of the prominent hostesses of New York," daughter of Cornelius Vanderbilt, who backed *Vogue* when it was launched as a weekly gazette in 1892, stares out imperiously from a glowing mist. She wears a "Persian" costume designed by Léon Bakst, the Russian painter whose decors for Diaghilev's Ballets Russes created a taste for Orientalism.

Gertrude Vanderbilt Whitney inherited a good part of one of the great American fortunes, and in the early thirties would both found the Whitney Museum of American Art and gain a certain amount of notoriety when she won the legal battle for custody of her niece, Little Gloria Vanderbilt. In 1913, Mrs. Whitney was leading the life of a society matron in her Fifth Avenue mansion and also the life of a bohemian sculptor in her Greenwich Village studio. *Schéhérazade*, the Ballets Russes ballet that inspired Mrs. Whitney's outfit, had opened to wild acclaim in Paris in 1910, and an unauthorized version was presented in New York the following year. "A whole debased and bastardized spirit of Orientalism was let loose," Beaton recalls. "Society women gave *tableaux vivants* dressed as Eastern slaves, with gold bangles on their ankles and headache bands over their eyes. Baron de Meyer took photographs of ladies in Paris and New York in a flash of gilt tissues and the metallic brilliance of the Orient."

De Meyer was a romantic, louche figure in turn-of-the-century Paris and London. He was married to a beautiful woman rumored to be Edward VII's illegitimate daughter, and was an early enthusiast of the Russian ballet and an avid photographer of Diaghilev's dancers. Although De Meyer had had a show of his work in New York in 1912, and had gained the attention of Alfred Stieglitz and the Photo-Secessionists, who were promoting photography as a legitimate art form, he didn't try to earn his living as a professional photographer until war broke out in Europe in 1914 and he fled to America. Condé Nast, who had become *Vogue*'s owner and publisher in 1909, put him under exclusive contract to *Vogue* and *Vanity Fair* at $100 a week.

De Meyer's view of fashion and society—photographs of shimmering and mysterious women who looked like "a vision in a dream or an apparition inside a backlit aquarium," as the photographer Hoyningen-Huene put it—dominated *Vogue* and *Vanity Fair* until 1922, when he defected to *Harper's Bazaar*. He was soon replaced by someone with a much more modern view of the world—Edward Steichen, cofounder with Stieglitz of the Photo-Secession Galleries. Steichen had been living in France, working primarily as a painter, but by 1923 he had decided to commit himself to photography. *Vanity Fair* had already dubbed him "the greatest of living portrait photographers," and he parlayed that encomium into an arrangement with Condé Nast.

Steichen's 1927 portrait of his favorite model in a Chéruit dress *(opposite page)* is "the key to modern fashion photography" for Alexander Liberman, editorial director of all the Condé Nast magazines today and a seminal force at *Vogue* since the early forties. "The picture really was a breakthrough," he recalled when asked to make a selection of exemplary photographs. "What I like," he says, "is that it is an immensely seductive image of a woman. She is alive. So many fashion photographers concentrate on the dress and throw away the woman." Steichen had not given short shrift to the dress—"The fashion showed very clearly"—but he had gotten at something more: "an image of a woman at her most attractive moment." The highly stylized De Meyer women had been replaced by the modern woman with a personality and sex appeal, in this case Marion Morehouse, who would soon give up modeling and marry the poet E. E. Cummings, in 1927 a regular writer for *Vanity Fair*. Morehouse was "no more interested in fashion than I was," Steichen wrote in his memoirs, and they were helped out in that department by Carmel Snow, one of the great *Vogue* fashion editors. Steichen's fashion shot of Morehouse as "the well-dressed horsewoman" in a rubber mackintosh *(page 14)* and his portrait of Katharine Cornell *(page 16)* as the heroine of Michael Arlen's play *The Green Hat* ("one of the sexiest stories ever unfolded in the theater," according to Walter Winchell) exude the physicality and humanness that mark his work for *Vogue* in the twenties.

Edward Steichen
Marion Morehouse in Chéruit dress
May 1, 1927

opposite preceding page

Baron Adolphe de Meyer
Gertrude Vanderbilt Whitney in Persian costume by Léon Bakst
January 15, 1913

Baron Adolphe de Meyer
Ann Andrews in horsehair braid hat
July 1, 1919

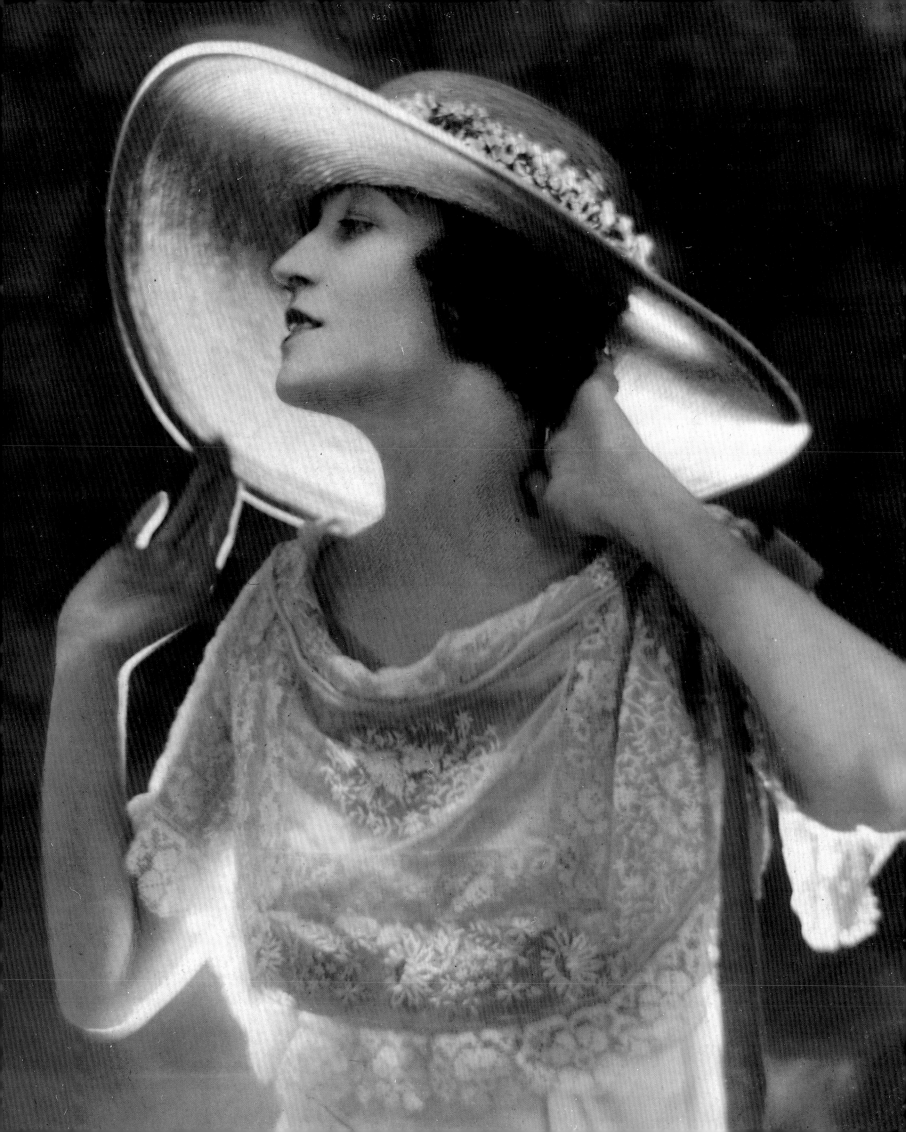

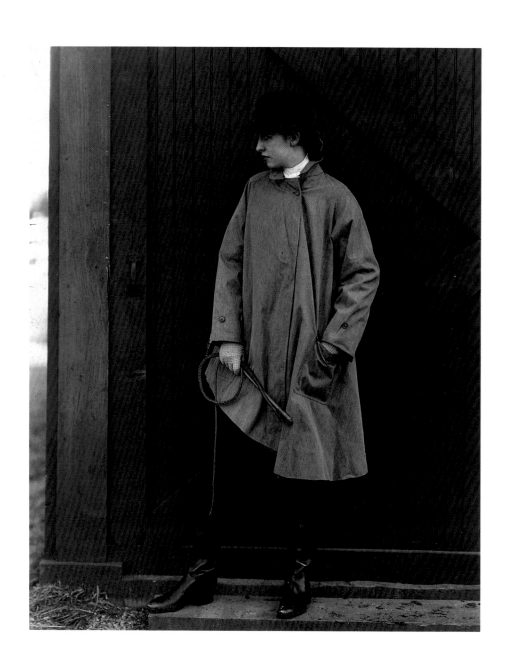

Edward Steichen
Marion Morehouse in rubber mackintosh
May 1, 1927

opposite page

Edward Steichen
Anita Chace in Art Deco shawl
June 1, 1925

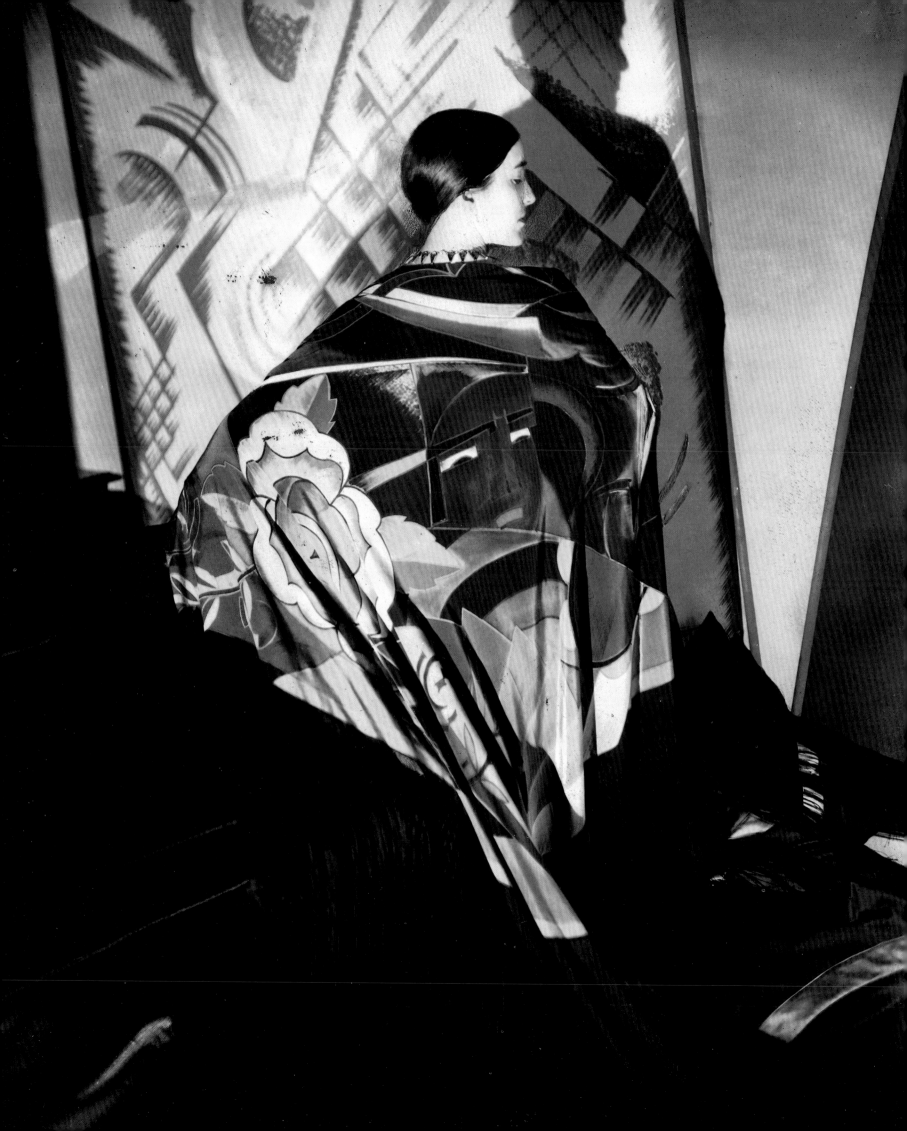

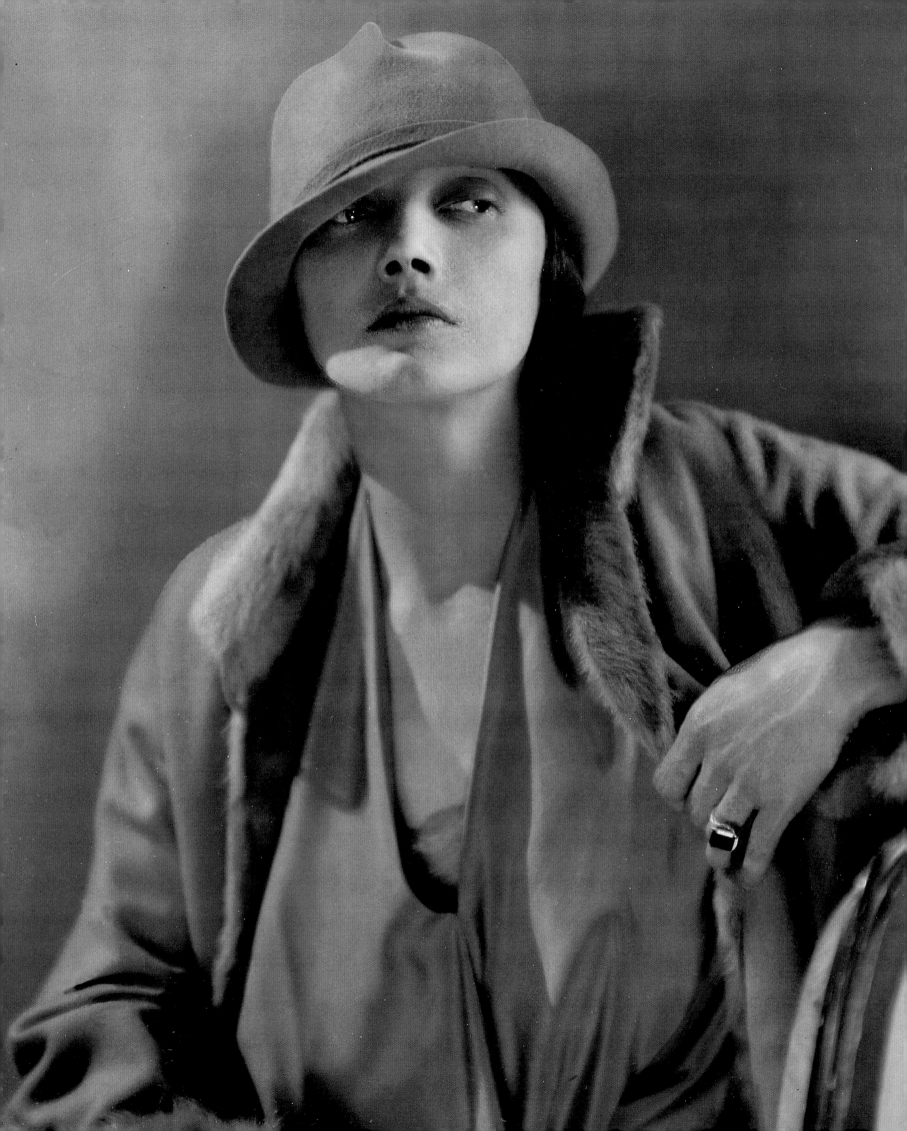

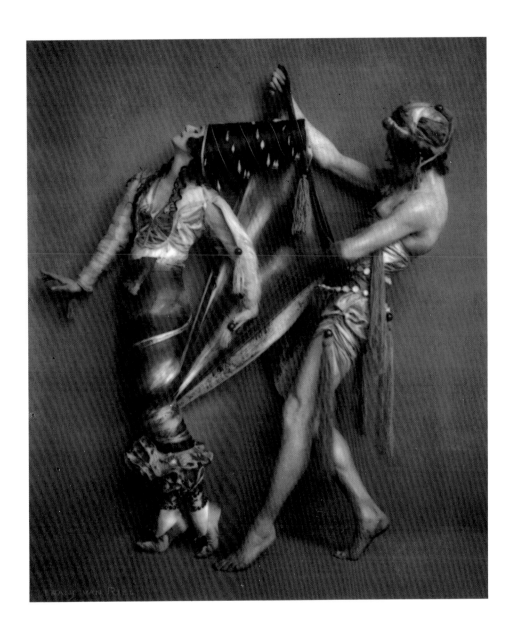

Frans van Riel
Anna Pavlova in Middle Eastern costume for her New York season
November 1, 1920

opposite page

Edward Steichen
Katharine Cornell, star of *The Green Hat*, in felt fedora
November 1, 1925

Edward Steichen
Gold sandals and patent-leather oxfords
December 15, 1926

"Baron Hoyningen-Huene was the most difficult star," Bettina Ballard writes in her memoirs of eighteen years as a *Vogue* editor. "He would walk into a sitting late, take one withering look at the model standing nervously in the dress he was to photograph, turn to the editor in charge, and say, 'Is this what you expect me to photograph?' snap the camera a few times, and walk away. Everyone was terrified of him except Mrs. Chase," *Vogue*'s inveterate editor in chief.

Huene was from a cosmopolitan St. Petersburg family. His father had been in charge of the czar's horses, and his mother was an American girl from Grosse Pointe, Michigan, the daughter of a high-ranking diplomat assigned to the court. The family fled Russia in the wake of the revolution, and young Huene ended up in Paris, where he studied drawing with the Cubist painter André Lhote and worked as an illustrator. His friends included Man Ray, with whom he collaborated in making a portfolio of the most beautiful women in Paris. In 1925, through the auspices of Main Bocher, then an editor in the magazine's Paris office, Huene was hired as an illustrator for *Vogue*, in spite of his reservations about "the dubious climate of fashion," and in spite of Mrs. Chase's reservations about his "typically Prussian" arrogance. "Somehow I was temperamentally unsuited to this work," Huene recalled later, and somehow he soon became a fashion photographer instead of an illustrator.

Huene's early work as a photographer was a struggle against slow film and cumbersome cameras. "There was that agonizing moment," he wrote in his memoirs, "after manipulating the ground glass in four directions and focusing on the subject, when the lens would be stopped down and the shutter was closed, then the insertion of the plate holder, removing of the plate holder cover, steadying the camera, and finally the exposure, the timing of which was guesswork as light meters had as yet not been invented. . . . No matter how fast we worked, the problem of creating an impression of movement seemed to remain insoluble." A benefit of the technologically limited equipment was that Huene "had to compose . . . upside down. This had the advantage of viewing the composition as a series of abstract elements."

Huene's primary frustration was that he couldn't render his models as they appeared in "real life." "Somehow the photographers had as yet not captured the attitudes and gestures that women assumed. The models seemed to freeze in front of the lens, as if posing for their portraits, whereas the top fashion illustrators would render them as they actually saw them. . . . Was there no way of achieving the same results with photography?" To compensate, Huene hauled into his studio the accoutrements of everyday activity—deck chairs, skis, even a car—and became incredibly inventive. The famous photograph *(opposite page)* illustrating swimwear by Izod, for instance, which appears to be shot from atop a diving board or on a platform overlooking the beach, was in fact taken on the roof of *Vogue*'s Paris studio. The models sit on boxes above the Champs Elysées, and the low, slightly out-of-focus wall around the edge of the roof takes on the appearance of the sea and the horizon.

The muscular young man at the end of the "diving board" was Horst Bohrmann, later Horst P. Horst, the son of a German hardware-store owner. He had come to Paris to study with Le Corbusier and ended up moving in with Huene and helping out with sets at the *Vogue* studio. He began taking pictures himself, and in 1935, when Huene and Dr. Mehemed Agha, *Vogue*'s art director, had a major blowup over lunch and Huene stalked off in a huff to *Harper's Bazaar*, Horst inherited his job.

Horst's elegantly composed, dramatically lit photographs from the thirties capture the spirit of the era. He moved in refined circles in Paris, with Coco Chanel and the eccentric and brilliant artist Christian Bérard his close friends, in a group that included the Vicomtesse de Noailles, Gertrude Stein, Luchino Visconti, and Janet Flanner. His 1937 portrait of Chanel on a couch in the *Vogue* studio *(page 24)* was her favorite. It was taken in a session she asked for after an earlier *Vogue* sitting had produced what Horst himself referred to as "a flop." Chanel showed up with a bag of her jewelry, which was laid out on a table so that she could choose which piece to wear. "This time she wasn't preoccupied with the photograph," Horst recalled in Valentine Lawford's book on his work. "She was thinking about a love affair with Iribe that was ending. You can see she's not paying attention to anything here—she's dreaming and thinking."

George Hoyningen-Huene
Horst P. Horst with model in Izod of London bathing suit
July 1, 1930

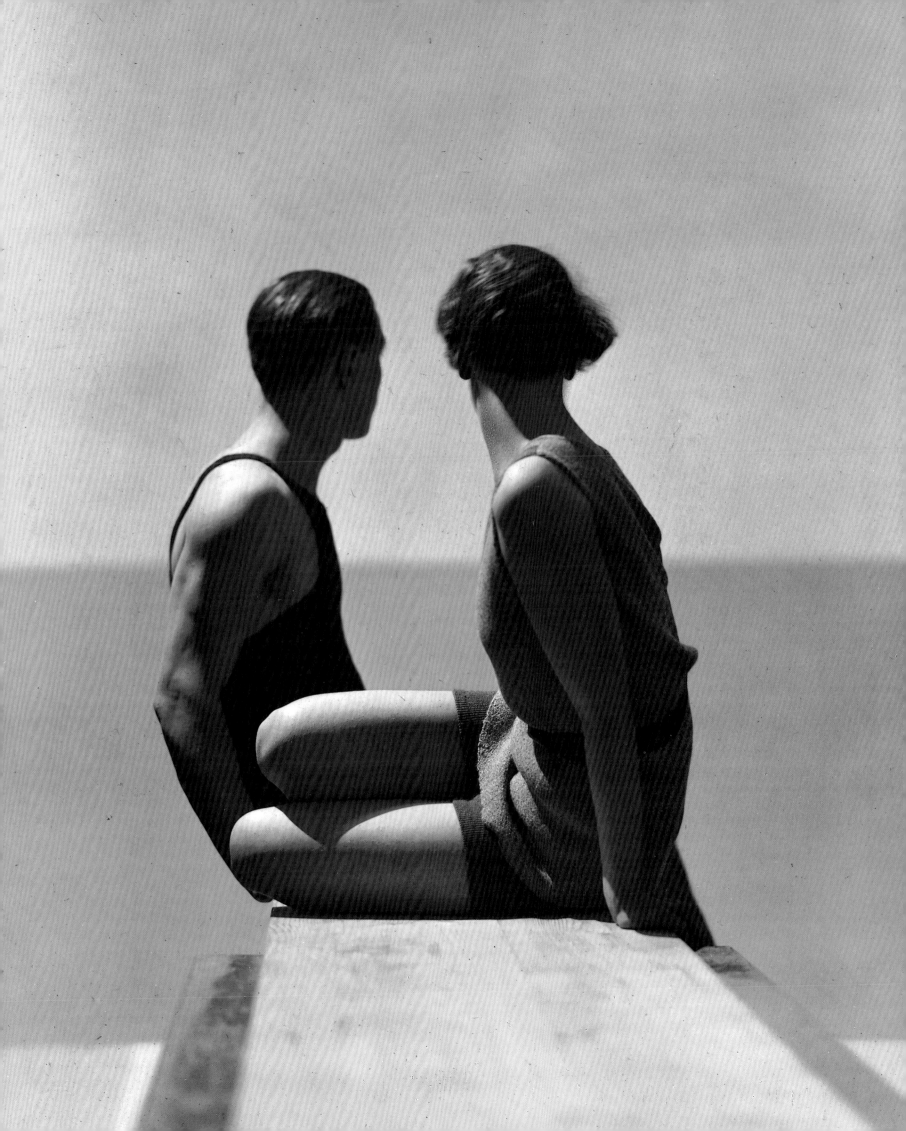

clockwise, left to right
Erwin Blumenfeld
Schiaparelli's harlequin hats
December 1, 1938

Horst
Maggy Rouff sequined sweater
and white crêpe skirt
December 1, 1937

Cecil Beaton
Schiaparelli coat
October 1, 1936

George Hoyningen-Huene
Evening dress by Augustabernard
September 15, 1933

Toni Frissell
White linen suit and Afghan hound
May 15, 1939

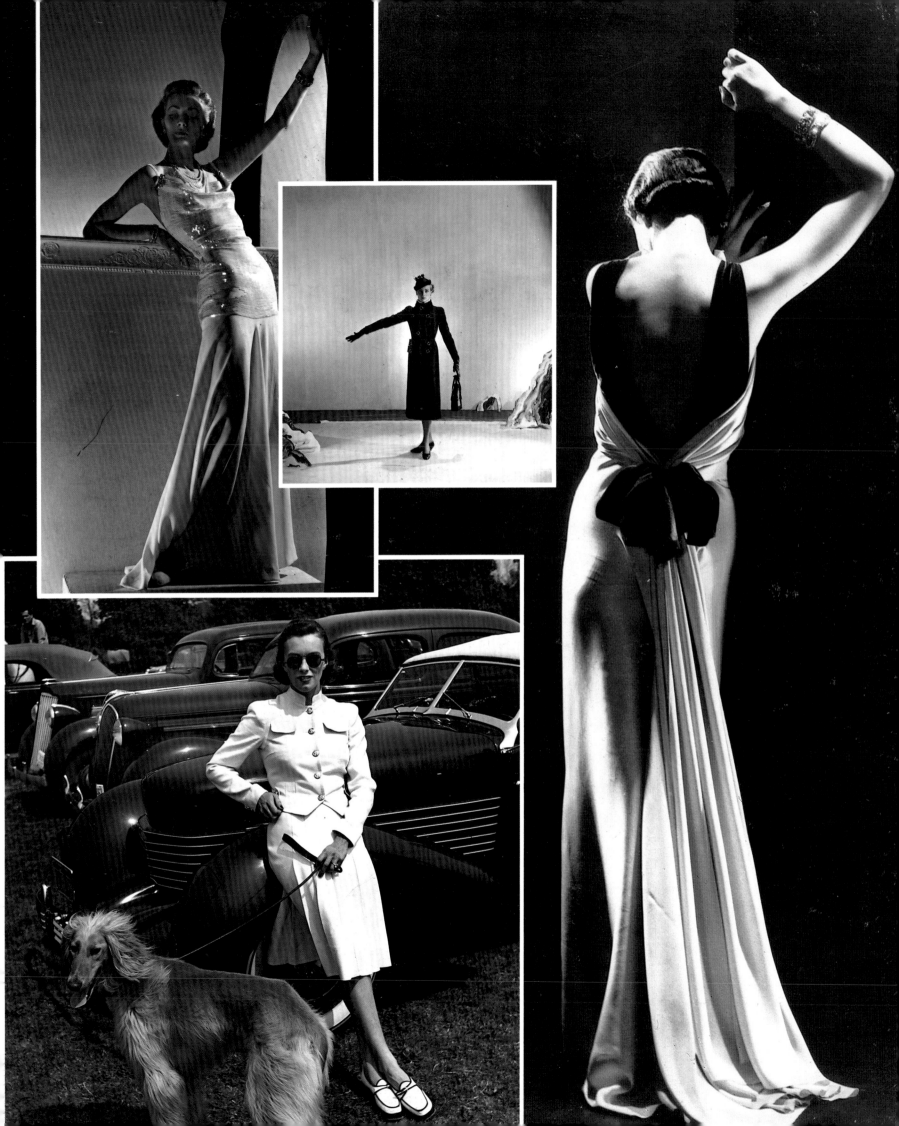

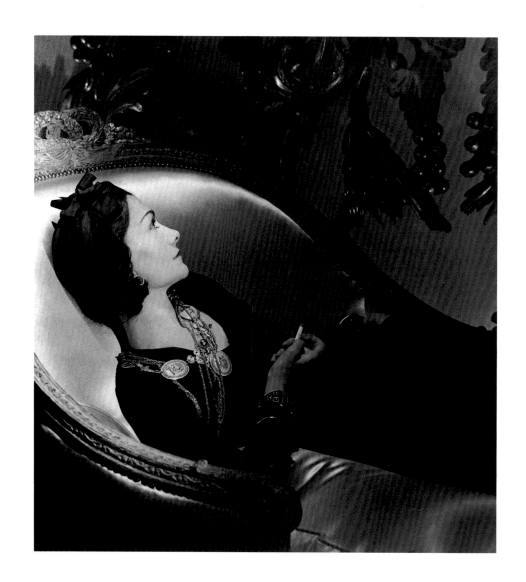

Horst
Chanel, 1937
February 15, 1954

opposite page

Horst
Corset
September 15, 1939

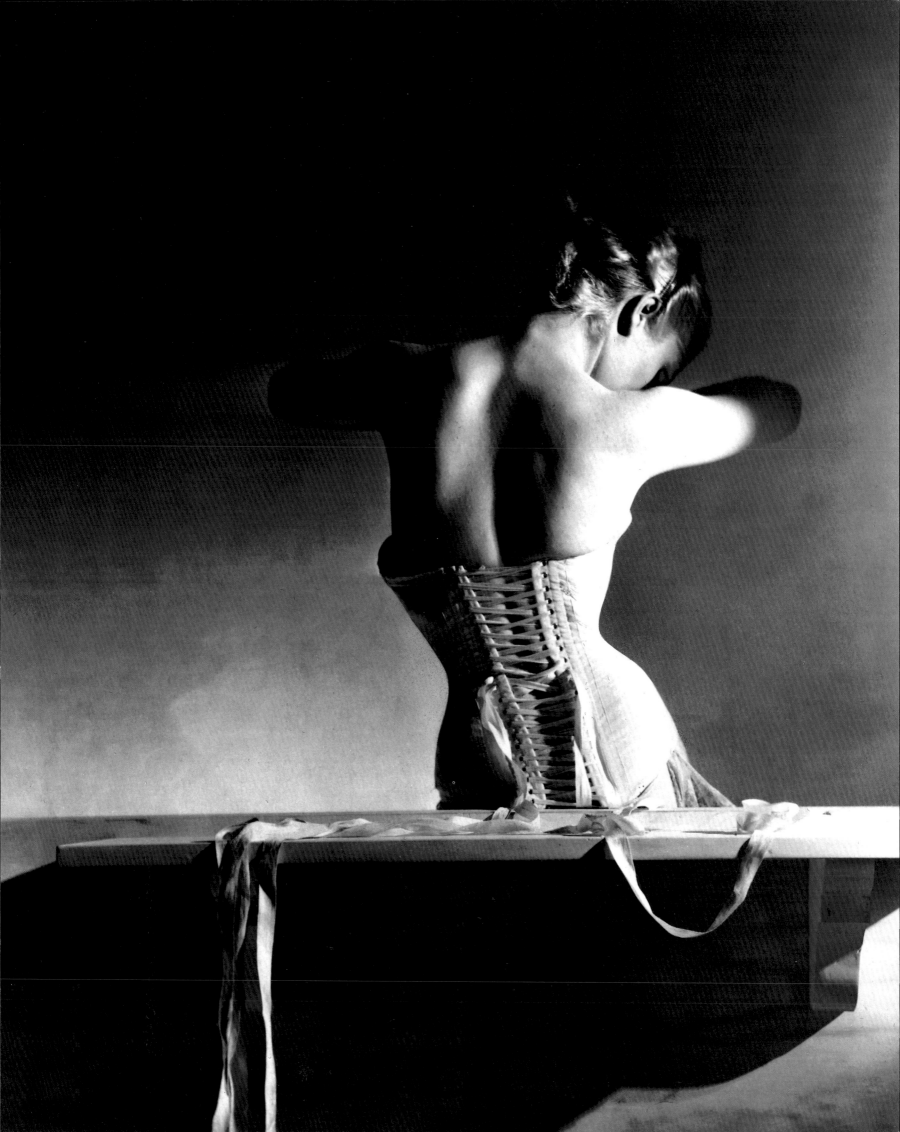

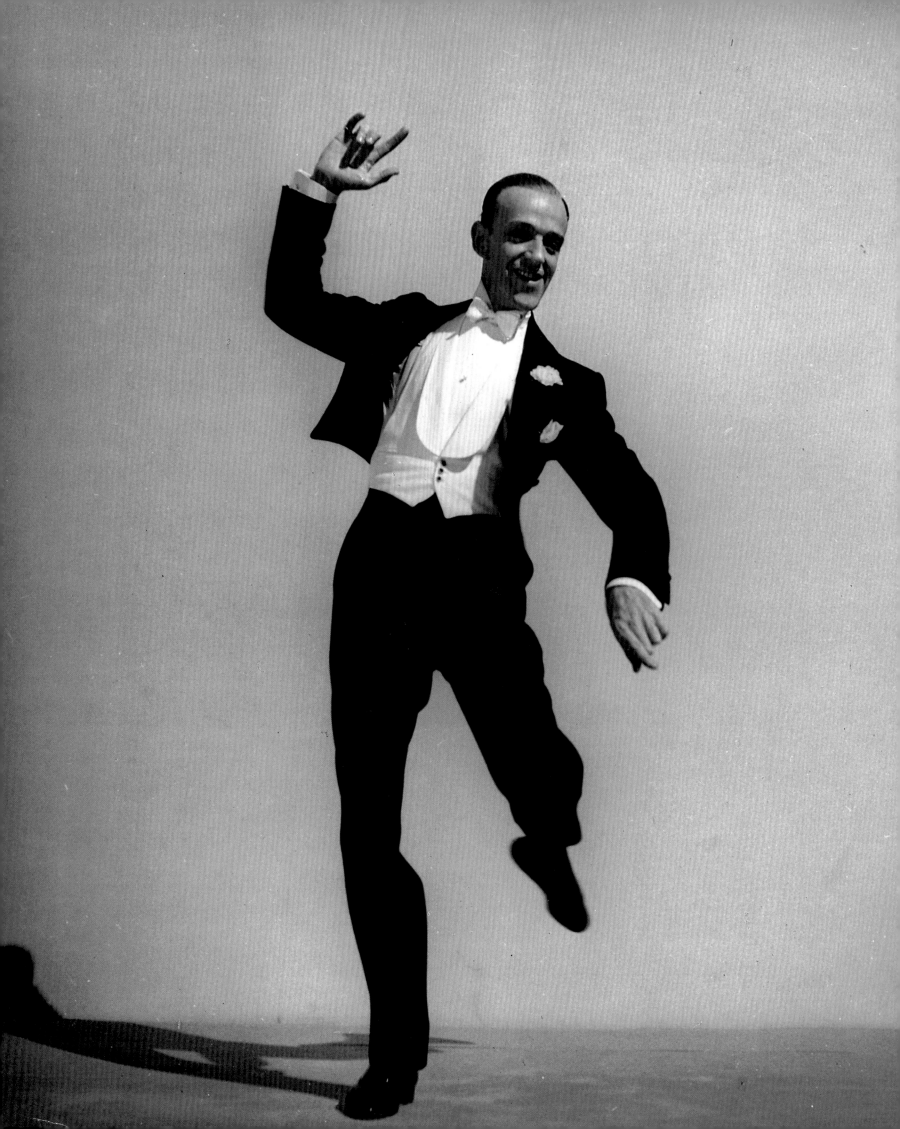

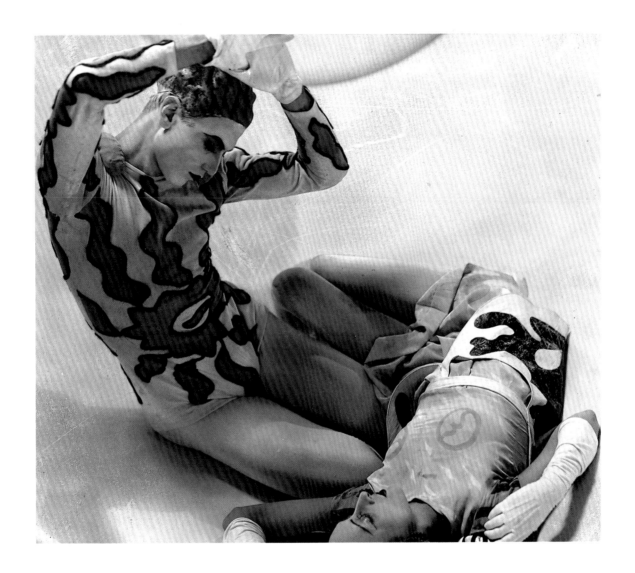

George Hoyningen-Huene
Serge Lifar and Olga Spessivtseva
in De Chirico costumes for *Bacchus et Ariane*
August 15, 1931

opposite page

André de Dienes
Fred Astaire as Vernon Castle
April 1, 1939

following pages

Cecil Beaton
Charles James capes and coats
November 1, 1936

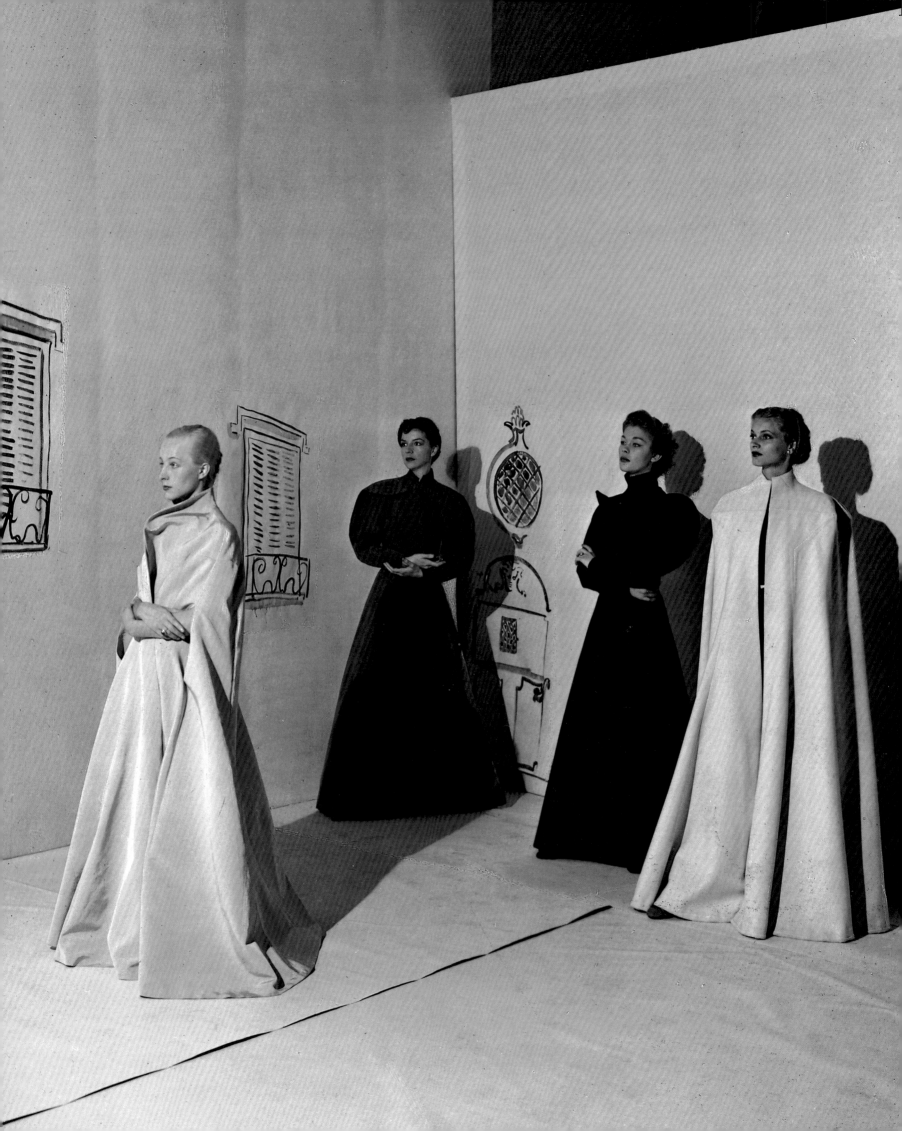

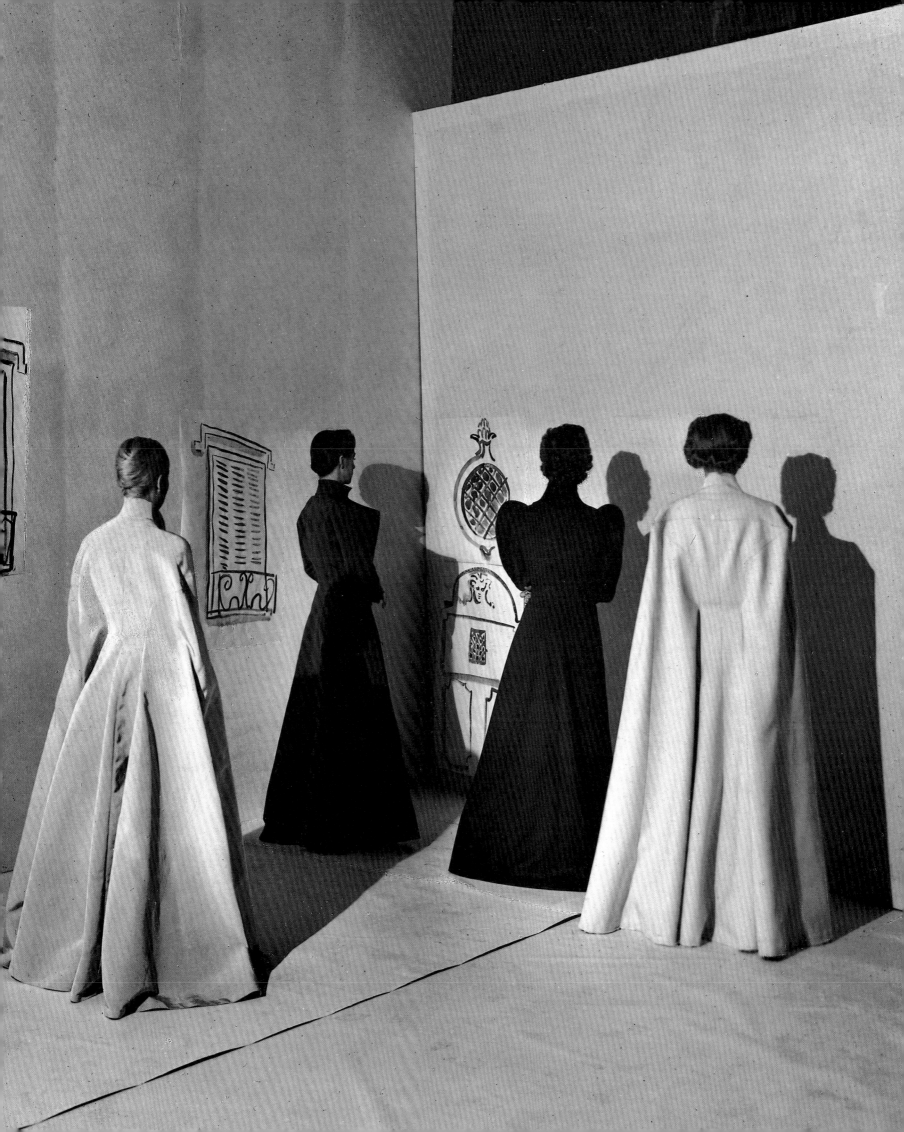

Horst's famous corset photograph *(page 25)*, published in *Vogue*'s September 15, 1939 issue, marked his farewell to prewar Paris. When he had finished taking pictures for the sitting, "I left the studio at 4:00 A.M., went back to the house, picked up my bags, and caught the 7:00 A.M. train to Le Havre to board the *Normandie*," he recalled many years later. "We all felt that war was coming. . . . And you knew that whatever happened, life would be completely different after. I had found a family in Paris, and a way of life. The clothes, the books, the apartment, everything was left behind. I had left Germany, Huene had left Russia, and now we experienced the same kind of loss all over again. . . . For me, this photograph is the essence of that moment. While I was taking it, I was thinking of all that I was leaving behind." It was the last shot he took that night. A gap between the corset and the left breast was retouched in New York for a closer-to-the-body fit. Mrs. Chase thought the original was too risqué.

Horst's principal rival at *Vogue* was Cecil Beaton, who had begun working for the magazine regularly in the late twenties. "I showed my latest photographs to Mrs. Chase, who considered that, although they might be poor technically, they had the merit of being unlike the pictures of any other photographer," Beaton wrote about his first trip to the *Vogue* offices in New York, in the winter of 1928. He had been making drawings of society figures such as Lady Diana Cooper and Mrs. Sacheverell Sitwell, and writing short articles, primarily for British *Vogue*, but after his visit to Mrs. Chase he was "taken into the *Vogue* fold and commissioned to photograph beautiful women up at Condé Nast's fabulous apartment on Park Avenue."

Beaton was born in London in 1904 and educated at Harrow and Cambridge. He had taken photographs from the time he was a child, primarily at first of his sisters dressed up in various fantastic costumes, but his principal interest was always the theater. "You can see traces of ballet, of Surrealism, of visual abstraction, in Beaton," says Alexander Liberman. In the thirties, when he was most prominent in *Vogue*, his theatricality flowered. "I must confess," he wrote in *The Glass of Fashion*, "to having indulged myself in the generally prevailing recklessness of style. My pictures became more and more rococo and Sur-

realist. Society women as well as mannequins were photographed in the most flamboyant Greek-tragedy poses, in ecstatic or highly mystical states, sometimes with the melodramatic air of Lady Macbeth caught up in a cocoon of tulle. . . . Perfectly normal ladies were pictured in extremes of terror, with one arm covering the face or thrust forward in exaggerated perspective straight toward the camera. Backgrounds were equally exaggerated. . . . Badly carved cupids from junk shops on Third Avenue would be wrapped in argentine cloth or cellophane. . . . Christmas paper chains were garlanded around the model's shoulders, and wooden doves, enormous paper flowers from Mexico, Chinese lanterns, doilies or cutlet frills, fly whisks, sporrans, egg beaters, or stars of all shapes found their way into our hysterical and highly ridiculous pictures." Diana Vreeland, editor in chief of *Vogue* many years later and herself a proponent of excess, would describe his photographs as having "the feeling of being inside an opal."

Beaton's decorative bent was made possible by the famous *Vogue* largess. "The extravagant cost of a fashion sitting, lightly borne by the magazine, never failed to delight me," he recalled.

" 'You want some white flowers?' an editor would enquire.

"Of course—if we may . . .

" 'We'll send down to the florist for them right away. Do you want more than a dozen bunches? You want some tapestry? Or a Louis XVI canapé?' "

The only demand that infringed on Beaton's happiness was Condé Nast's insistence that he give up his "toy" Kodak, a small instrument that enabled him to crawl around on ladders and get at things from odd angles. He was asked to replace it with an eight by ten camera that would provide the quality of print *Vogue* readers expected. Beaton later wrote that "certain magazine editors accompanying me to the photographic sessions confessed that it was sometimes hard to convince their fashionable sitters, accustomed to being taken by vast and wonderful technical equipment, that they were not being palmed off with a makeshift sitting. Carmel Snow . . . relates how she met with great difficulty in reassuring the sitters that they were not being made fools of by me, manipulating a 'child's camera,' and that the pic-

tures would be 'perfectly lovely.' " Beaton gave in: "I bought a huge camera fitted with the same lens, so I was told, that Mr. Steichen used." He hated it for a few days, but then, "I took a close-up of Janet Gaynor lying in a field of wildflowers and every detail of the smallest chickweed was seen with incredible clarity." He decided he could live with an eight by ten.

Edna Chase called Beaton "our blessing and our trial...a kind of hot cross boon," and admitted that since he had come to the magazine at such a young age, she had "inevitably developed a maternal feeling for him." And he quickly became a star in his own right. He was friends with the Vanderbilts and the Lunts and Hollywood celebrities and cabaret performers in Harlem. He wrote witty articles on "Modern Chic" and Palm Beach and reported back to Americans about what trendy Londoners were up to. His greatest coup, however, came in 1937, when he helped *Vogue* land photographs of his friend Wallis Simpson a few weeks before her marriage to the Duke of Windsor. Bettina Ballard remembers it as "the biggest woman's story of [Chase's] editing career and she wasn't going to muff it." The mission to France, where Mrs. Simpson was staying while her divorce became final, was so hush-hush that the editors in the Paris office were forbidden to peek at the photos. They were published with no text, only headlines announcing "The Future Duchess of Windsor" and that these were "new photographs taken at the beautiful Château de Candé exclusively for *Vogue* by Cecil Beaton." The magazine gave six pages to the sitting, and the issue sold out immediately. "Although a certain amount of criticism was directed at the over-life-size lobster which decorated the skirt of one of the dresses," Beaton recalled, "so spectacularly successful had the results of the photographs been that in June I was asked to return to the chateau to take photographs of the wedding."

Beaton was contributing a great deal of material to *Vogue*. "Occasionally a reprimand would come from New York regarding my efforts," he recalled later: " 'At the instigation of Mrs. Chase I am writing to suggest that you refrain from posing any more models in the act of ecstatically sniffing flowers or holding blossoms á la Blessed Damozel. We are all weary of these postures...' However, my enthusiasm was undaunted; a vast amount of my work appeared without further serious complaint."

Until 1938, that is. Beaton was asked to illustrate an article by Frank Crowninshield about "the left wing of New York society," which Crowninshield referred to as "Café Society." Included among Beaton's drawings of martini shakers and jazz bands were some tiny handwritten references to "kikes" and several other anti-Semitic remarks. The lettering was almost illegible, but the press got wind of the story very quickly, perhaps through leaks from Dr. Agha, *Vogue*'s art director, who had never been a Beaton fan. When Walter Winchell published the story of Beaton's offense in his *Daily Mirror* column, Nast altered the copies of the magazine still on the press and summoned Beaton from his opera seat in order to control the damage. "We're in a tough spot....I could not mind more if I were losing my own son, but I can see nothing else but to ask for your resignation," Beaton recorded him saying. Beaton's byline was not to appear for some time.

Beaton's departure and the earlier defection of Huene to *Harper's Bazaar* were big losses for *Vogue* (although in Beaton's case Dr. Agha was more than happy to see him go). But the magazine has always seemed to come up with new talent, and in the thirties Toni Frissell, a New York debutante who had studied acting and worked in an advertising agency before becoming a caption writer (and briefly Beaton's assistant) at *Vogue*, came into her own as a photographer. Frissell specialized in sports clothes shot out of doors. "With her social connections, her passion for skiing that took her to Switzerland every winter, and her willingness to travel any place at any time," Bettina Ballard recalls, "she was a valuable combination editor-photographer for the magazine." Frissell's models (sometimes friends) leaned against cars with their dogs *(page 23)* and posed robustly on their bicycles or at the beach *(page 37)*, beaming with American healthiness, the wind blowing in their hair. Frissell was an early practitioner of the art of the fashion photograph that simulates "real life." "Little by little you see the great revolution that happened in photography," Alexander Liberman explains, looking through her photographs. "It was action, movement, and what a small camera made possible. Little by little we're getting to snapshots. The magnificent snapshot."

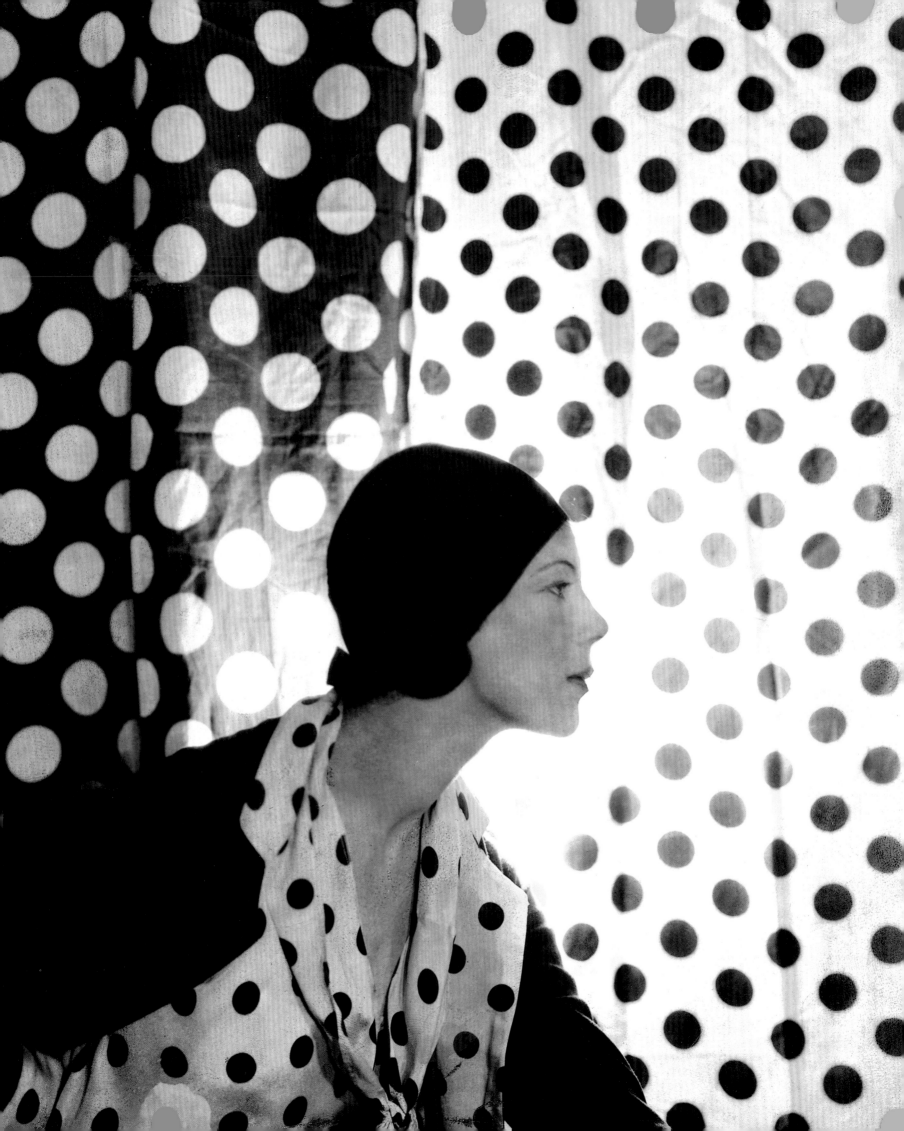

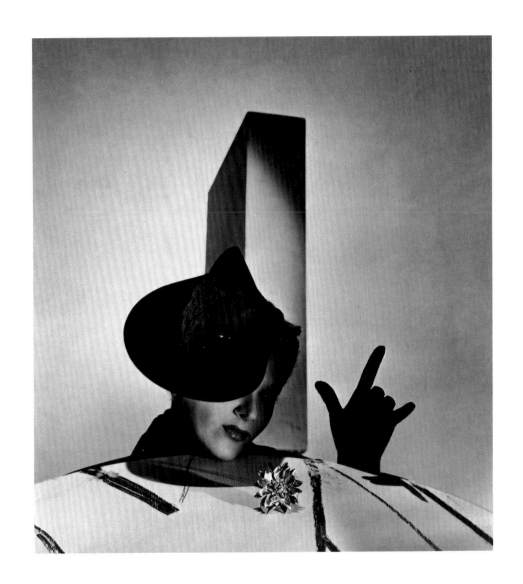

Horst
Lisa Fonssagrives signing "I love you" in black felt tricorn
August 1, 1938

opposite page

Cecil Beaton
Tilly Losch
May 10, 1930

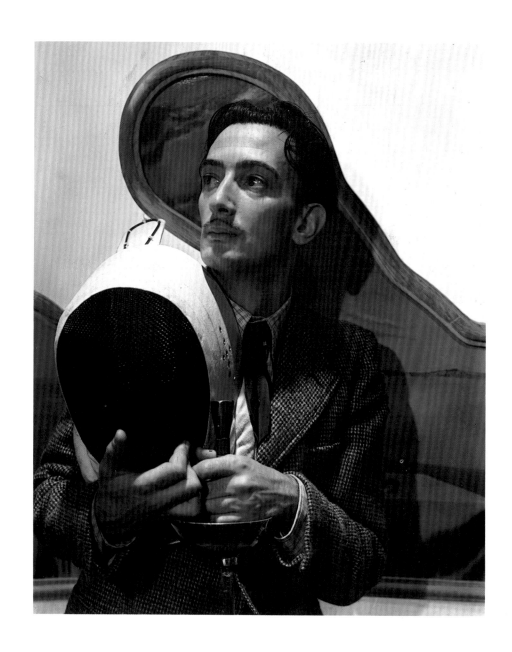

Cecil Beaton
Salvador Dali
November 1, 1936

opposite page

Horst
Dali's costumes for the Ballet Russe de Monte Carlo production
of Massine's *Bacchanale*, executed by Chanel
October 15, 1939

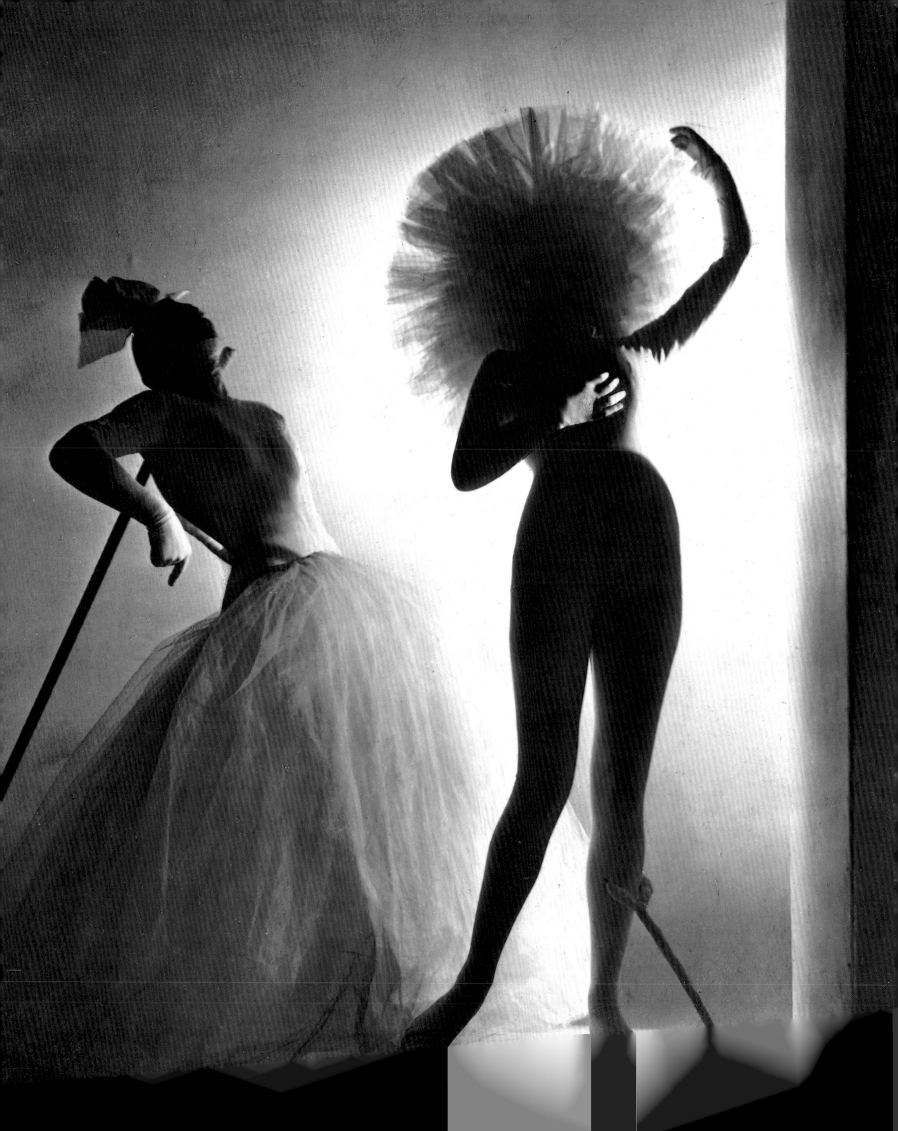

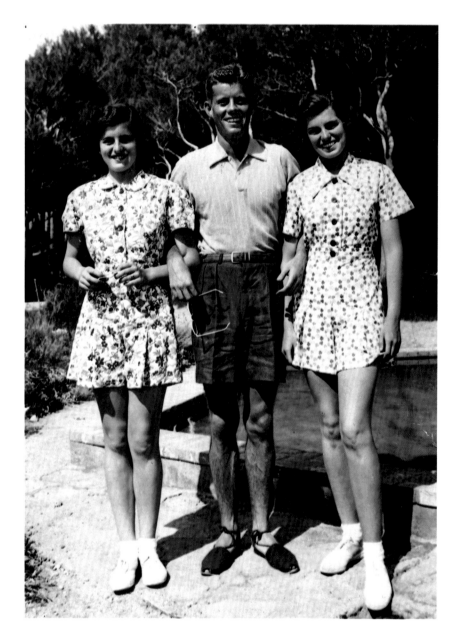

John Rawlings
Eunice, Jack, and Patricia Kennedy, children of
the American ambassador to the Court of St. James
November 1, 1938

opposite page

Toni Frissell
Ballerina skirt swimsuit, Marineland, Florida
(unpublished version)
December 1, 1939

following pages

Remie Lohse
Intermission at the Music Box theater in New York
November 1, 1933

Roger Schall
Mrs. Robert Lounsberry and rue Saint-Honoré manicurist
June 1, 1937

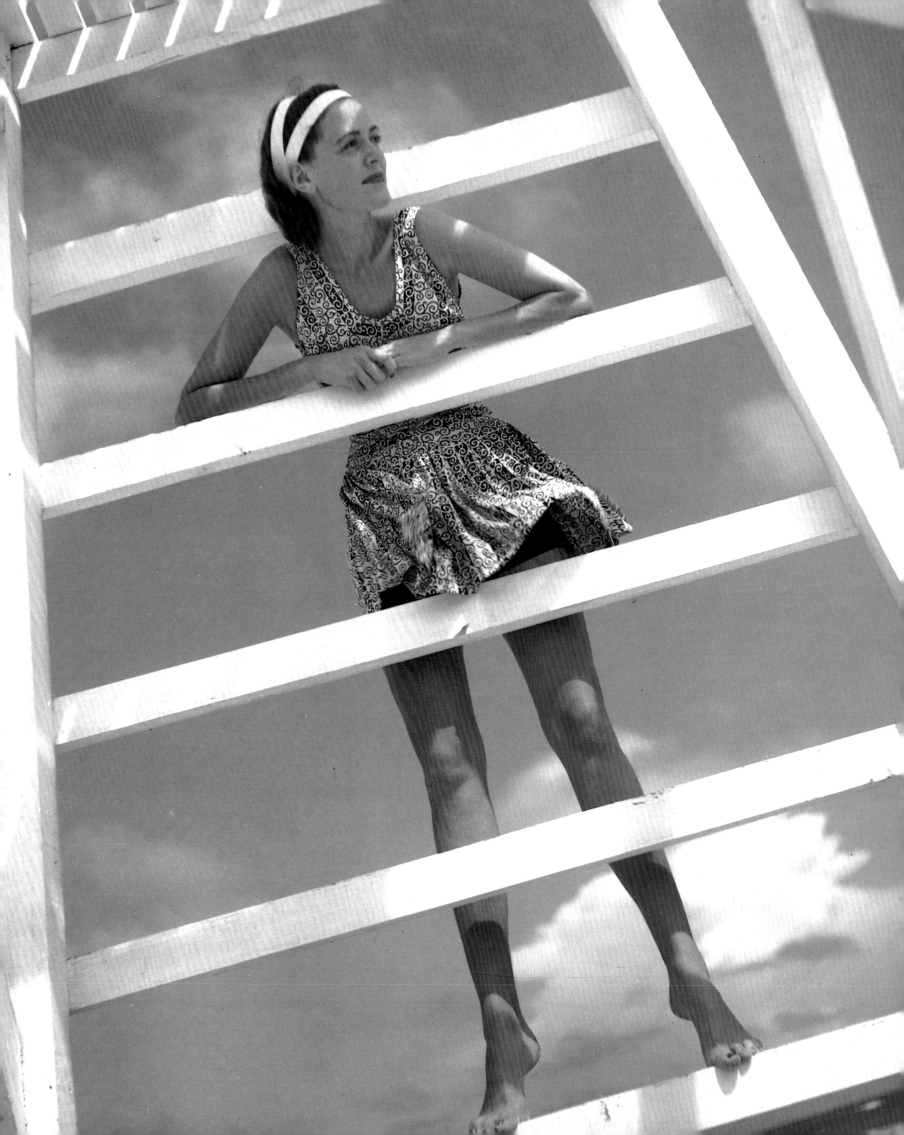

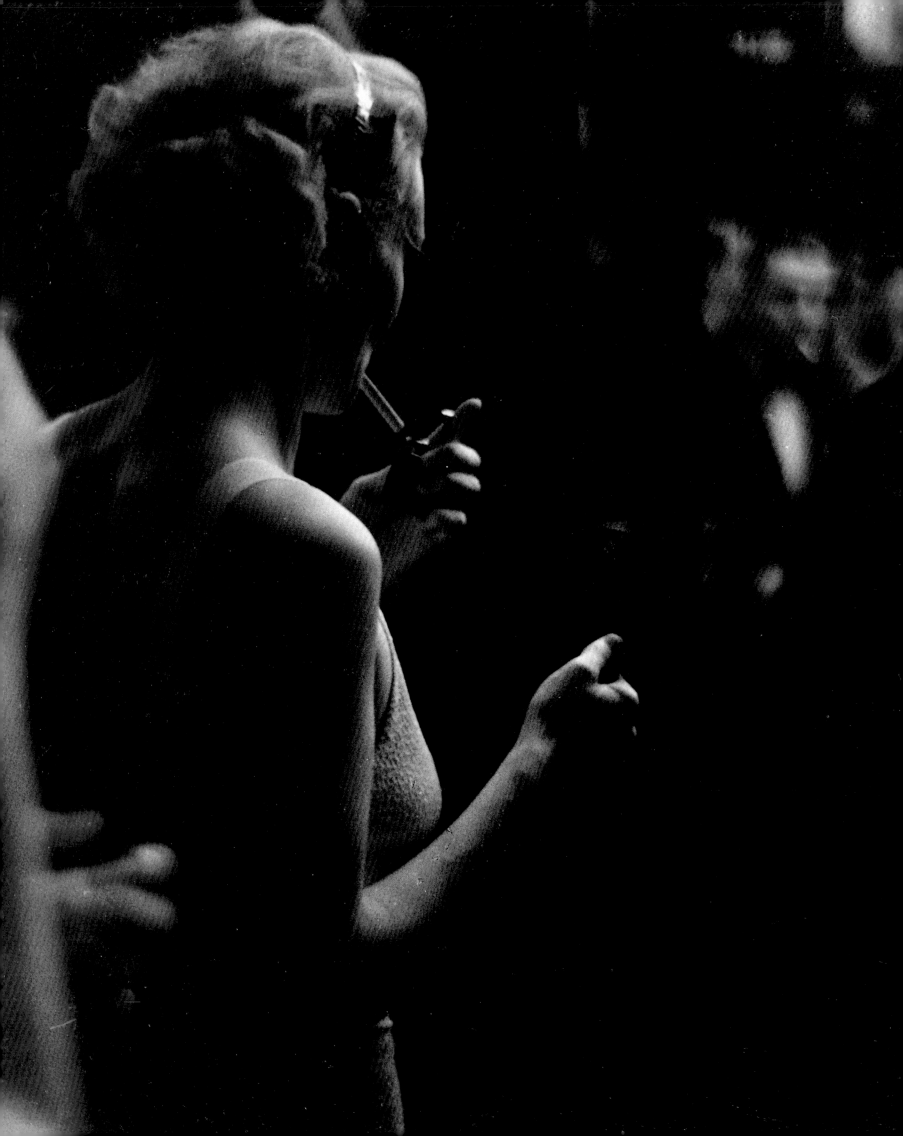

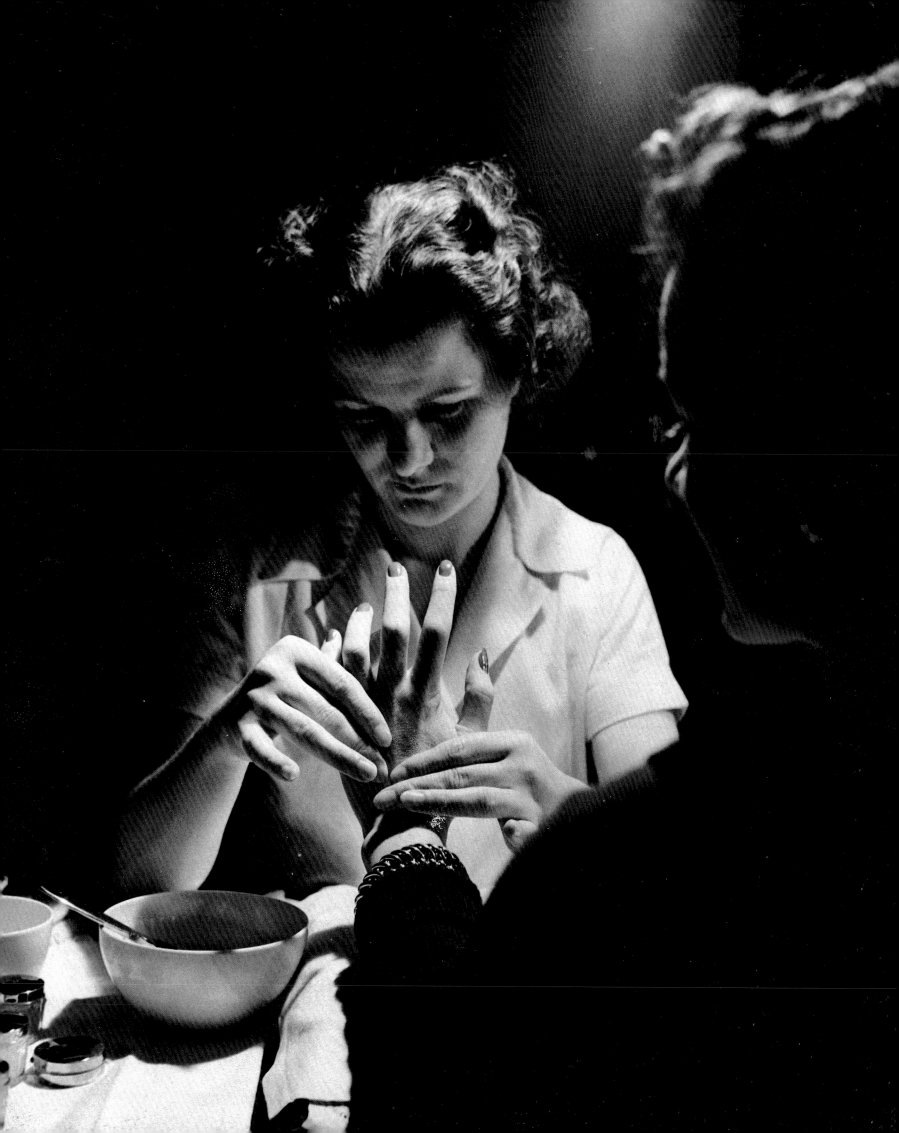

I WILL NOT SIT HERE WORKING AT MY LITTLE JOB & LET THE WAR PASS ME BY

— MARLENE DIETRICH, *Vogue*, August 1944

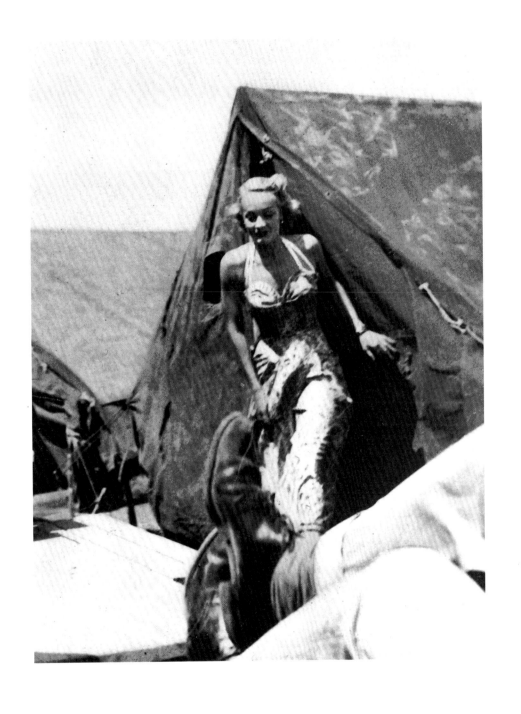

Lin Mayberry
Marlene Dietrich on USO tour
August 15, 1944

When Condé Nast died in 1942, his successor as president of the company was a Russian émigré named Iva Patcévitch, "probably the most glamorous man in New York," according to Cathy di Montezemolo, later a fashion editor at *Vogue*. One of Patcévitch's most glamorous friends was Marlene Dietrich, who appeared frequently in the pages of the magazine. Dietrich became an indefatigable entertainer of troops during World War II, and shortly after D-day another of her *Vogue* friends, Leo Lerman, interviewed her about her USO experiences. The accompanying photograph *(page 41)*, captioned "Be-sequinned Dietrich makes typical entrance from a tent dressing-room," was a snapshot taken by a member of her troupe and then passed along to Lerman. "We gave the first show they'd had in Anzio," Dietrich recalled. "We played on the dunes around the hospital at two in the afternoon. It was just a beach with a few little houses, but the boys we played to were in terrifically high spirits. The other boys had just gone into Rome. The day after our boys entered the city, we were there, too."

While Dietrich sang for soldiers, some *Vogue* editors worked for the Red Cross or served overseas as correspondents. At home, *Vogue*'s wartime role was "to whip the female public into action to support the boys and run the house well without a man and dress nicely and make their contributions," recalls Carol Phillips, later the magazine's managing editor. "It was perfect for Jessica Daves," who had taken over many editorial duties from the aging Mrs. Chase and who was "a leader in terms of development of character." In the September 15, 1940 issue, Pamela L. Travers, author of *Mary Poppins*, had written about "the courage of British mothers who sent their children to safety in America." Typical stories of the period were the July 1, 1941 salute to "Women in Defense," a ten-page feature with a cover shot of model and pilot-in-training Sandy Rice ascending a biplane. In July 1943 Private Zero Mostel discussed his encounter with boot camp. One of *Vogue*'s first covers portraying a working woman in a business suit ran in September 1943. Dressed in a veiled hat and Norell jacket and skirt, with a gloved hand resting confidently on her hip, a model perused a notice about "Women in necessary civilian jobs," while cover lines shouted "Take a Job!

Release a Man to Fight!" The accompanying article was placed in a section usually reserved for fashion news.

In 1941, Edward Steichen, who had given up his position as chief photographer for *Vogue* in the late thirties but had retained a loose affiliation with the magazine, formed a small unit of photographers to cover the story of naval aviation during the war. This led to an appointment as director of all Navy combat photography, and in December 1945 *Vogue* published four photographs chosen by Steichen from hundreds of thousands in the military archives. "No previous happening in the history of man has produced a visual record comparable to that made by the photographer of World War II," he wrote in an article accompanying the photographs. But "out of all this mass . . . certain photographs have already made a place for themselves—photographs that possess elements of greatness, photographs that go deeper and beyond the surface representation of facts and men and things" *(page 48)*.

Cecil Beaton also covered the war for *Vogue*. His banishment from the magazine for the anti-Semitic remarks of 1938 had been rescinded in October 1940, when one of his fashion photographs appeared. In 1941 he was writing from London about the devastation wrought by the Luftwaffe's bombs: "Sometimes quite remarkably spectacular Piranesi effects of ruin are achieved, but it is heartrending to potter among this frightful desolation, unrecognizably squalid in its covering of colourless dust, exuding its horrible smells of charred wood and the sickly, deathly damp smell of cement and brick dust. . . . It shocks one to find houses that one knew, where one talked with friends late into the night, danced, or was brought up in from childhood, with their innards gaping to the street below." Beaton was made an official photographer for the RAF, and late in 1942 sent *Vogue* photographs of a burned-out German tank and other eerie "abstractions of destruction" from the North African desert *(page 52)*. In December 1945 he was reporting on what there was left of French fashion, using the crumbling walls of Paris as a backdrop for models wearing Balmain coats and Bruyère gowns. "There have been very great technical difficulties," he wrote. "However, in some cases I think the cutting of electricity and other drawbacks

have resulted in our getting some pictures that are outside the usual fashion sphere—in particular, one, of a girl standing in an artist's backyard in a flannel Chinese blouse, in which I tried for some of the lighting of a Corot portrait [page 53]. I think it is one of the best I have ever taken.''

But it was the American Lee Miller, once a *Vogue* model, who delivered the most extraordinary reports during the war. Miller had been a regular model for Steichen in New York and had appeared on the March 1927 cover. She had lived with Man Ray in Paris and modeled for Hoyningen-Huene and had learned to be a photographer under their tutelage. Back in America, she had taken fashion and celebrity shots for *Vogue*, *Harper's Bazaar*, and *Vanity Fair*, and had then married an Egyptian businessman and moved to Cairo. At the beginning of the war she was back in London, working for British *Vogue*, where she began writing the articles that went along with her photographs. Her first piece was a profile of Edward R. Murrow, who was broadcasting from London for CBS.

The first of Miller's wrenching accounts of the war was a report from a U.S. Army field hospital in Normandy after D-day. The piece ran simultaneously, although at different lengths, in both the British and American editions of *Vogue*. Under a photograph of a soldier almost completely swathed in bandages that made him look like a mummy, she wrote: ''A bad burn case asked me to take his picture, as he wanted to see how funny he looked. It was pretty grim, and I didn't focus well.'' In a surgical tent a ''wounded man had watched me take his photograph and had made an effort, with his good hand, to smooth his hair. I didn't know that he was already asleep with sodium pentothal when they started on his other arm. I had turned away for fear my face would betray to him what I had seen.'' ''The *Vogue* editors were astonished,'' writes Antony Penrose, Miller's son and biographer. ''Lee's contribution had given both British and American *Vogue* an involvement with the war and was dispelling somewhat the guilt and frustration among the staff that arose from their seemingly frivolous work. Audrey Withers [editor of British *Vogue*] described it as 'the most exciting journalistic experience of my war. We were the last people one would conceive having this type of article, it seemed so incongruous in our pages.' '' Penrose says today that it was, ironically, *Vogue*'s apolitical status that allowed Miller to have special access to sensitive people and places.

Miller followed the U.S. 83rd Division into France, sending back photographs and a story about the siege of St.-Malo and then the liberation of Paris. She visited Picasso and Colette, and Michel de Brunhoff, *Vogue*'s Paris editor, ''in his apartment high above the Palais of the Légion d'Honneur. He was exalted and voluble about the liberation, in spite of the tragedy of his son Pascal's execution.'' Miller continued sending back reports from the front lines, working with a photographer from *Life* who took her picture in Hitler's bathtub in Munich. At the end of April 1945, they were among the first Americans to enter the concentration camp at Dachau. Miller's report of what she saw, there and at Buchenwald, was horrifying *(following pages)*. ''We hesitated a long time and held many conferences deciding whether or not to publish [the photographs],'' Edna Chase recalled in her memoirs. ''In the end we did it and it seemed right. In the world we were trying to reflect on our pages, the wealthy, the gently bred, the sophisticated were quite as dead and quite as bereft as the rest of humankind. Anguish knows no barriers.'' The title of the article was ''Believe It.'' ''This is Buchenwald Concentration Camp at Weimar,'' the editors explained. ''The photograph on the left shows a pile of starved bodies, the one above a prisoner hanged on an iron hook, his face clubbed. Lee Miller has been with American Armies almost since D-Day last June; she has seen the freeing of France, Luxembourg, Belgium, and Alsace, crossed the Rhine into Cologne, Frankfurt to Munich. Saw the Dachau prison camp. She cabled: 'No question that German civilians knew what went on. Railway siding into Dachau camp runs past villas, with trains of dead and semi-dead deportees. I usually don't take pictures of horrors. But don't think that every town and every area isn't rich with them. I hope *Vogue* will feel it can publish these pictures . . .' Here they are.''

''*Vogue* had evolved from a purely artificial magazine of ladies in attractive clothes to something with a closer relationship to reality,'' notes Alexander Liberman.

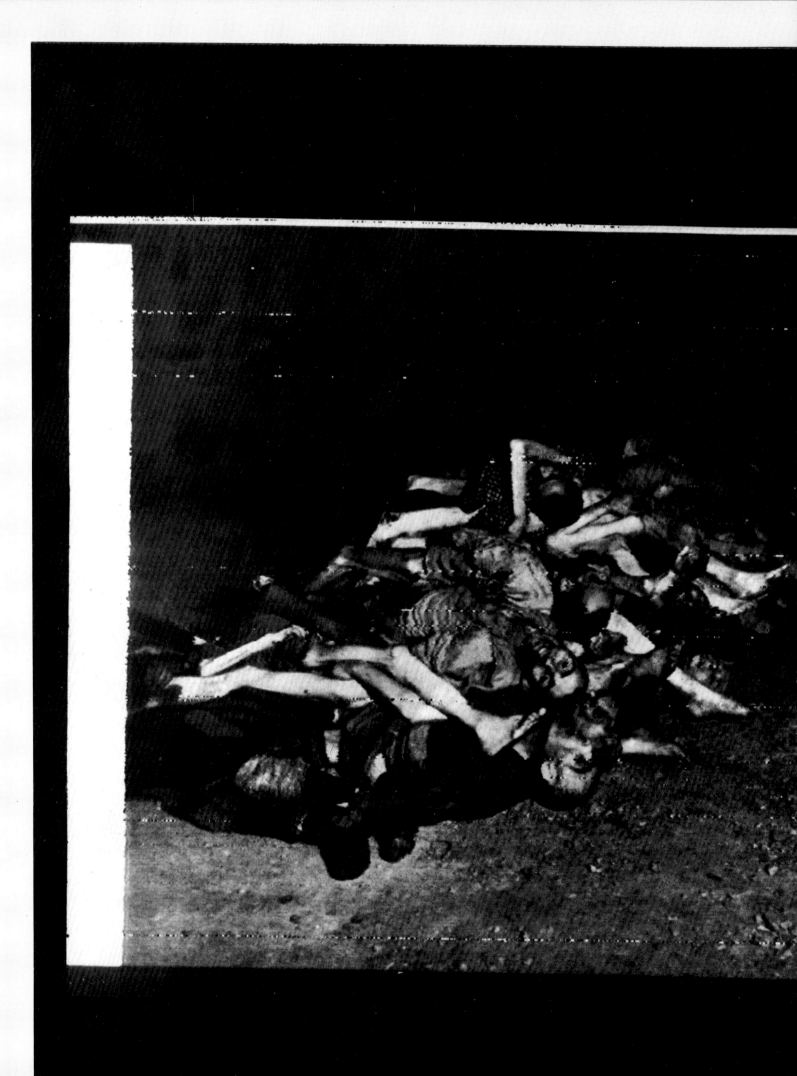

"BELIEVE IT"
Lee Miller cables from Germany

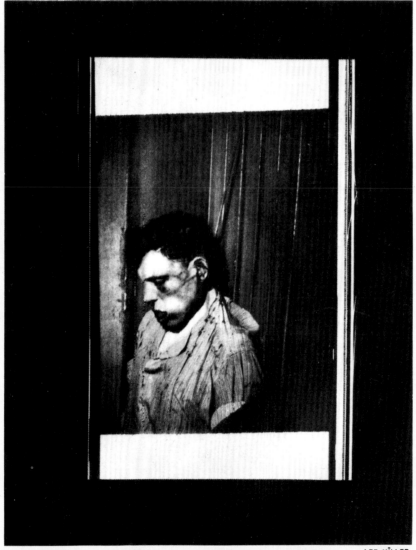

LEE MILLER

"THIS is Buchenwald Concentration Camp at Weimar." The photograph on the left shows a pile of starved bodies, the one above, a prisoner hanged on an iron hook, his face clubbed.

Lee Miller has been with American Armies almost since D-Day last June: she has seen the freeing of France, Luxembourg, Belgium, and Alsace, crossed the Rhine into Cologne, Frankfurt to Munich. Saw the Dachau prison camp. She cabled: "No question that German civilians knew what went on. Railway siding into Dachau camp runs past villas, with trains of dead and semi-dead deportees. I usually don't take pictures of horrors. But don't think that every town and every area isn't rich with them. I hope Vogue will feel that it can publish these pictures...."

Hara thay ara

Lee Miller
Germany
June 1945

NAZI HARVEST

Justice amid the ruins

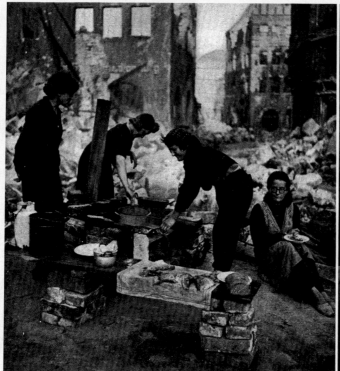

Homeless: Like the women of German-invaded countries, German women now cook in the ruins

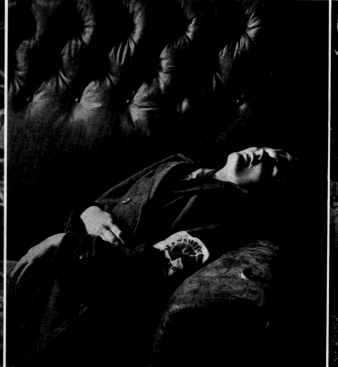

Suicide: Leipzig Burgomaster's pretty daughter, a victim of Nazi philosophy, kills self

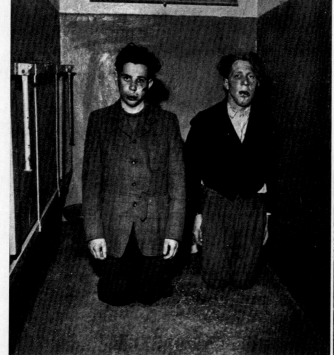

Punishment: S.S. Guards who tortured prisoners, beg mercy on their knees, are beaten by ex-prisoners

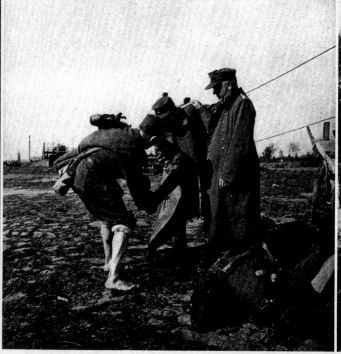

Humiliation: While Allied soldiers use bridge, German officers, boots pulled off, wade river

Retribution overtakes the Germans:
the people shamed, humiliated;
the country destroyed, and honour lost

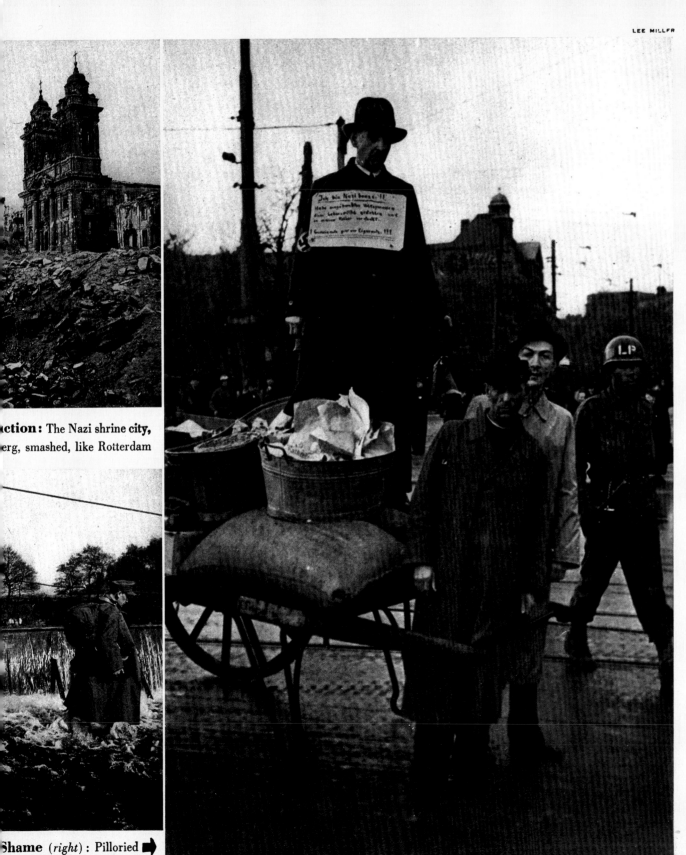

LEE MILLER

ction: The Nazi shrine **city,**
erg, smashed, like Rotterdam

Shame (*right*): Pilloried ➡
Nazi labelled as food-thief

Lee Miller
Germany
June 1945

Chief Photo Mate Ray R. Platnick, U.S. Coast Guard
Marines after battle for Engebi Island
December 1, 1945

following pages

Weegee
V-E Day in New York's garment district
June 1945

Erwin Blumenfeld
Red Cross
(cover)
March 15, 1945

Cecil Beaton
Remains of a German tank, North Africa
December 15, 1942

Cecil Beaton
Flannel Chinese jacket and trousers by Pierre Balmain
December 15, 1945

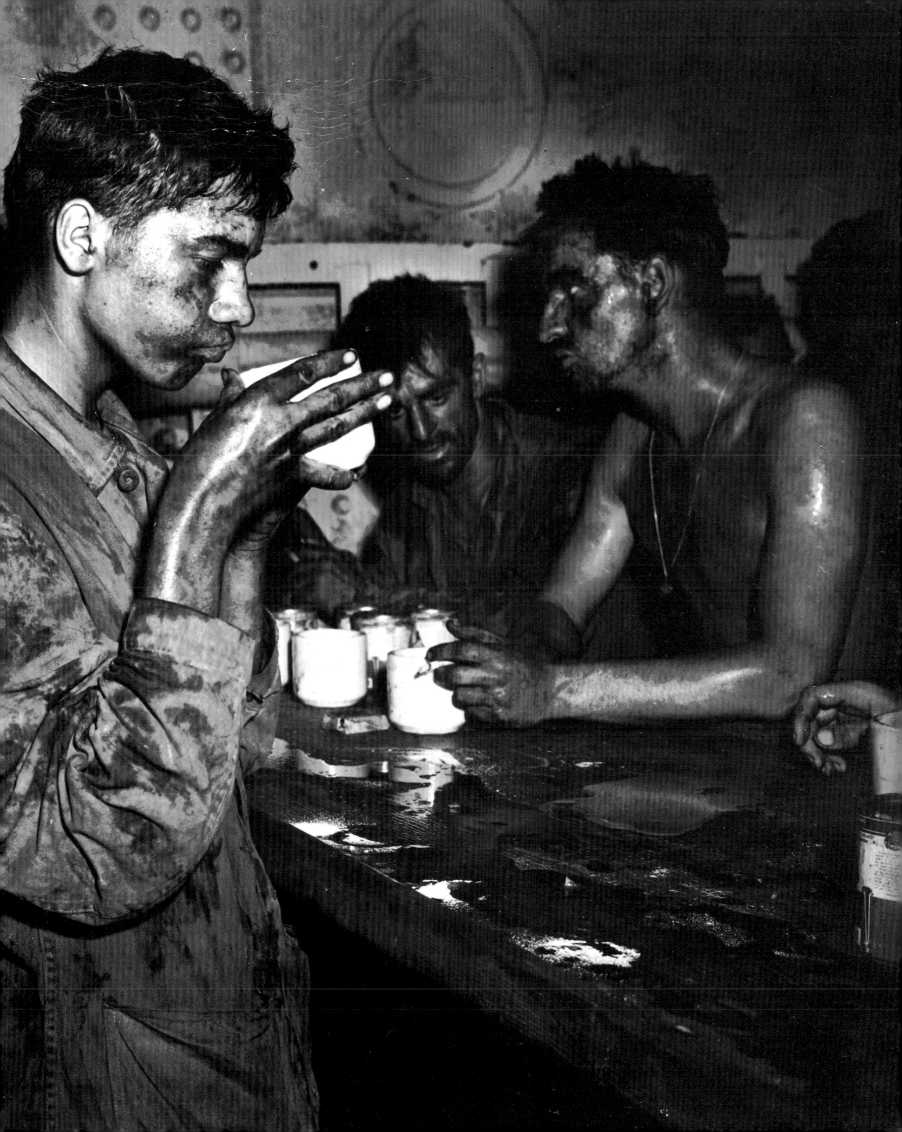

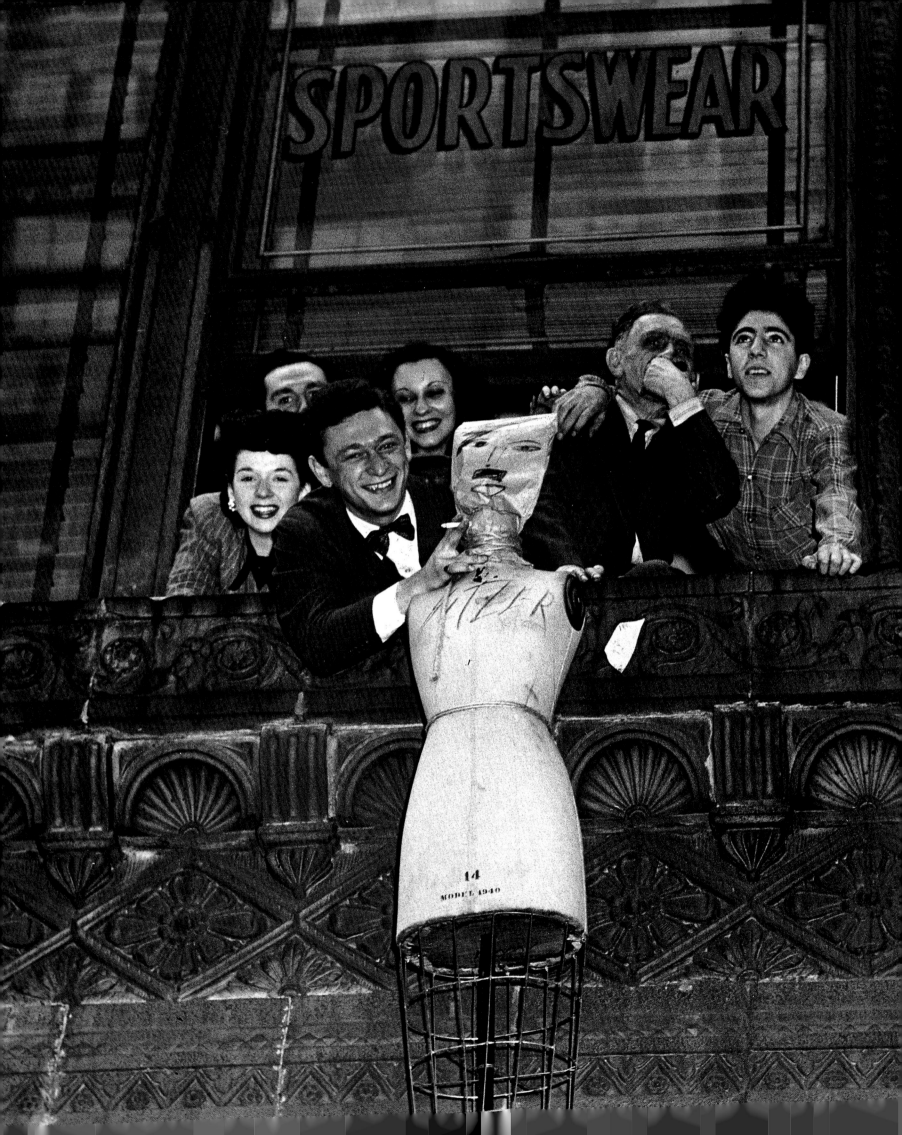

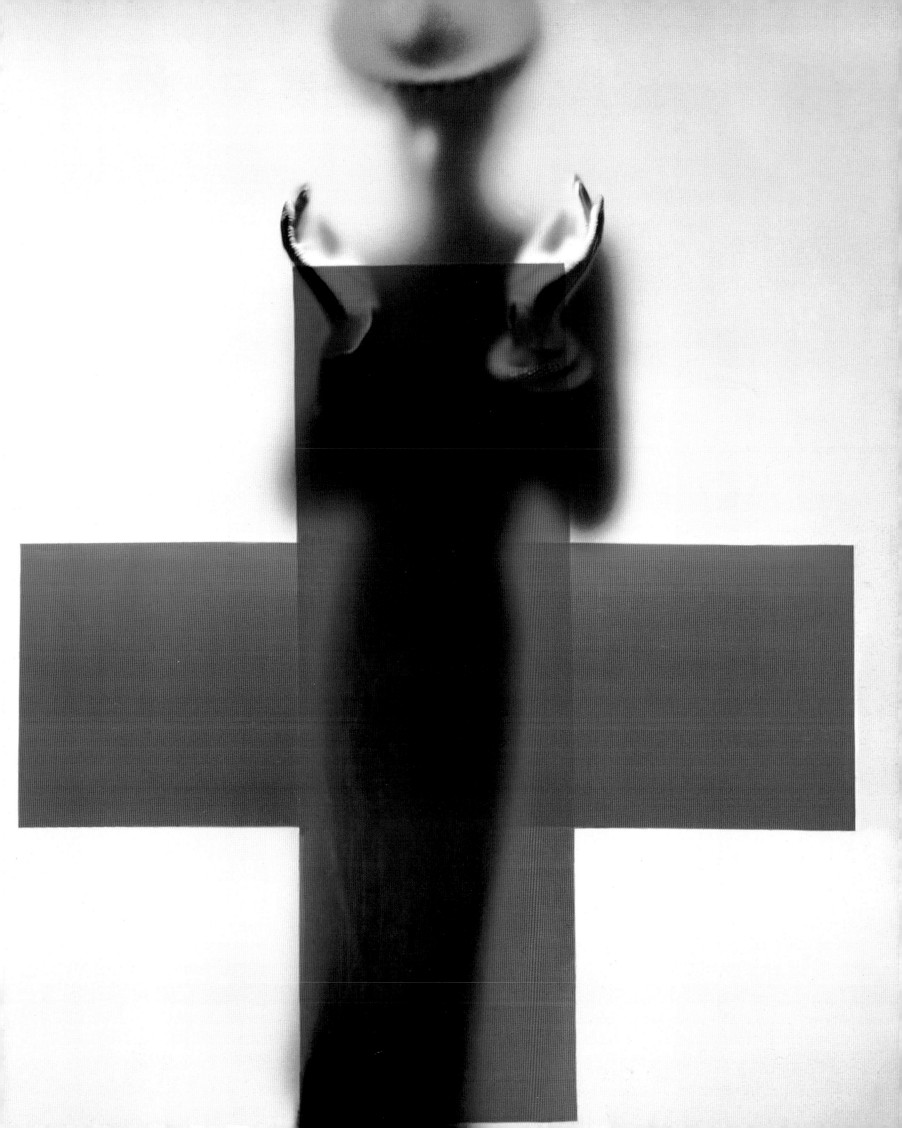

One of the consequences of the war in Europe was the emigration of artists, writers, and intellectuals to the U.S. Alexander Liberman, who was to be closely associated with *Vogue* for half a century, was among those who fled Occupied France. Liberman had been managing editor of the photo magazine *Vu* in Paris, and when he arrived in New York, in 1941, he got a job in the *Vogue* art department. Liberman had grown up in St. Petersburg and Moscow and had gone to school in London and Paris. He was a student of the Cubist painter André Lhote and had studied architecture at the Ecole des Beaux Arts and worked with the poster artist Cassandre. He became art director of *Vogue* in 1943, and his relationships with European artists and his cultivated, modernist tastes soon began to be reflected in the pages of the magazine.

One of the artists Liberman had worked with at *Vu* was the German photographer Erwin Blumenfeld, who was known for his photographic manipulations—solarization, multiple exposures, bleaching, etc. After an unsuccessful career as a businessman in Holland, Blumenfeld had moved to Paris and become a well-known portrait and fashion photographer. He went to work for Paris *Vogue* in 1938, and when the Germans invaded France he was interned in a concentration camp. He escaped, and he too arrived in New York in 1941. Blumenfeld was a "very interesting, curious man," Alexander Liberman recalls. "He brought with him some of the terror of Eastern Europe. There is a certain undercurrent to his pictures, a not-so-innocent quality." In 1947, when Blumenfeld photographed Barbara Cushing Mortimer, then a *Vogue* editor and later Mrs. William (Babe) Paley, he had very European references in mind *(page 65)*. To him, he wrote, she was "the most feminine beauty.... Only Velázquez could paint her coloring on canvas. Her mouth is like that of the fascinating Madame Arnoux in Flaubert's novel *Education Sentimentale*. She has the gentleness, the poise, and the dignity of those grandes dames whom Balzac described in his *Comédie Humaine*." Carol Phillips, who was an editor at *Vogue* with Mrs. Mortimer at the time, recalls her in a slightly more American light: "She used to roller-skate to work down Park Avenue."

Another editor at *Vogue*, Margaret Case, was the catalyst in a drama involving Cecil Beaton, who was attempting to conduct a romance with Greta Garbo. Beaton had had a titillating encounter with Garbo at a friend's house in California in 1932, and they met again in 1946 at a party at the Park Avenue apartment of Case, who was Beaton's editor. A flirtation conducted on Case's rooftop led to a photo session, the conceit being that it was for passport photos, although this seems highly unlikely, since Garbo posed with a bunch of flowers, in a clown's costume, and lying on a couch *(page 66)*. Beaton sent the pictures over to Alexander Liberman, who was of course delighted. Garbo, always publicity shy, had not made a movie in five years, and the new material was seen as a great scoop. Liberman laid out fourteen of the photographs on a two-page spread, with copy noting that they were "the only current addition to the public album of this face—the most fascinating, most missed face of the screen." For Beaton, the Garbo pictures meant "achieving my greatest ambition, and crowning my photographic career." Garbo, however, swore that she had given permission for only one photograph to be printed and refused to speak to Beaton. She tortured him for well over a year before giving in to his supplications one afternoon in his room at the Plaza Hotel.

Garbo's retirement from the screen had been due partly to the demand for "American" images during the war. The American girl had usurped the European femme fatale as an ideal. This was true in the fashion world also, where American sportswear was coming into its own. In his book on Horst (who had worked for *Vogue* until he was inducted into the army), Valentine Lawford reports that Condé Nast insisted that the magazine "required a new kind of photograph...to reflect the qualities he regarded as specifically 'American.' They must be 'fresh and spontaneous'; and the models must not seem 'remote,' as in the past, but 'friendly and relaxed,' as in 'real life.' " Following these strictures, *Vogue* increased its use of Toni Frissell, who took her camera out-of-doors and in pursuit of realism dunked a model in an evening dress in a fish tank at Marineland *(page 64)*. "This looks like pure fantasy," the desperate *Vogue* caption writer explained, "but it really happened.... The resulting picture [opposite an article on summertime skin care] was so cooling to the eye we thought it might refresh you, when the mercury teases 90."

Erwin Blumenfeld
Mannequin and live model
(unpublished version)
November 1, 1945

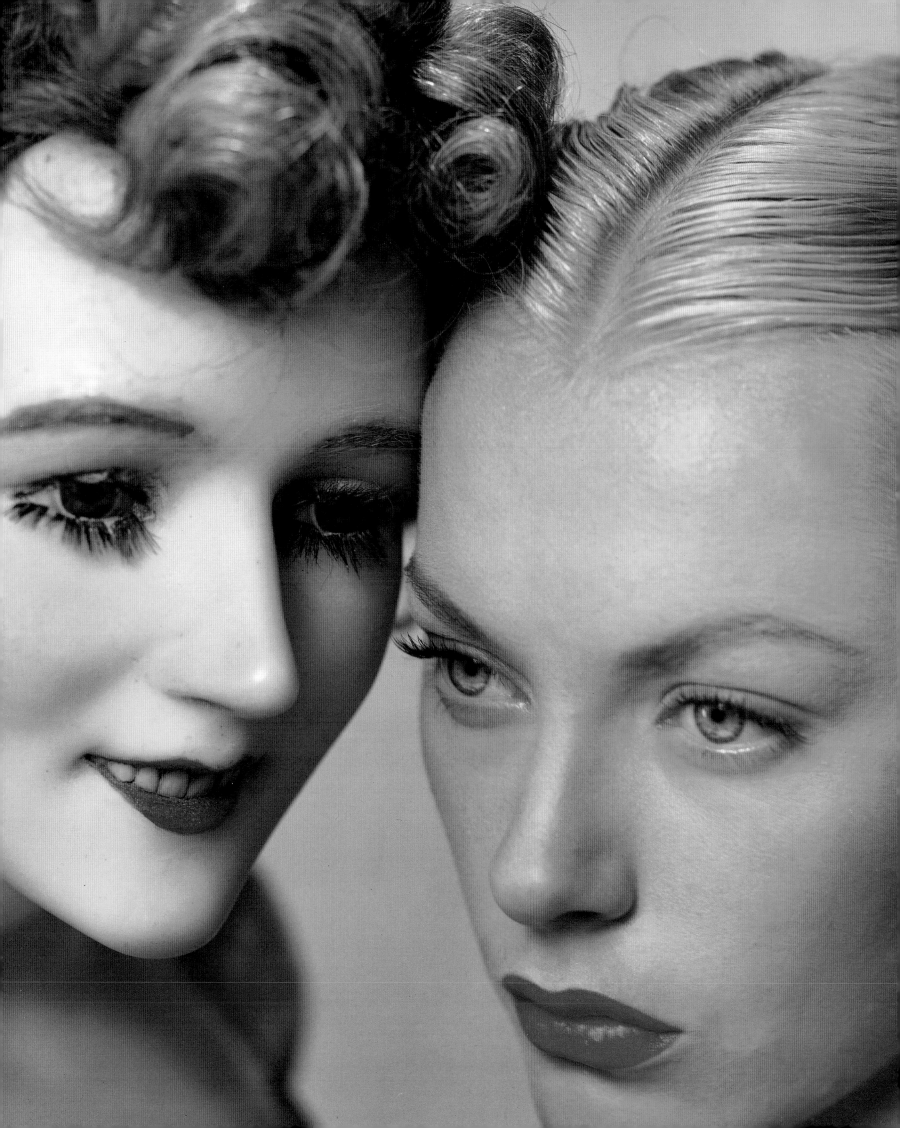

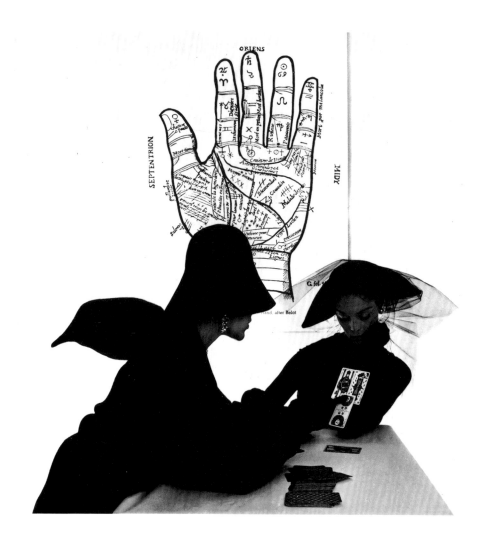

Irving Penn
Tarot reader
October 15, 1949

opposite page

Irving Penn
Jean Patchett, Lima, Peru
February 15, 1949

following pages

Cecil Beaton
Charles James gowns
June 1948

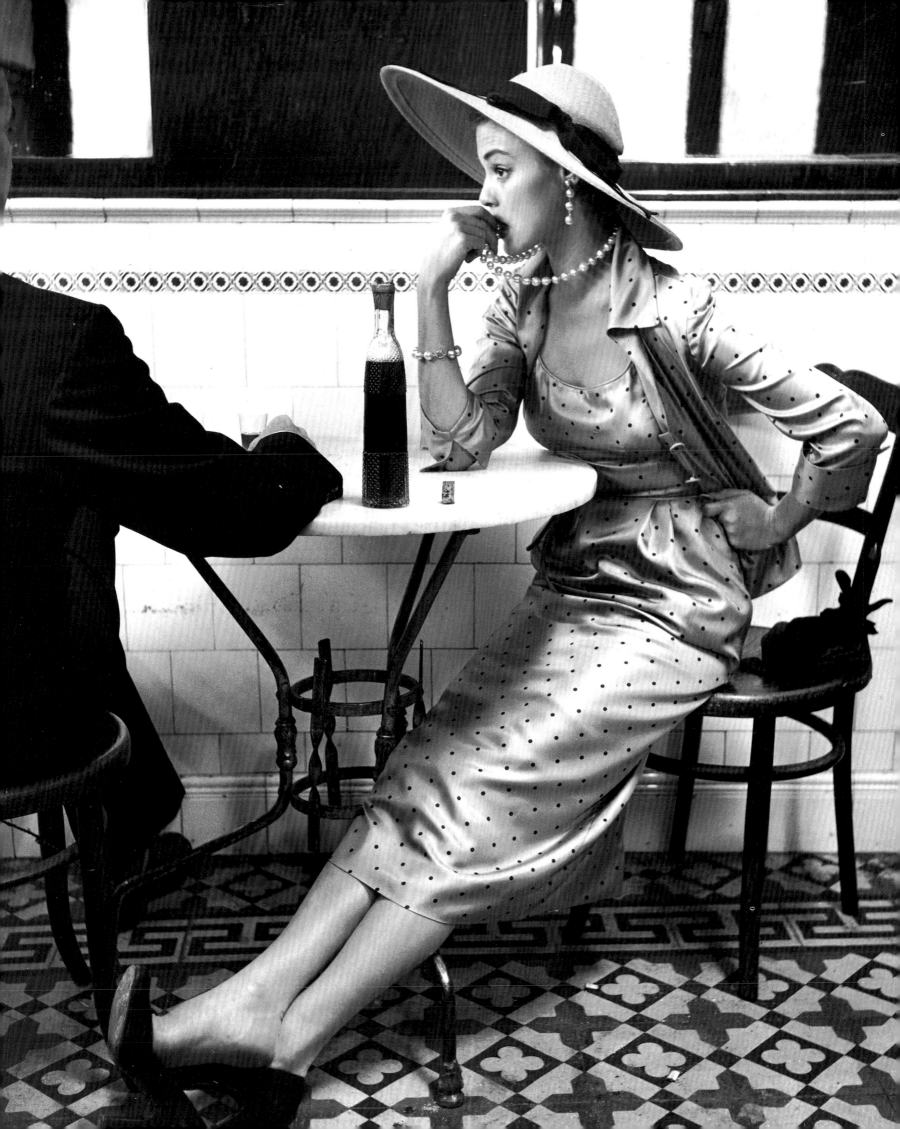

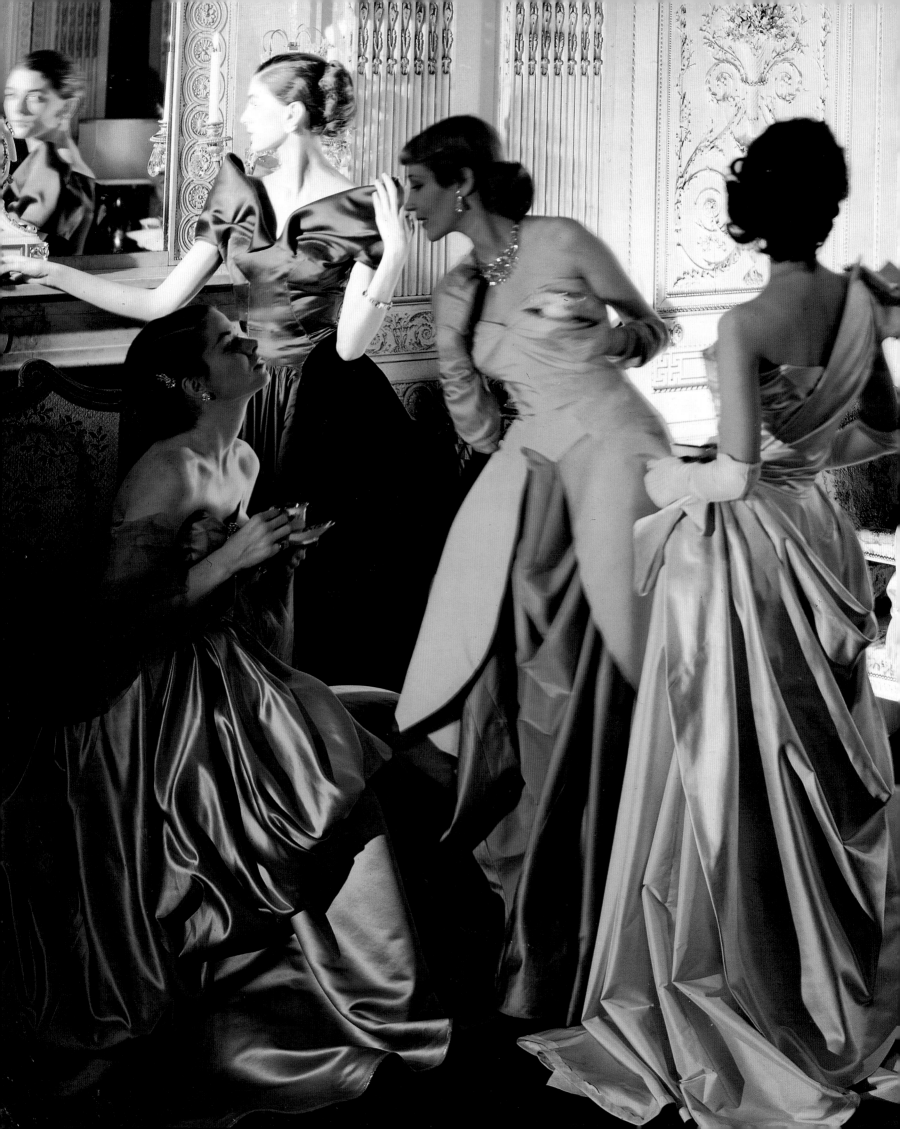

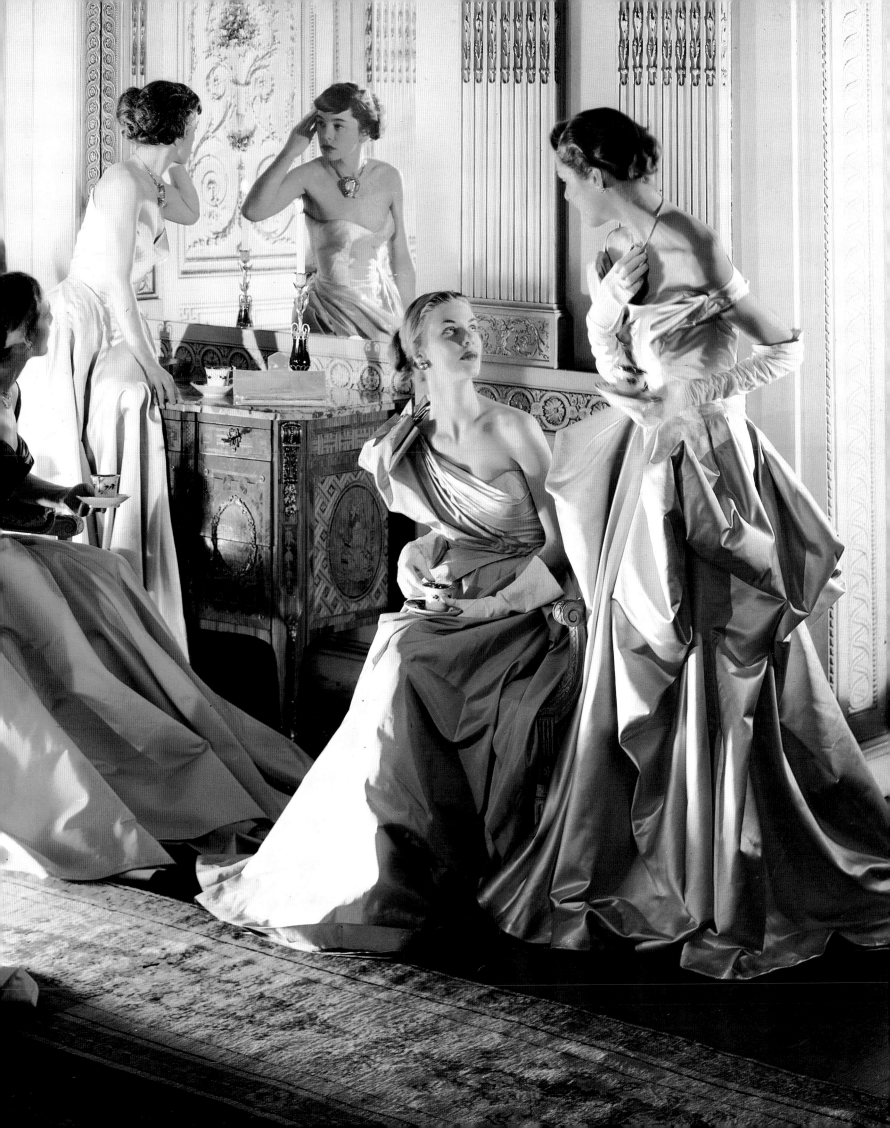

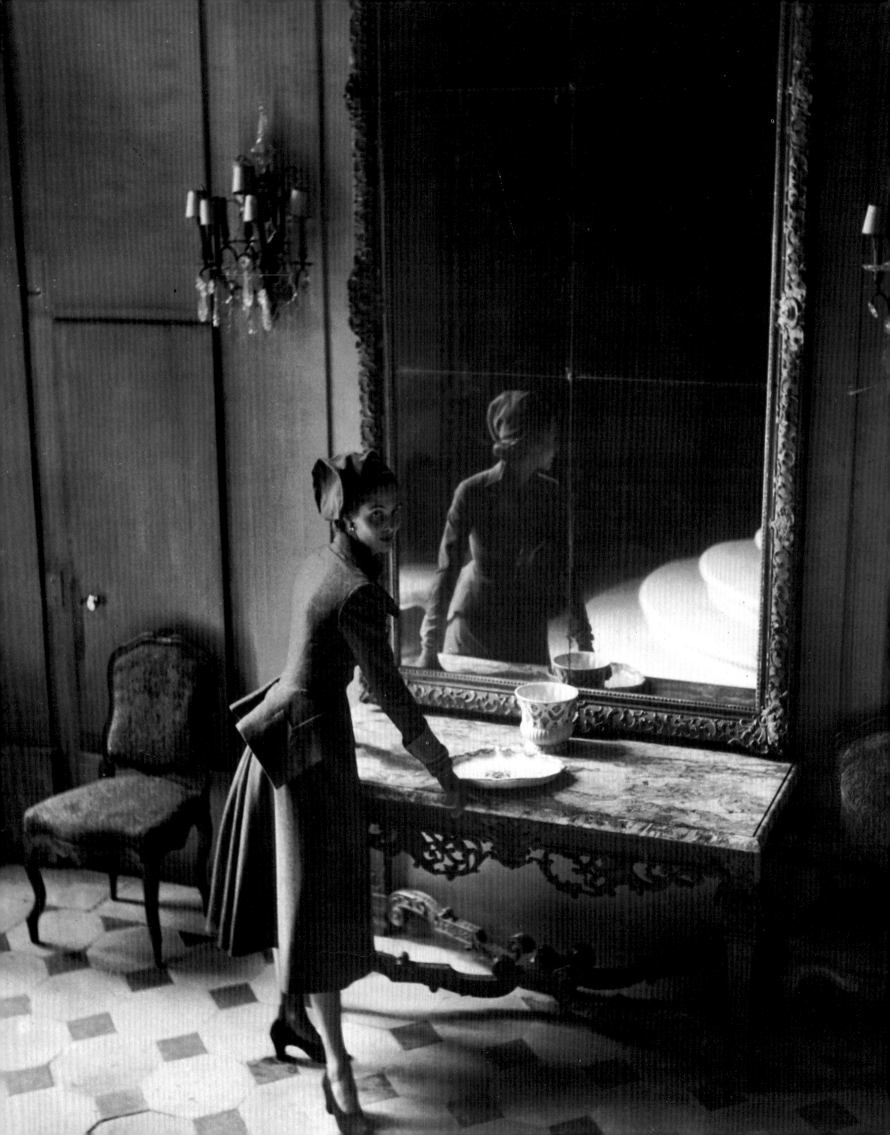

Clifford Coffin
Dior's "New Look" suit in gray flannel
September 15, 1948

following pages

Irving Penn
Jean Patchett's back
May 1, 1949

Erwin Blumenfeld
Summer beauty under a sunshade
(unpublished version of cover)
May 1945

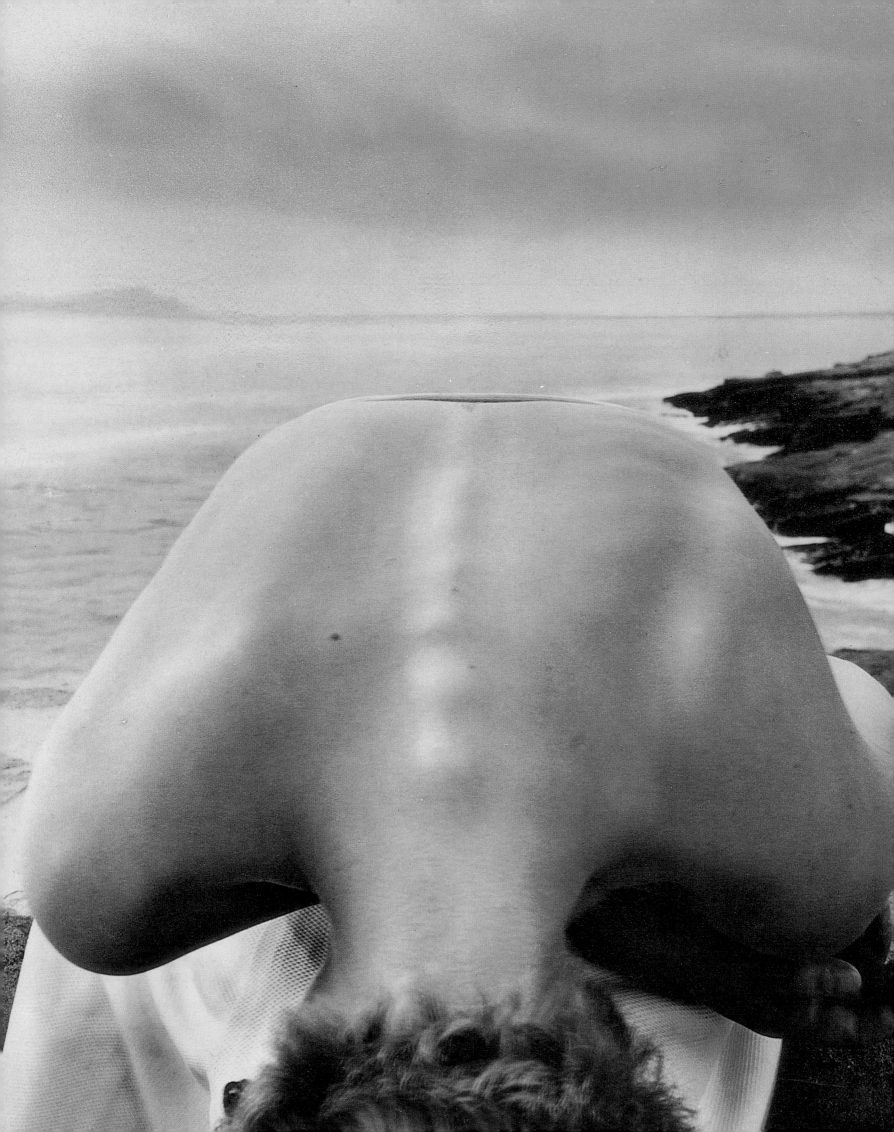

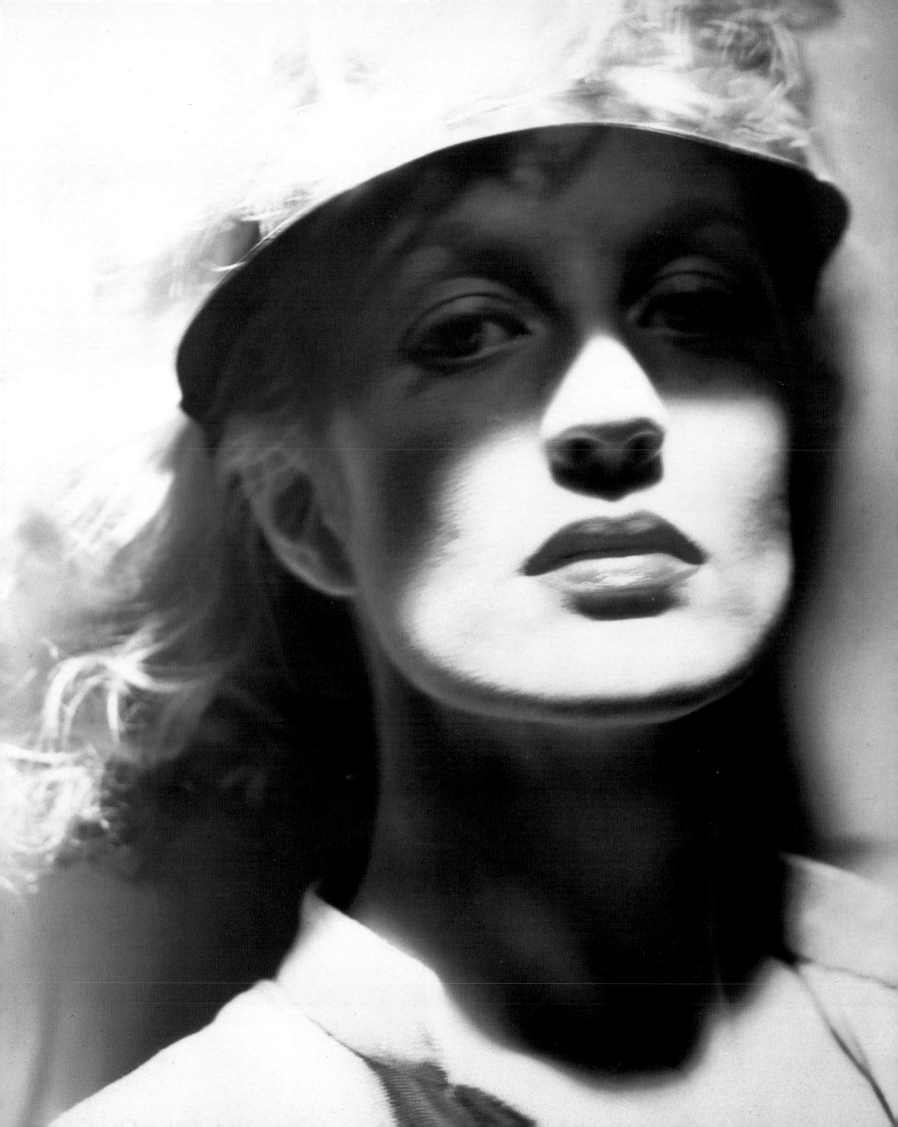

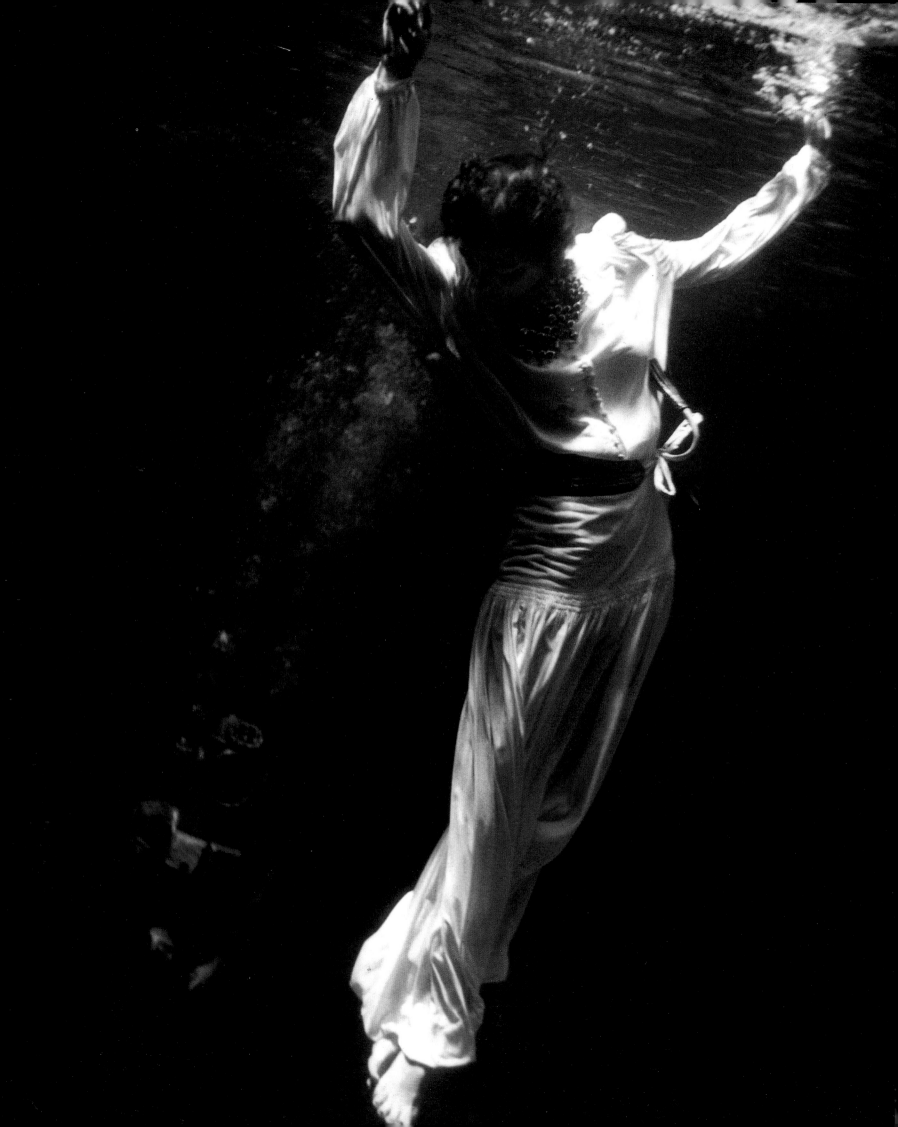

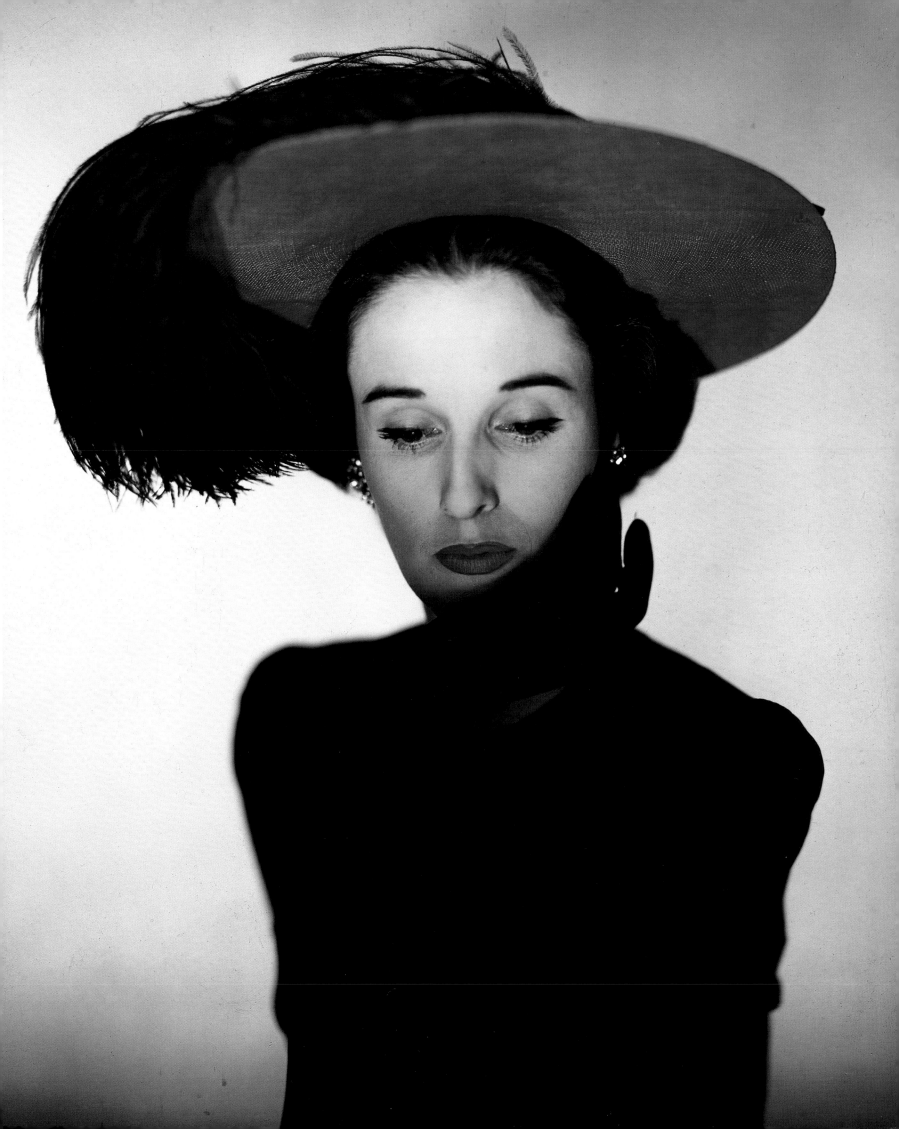

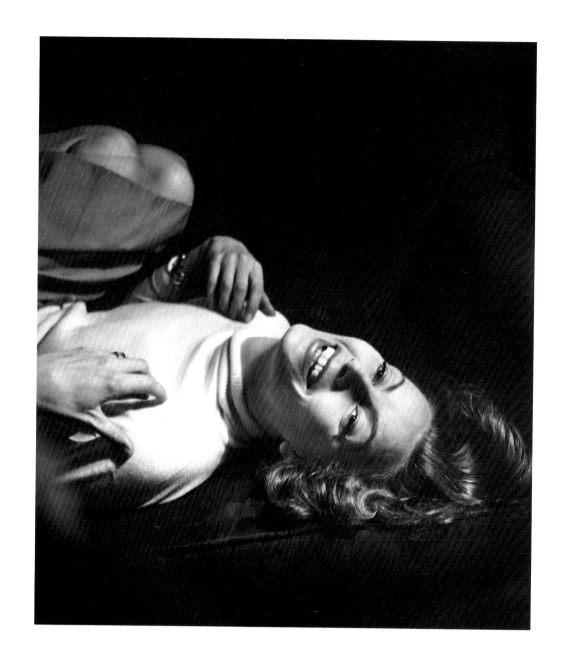

Cecil Beaton
Greta Garbo, 1946
November 1, 1968

opposite page
Gjon Mili
Deanna Durbin and Jerome Kern
February 1, 1945

preceding pages
Toni Frissell
Woman in fish tank, Marineland, Florida
May 15, 1941

Erwin Blumenfeld
Barbara Cushing Mortimer
February 1, 1947

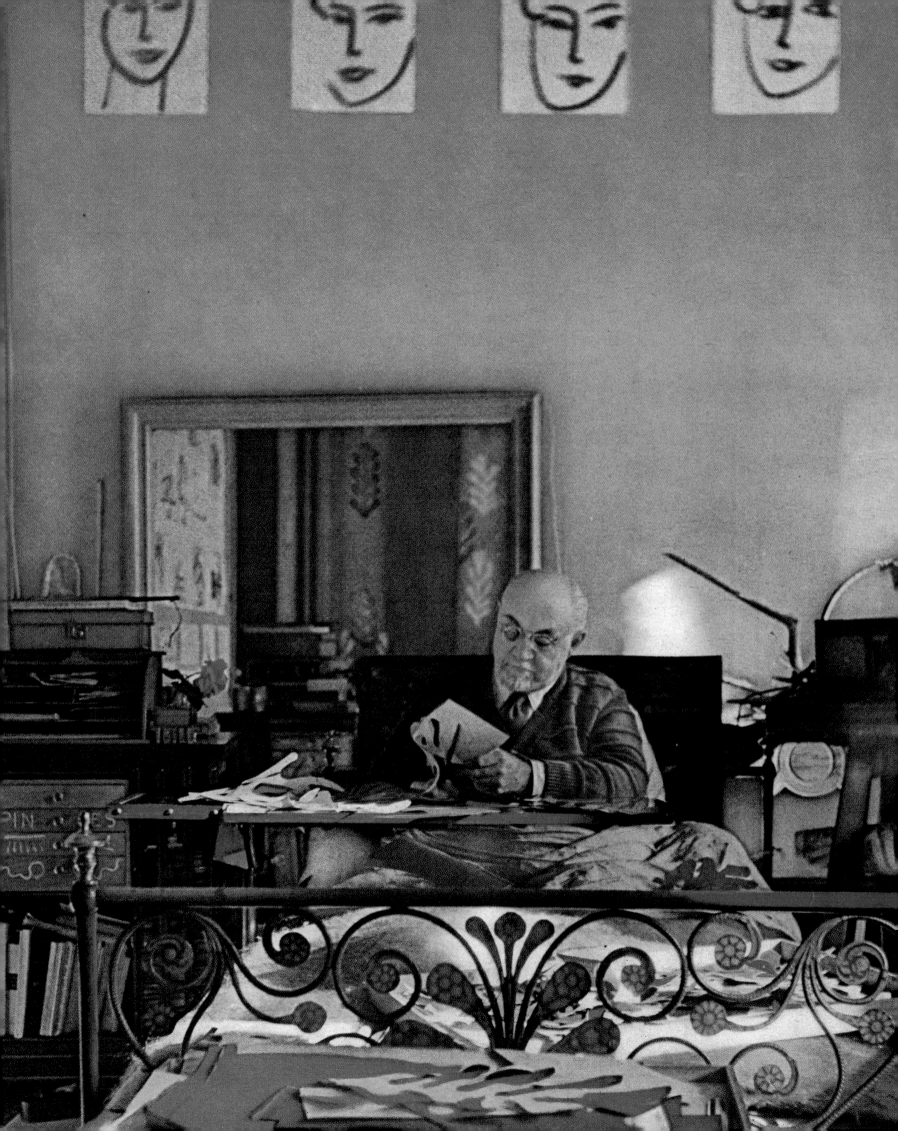

In 1936, *Vanity Fair*, the stylish Condé Nast magazine edited by Frank Crowninshield, was merged with *Vogue*. *Vanity Fair* had been introducing avant-garde writers and artists to mainstream America since 1914. It was irreverent, snobbish, and always entertaining. By the mid-thirties, however, it was also hopelessly in the red, with little chance of increasing advertising revenues. The "merger" with *Vogue* effectively killed off *Vanity Fair* while keeping Crowninshield as a contributor. The consequence for *Vogue* was that its pages were infused with celebrities and artists formerly the bailiwick of *Vanity Fair*. "Certain *Vogue* pages were basically part of a *Vanity Fair* section," Alexander Liberman recalls.

Matisse *(opposite page)* was one of the artists who had been introduced to *Vanity Fair* readers before the world at large was ready to accept his work. By the late forties he had become a grand old man, and *Vogue* went to Vence, in southern France, to visit the eighty-year-old painter, where he was working from his bed, designing a chapel for Dominican nuns and making his famous cutouts. Irving Penn's great portraits of artists, writers, sports figures, and performers of all kinds also began appearing in the late forties. Penn was to become *Vogue*'s most prolific photographer, in a relationship with the magazine that would last for half a century. Penn had been raised in Philadelphia and was a quintessentially American type. He "seemed unspoiled by European mannerisms or culture," Liberman recalled. "I remember he wore sneakers and no tie." The two met in 1941, just after Liberman arrived in New York. Penn, who had been a protégé of Alexey Brodovitch at *Harper's Bazaar*, was art director of Saks Fifth Avenue's advertising department, but he was leaving for Mexico to paint, and he offered Liberman his job. Liberman declined, and when Penn returned to New York a year later he became Liberman's assistant at *Vogue*. He was quickly promoted to photographer, and in the October 1, 1943 issue published his first cover—a still-life of accessories.

Vogue's clout gave Penn entrée to practically any subject he desired, and during the forties he produced a breathtaking number of portraits, most of them austere, black-and-white studio sittings, often with the subject in a corner—so "they couldn't run away," he explained many years later. *Vogue*'s "portrait with symbols" series took a more playful approach. "The editors would choose the personalities, and then we would sit down and think, as if it were a game, what one associated with them," Liberman recalls. Dorothy Parker is "introspective as a conch shell, capable as a corkscrew, sharp as a kitchen knife," *Vogue* explained in the text attached to her portrait *(page 72)*. When the magazine gave Orson Welles its "symbolist treatment" *(page 73)* it claimed that "the Doré *Inferno* engraving suggests his hell-fire intensity; the raven, his voice of doom."

Penn's first, and last, excursion out of the studio for a fashion sitting was an ambitious journey to Lima, Peru, to shoot spring styles for *Vogue* patterns. The model was Jean Patchett, who had not worked with Penn much before, and she began early on to have serious doubts about the success of the venture. "We flew 3,200 miles and after we got there, a week went by and Mr. Penn still hadn't used his camera," she recalls. "I started getting nervous about it. Every day I got up and got dressed but he never took a picture. Finally one day we found this little café, and there was a young man sitting across from me; and I was getting frustrated. So I just sort of said to myself to heck with this and I picked up my pearls and I kicked off my shoes. My feet were hurting. And he said, 'Stop!'" The picture taken at that moment was a watershed in fashion photography, with its impression of sexual tension and the implication that it was part of a more complicated narrative *(page 57)*.

"From then on," Patchett says, "he gave me stories to play act with every picture we did. I could be in front of a piece of white paper in a studio and he would say, OK, now you're out on Fifth Avenue and you can't get a cab. Or we are at the opera and my gentleman friend has gone to get me an orangeade and hasn't come back and I can't find him and I'm looking all over the place. Mr. Penn gave me all these little stories. And it was really fun." And it was what Alexander Liberman was looking for. "The pictures of ladies and gentlemen were progressively modernized," says Liberman. "The couture receded. Little by little the point was to find interest and beauty in the everyday, in Patchett sitting in a chair. Instead of the artificial pose, here was a woman caught in an everyday moment. It's the imperfection of actual life."

Clifford Coffin
Matisse in bed
February 15, 1949

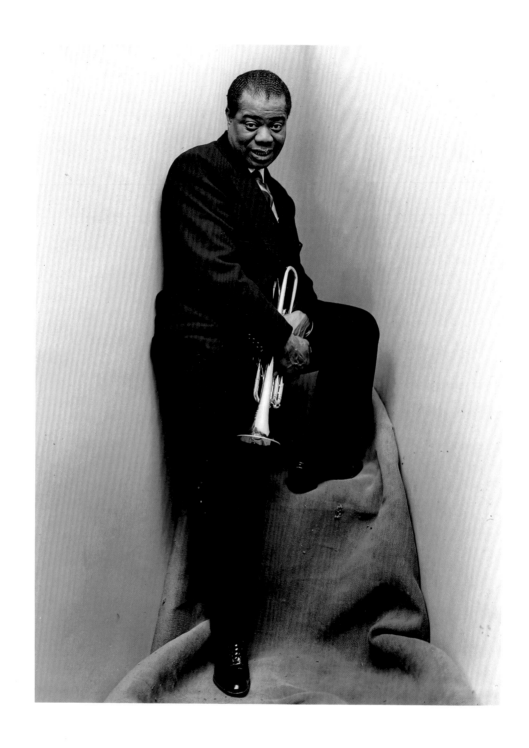

Irving Penn
Louis Armstrong
July 1948

opposite page

Irving Penn
Alfred Hitchcock
February 15, 1948

following pages

Irving Penn
Dorothy Parker, "Portrait with Symbols"
March 15, 1945

Irving Penn
Orson Welles, "Portrait with Symbols"
August 1, 1946

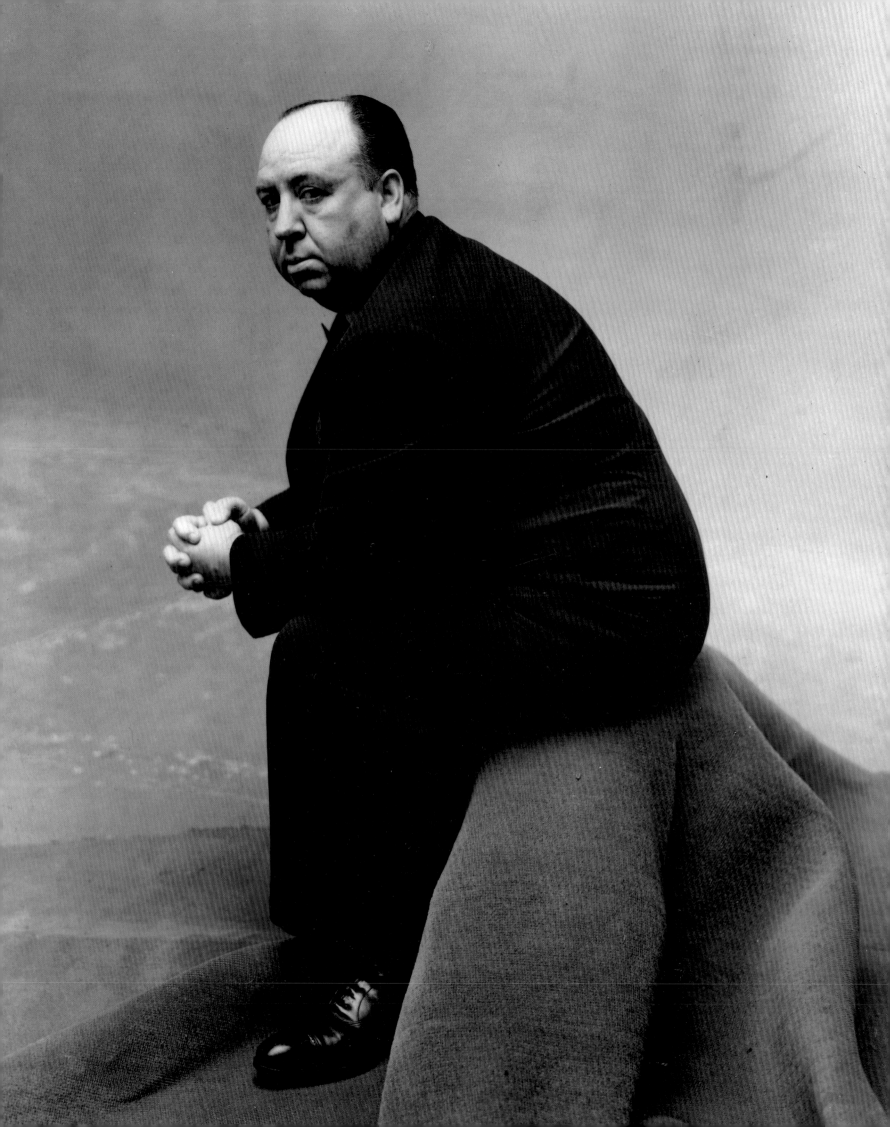

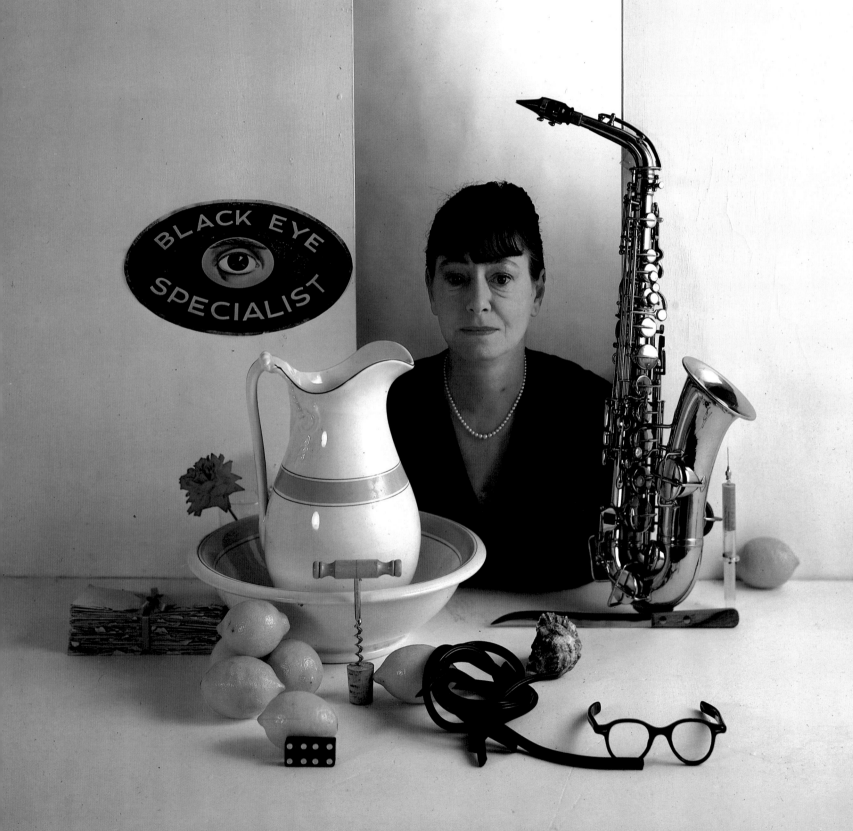

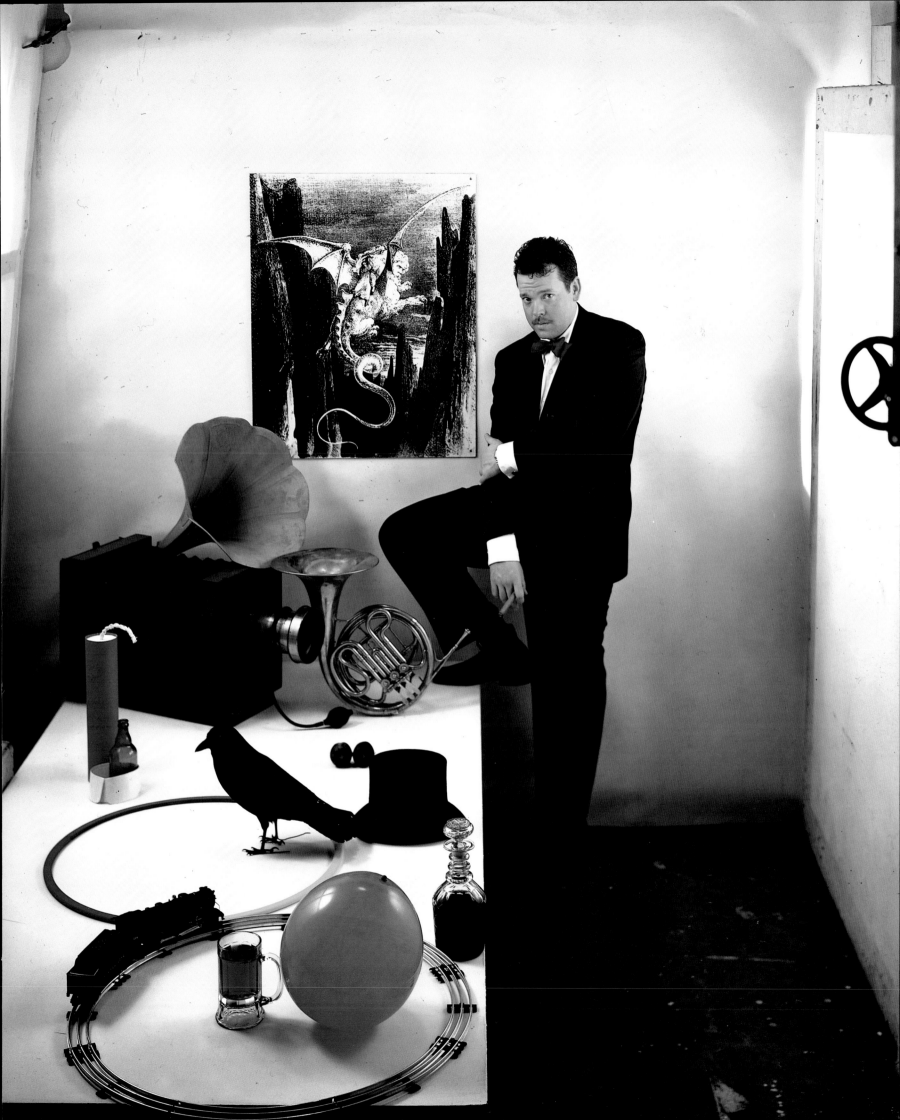

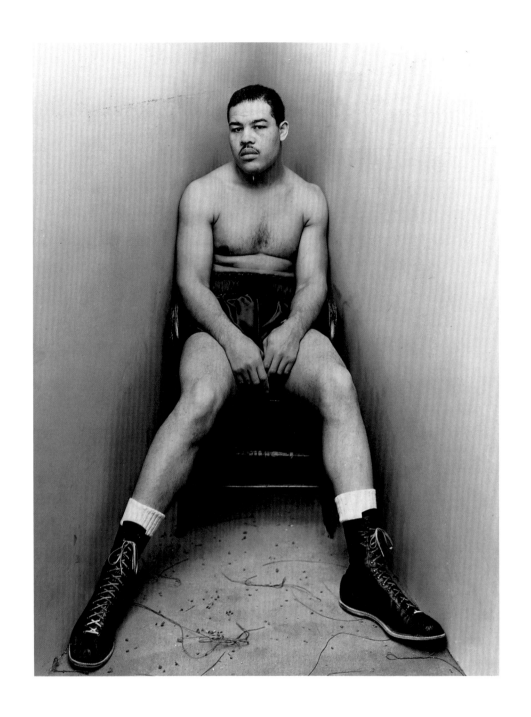

Irving Penn
Joe Louis
July 1948

opposite page

Irving Penn
Jean-Louis Barrault
March 15, 1949

following pages

Irving Penn
Jean Cocteau
February 15, 1949

Irving Penn
Leonard Bernstein
July 1948

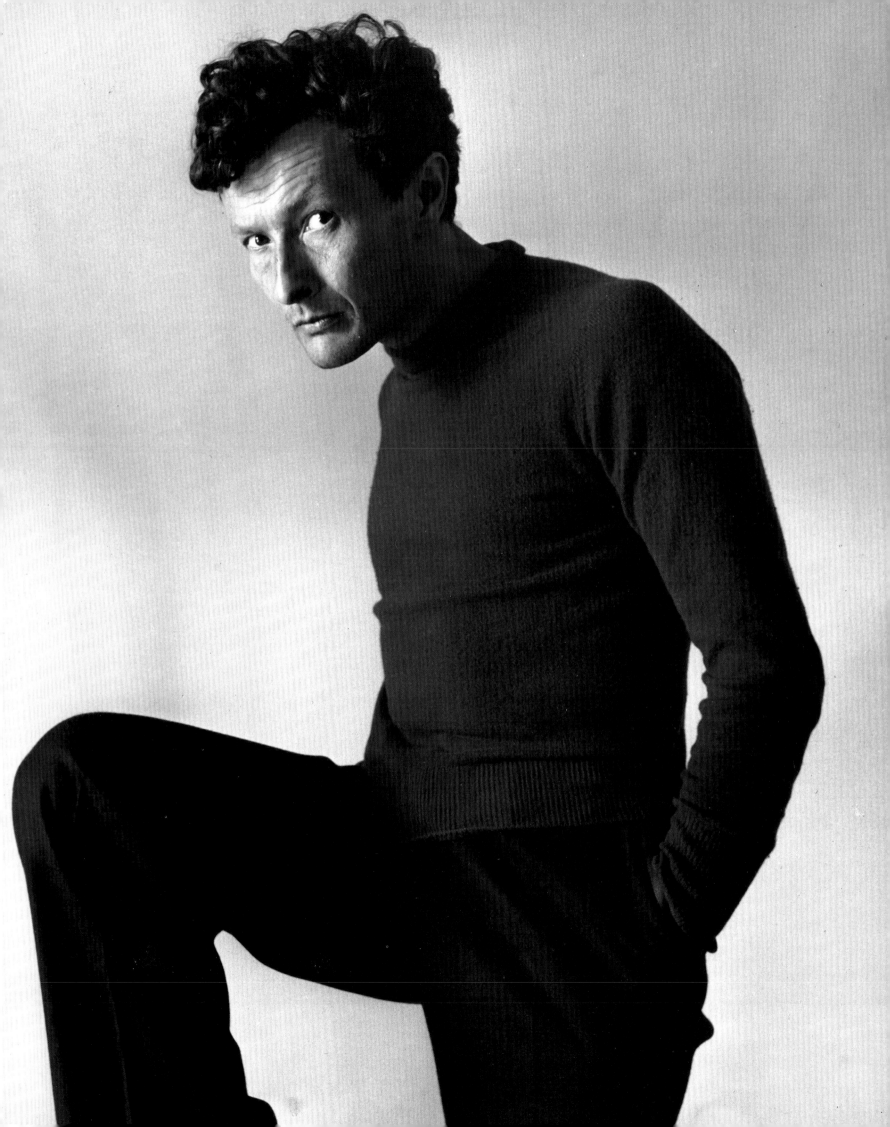

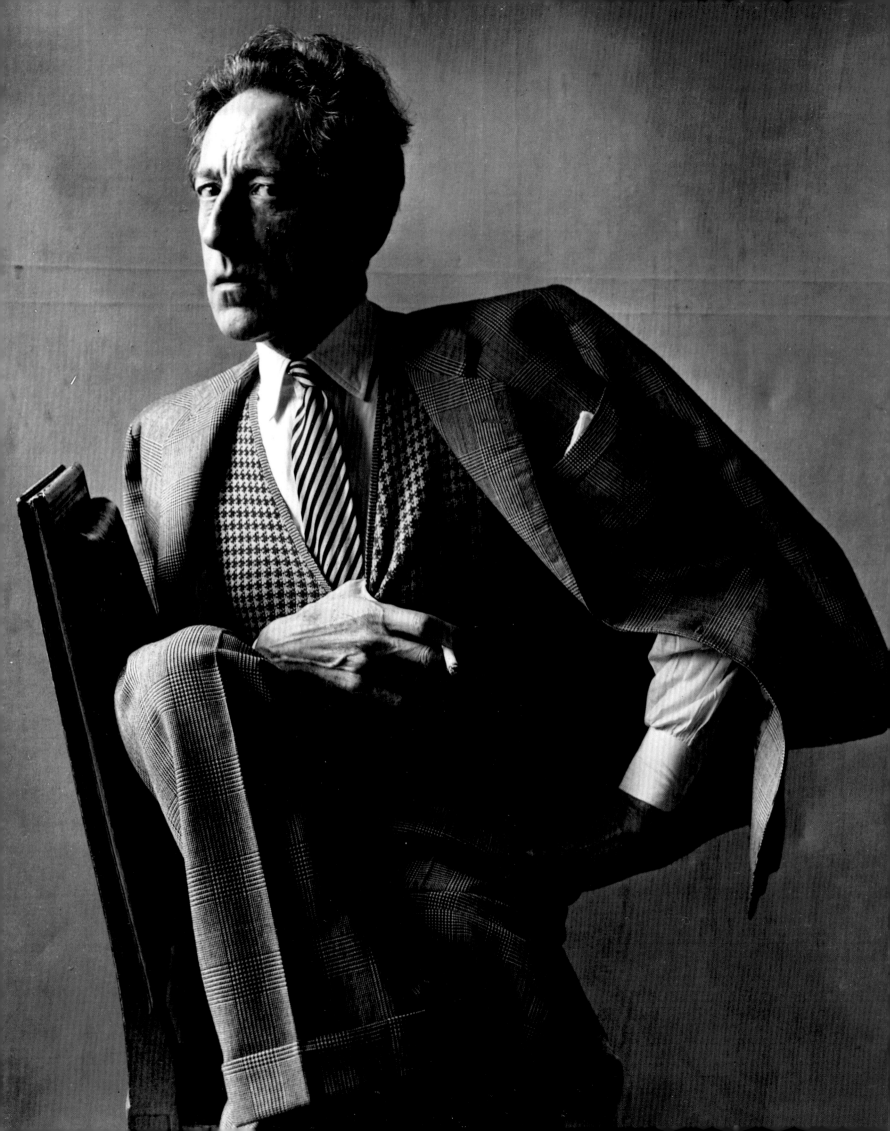

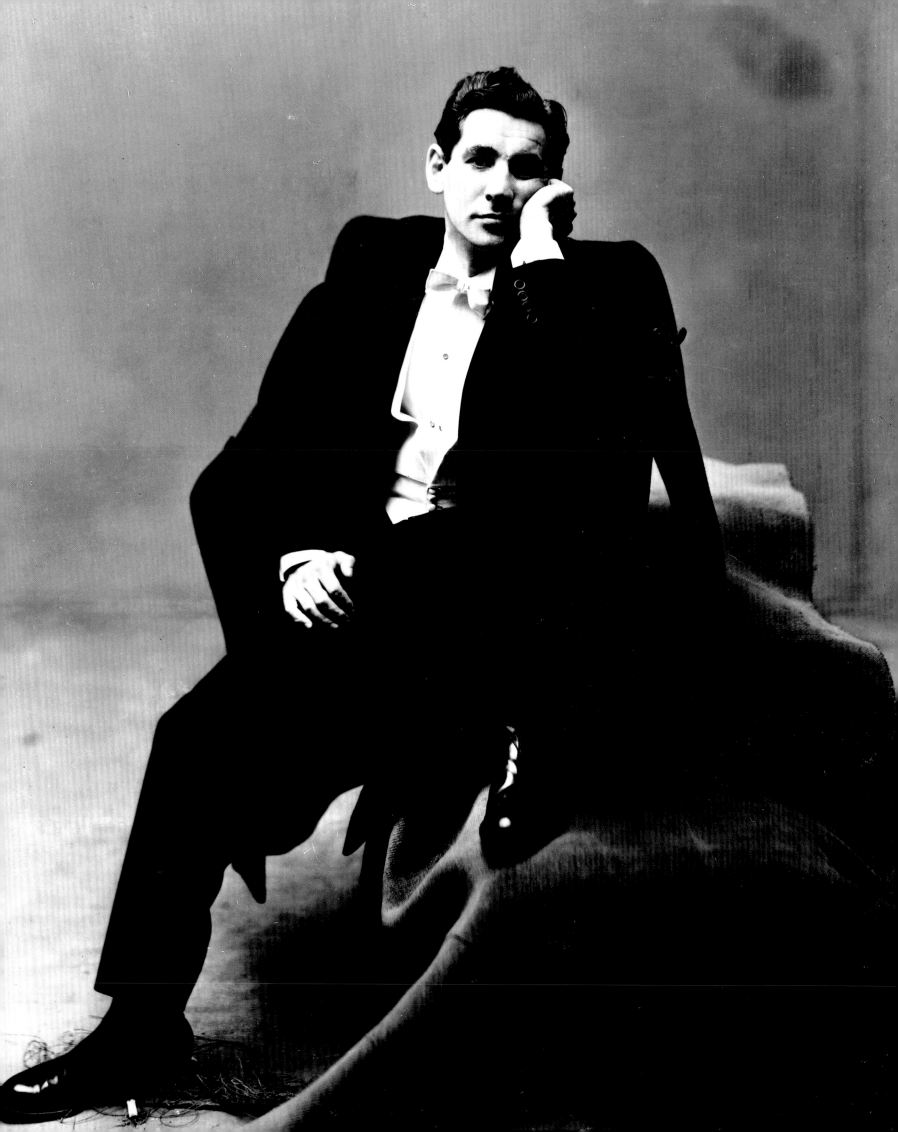

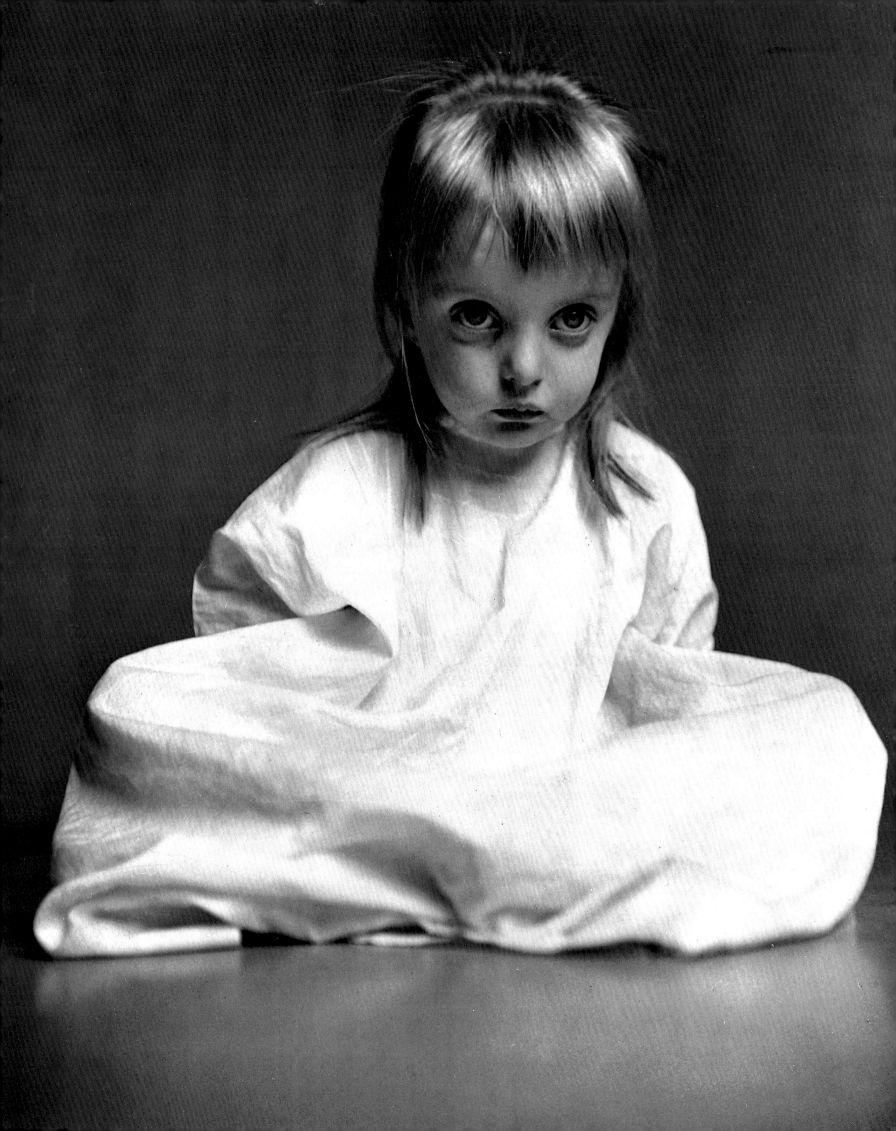

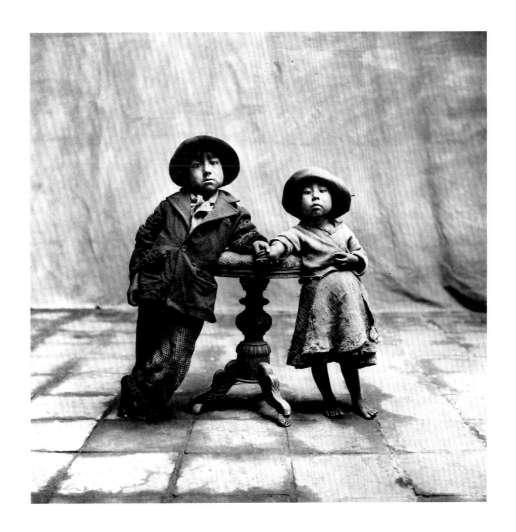

Irving Penn
Children in the Peruvian Andes, 1948
September 1, 1960

opposite page

Irving Penn
Juliet Auchincloss, 1949
December 1953

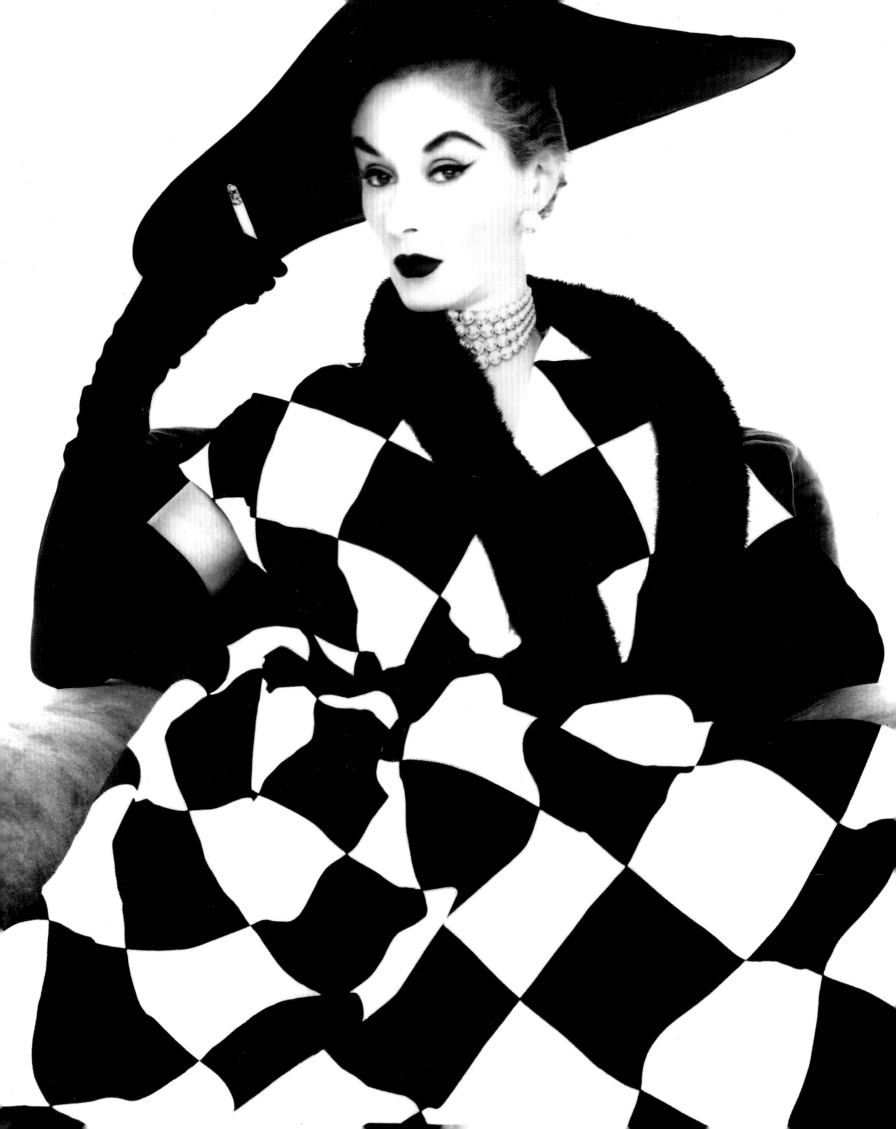

*...the showings
were at night, black-tie,
no mob of paparazzi,
no loud music.
Just little gold chairs....
very civilized.
Then the girls came out,
and they were so
snotty to the audience.
It was wonderful.*

— IRVING PENN

Irving Penn
Lisa Fonssagrives in harlequin dress by Jerry Parnis
April 1, 1950

In 1947. Irving Penn photographed the twelve top models of the decade in a group shot *(page xii)* that Alexander Liberman maintains is "one of the most extraordinary *tours de force* of fashion photography." The picture suggests traditional groupings of ladies in their finery. but as Liberman pointed out to *American Photographer* in 1980. there is "a certain—what shall I say—grubbiness of the times. . . . There is an awareness of a new reality beyond the fashion studio. . . . The unpainted ladders and the pieces of rug. if you look at them carefully, are really texture-making devices that contrast with the slickness of the clothes. . . . There's something very tragic and sad about this picture. . .a sense of the transitoriness of beauty that is very touching. But at the same time it has great dignity. . . . It's a very noble image."

One of the twelve models in the photograph is Lisa Fonssagrives, who soon became Mrs. Penn. The photographer fell in love with her the moment she came into the studio. Fonssagrives is also the model in several of the photographs from Penn's sittings of 1950. work that the art historian Martin Harrison has referred to as "a landmark in fashion photography." Alexander Liberman had prepared Penn for these sessions the previous year by sending him to watch the Paris collections for the first time. "Alex called me and told me that I'd need to go out and buy myself a dinner jacket." Penn recalled many years later. "Can you believe it? In those days the showings were at night. black-tie. no mob of paparazzi. no loud music. just little gold chairs. huge arrangements of flowers. champagne. very civilized. Then the girls came out. and they were so snotty to the audience. It was wonderful."

Fonssagrives in Jerry Parnis's harlequin dress *(page 80)* was one of the most striking images in *Vogue*'s famous April 1. 1950 "black-and-white idea" issue. which had the magazine's first black-and-white cover. The September 1. 1950 *Vogue* featured Penn's photos from the Paris collections *(pages 90 and 91)*. "The intensity which Penn brought to his portraits would never be more evident in his fashion photographs than in the 1950 collections." Martin Harrison writes. "These elegant women in their strange dresses were as threatened a species as the Asaro mud men. and Penn chronicled their existence in the same spirit that he would record the appearance of a distant tribe."

The early fifties saw a shift in the power structure at *Vogue*. In 1952. Edna Chase. by then seventy-four years old. was formally replaced by Jessica Daves as editor in chief. Daves had come to the magazine in 1933 from the advertising department of Saks Fifth Avenue. "She was kind of round and plump and very scholarly." remembers Carol Phillips. "And the correctness of things was her bag." Her natural conservatism was counterbalanced by other forces in the magazine. however. In 1954 Alexander Liberman approached the artist William Klein. an American living in Paris. and asked him to do some work for *Vogue*. Liberman had seen an exhibition of Klein's drawings and photomurals. and some experimental covers for an Italian architecture magazine. "Those pictures had a violence I'd never experienced in anyone's work." Liberman said later. "The strong graphic aspect of the streets interested me very much. There was a wonderful iconoclastic talent. seizing what it saw. I thought it should be let loose." Klein made it clear that he took the contract from *Vogue* in order to subsidize his other projects. but this didn't mean he would turn in perfunctory work. "He went to extremes." said Liberman. "which took a combination of great ego and courage. He pioneered the telephoto and wide-angle lenses. giving us a new perspective. He took fashion out of the studio and into the streets." Not all of his work got into the magazine. In 1958 he was disappointed when *Vogue* chose the "straight" shot from his sitting with Brigitte Bardot. "The picture was done in her apartment." he recalls. "and at one point I spotted her very low dressing table. I asked her to show me how she got made up every morning. and she got down on her knees in front of it saying that's what she always did." Then he coaxed her onto her bed and let her menagerie of pets—a mongrel dog. doves. and pigeons—join her. That's the shot he liked. Diana Vreeland. then fashion editor of *Harper's Bazaar*. was so covetous of the picture that actually ran *(page 104)* that when she was putting together her book *Allure*. she begged Klein for a print. When he offered her the picture he preferred. she photographed the page from the issue itself and published that with the caption: "Bill Klein's Brigitte Bardot was the only thing I ever envied *Vogue* for when I was working on *Harper's Bazaar*."

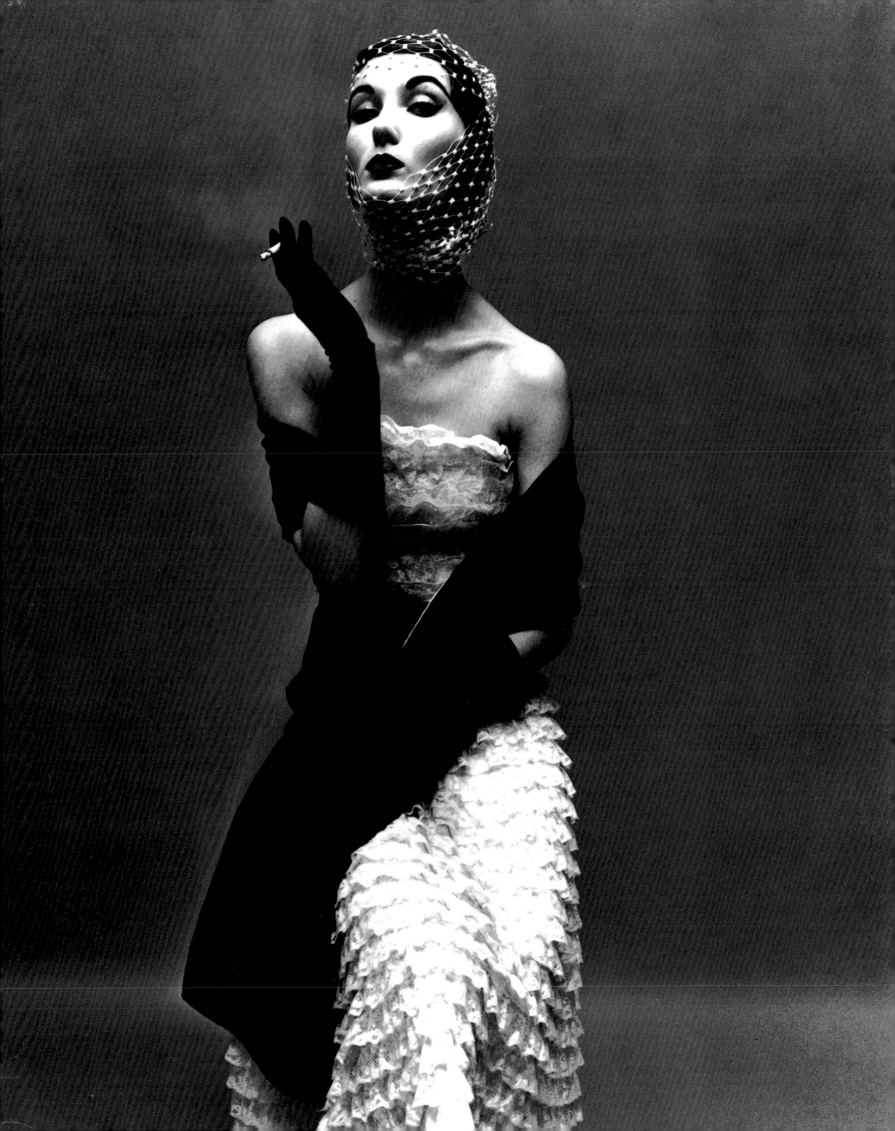

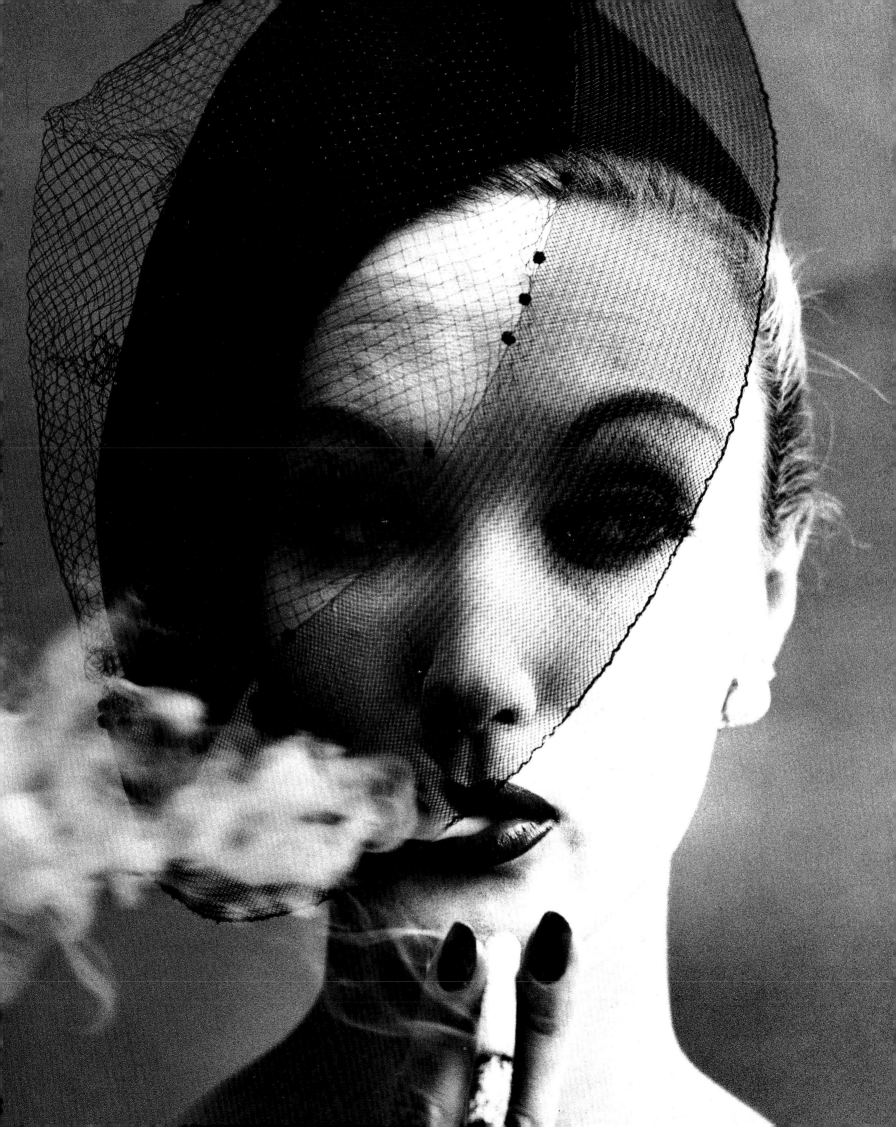

preceding pages

William Klein
Cyclamen wool-tweed coat and Great Dane
July 1958

William Klein
Evelyn Tripp in velvet hat, "Smoke and Veil"
September 15, 1958

Irving Penn
Dorian Leigh and Evelyn Tripp
in Claire McCardell wool
jersey dress and jumper with leotard
January 1, 1950

Irving Penn
Lisa Fonssagrives in Lafaurie's pleated chiffon evening dress
September 15, 1950

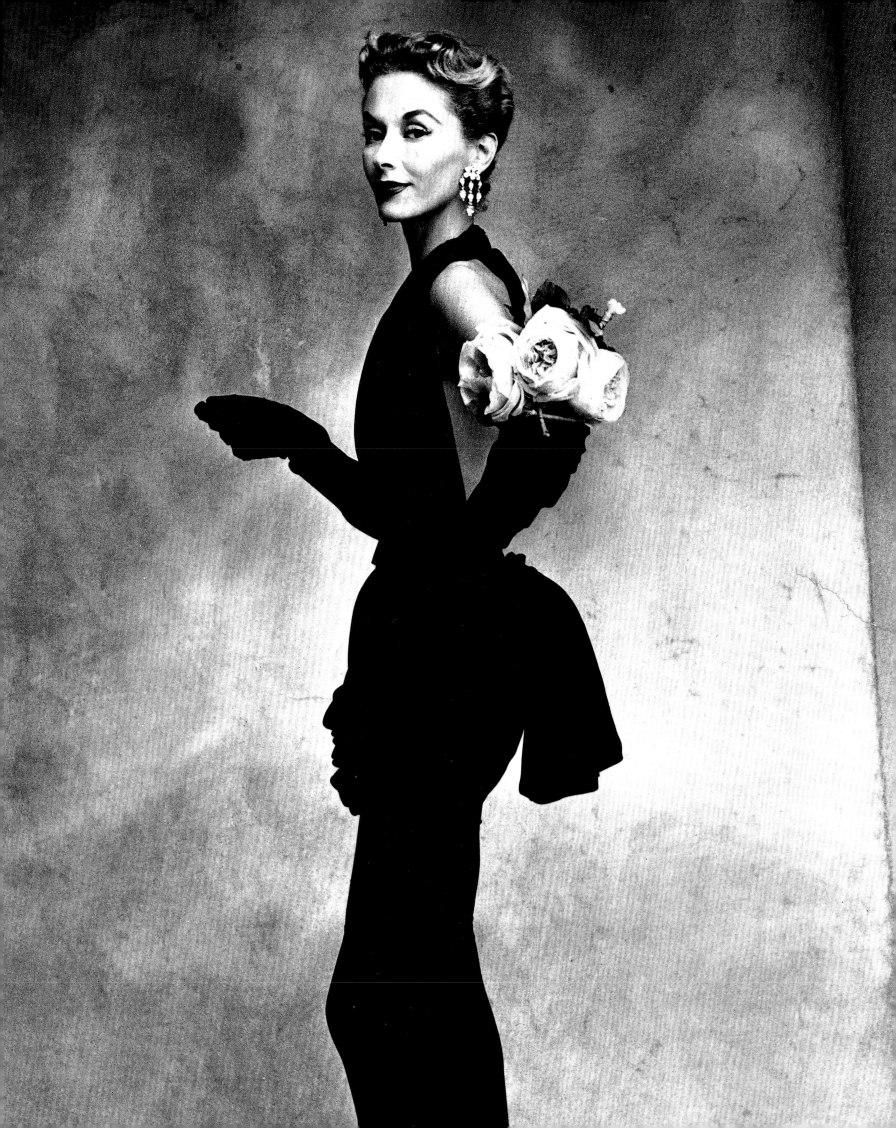

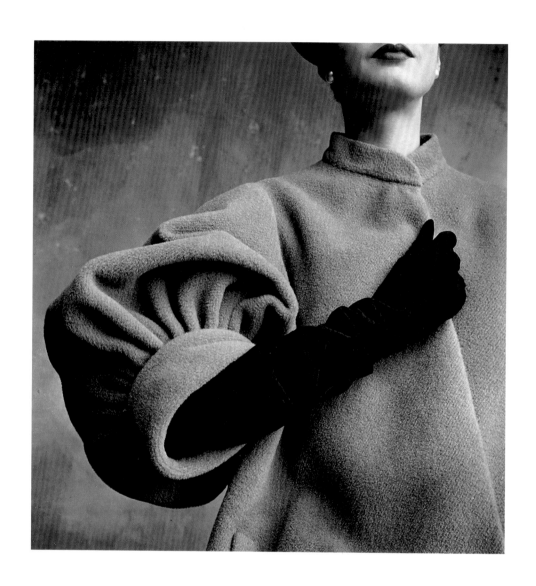

Irving Penn
Balenciaga's gathered sleeve
September 1, 1950

opposite page

Irving Penn
Balenciaga harem dress and cape
September 1, 1950

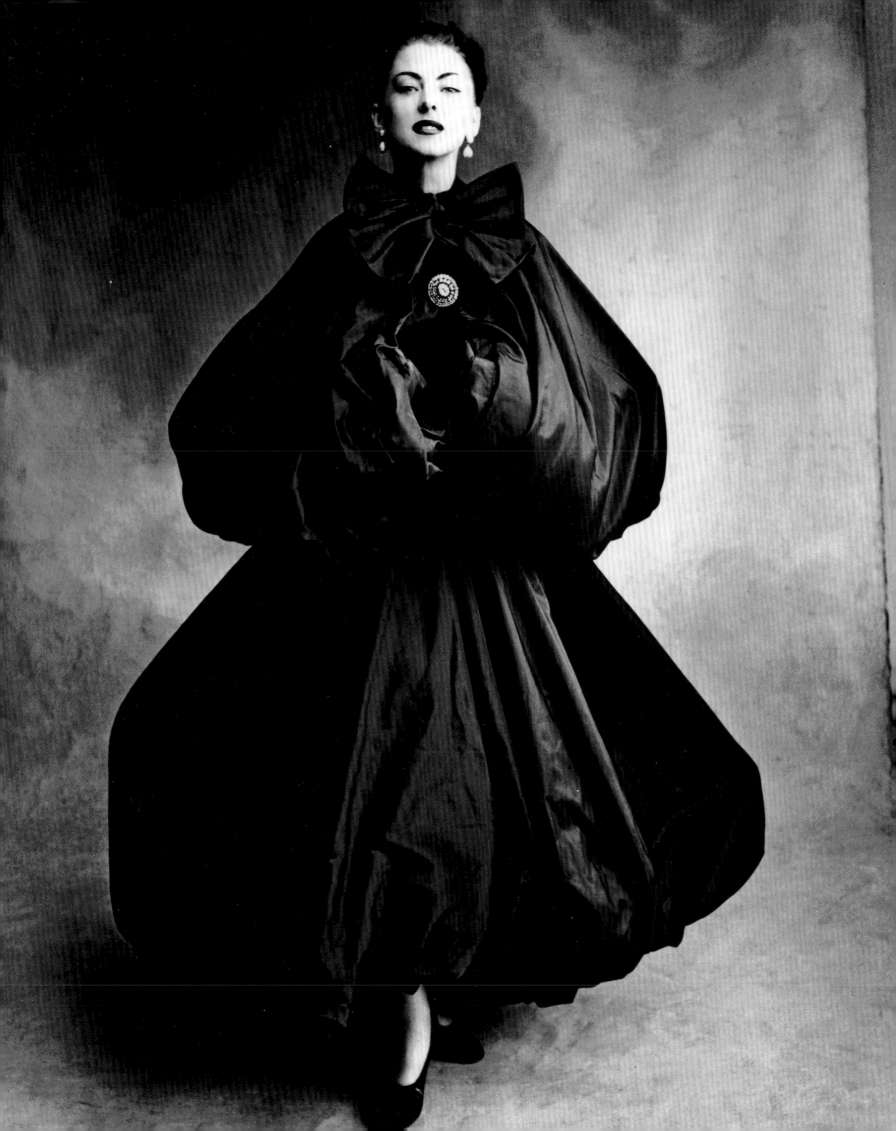

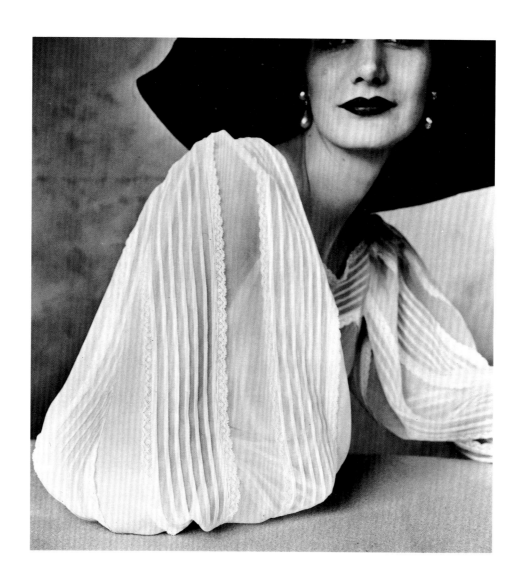

Irving Penn
Sunny Harnett in
Ben Reig silk-chiffon blouse
April 1, 1951

opposite page

Erwin Blumenfeld
Jean Patchett
(cover)
January 1, 1950

The January 1, 1950 issue of *Vogue* featured a series of photographs by Irving Penn in homage to a half-century of fashion. "There is never a fashion with nothing to say," the anonymous *Vogue* editorial voice explained to its readers. "No fashion that hangs on to a period and stamps it is whimsical, arbitrary, or irrelevant." The photograph taken to represent the forties *(page 86)* is a witty comment on aloof fashion models, with perhaps a nod to Penn's own famous photograph of model Jean Patchett with her pearls in her mouth in the café in Lima, Peru *(page 57)*. Two models in the "forties" photograph slouch at the same angle at a café table and are also studiously oblivious to the camera.

Jean Patchett herself appears in that issue, in a photograph taken by Erwin Blumenfeld for a beauty feature. An alternate version is on the cover *(page 93)*, this one processed so that all that remains of Patchett's face is a very graphically defined eye, eyebrow, mouth, and beauty mark. Patchett says that she had no idea during the sitting that a special effect was intended, and most likely it was not. Blumenfeld was always interested in what could be done with a photograph after the picture was taken. "The technical work is the greatest joy," he had explained to Cecil Beaton years earlier, before he became a successful magazine photographer. "I have such willpower, such belief that the pictures must come out as I hope. Even if they were washed in water instead of a developer, I think they would gradually appear in the basins. To me, the greatest magic of the century is in the darkroom."

Patchett was also involved in an earthier sitting that year, when *Vogue* sent her to Havana for a feature on "sun fashions." Trips on location during the fifties were much more loosely organized than they were to become later, and involved fewer people. A photographer would take perhaps one assistant, and the editor in charge of the feature would also serve as the hair-and-makeup person. In this case the editor was Babs Simpson, whose father was Cuban and who was relied upon to make the necessary connections once she and her little team had arrived in Havana. She easily rounded up a retinue of interesting local people to provide backgrounds—the artist Wilfredo Lam to hold up one of his voodoo-inspired paintings next to Patchett in a white silk dress, jai alai star Carlos Pita to banter with a model wearing a beige silk dress. But Simpson also wanted Ernest Hemingway, a main attraction in Havana at the time. There were two problems, however. Hemingway was still smarting over the bad reviews he had just gotten for his new book, *Across the River and Into the Trees*, and was not in a good mood. Also, he "loathed everything to do with *Vogue*," Simpson says, because one of his ex-wives, Pauline Pfeiffer, had been a fashion editor for *Vogue*'s Paris office, and there was some sort of residual ill will toward the magazine.

Simpson rang up the Hemingway house, and when Hemingway came to the phone, he confused Simpson with her Cuban cousin, who was in fact an old friend of his. But an invitation to visit was offered even after he realized his mistake. So at seven-thirty the next morning, Simpson, Patchett, and Clifford Coffin, the photographer, arrived at the famous Finca Vigía in what was already sweltering heat. They found an apparently abandoned house littered with half-filled champagne glasses, but then Hemingway finally appeared with a drinking companion, a priest who immediately attached himself to Simpson. Hemingway's hostility toward *Vogue* cooled considerably after he met Patchett, as can be deduced from the photograph the magazine ran *(page 99)*. She perches warily at the end of the couch under his predatory gaze. "It was a very sweaty situation," Simpson recalls. And she ended up with a terrible hangover at three in the afternoon.

The trials of editors and models and photographers in pursuit of the right picture are legendary. Shoots on location are frequently arduous, and even studio sittings can go on for days. Cecil Beaton rarely had the patience to do more than a few shots before he was off to lunch or some more interesting appointment. Irving Penn, on the other hand, worked obsessively. "Irving would put those poor girls into some impossible contortion and then ask them to hold the pose for twenty-five minutes, and then he'd complain that they didn't look spontaneous and they'd burst into tears," Babs Simpson recalled in an interview with the journalist Martin Filler. He was equally demanding of nonhuman subjects. "There's the famous story of Irving photographing the lemon," Simpson said. "First, you had to buy five hundred lemons for him to pick the perfect one. Then he had to take five hundred shots of that lemon."

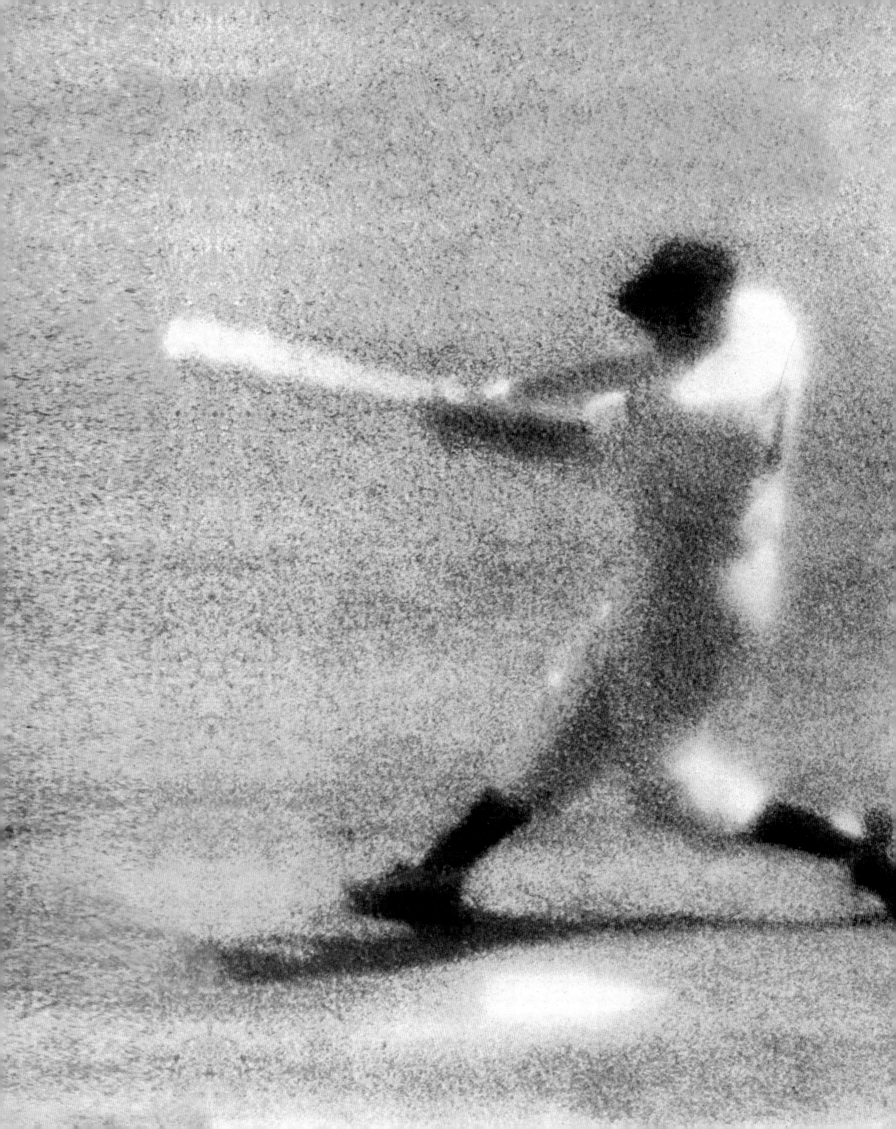

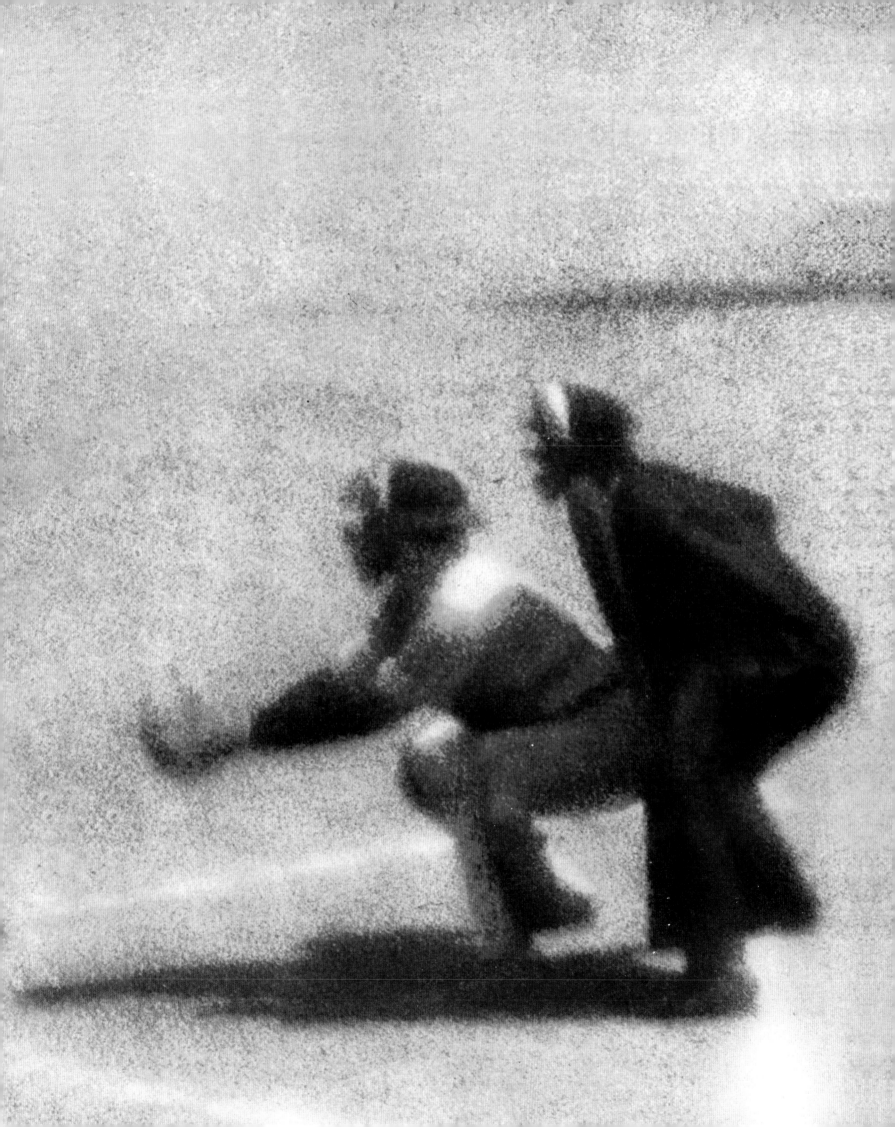

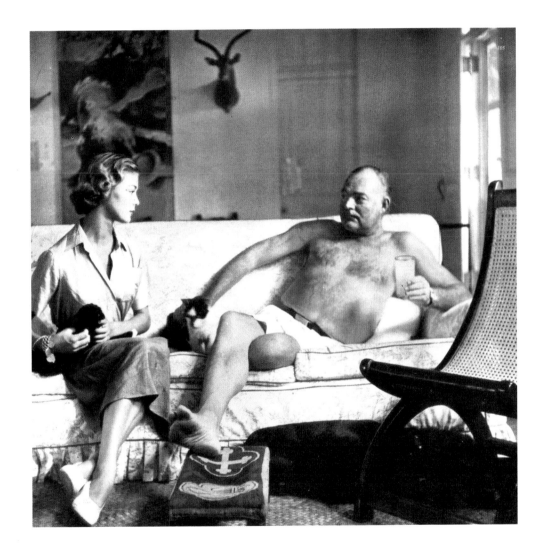

Clifford Coffin
Jean Patchett and Ernest Hemingway at Finca Vigia, Cuba
November 15, 1950

opposite page

Irving Penn
American summer still life
July 1952

preceding pages

Irving Penn
Johnny Mize at Yankee Stadium
October 1, 1951

People are talking about. . . "the Bix Beiderbecke album." *Vogue* told its readers in July 1952, and about "Katharine Hepburn, knocking them dead on the old London road with G. B. Shaw's play. *The Millionairess*," about James Thurber and Dean Martin and Jerry Lewis. And, somewhat curiously, about "the fine art of making baseballs for the major leagues; the balls are made at Chicopee, Massachusetts; the horsehide cover, put on after a cement bath, is stitched by hand, usually female." This arcane bit of Americana accompanied Irving Penn's summer still life *(page 98)*, a carefully composed study of a hot dog, a Coke, chewing gum, and a baseball. It is a quintessentially fifties image, and it also reflects the interests of both Penn and Alexander Liberman, who were avid baseball fans. Their passion for the subject, which was slightly anomalous at *Vogue*, had been in evidence the previous year in a Seurat-like photograph of first baseman Johnny Mize swinging at a ball in Yankee Stadium *(page 96)*. This photograph was attached to a story by sportswriter Red Smith on the occasion of the World Series. "I loved baseball and Penn loved baseball," says Liberman, "but in this case we were actually more interested in getting the grain of the Kodachrome to register."

Liberman and Penn often collaborated closely. In general, Liberman chose not to discuss assignments with a photographer in detail. "You can't direct," he says. "I never went to a studio sitting in my life." But with Penn, "we'd sit for a half an hour or forty minutes and discuss what could be done. Or I would make a sketch." When Penn began working for *Vogue*, the magazine "offered wonderful possibilities for creative photographic experimentation," Liberman remarked in his introduction to Penn's book *Passage*. "Each selected photographer was given his own studio, a salary, plus all technical means and assistance. In exchange he was always on call and would execute any assignment he was given." The assignments often involved famous people, and Penn has over the years taken pictures of a great many of the celebrated men and women of our time. "His portraits are not idealizations," Liberman wrote elsewhere, "and he is never over-impressed by the sitter, as so many photographers are. . . . There is no deceit in his pictures; his camera does not lie. He seeks to convey individuality by showing how light hits the planes of the face, the knobs of bones. . . . Sometimes he uses an extreme close-up, sometimes a long shot, a change of angle or point of view, all subtle means of making us see a person entirely. He can not and will not compromise with flattery."

The great portraits of the fifties include one of Colette in the last years of her life *(page 103)*. "She was eighty when it was taken," Penn recalled in his book *Moments Preserved*, "some time after she was permanently confined to bed. One foot of the camera's tripod stood on the sheet between Colette's immobilized feet, immaculately pedicured with the nails lacquered scarlet." Picasso posed for Penn at La Californie, his villa in Cannes. He removed his sweatshirt and donned a Spanish bullfighter's cloak with embroidered collar and a stiff-brimmed Cordoban hat. "A great presence, deeply aware of his own image," Penn noted, "he peered silently at the reflection of his head in the camera's lens, occasionally altering the attitude." Liberman himself had embarked on a series of portraits of artists in the late forties, many of which were published in *Vogue*. He was interested in French painters and sculptors of the modern period. The photograph of Georges Braque *(page 106)* in the garden of his summer house in Varengeville, Normandy, was taken during lunch. "Someone was pouring him some wine," Liberman recalls, "and he was saying, no, no, that's enough. There was such extraordinary passion in his expression."

Toni Frissell's portrait of Winston Churchill in the formal robes he wore to the coronation of Queen Elizabeth II *(page 105)* was taken the day of the coronation at the request of Lady Churchill, who wanted some photographs for the family. Frissell found a sunny spot to take the picture in a room with three windows overlooking a parade grounds at No. 10 Downing. Churchill was draped in honorary ribbons and medallions, including an extraordinary gold figure of St. George and the Dragon. He "put on a black velvet hat with a wide brim and an ostrich plume that tickled his neck," Frissell recalled. "But somehow it made him look like a baby in a perambulator. So when he sat down I suggested that he hold the hat, in order to look more like a 'man of destiny.' . . . It wasn't long before he looked impatient, and I snapped that bulldog expression."

Constantin Joffé
Roller Derby stars
February 1, 1950

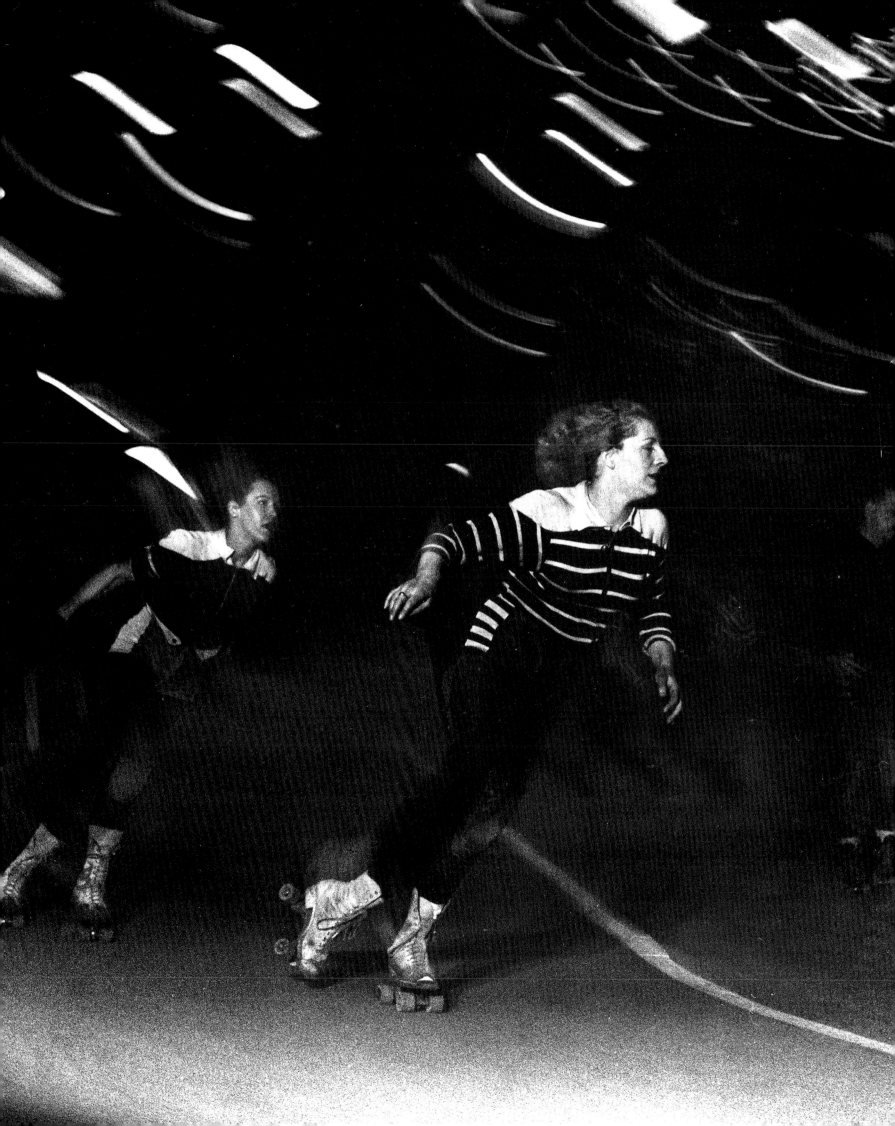

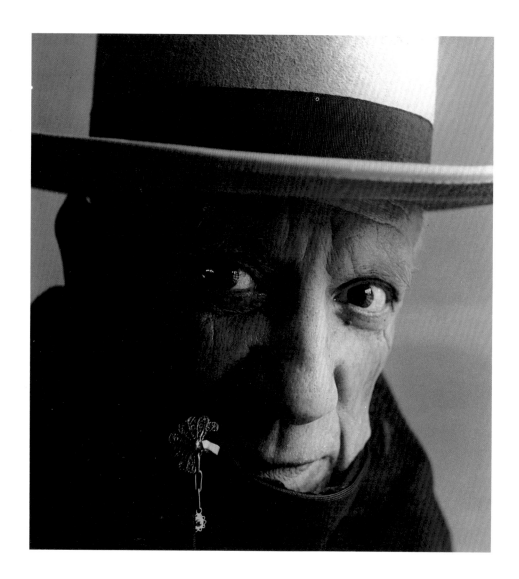

Irving Penn
Picasso
April 15, 1959

opposite page

Irving Penn
Colette in bed, 1951
November 1, 1960

following pages

William Klein
Brigitte Bardot
March 15, 1958

Toni Frissell
Winston Churchill in the uniform and robe he wore
to the coronation of Queen Elizabeth II
August 1, 1953

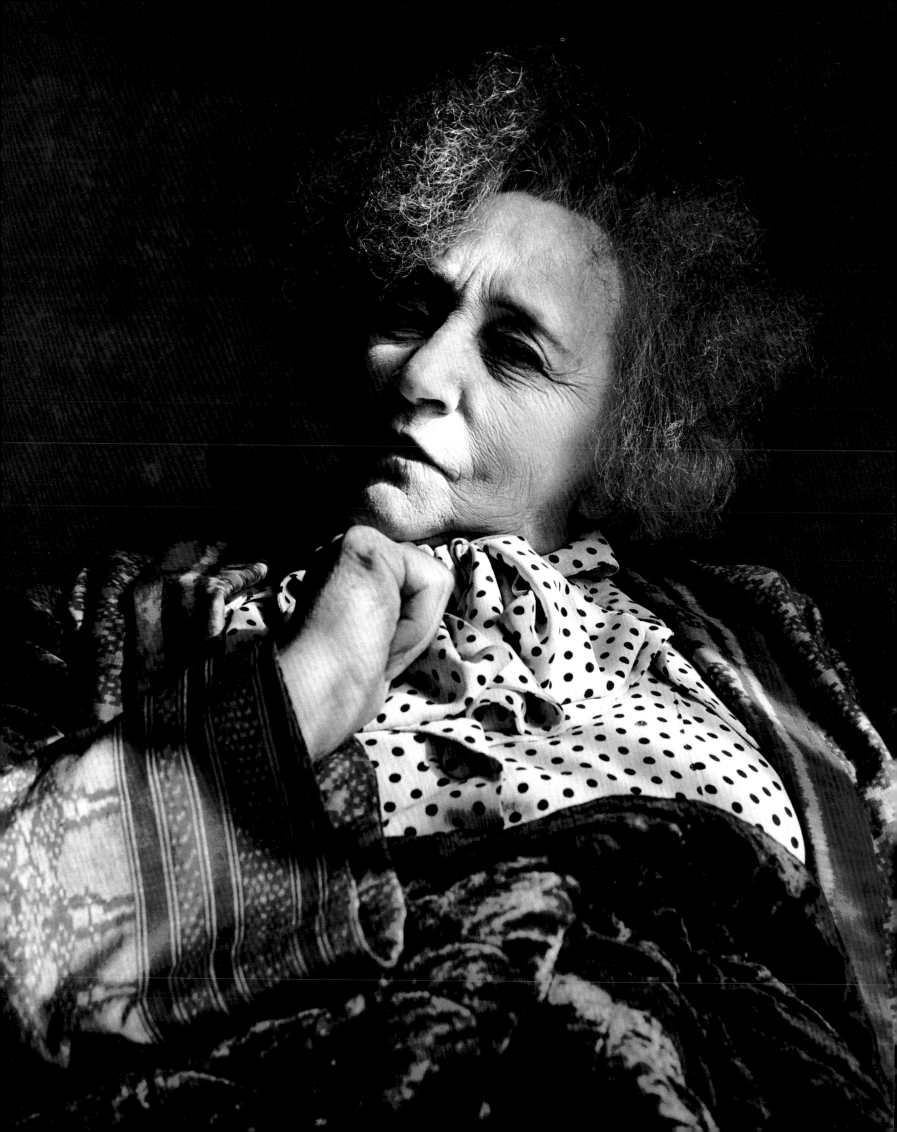

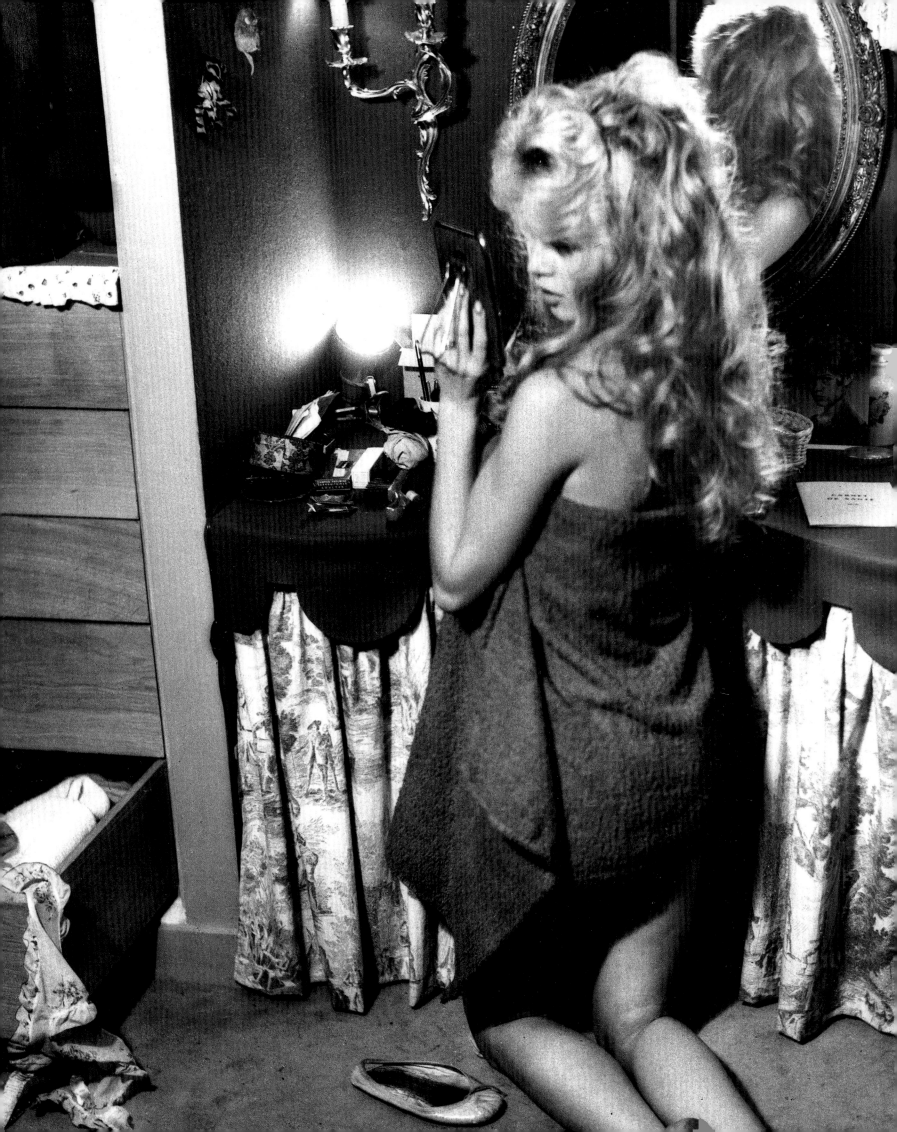

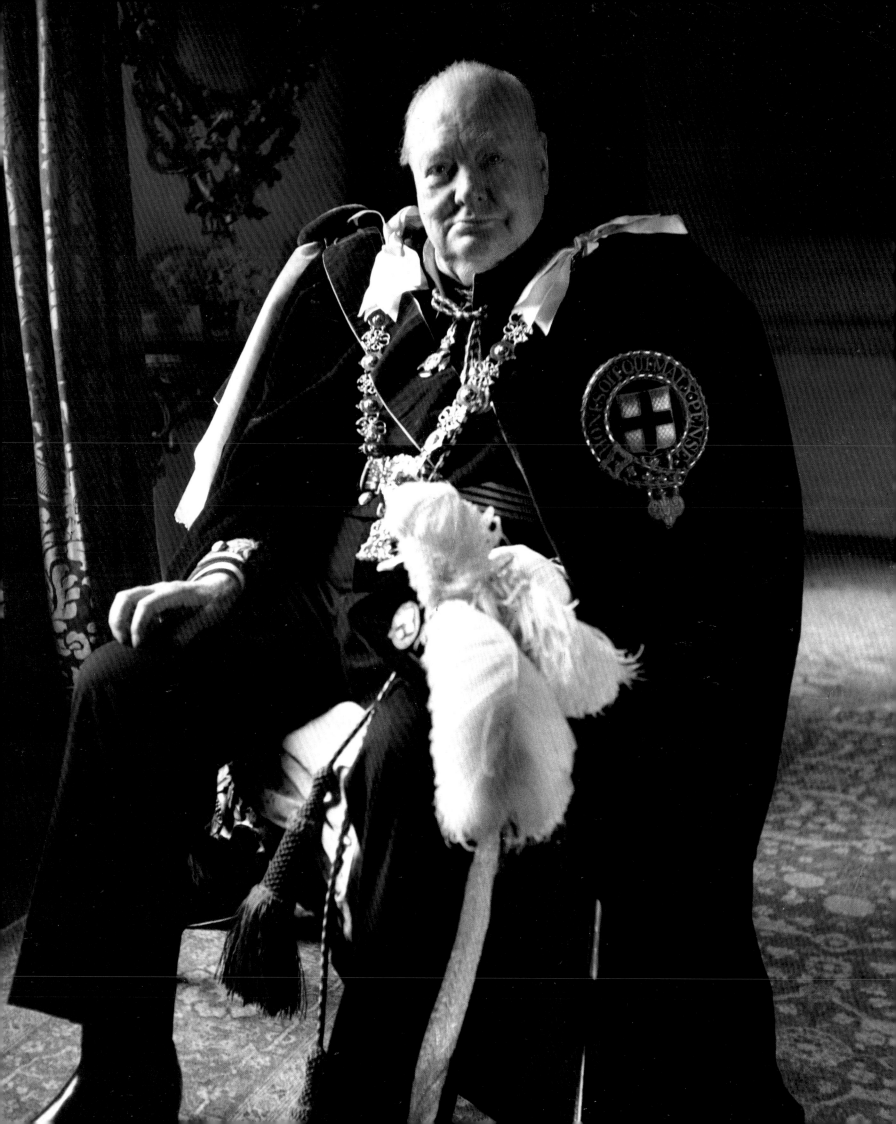

Alexander Liberman
Georges Braque
at home in Normandy
October 1, 1954

following pages

Irving Penn
Liqueur glasses
November 1, 1951

Irving Penn
Children in a Moroccan street
December 1953

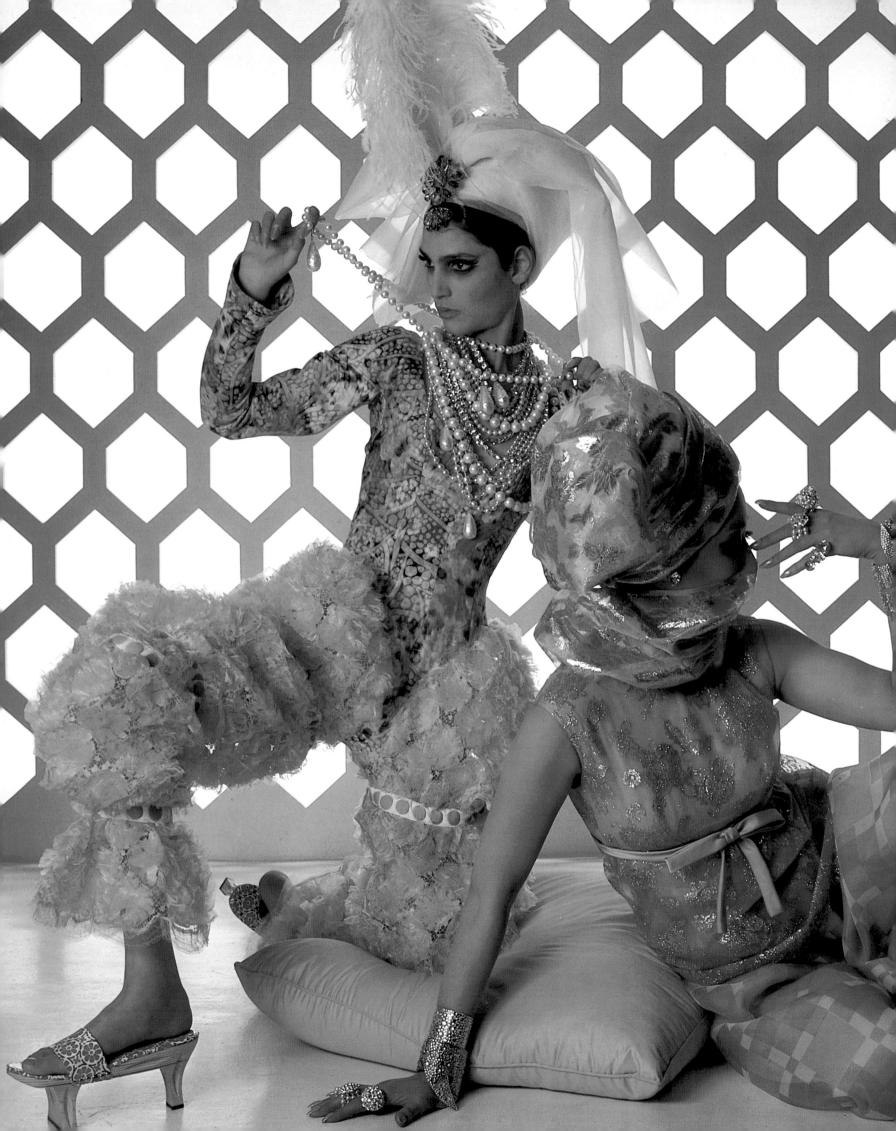

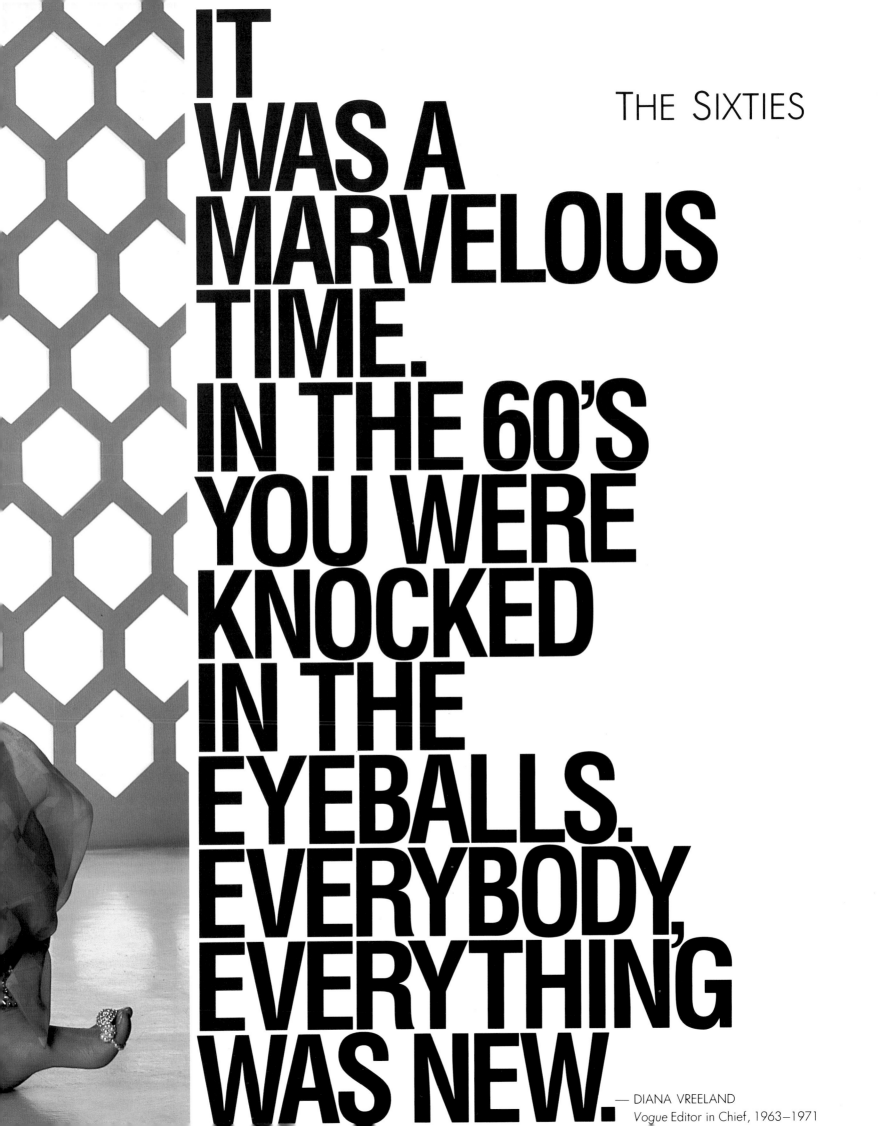

THE SIXTIES

IT WAS A MARVELOUS TIME. IN THE 60'S YOU WERE KNOCKED IN THE EYEBALLS. EVERYBODY, EVERYTHING WAS NEW.

— DIANA VREELAND
Vogue Editor in Chief, 1963–1971

In the early sixties. Alexander Liberman recalls. "we felt at Condé Nast that *Harper's Bazaar* was a more elegant magazine than *Vogue*. The team at the *Bazaar*—Brodovitch. Vreeland. Avedon. and of course Carmel Snow—had been quite exceptional. And we thought it would be a great coup to bring Vreeland to *Vogue*." Diana Vreeland had been the fashion editor at *Harper's Bazaar* since 1937 and was, according to her possibly slightly apocryphal memoirs. *D.V.*, still making only $18.000 a year. "So when the boys at *Vogue* came to see me. I made up my mind to listen to them. . . . They offered me a very large salary. an endless expense account. . .and Europe whenever I wanted to go. That's what hooked me." In 1963. Jessica Daves. who had been at *Vogue* for thirty years. retired and Vreeland became the magazine's third editor in chief since Condé Nast had taken it over in 1909. "It was a marvelous time to be a fashion journalist." she said later. "I don't think anyone has ever been in a better place at a better time than I was."

Vreeland was a very cosmopolitan figure. "She loved clothes. mainly French clothes." remembers Susan Train. who has been working in American *Vogue*'s Paris office since the early fifties. "And she was plugged in to everybody all over the world. She had her fingers on the pulse of everything. *Vogue* had never been so international." Vreeland was born in Paris. the daughter of a Scottish stockbroker and his American wife. She later described her parents as "racy. pleasure-loving. good-looking Parisians." who entertained Diaghilev and the Castles and Chaliapin and sent their small children to London to watch the coronation of George V. The family moved to New York in 1914. and young Diana went briefly to the Brearley School and then had a coming-out party in 1923. She married a young banker. Reed Vreeland. and they soon moved to London. where Mrs. Vreeland had a chic lingerie shop. (She recalls that Wallis Simpson bought three nightgowns there for her first weekend alone with the Prince of Wales.)

When the Vreelands and their two young sons returned to New York in the late thirties. Mrs. Vreeland was approached by Carmel Snow. who "had seen me dancing at the St. Regis one night. . . . She said she'd admired what I had on—it was a white lace Chanel dress with a bolero. and I had roses in my hair—and she asked me if I'd like a job.

" 'But Mrs. Snow.' I said. 'except for my little lingerie shop in London. I've never worked. I've never been in an office in my life. I'm never dressed until lunch.'

" 'But you seem to know a lot about clothes.' Carmel said.

" 'That I do. I've dedicated hours and *hours* of very detailed time to my clothes.'

" 'All right. then why don't you just try it and see how it works?' "

It worked until the late fifties. by which time Mrs. Snow "simply stopped coming into the office. . .and although it never occurred to me that I was running the magazine during those years. that's what I was doing." Vreeland had become a great editor. Years later. Truman Capote remarked that "she has contributed more than anyone else I can think of to the level of taste of American women in the sense of the way they move. what they wear and how they think. She's a genius but she's the kind of genius that very few people will ever recognize because you have to have genius yourself to recognize it. Otherwise you think she's a rather foolish woman." At *Bazaar* she advised readers to "Wash your blond child's hair in dead champagne. as they do in France." and "Have a furry elk-lined trunk for the back of your car." S. J. Perelman wrote a parody of this sort of thing for *The New Yorker*. and she was the model for the Kay Thompson character in *Funny Face* who keeps insisting that everyone "Think pink!"

Vreeland "was probably the oldest person at *Vogue*." says model Lauren Hutton. "but she was so hip that she picked up right away what people were wearing in the street." And people were wearing some pretty strange things by then. "She was big on exotica." Susan Train remembers. "Diana had us running all over the world. We did Turkey and Mexico. We did North Africa nonstop. I've got twenty caftans sitting in my closets from those days. The world was wide open. But that was the whole idea of the sixties anyway." Irving Penn shot a twelve-page homage to Orientalism—"Schéhérazaderie." *Vogue* called it *(page 110)*—with an accompanying article by Lesley Blanch that declared that "exoticism is now ardently pursued. Never has the Oriental idiom been so calcu-

preceding pages
Irving Penn
"Schéhérazaderie" by Arnold Scaasi and Sarmi
April 15, 1965

lated, so abandoned, or so widespread." The young designer Giorgio di Sant'Angelo was sent off to Arizona with the photographer Franco Rubartelli to wrap Veruschka in a cocoon of furs and fabrics, all lashed together with cords knotted with uncut stones *(page 120)*. Another sitting took Veruschka to Libya, where Ara Gallant wrapped her head in Dynel braids *(page 120)*. "I was in the middle of my Dynel period," Vreeland wrote later, "one of the happiest periods of my life, to tell you the truth, because I was *mad* about all the things you could do with Dynel hair."

Vreeland had Pucci tights photographed in the Israeli desert and ran pictures of Courrèges' bridal outfits *(page 121)*, white chains with a few strategically placed vinyl plates. "She loved Courrèges," Susan Train remembers. "All those big, tanned, athletic girls would come leaping out in their little white boots and their short skirts. Diana liked unusual looking girls, girls with a face. She was always finding new faces." And she made them stars. "She published their names in the magazine," Cathy di Montezemolo points out. "Lauren Hutton, Penelope Tree, Veruschka, Twiggy. We had never done that before." She was creating a theater of fashion. "Vreeland was an extraordinary impresario," says Liberman. "She was a bit like Diaghilev, or at any rate she wanted to be. She had a feeling for the grand gesture, and there was something very regal in her generosity. She would give sixteen or twenty pages to something she liked."

"Diana really didn't enjoy people her own age," says Susan Train. "She was always surrounded by young people. She was very unjudgmental, but she wanted young photographers, young models—anything but the girl next door." Someone like Twiggy, one of the models who became a personality. "I didn't discover her," Vreeland said, "not *actually*. I knew who she was and I sent for her. I'd seen her once in *Elle* in a very, very small picture—just the head. Then this strange, *macabre* little *bit*, like a waif, came to see me in New York with hair like cornsilk, the most wonderful skin and bones . . . and then she'd open her mouth and the most extraordinary English would come out. 'Blimey!' she'd say, with the *face* of an English beauty. There's never been a Cockney like Twiggy—but then, the sixties were a great era for Cockneys." The reverse side of the model as personality

was the personality as model. "It was my idea to use Barbra Streisand as a mannequin," recalled Vreeland. "Her success was *overnight*. I sent her to Paris with Dick Avedon to model the collections. We sent her twice. We shot her profile with that Nefertiti nose of hers . . . the pictures were awfully chic."

Vogue under Vreeland invented the word "youthquake" one month (June 1965) and liked it so much that two months later the magazine presented six pages of youthquakers, people who other people were talking about, or should have been. Liza Minnelli, then only nineteen, and twenty-eight-year-old Zubin Mehta, and a "twenty-odd" Joan Rivers. Edie Sedgwick, already a doomed Warhol star, balanced in arabesque in her apartment *(page 120)*, "to a record of the Kinks." Warhol was one of Vreeland's "oldest friends." "He was just a fey little boy who used to draw shoes for I. Miller in the early fifties," she reminisced later. By 1965 he was being written about in *Vogue* and photographed with his friend the painter Robert Indiana *(page 116)* "in a weird-looking warehouse, downtown." "This Pop Art is not so popular, really," Warhol said in the attached interview.

Vogue published a photograph of the Beatles in January 1964. The copy noted that "the boys are beginning to spread themselves toward groups not notably pre-adolescent." Six months later *Vogue* published a photograph of Mick Jagger taken by David Bailey, another of Vreeland's friends *(page 114)*. Bailey was Swinging London's preeminent photographer, an inspiration for the David Hemmings character in Antonioni's *Blow-Up*. His girl friend was the model Jean Shrimpton, and Mick Jagger's girl friend at the time was Shrimpton's sister. "I was going to Paris to shoot I think for French *Vogue*," Bailey recalls, "and Mick asked if he could come along for fun. I did the portrait of him in the French *Vogue* studio. Vreeland saw it and loved it. That was the first time it was published." The Rolling Stones "are quite different from the Beatles," *Vogue* explained, "and more terrifying."

The youthquake, Vreeland said years later, "was a small revolution and not bloody, thank God. Youth went out to life, instead of waiting for life to come to them, which is the difference between the Sixties and any other decade I've lived in."

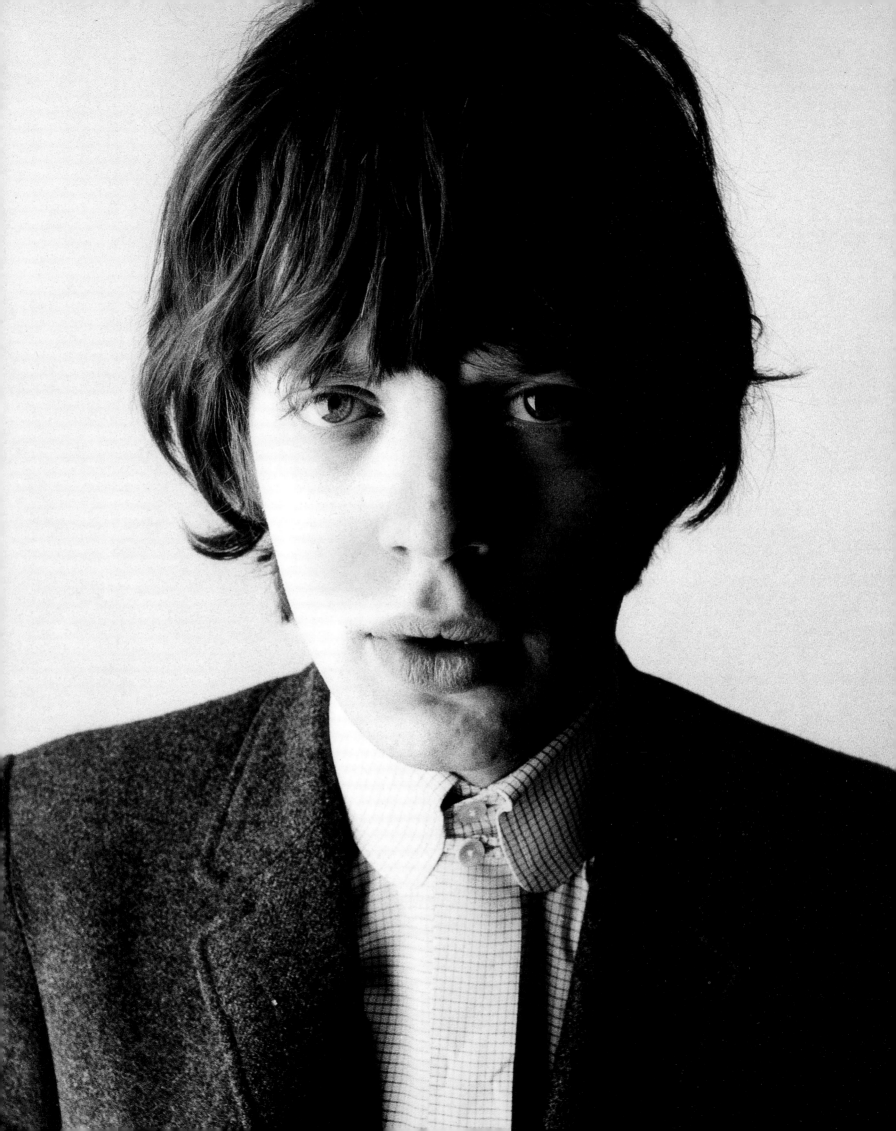

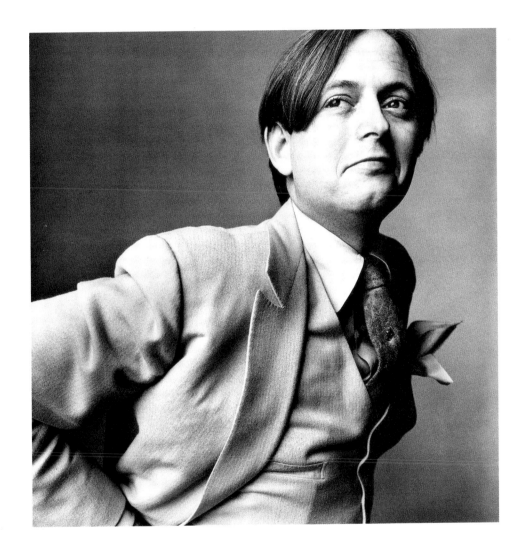

Irving Penn
Tom Wolfe
April 15, 1966

opposite page

David Bailey
Mick Jagger
July 1, 1964

following pages

Bruce Davidson
Robert Indiana and Andy Warhol
March 1, 1965

Peter Laurie
The Beatles
January 1, 1964

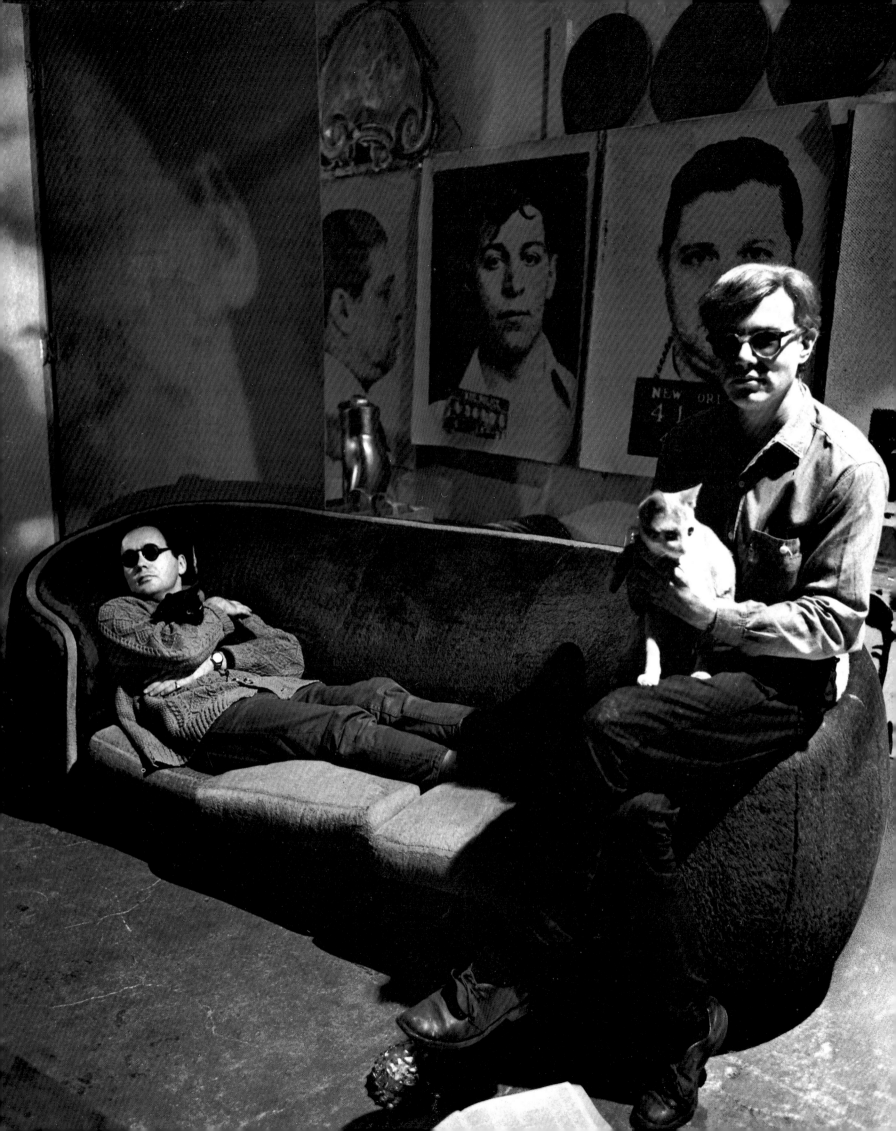

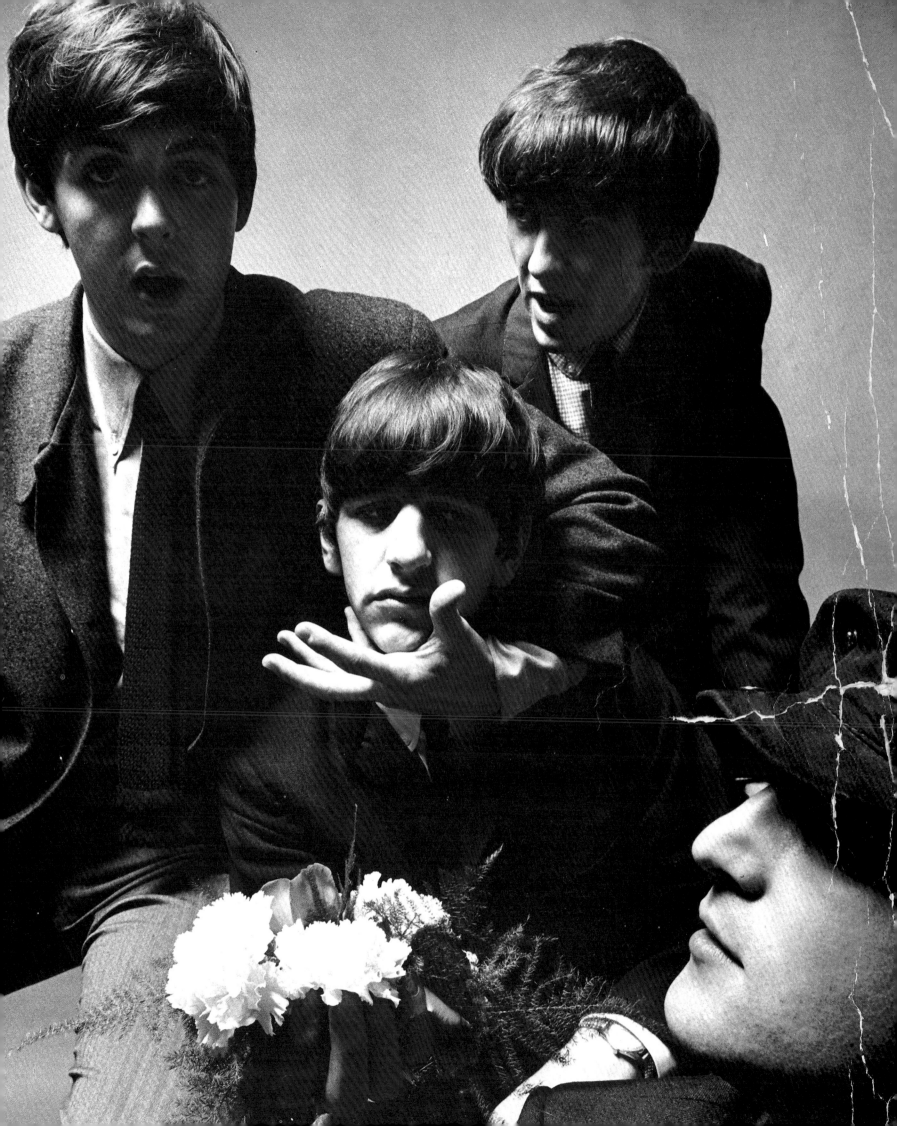

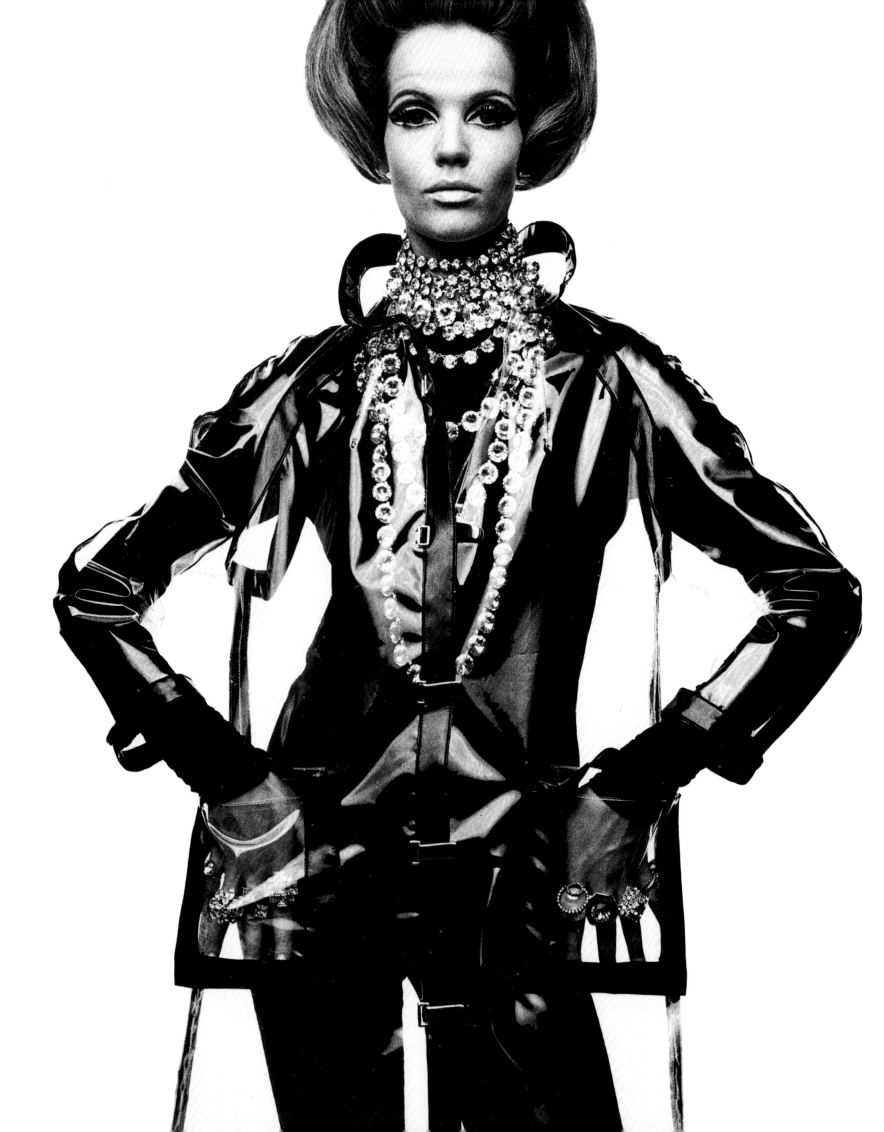

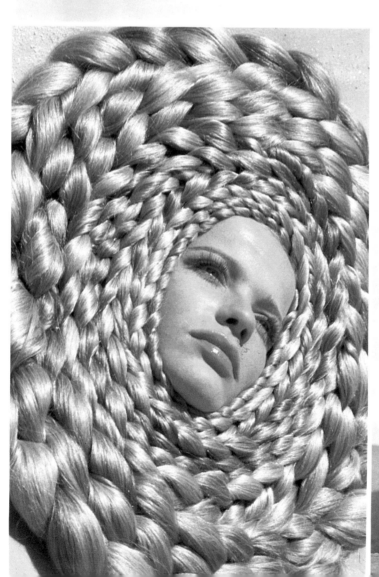

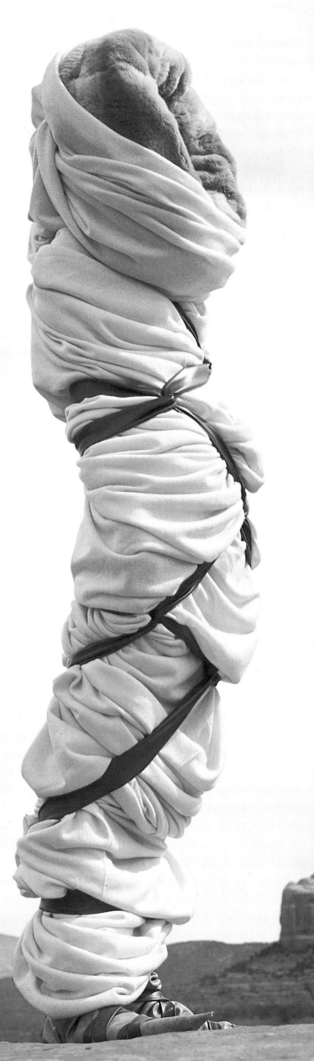

clockwise, left to right

Enzo Sellerio
Edie Sedgwick
August 1, 1965

Franco Rubartelli
Veruschka wrapped in fur and jersey
by Giorgio di Sant'Angelo
July 1968

Franco Rubartelli
Giorgio di Sant'Angelo
desert fantasy, with
Veruschka
July 1968

Irving Penn
Bridal clothes for Courrèges
fall collection
November 15, 1967

William Klein
Saint Laurent evening dress
photographed in the
Musée Grévin, Paris
March 15, 1963

Leombruno-Bodi
Madame Jean-Claude Abreu
in Giza in a cat suit
August 15, 1965

Franco Rubartelli
Veruschka and braids
April 1, 1967

preceding pages

Irving Penn
Veruschka in transparent vinyl coat
August 1, 1965

Irving Penn
Faucet and diamonds from
Harry Winston
October 1, 1963

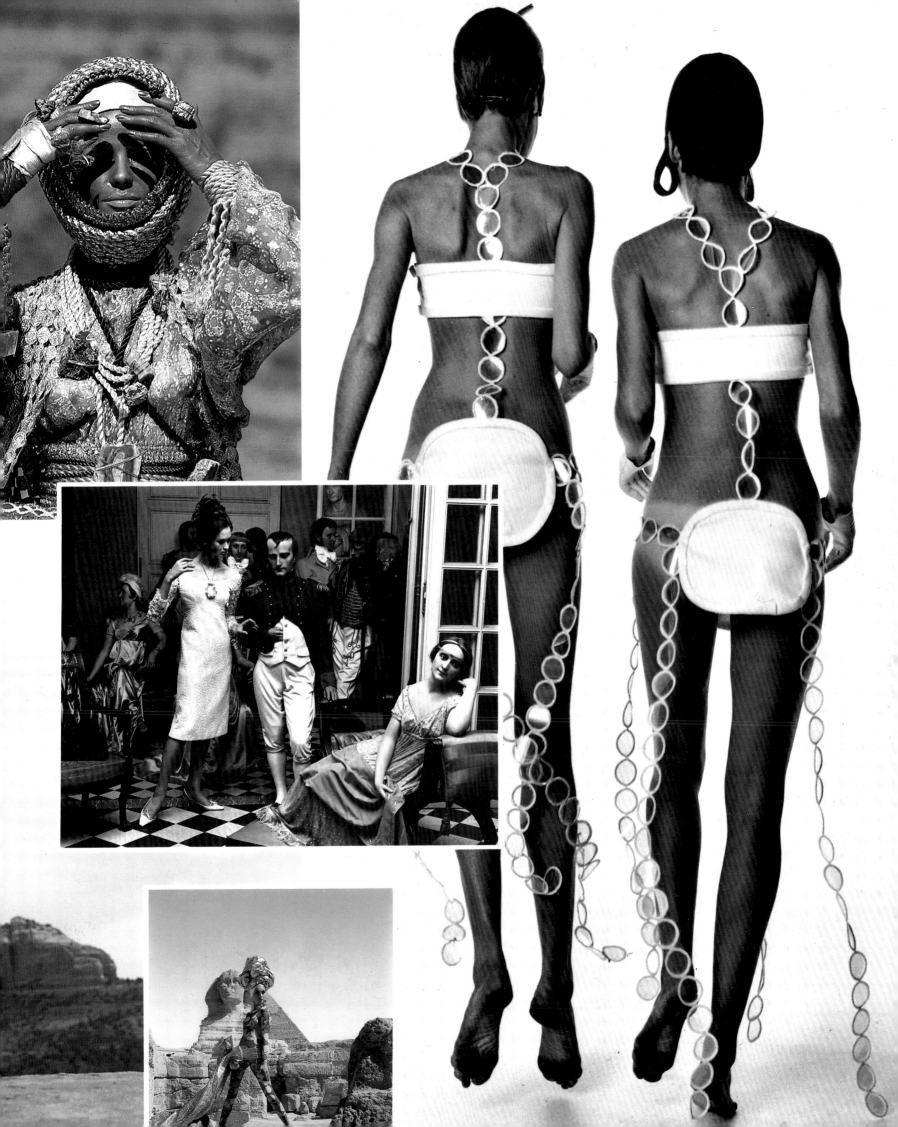

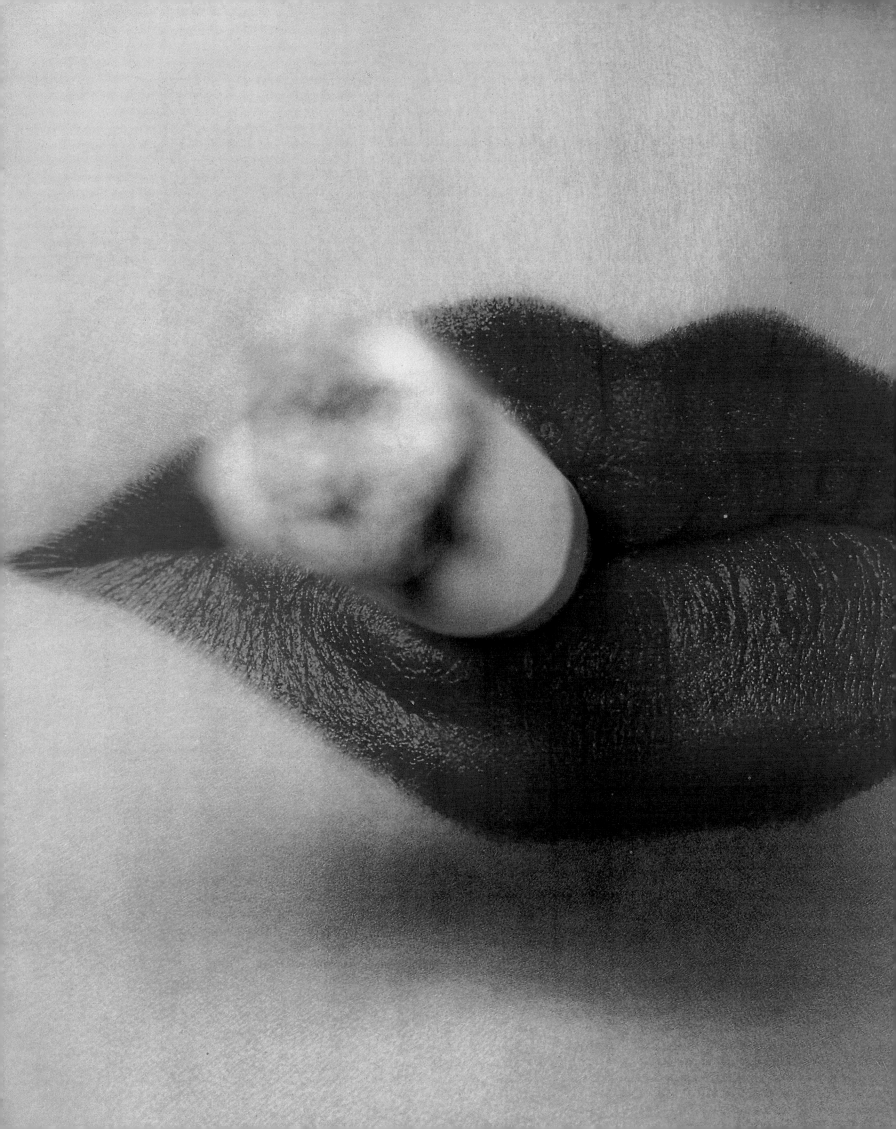

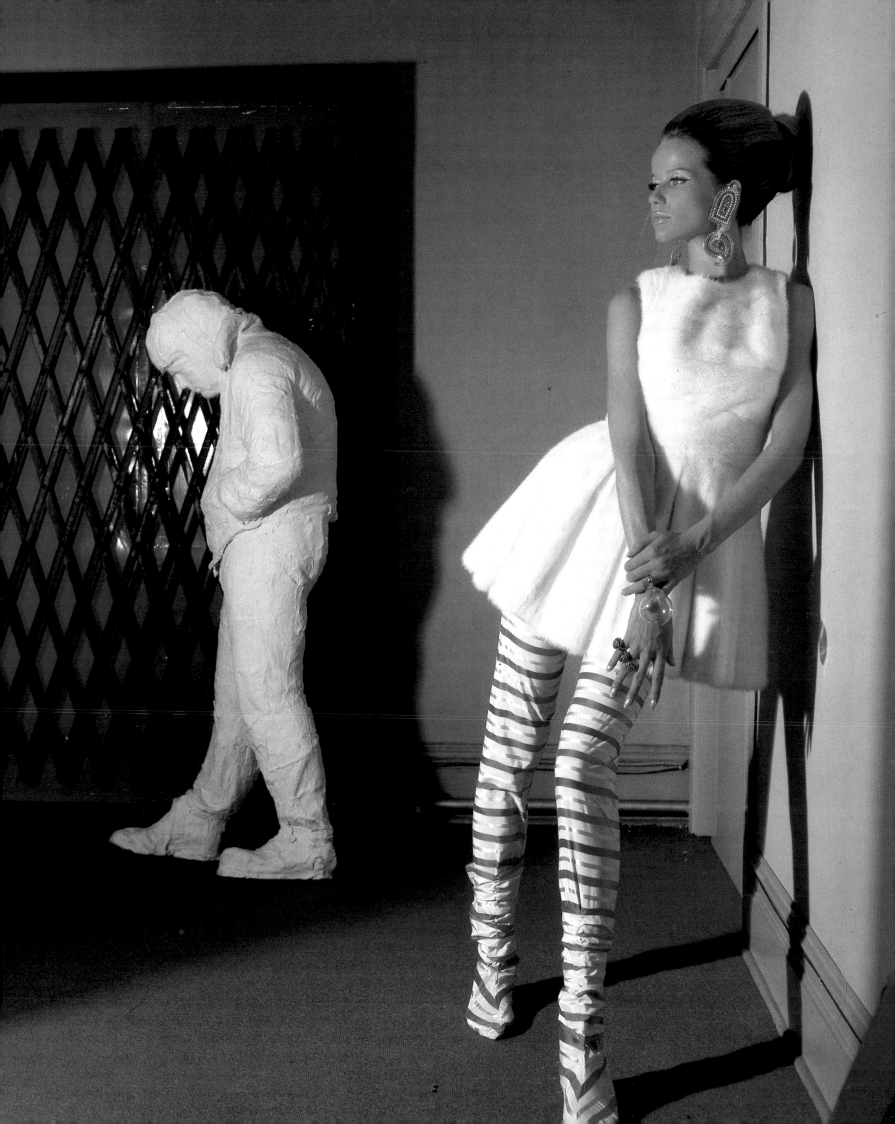

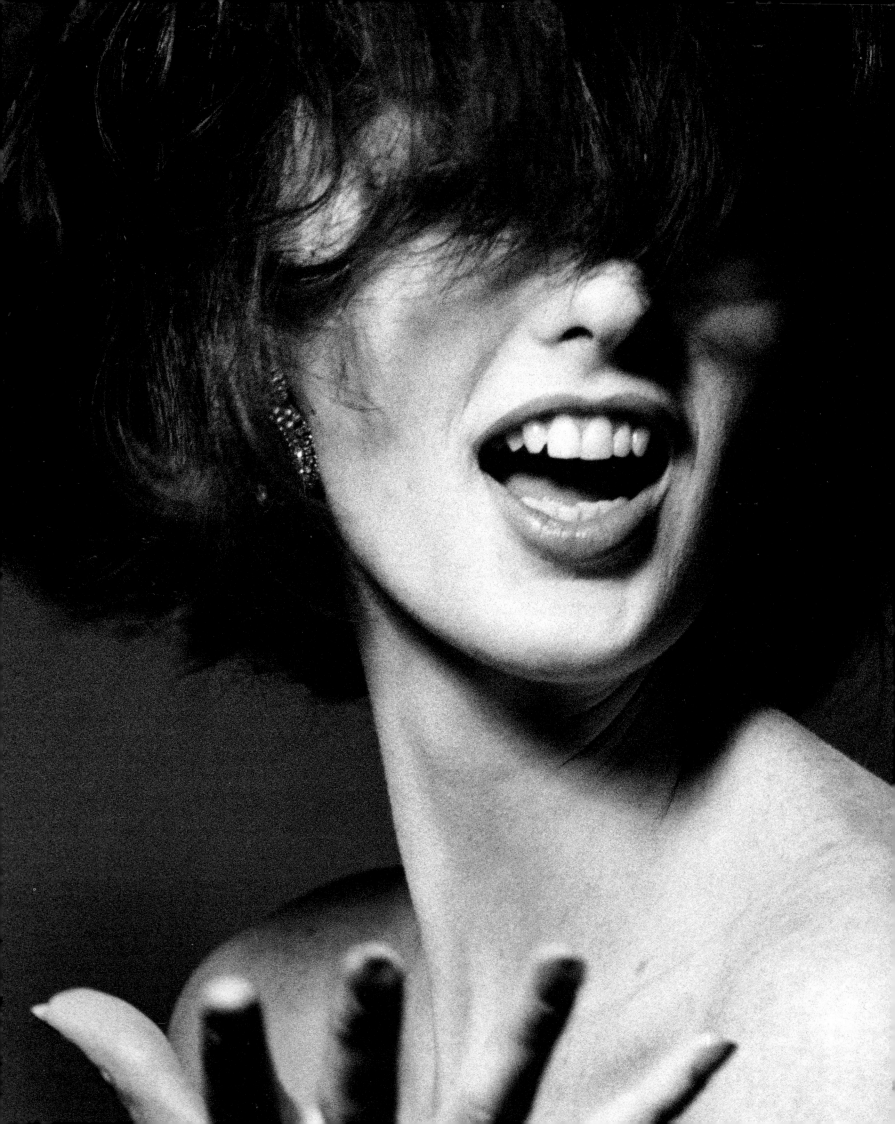

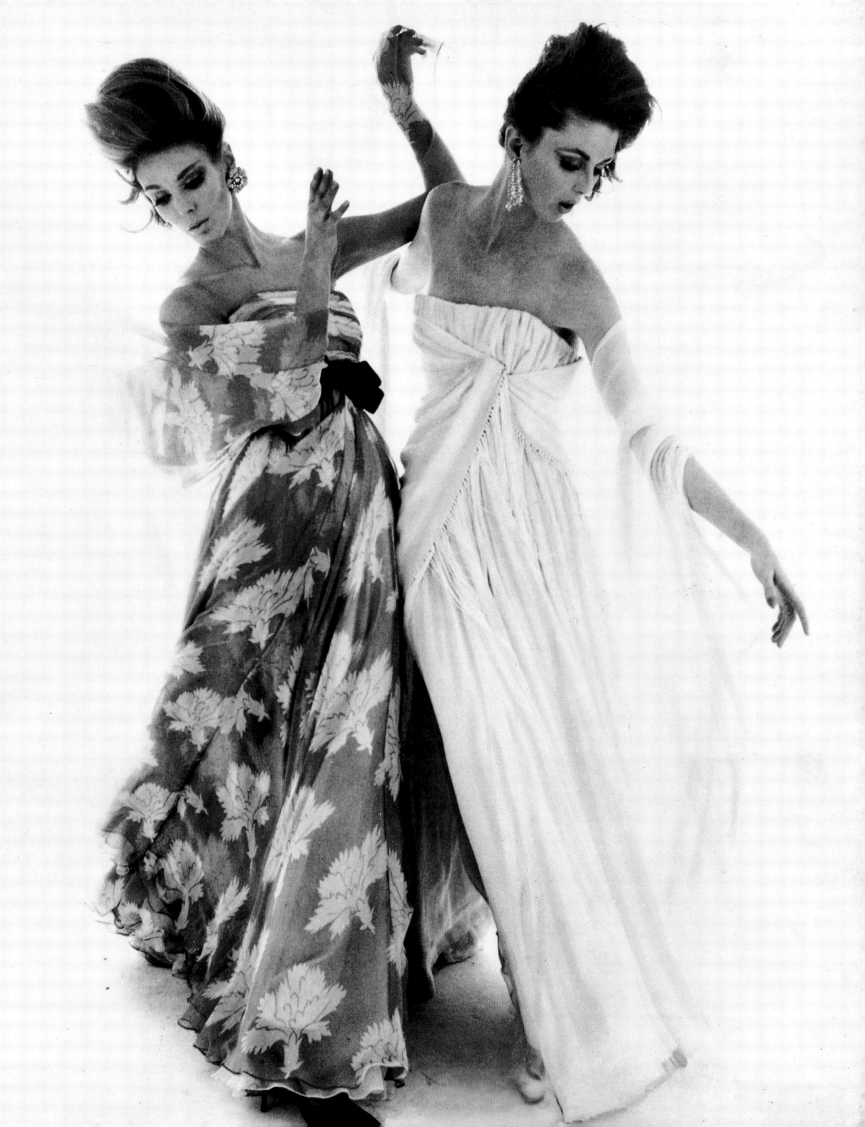

preceding pages

Irving Penn
"Beauty in Our Time"
May 1961

Horst
Veruschka in white mink tennis dress with George Segal's "Walking Man"
November 15, 1966

Bert Stern
Dorothea McGowan
November 1, 1961

Bert Stern
Evening dresses by Sarmi and Arnold Scaasi
February 1, 1961

"I had fallen in love with photography at eighteen by opening an issue of *Vogue* and seeing a color still life by Irving Penn." Bert Stern wrote in *The Last Sitting*, his book about photographing Marilyn Monroe. He had been plucked out of the mail room at *Look* magazine by an astute art director, who gave him a job as his assistant. Stern soon became an art director too, and then an award-winning photographer of advertisements, such as the famous one of a vodka martini sitting in the sand in front of a pyramid at Giza, with the pyramid reflected upside down in the vodka. In 1959 he began working for *Vogue*. And he got married, to Allegra Kent, a principal dancer with the New York City Ballet. "It all began happening then," he says. "The arts began opening up. . . . I was going to the ballet every night." His 1961 photograph of the two models in chiffon dresses *(page 125)* was influenced by those nights at the ballet. "In the dance you always had girls dancing together, so why not in fashion?" he says.

"Everything Stern did was extremely inventive," Alexander Liberman recalls. "He had a certain brashness, and—because of his wife—an interest in show business and theater. He seemed like a natural for interesting sittings with personalities." The personality Stern most wanted to photograph was Marilyn Monroe. "The definitive picture of her had still to be taken—one immortal black-and-white photograph—like Edward Steichen's portrait of Greta Garbo. That was the only picture I considered a great photograph of a movie star. And there was no picture of Marilyn Monroe that came close to being as good." There was also the lust factor. When both *Vogue* and Monroe's publicists had agreed to a sitting, Stern began planning what he would do next. "I was going to do a head shot. One classic black-and-white photograph that would last forever. But if I was honest with myself, what did I really want? . . . To get Marilyn Monroe alone in a room, with no one else around, and take all her clothes off."

The site chosen for the event was the Bel-Air hotel in Los Angeles, where Stern and his assistant set up a sort of studio in a large suite. He brought some scarves and costume jewelry as props, and a case of 1953 Dom Perignon. Monroe showed up around seven in the evening (the appointment was for two P.M.) and, encouraged by her hairdresser, agreed right away to a semi-nude session. Around dawn, "I finally got all her clothes off," Stern recalled. And by around seven A.M. there was a large collection of color and black-and-white film to show for a very intense night of photographing. (He insists that the final barrier between the artist and his subject was never crossed.)

Diana Vreeland had just arrived at *Vogue*, and Jessica Daves had not yet left, so the two editors and Alexander Liberman looked over the pictures. They loved them, they said, but perhaps it would be a good idea if there was another sitting. And this time Kenneth would be sent out to do Monroe's hair, and a fashion editor, Babs Simpson, would take some clothes along. The second sitting was again at the Bel-Air, this time in a larger suite. And this time there was more Dom Perignon, plus a case of Château Lafite-Rothschild. There were "heaps" of clothes—a floor-length chinchilla coat, a lot of black dresses, long sequinned gloves, hats and veils and strings of pearls. Hours later, everyone but the photographer and the subject went into the next room, and more photographs were taken, including the one of Stern and Monroe on the hotel bed, laughing in front of a mirror. This session too ended at dawn.

Back in New York, Stern received a call from the publicist, who said Monroe wanted to approve the photographs. He sent transparencies and contact sheets to Los Angeles, and got back some images with big Magic Marker x's over them, and transparencies that had been mutilated with a hairpin. *Vogue* ran eight pages of black-and-white fashion photographs, which were at the printer when the news was announced that Monroe had committed suicide. "The word of Marilyn Monroe's death came just as this issue of *Vogue* went on the press," the editors wrote. "We debated whether it was technically possible to remove the pages from the printing forms. And then while we waited for an answer from our printers, we decided to publish the photographs in any case." They changed the fashion copy to a short homage.

Twenty years later, several of Stern's shots of Monroe nude ran in *Vogue (pages 128, 129, and 130)*, along with excerpts from a "revelatory text" by him, a "view into the photographic moment itself—what happens when a master of the art of seeing confronts a woman who has mastered the art of being seen."

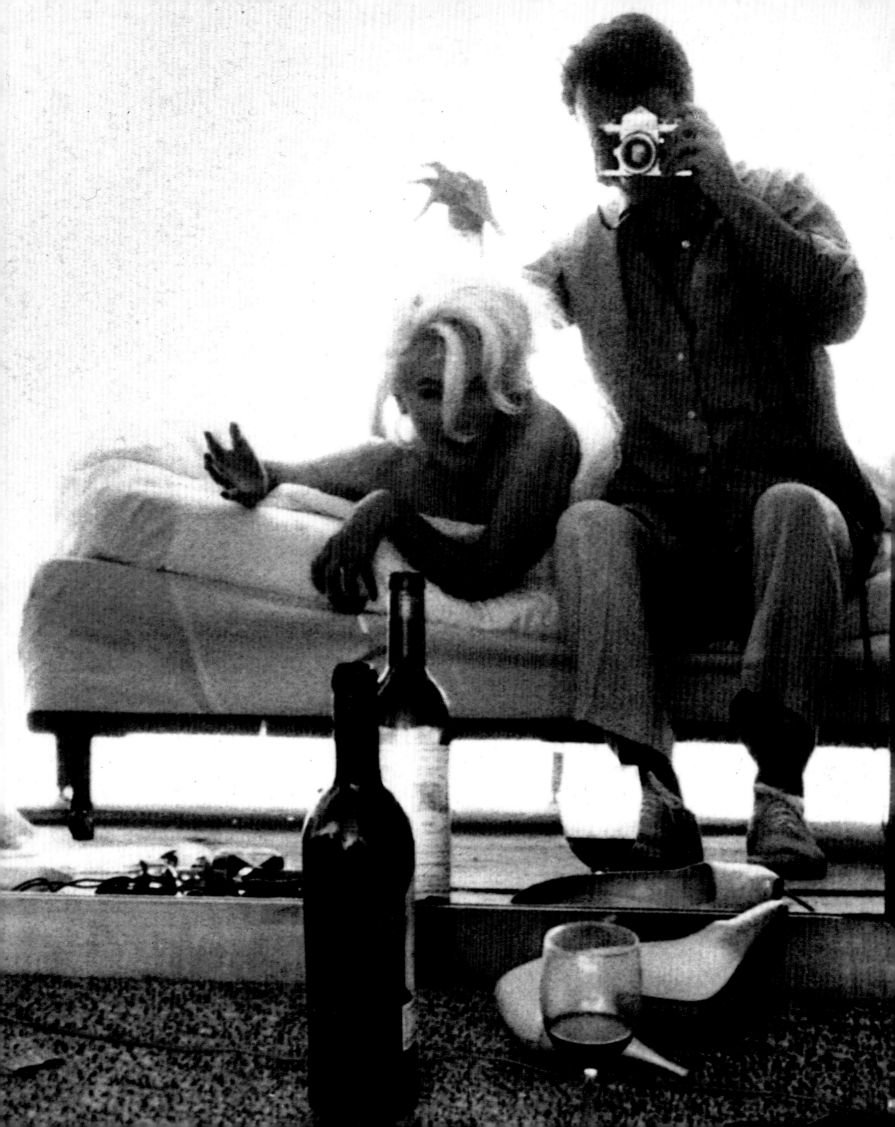

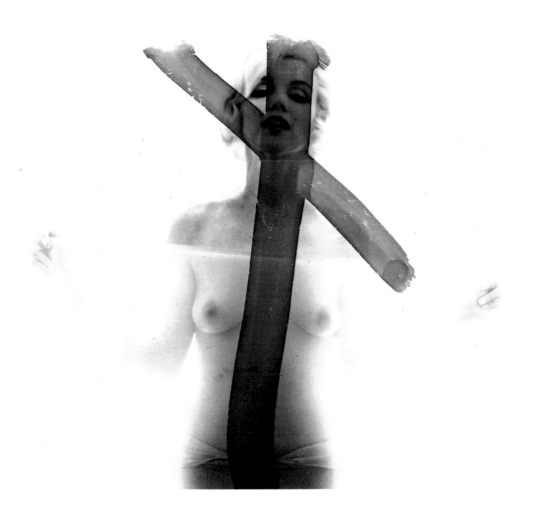

Bert Stern
Marilyn Monroe
Contact sheet x'd out by Monroe after The Last Sitting, 1962
September 1982

opposite page

Bert Stern
Marilyn Monroe
and the photographer during the sitting
September 1982

Bert Stern
Marilyn Monroe, The Last Sitting
September 1982

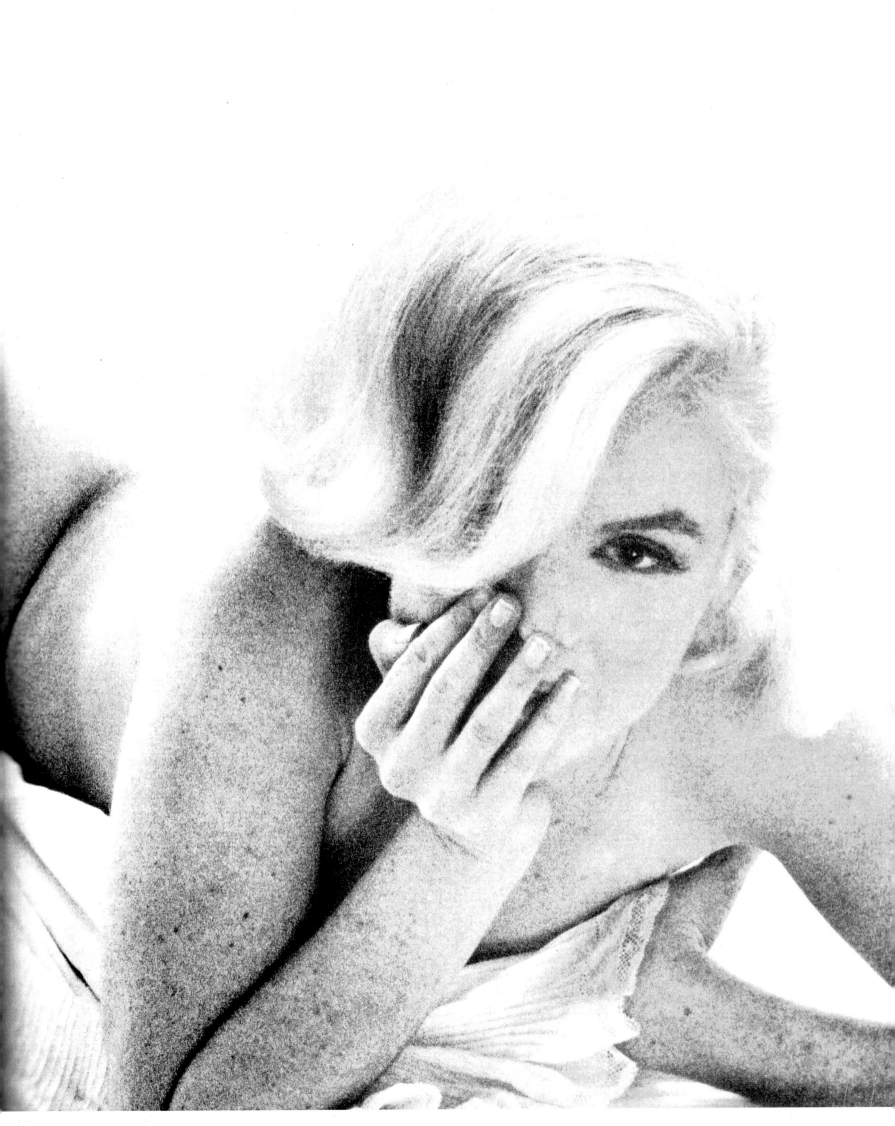

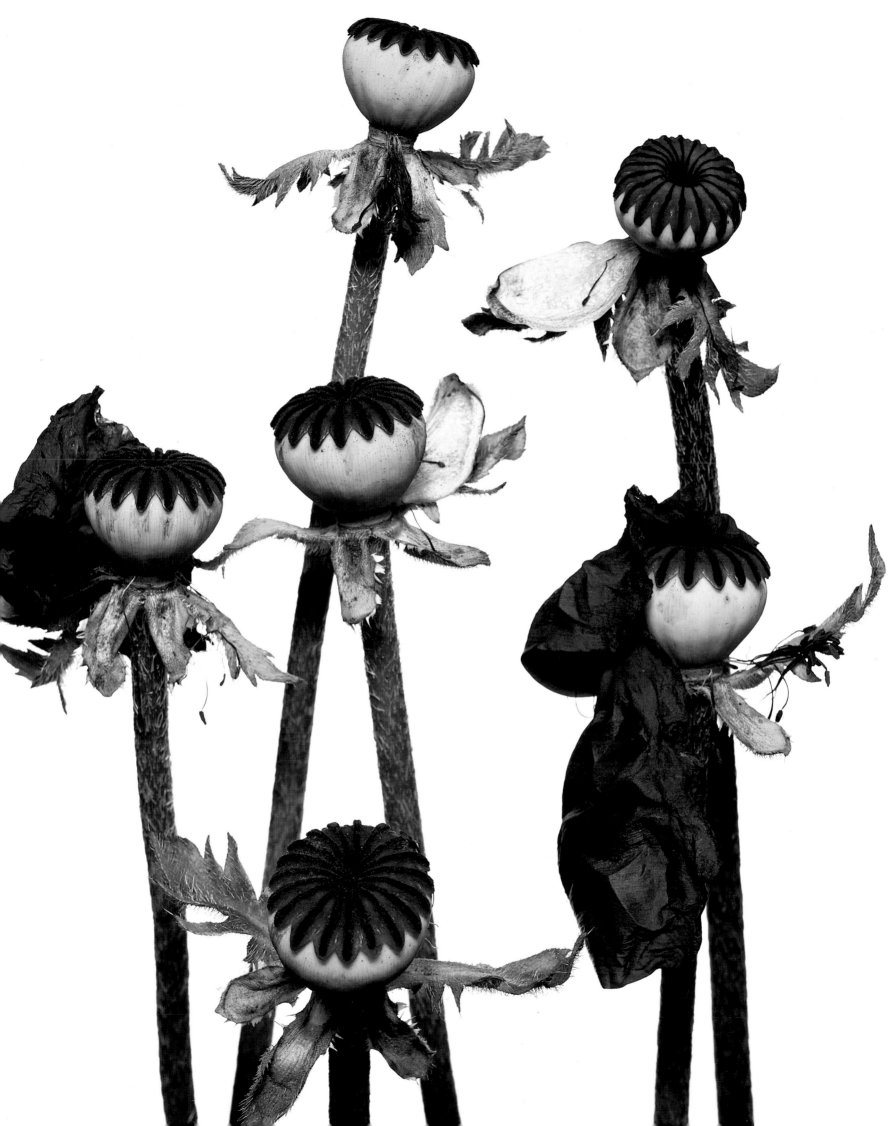

preceding pages

Irving Penn
Poppies
December 1969

Irving Penn
Dying poppies
December 1969

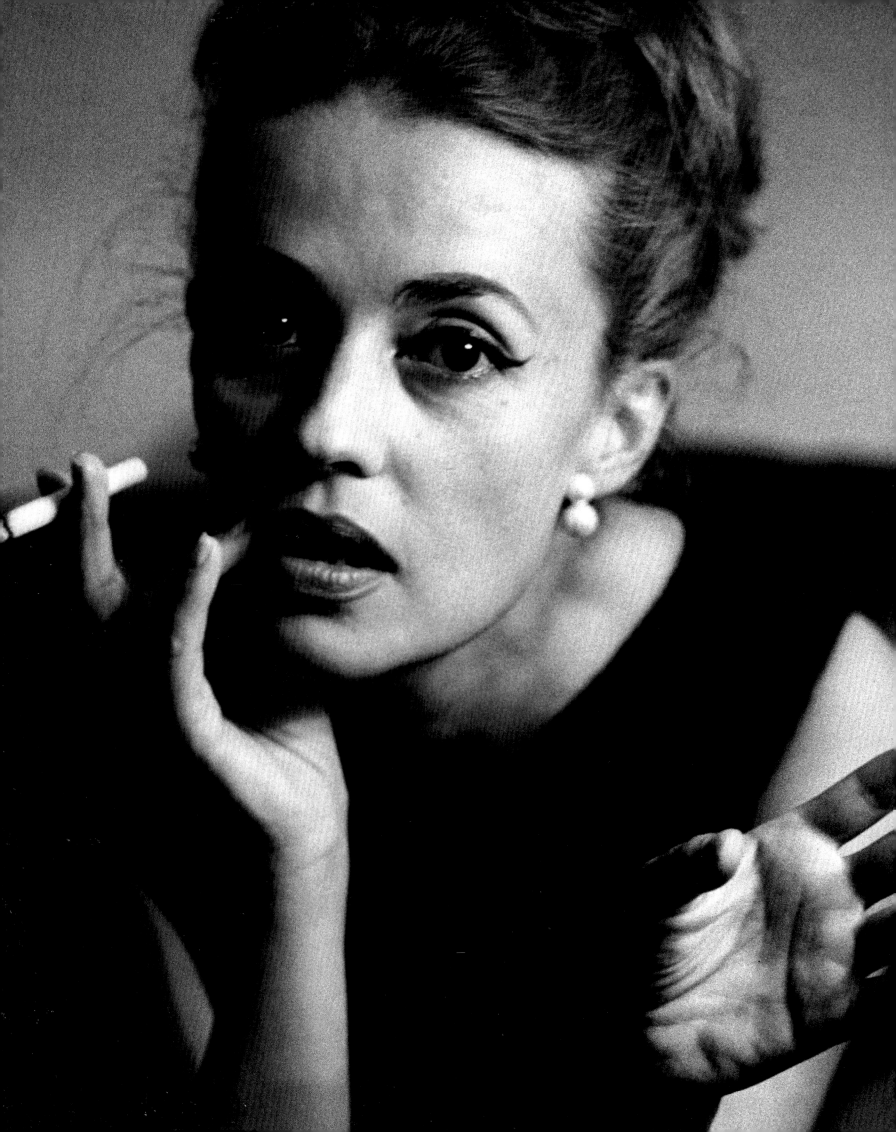

Cecil Beaton
Martha Graham
May 1967

preceding pages
Dan Budnik
Jeanne Moreau
September 15, 1962

Horst
Pauline de Rothschild
June 1969

following pages
Irving Penn
Sophia Loren
January 1, 1960

Irving Penn
Francis Bacon
November 1, 1963

Irving Penn
Vladimir Nabokov
December 1966

following pages

Irving Penn
Mountain men of Crete
January 15, 1965

Irving Penn
Truman Capote
October 15, 1965

Irving Penn
Beaded head from northern Cameroon
December 1966

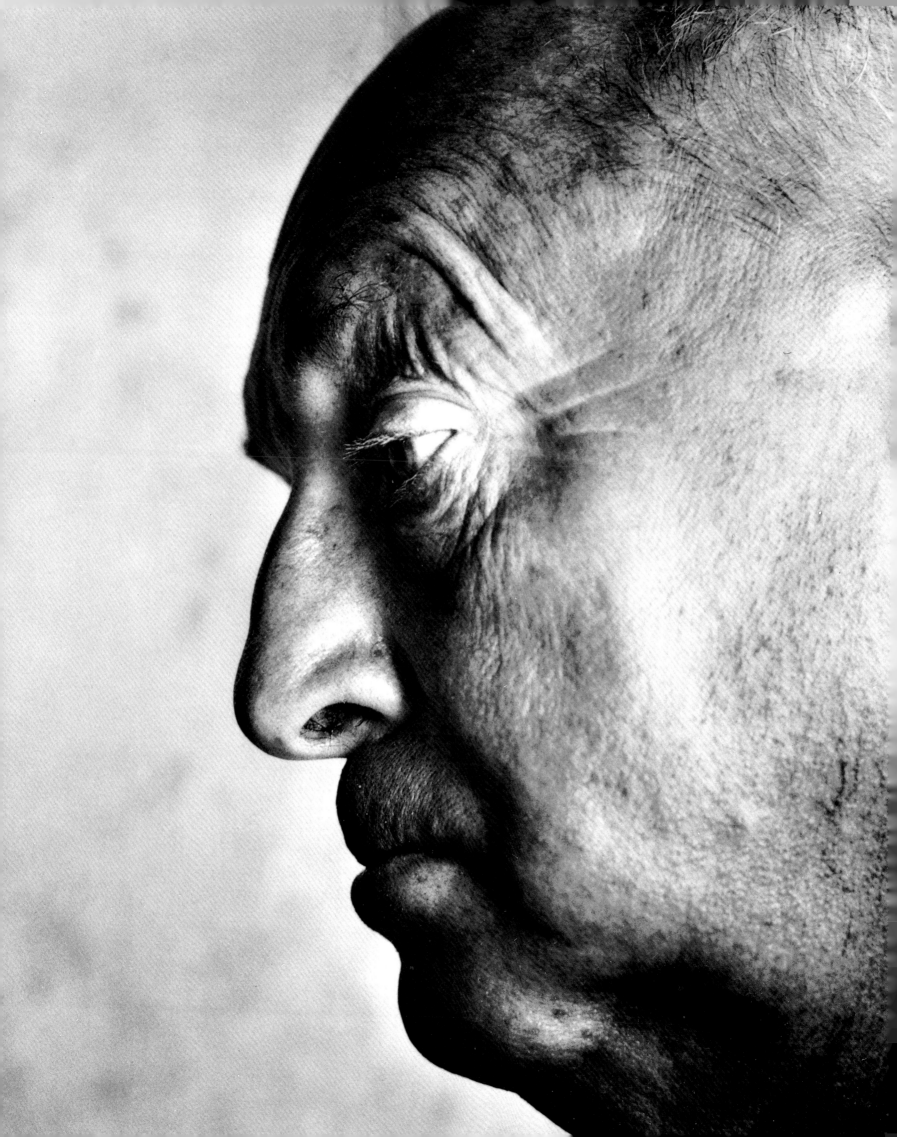

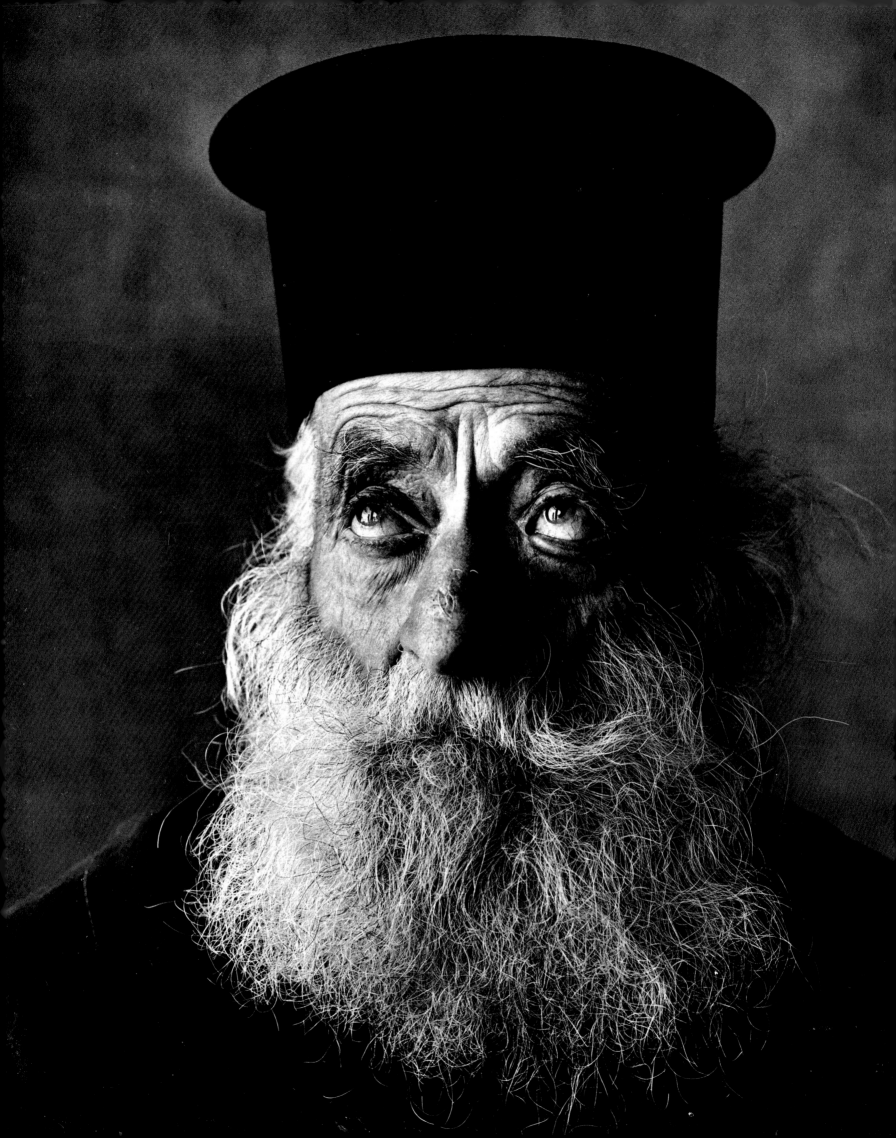

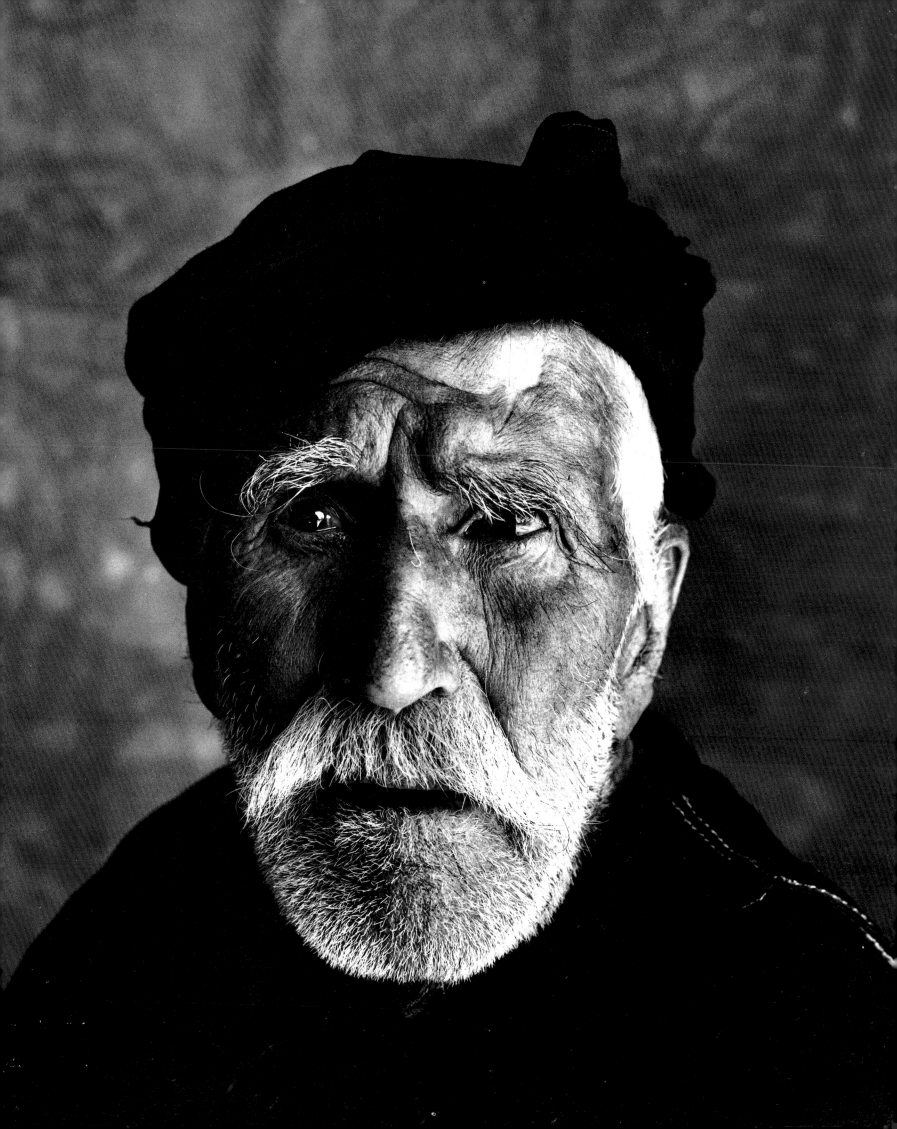

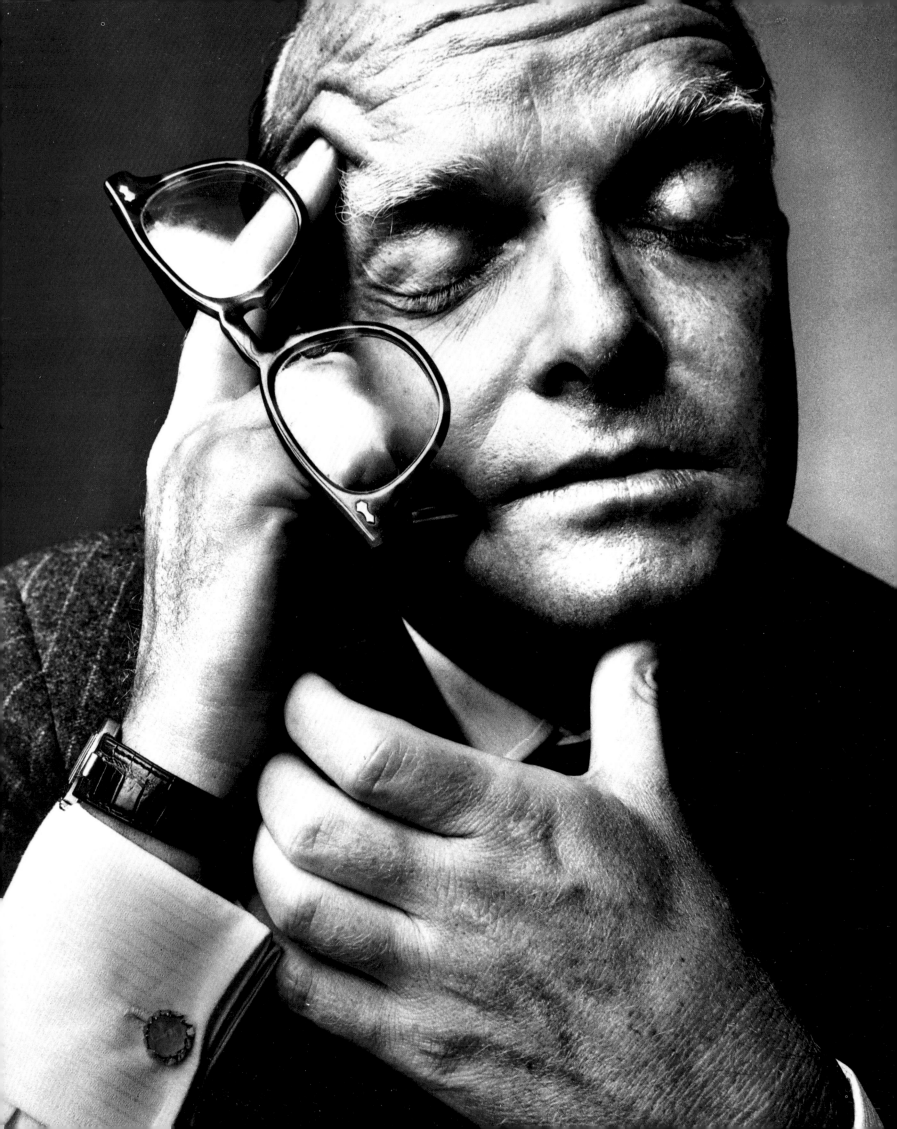

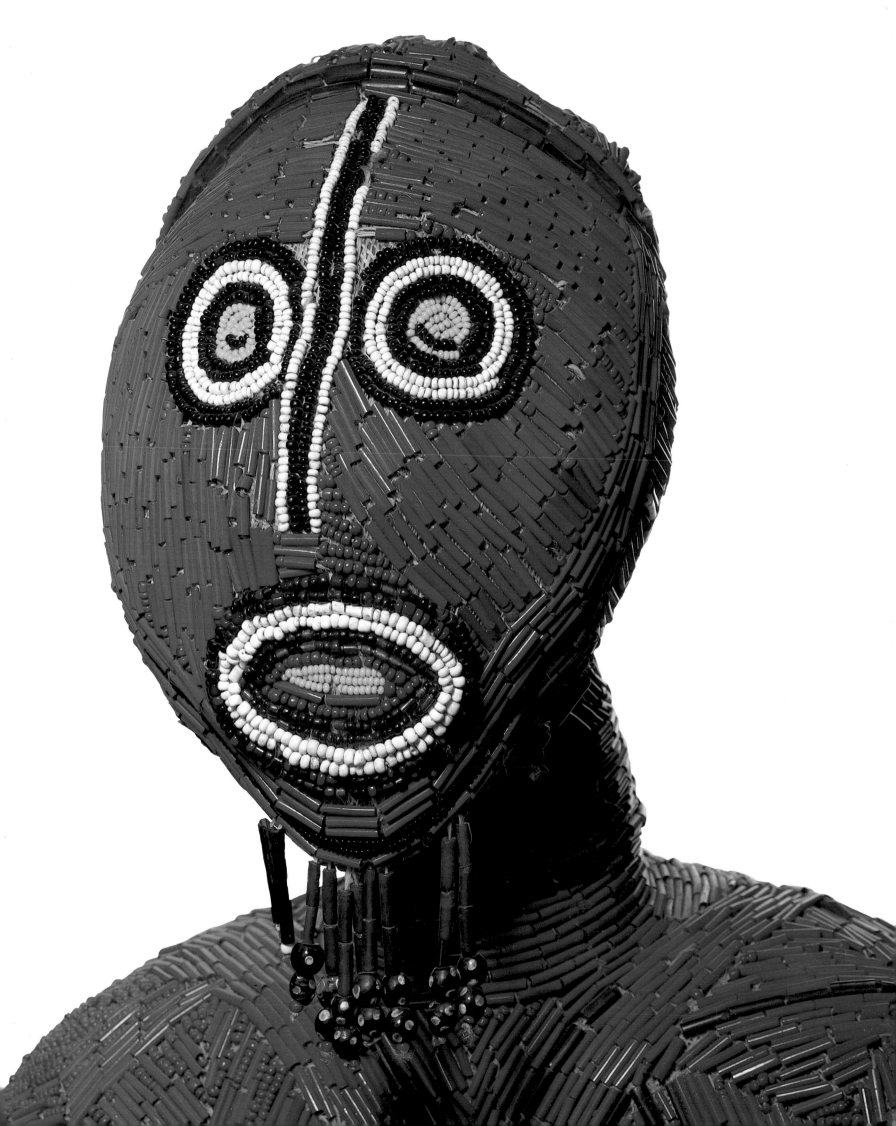

"Shortly after Vreeland arrived, we realized that we were missing a top fashion photographer," Alexander Liberman recalls. Diana Vreeland had come to *Vogue* in 1961 from *Harper's Bazaar*, where she and Alexey Brodovitch and Richard Avedon had worked together since the late forties. But Brodovitch had resigned as *Bazaar*'s art director in 1958, and with Vreeland now ensconced at *Vogue*, "we all felt that if we could get Avedon, *Vogue* would be at the top." So Liberman made some calls, and there were "negotiations," and in 1965 Richard Avedon came to *Vogue*. Avedon was only in his early forties then, but he had been a famous photographer for nearly twenty years. He had grown up with a camera, taking snapshots of his family in Long Island and later Manhattan, and then photographing his fellow merchant marines with his Rolleiflex during World War II. After the war he enrolled in Brodovitch's design course at the New School for Social Research, and his work was soon appearing in *Harper's Bazaar*. By 1947, when he first covered the Paris collections, he was the magazine's chief photographer.

Avedon's arrival at *Vogue* ushered in what Liberman calls "the period of intellectual eroticism," exemplified by the model Penelope Tree, "a curious, sort of non-high-fashion young woman," the daughter of the socialite Marietta Tree. Polly Mellen, who had worked with Avedon at *Harper's Bazaar* and would be his closest collaborator at *Vogue*, remembers being fascinated by Tree at their first meeting. "She was gawky, a little hunched over, with stringy hair, absolutely not a beauty at all." When Tree came to the studio for a sitting one summer morning in 1967 in her bell-bottomed black Beatles suit, Mellen thought that "she looked like a gangly little urchin. . . . I came out and said to Dick, 'I don't know. She doesn't fit the clothes. Look, the arms are much longer than they should be.' He said, 'She's ready. Don't touch her. She's perfect.' " And he was right. *Vogue* called Tree "the spirit of the hour."

When Alexander Liberman made his selection of exemplary fashion photographs for *American Photographer* in 1980, he chose the one of Penelope Tree in her little black suit *(page 152)*. "No picture of the sixties really captures the era as strongly as this dramatic image," he wrote. "The sixties was a decade of great hope and deep misgivings, and I think Avedon caught all this in this picture." The process by which photographs were chosen at *Vogue* had shifted once the Avedon/Vreeland team was in place. Liberman had up until then chosen every picture for the magazine, but the new editor in chief and her photographer "worked quite secretly together," Liberman recalls. "Vreeland liked to pick her own pictures, and Avedon would only send in two or three of his preferences. So the whole operation was rather, you might say, 'confidential.' "

"Dick had perfected a certain kind of jump-walk that made fashion come alive and the woman's presence come alive," Liberman recalls. "His pictures are striking. And he thrived on Vreeland's exaggerated vision and disregard for the literal." Polly Mellen's first trip for *Vogue* was with Avedon to Japan with a trunkload of extraordinary furs and a sixteen-foot wig. "We were on a hill and it was late in the day and we were on the island of Hokkaido, which is the northernmost island of Japan," she says, pointing to the photograph of Veruschka swaddled in layers of exotic furs and shouting into the bleakness *(page 173)*. "And we were at a spot where we could see Siberia beyond the Sea of Japan. We were in twenty-seven feet of snow. When you are in rough country it affects the picture." Mellen was also part of the team sent to Eleuthera to photograph Lauren Hutton in beach clothes. Hutton recalls that "it was the first time I'd ever been on a job where Dick decided that we were actually going to have fun." Instead of the usual scurrying to get started at dawn, work never began before eleven in the morning. The famous shot in the bodysuit with one bare breast *(page 180)* "looks planned," Mellen says, "but it wasn't. When you're on a trip and part of a team and have a certain rapport, you begin to have more confidence in what you can do—always within a taste level, of course. With that shot I found myself unbuttoning and unbuttoning and unbuttoning."

When the Metropolitan Museum of Art put on a retrospective of Avedon's photographs in the late seventies, *Newsweek* magazine asked Irving Penn, the other great *Vogue* photographer, to comment. "I stand in awe of Avedon, you know," he said. "For scope and magnitude, he's the greatest of fashion photographers."

Richard Avedon
Penelope Tree in Ungaro suit
(unpublished version)
March 15, 1968

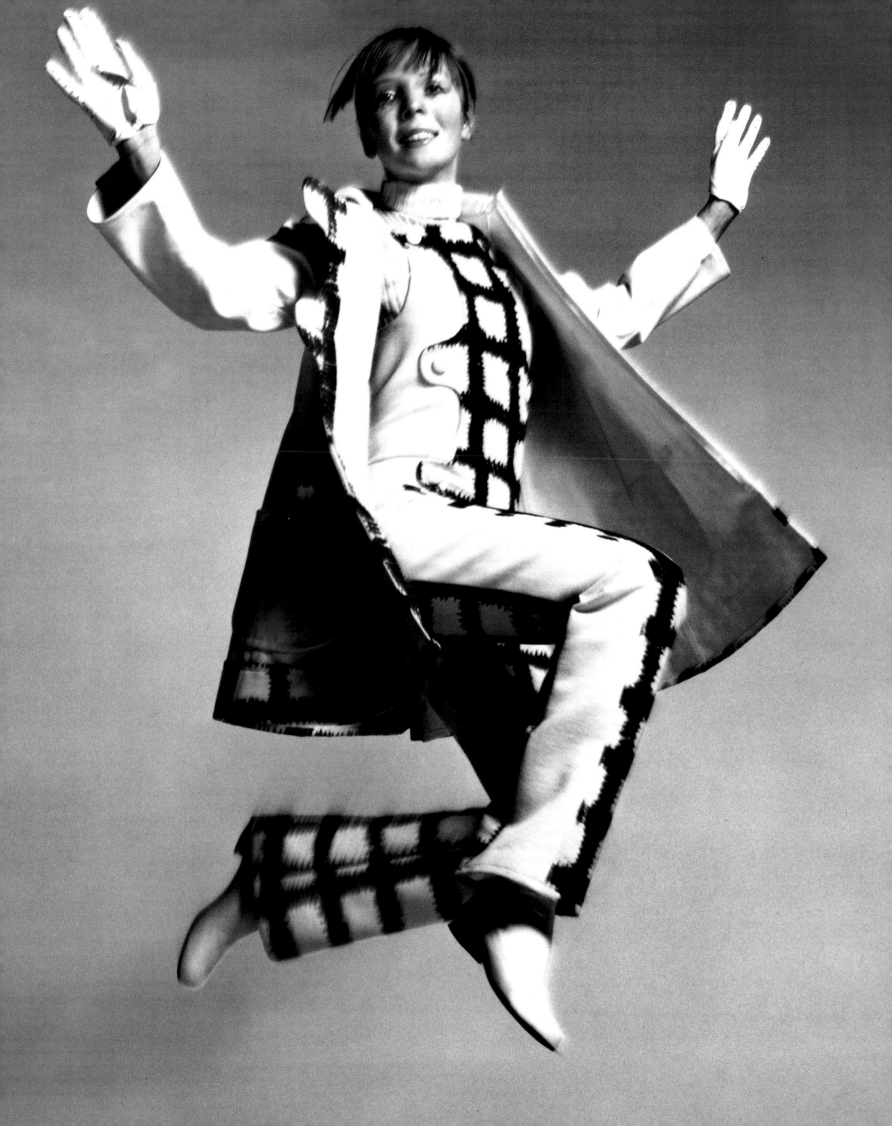

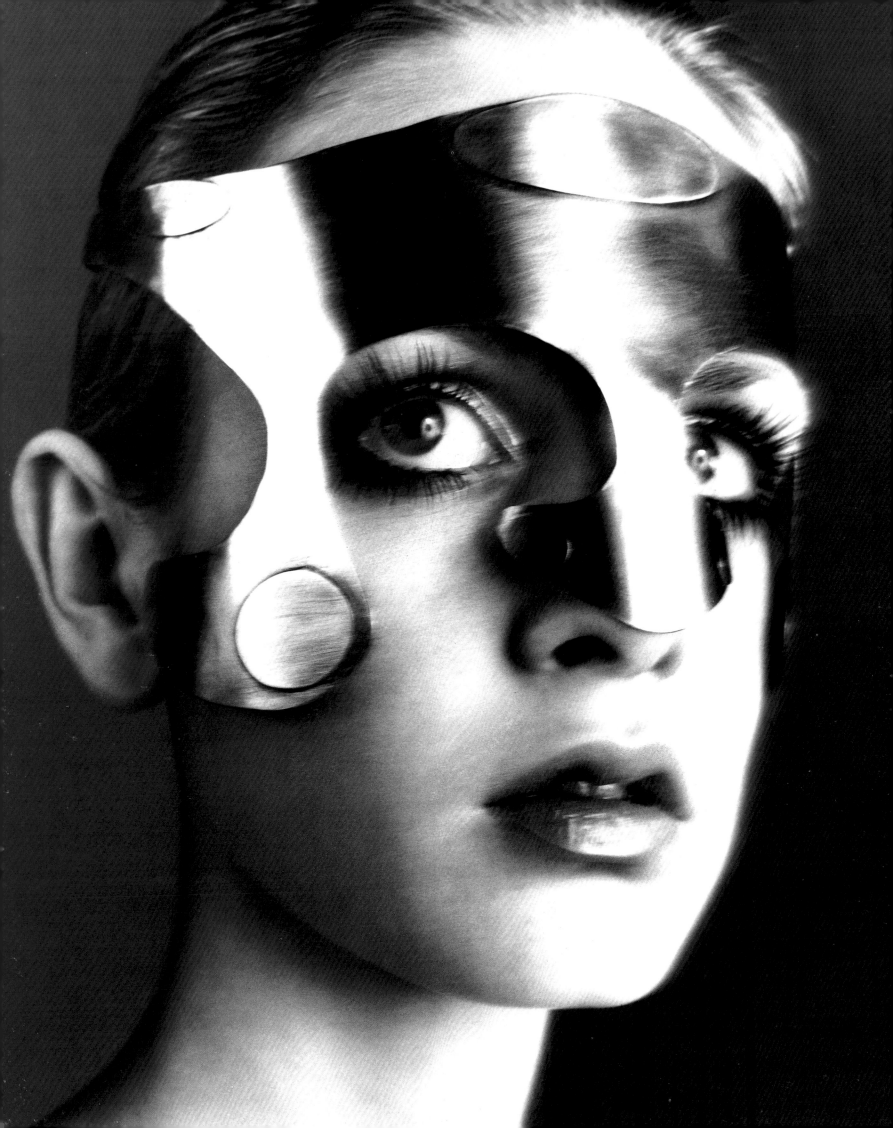

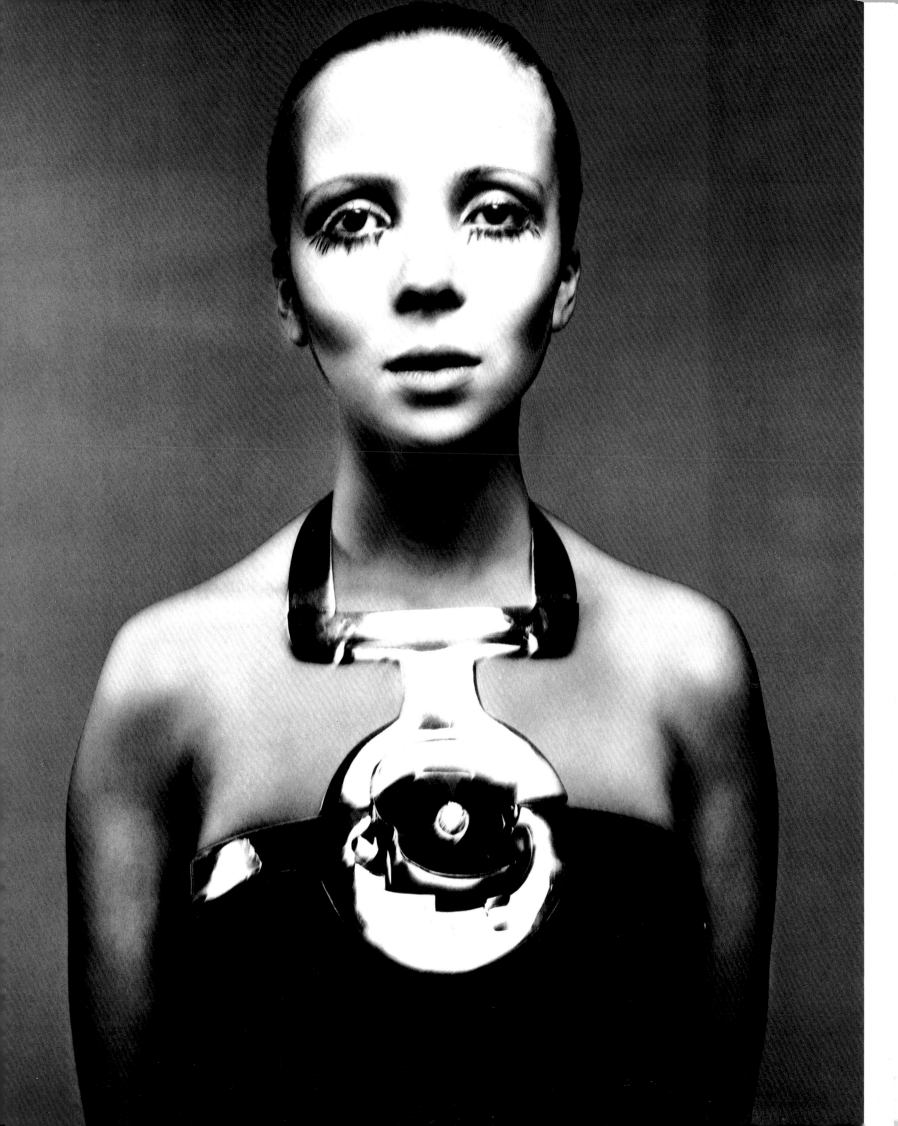

Richard Avedon
Penelope Tree
October 1, 1967

preceding pages

Richard Avedon
Twiggy in mask by Ungaro
(unpublished version)
March 15, 1968

Richard Avedon
Penelope Tree in Cardin dress
March 15, 1968

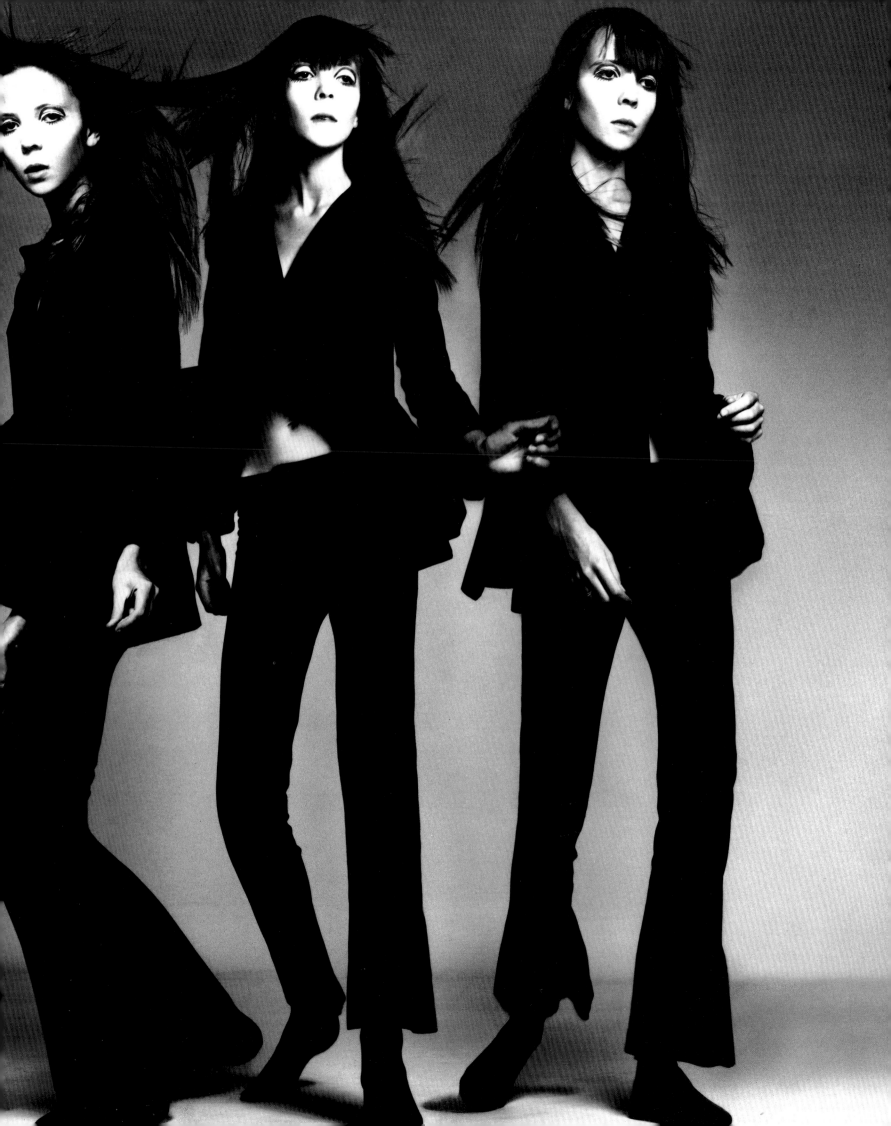

Richard Avedon
Simon and Garfunkel
June 1967

following pages

Richard Avedon
Louise Nevelson
June 1976

Richard Avedon
Ingrid Boulting
October 15, 1969

155

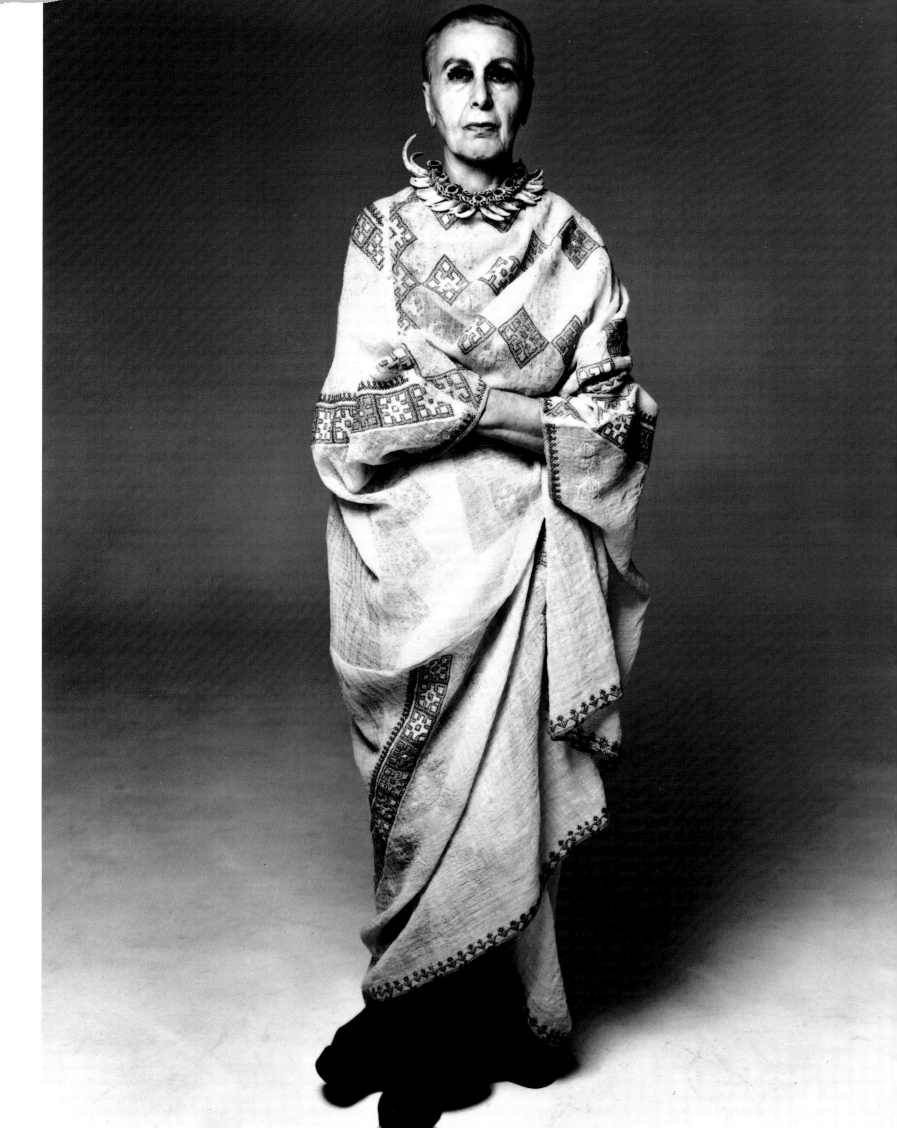

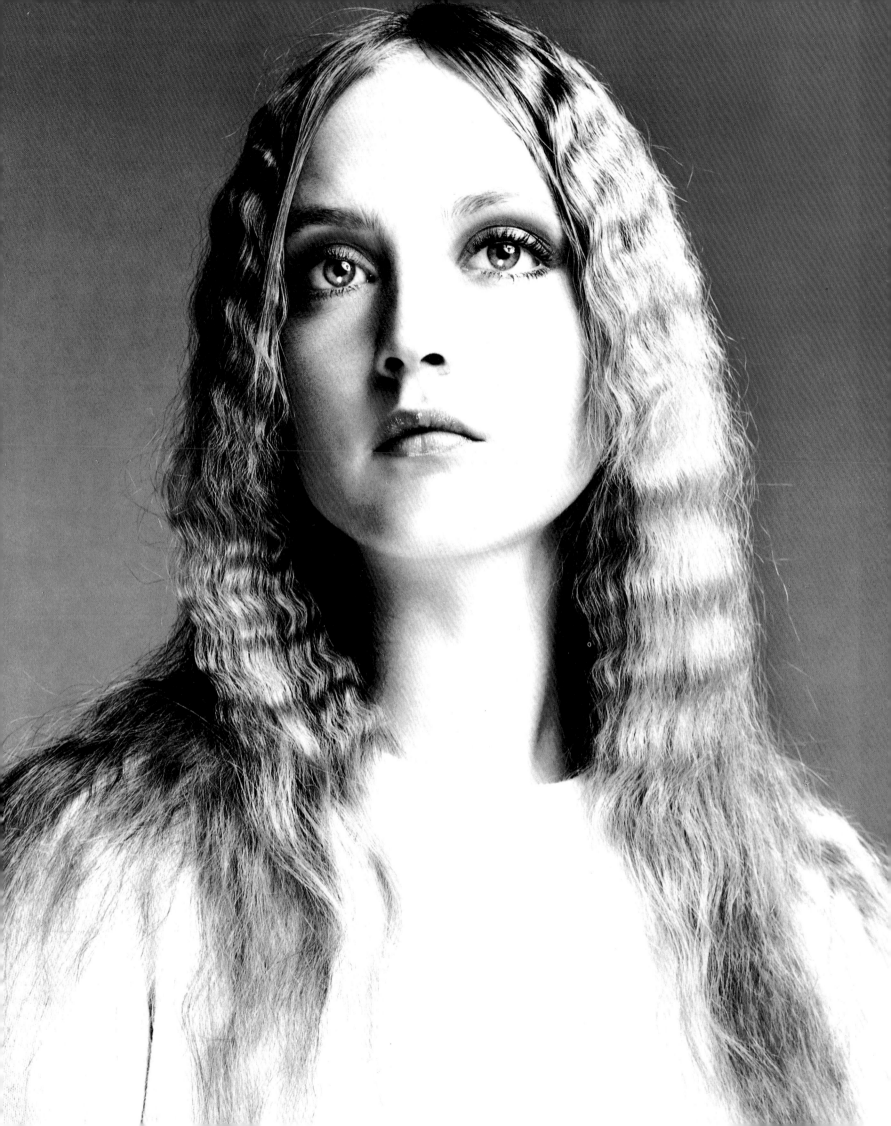

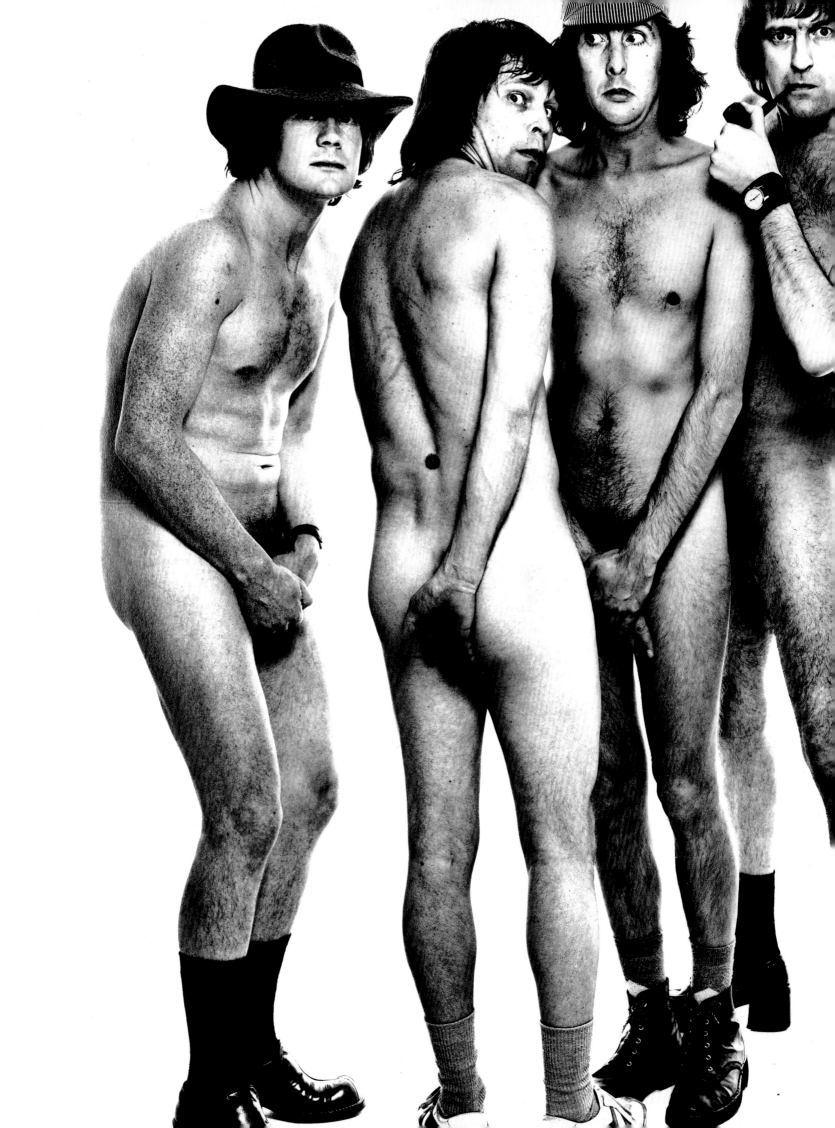

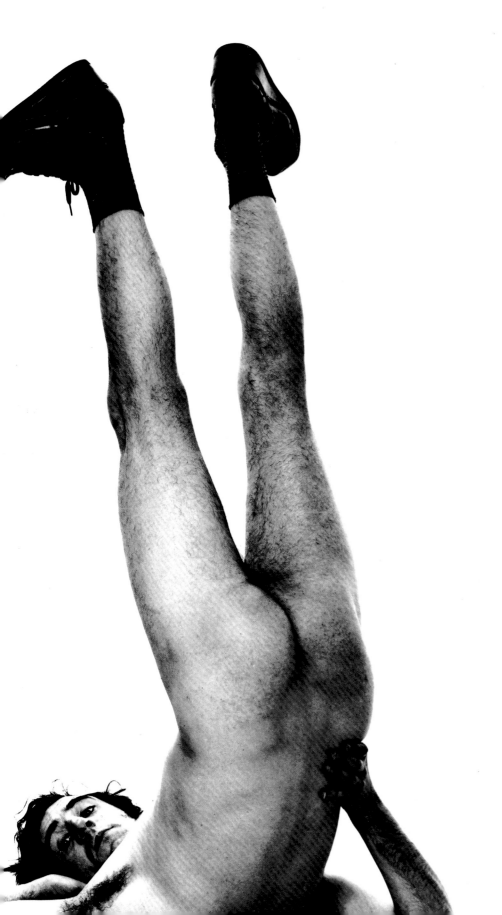

Richard Avedon
Monty Python's Flying Circus
July 1975

following pages

Richard Avedon
Rudolf Nureyev
December 1967

Richard Avedon
Mikhail Baryshnikov
September 1978

Richard Avedon
Veruschka wrapped
by Giorgio di Sant'Angelo
May 1972

Richard Avedon
Tony Spinelli and René Russo
in jumpsuit by John Anthony
December 1975

Richard Avedon
Tina Turner
(unpublished)
1971

Richard Avedon
Sonny and Cher
December 1972

Richard Avedon
Charles Ludlam and
The Ridiculous Theatrical Company
March 1975

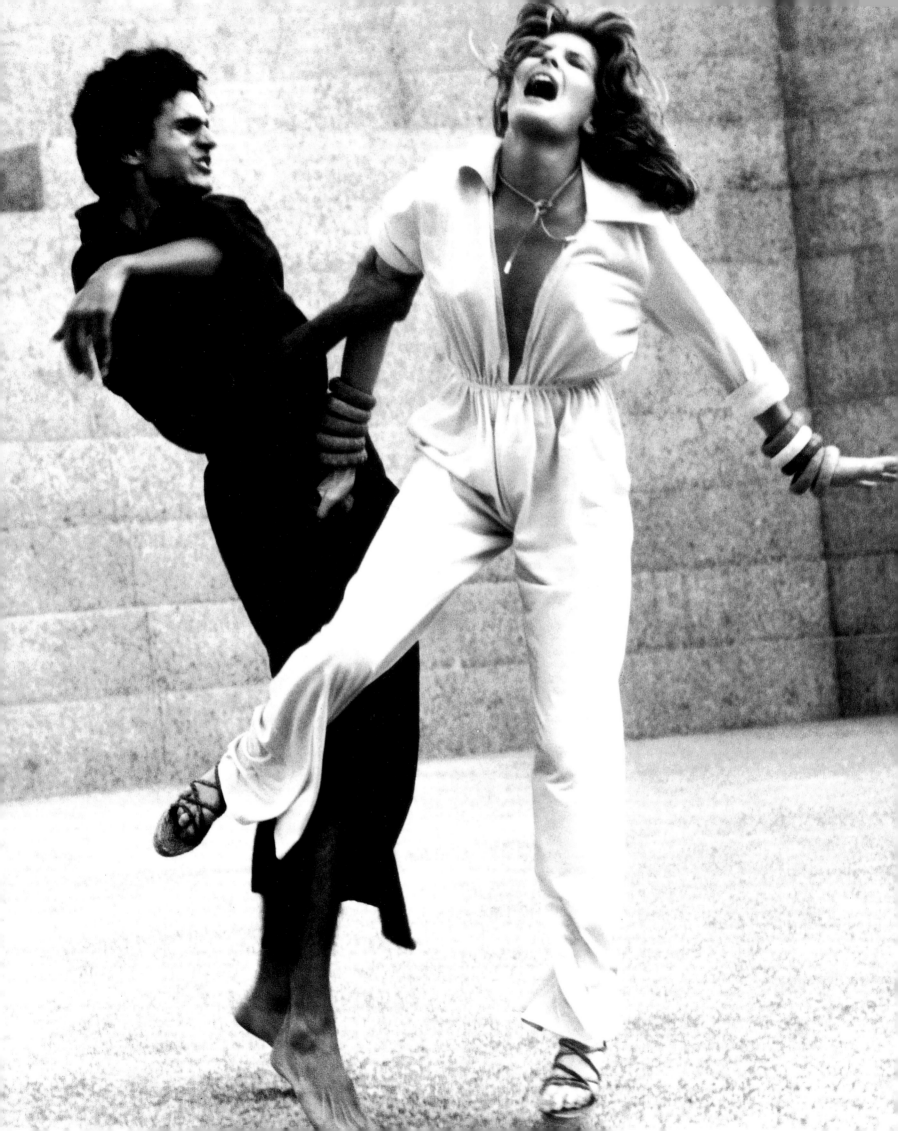

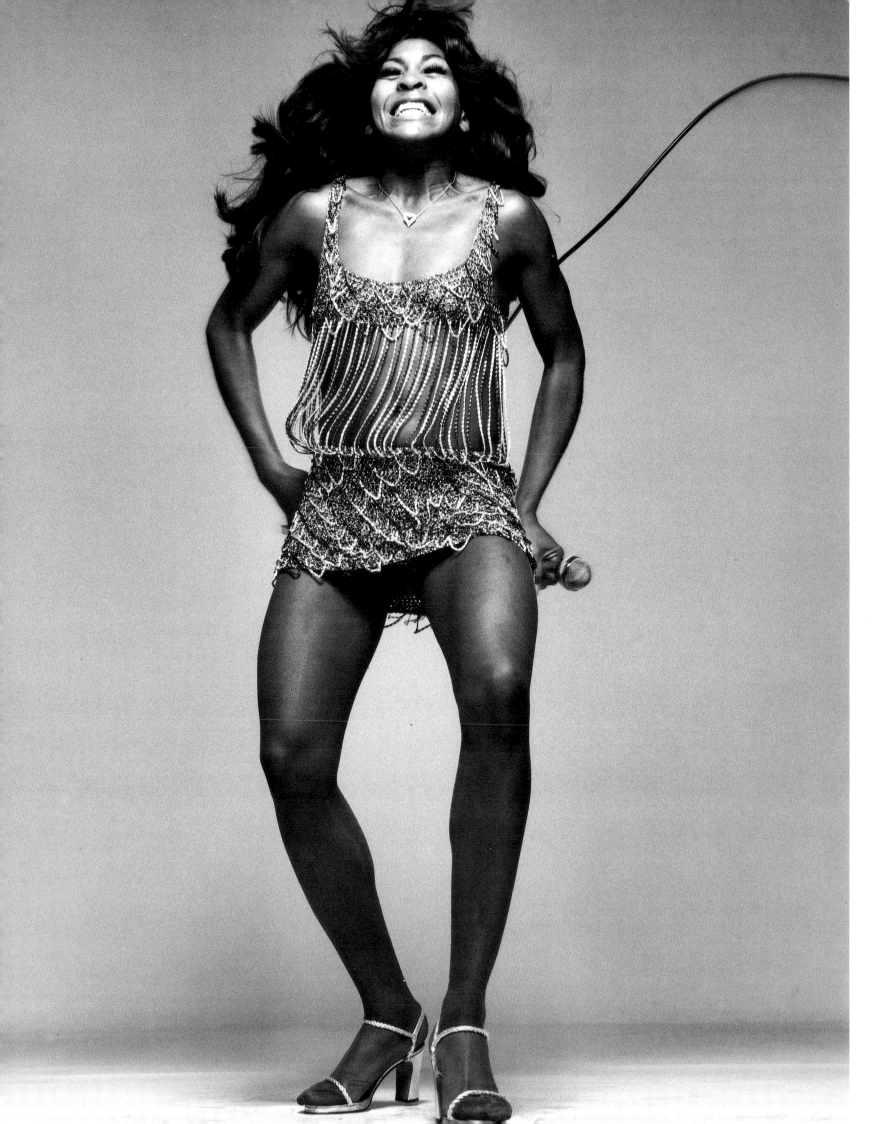

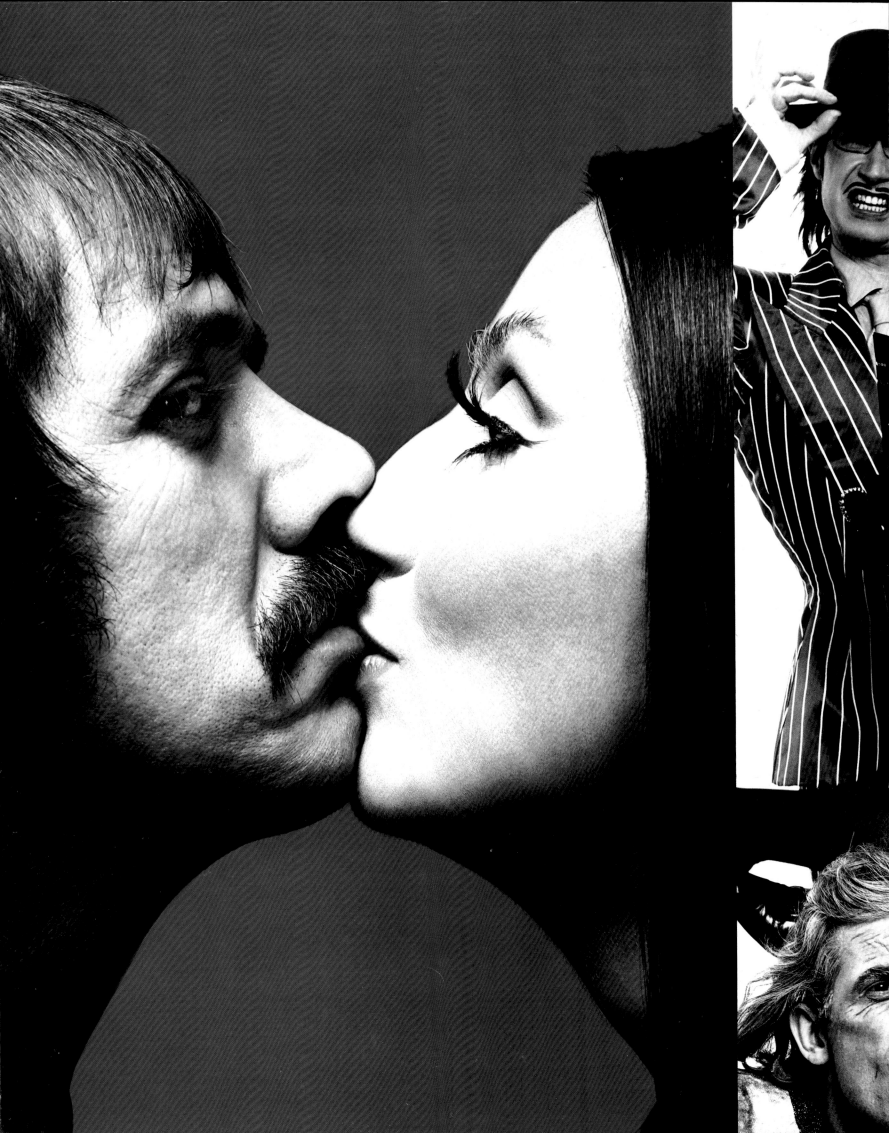

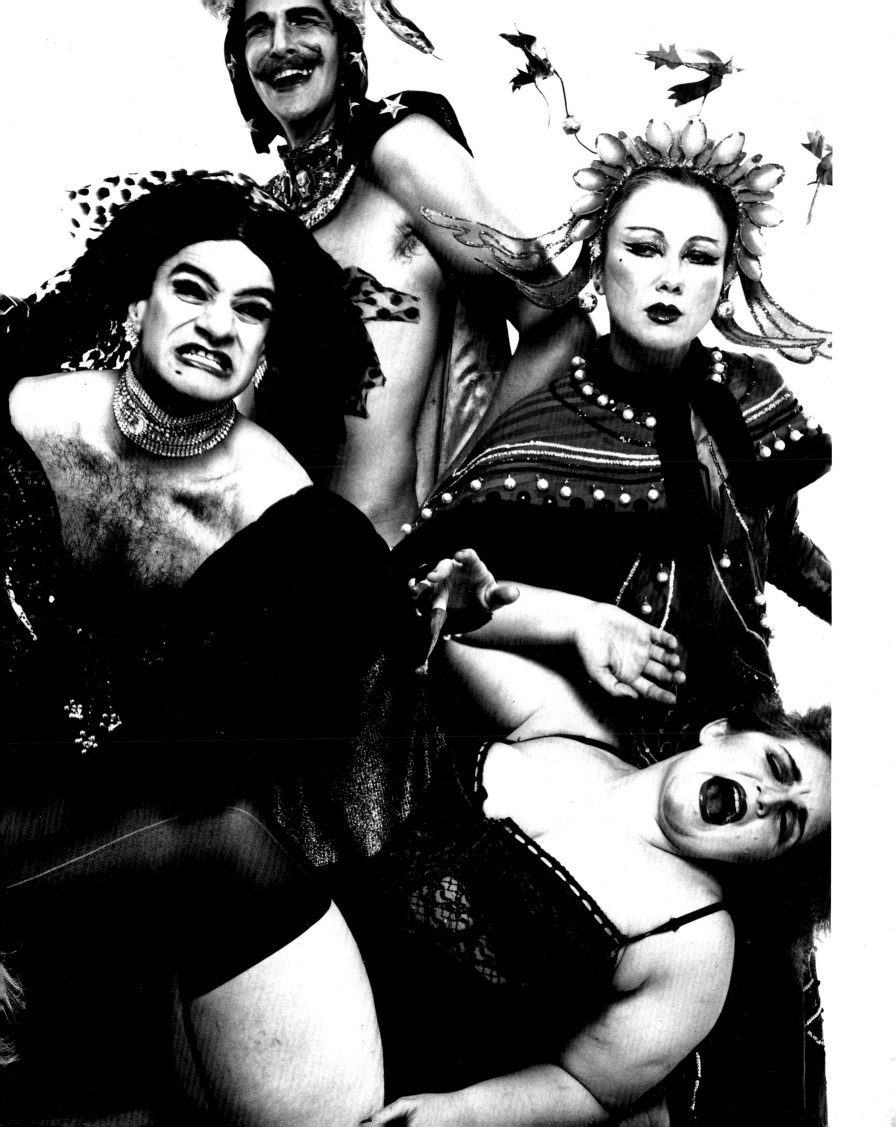

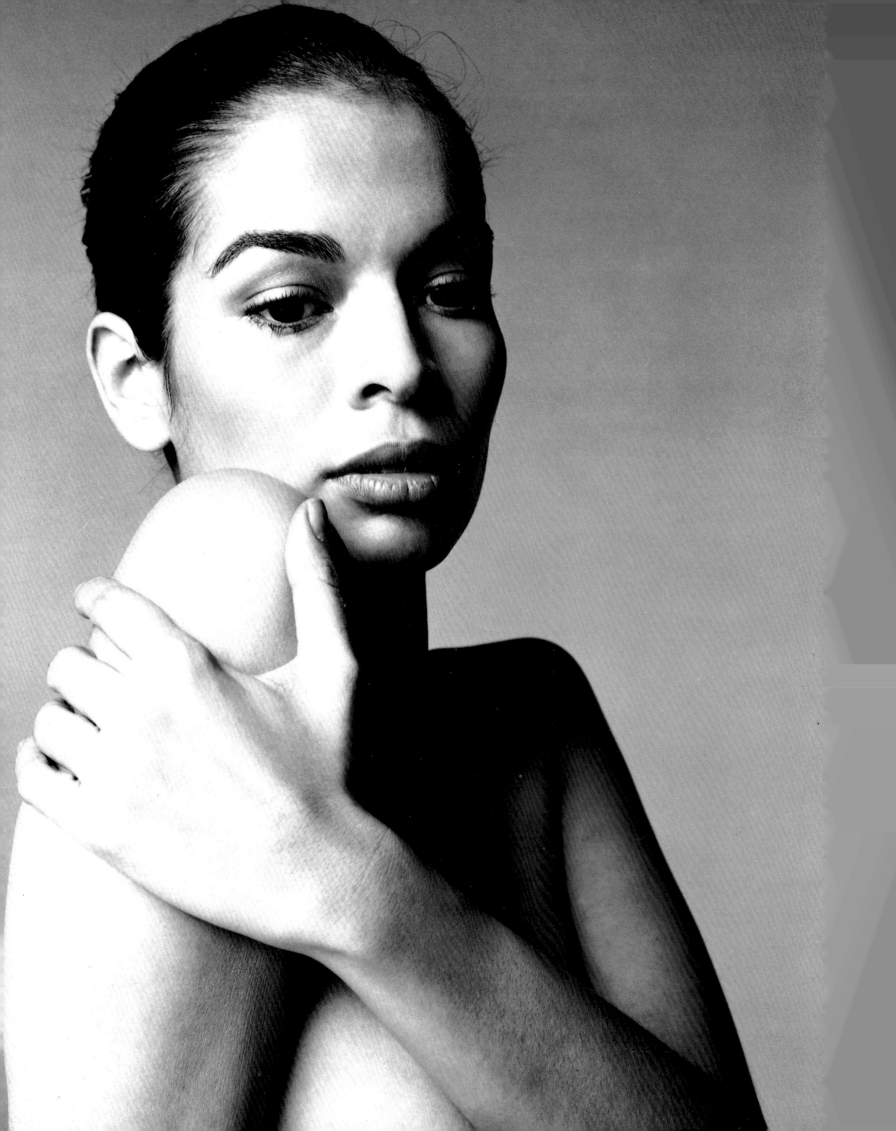

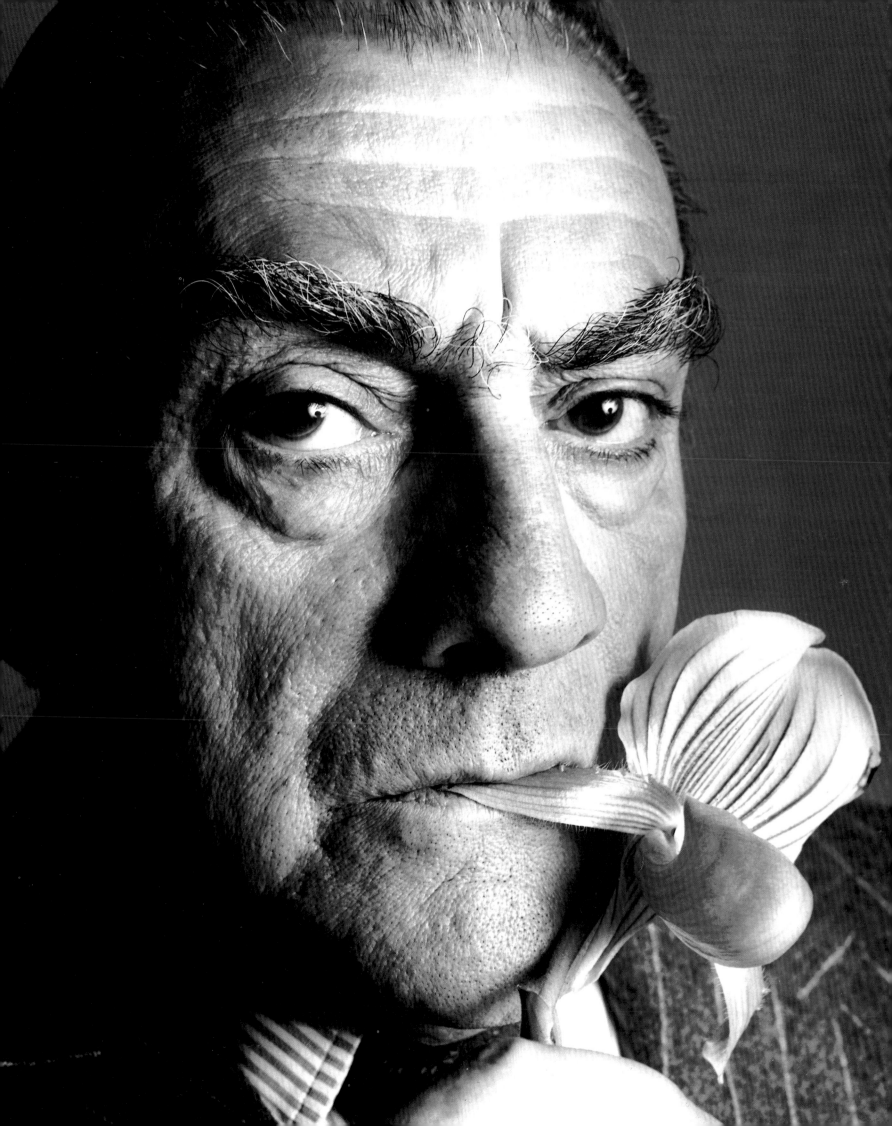

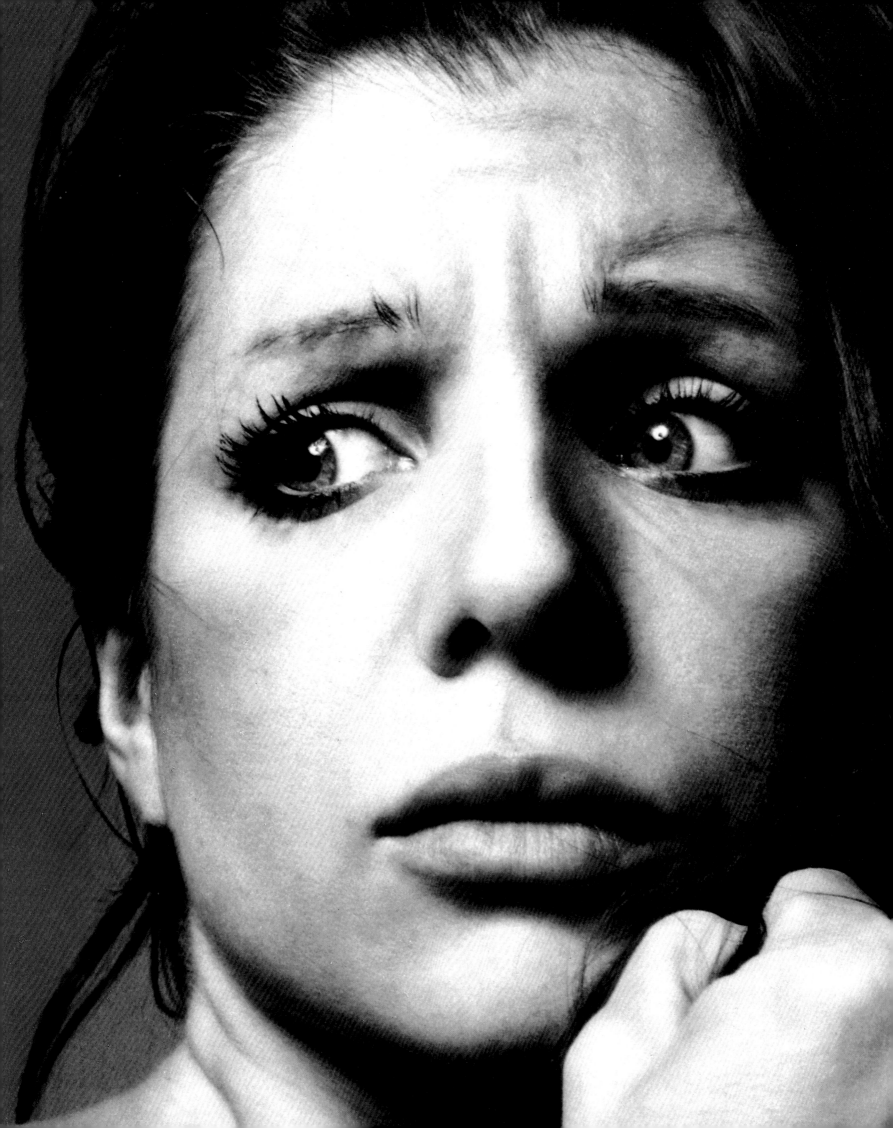

Richard Avedon
Gelsey Kirkland
December 1975

preceding pages

Richard Avedon
Bianca Jagger
(unpublished version)
February 1973

Richard Avedon
Luchino Visconti
December 1972

following pages

Richard Avedon
Rudolf Nureyev
December 1967

Richard Avedon
Veruschka in poncho by John Paul Goebel
October 15, 1966

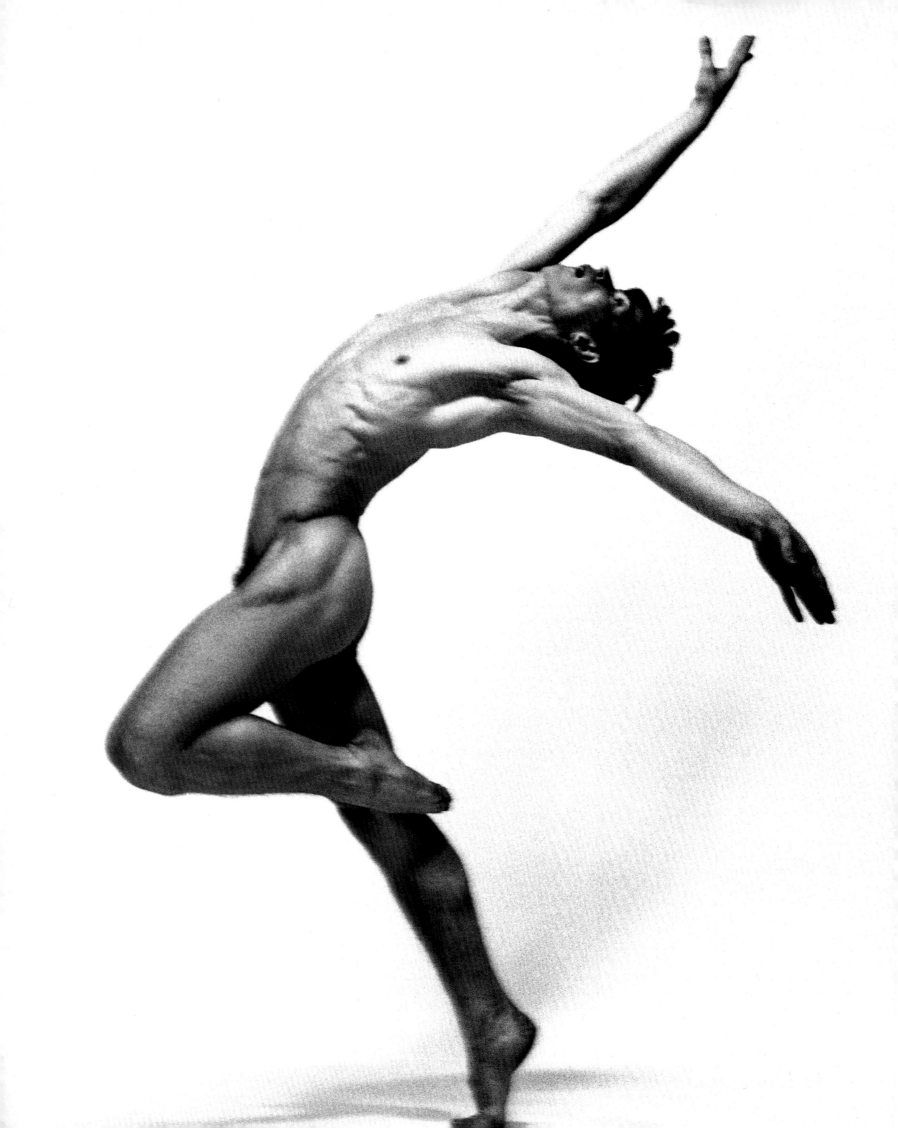

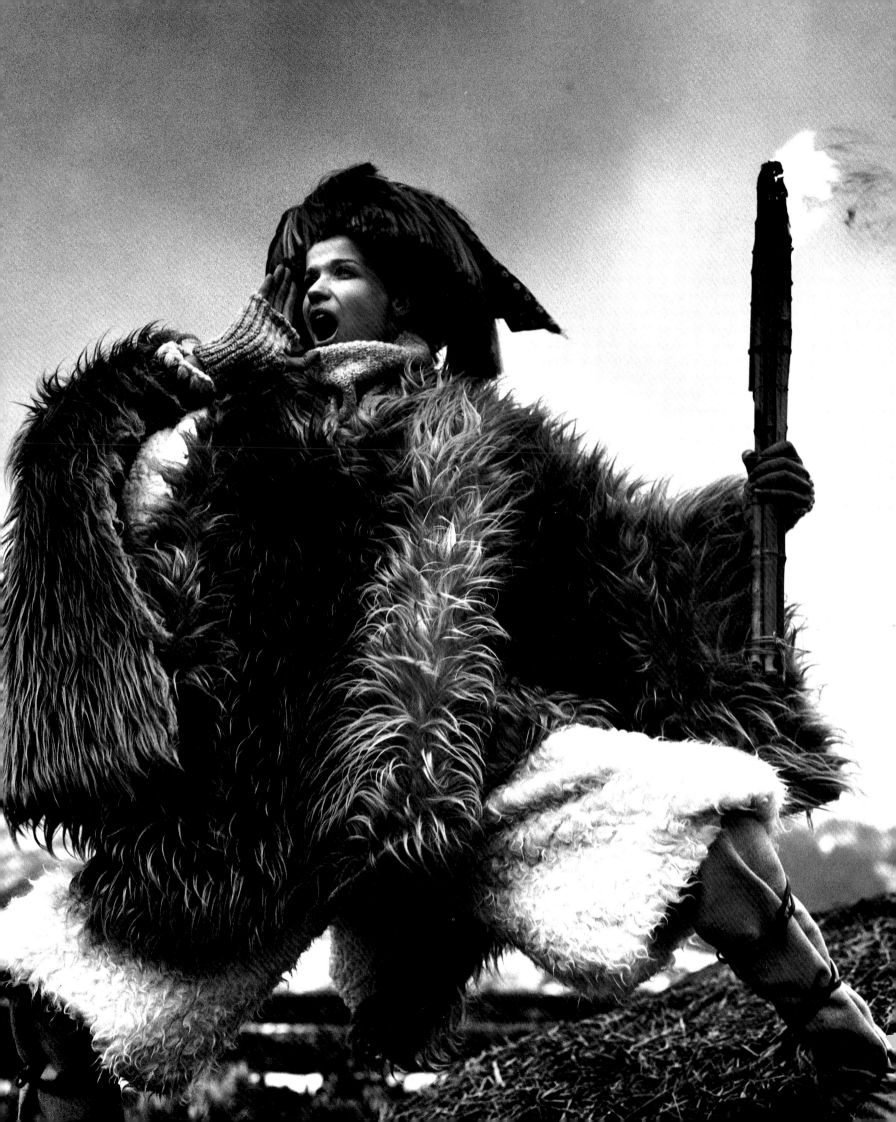

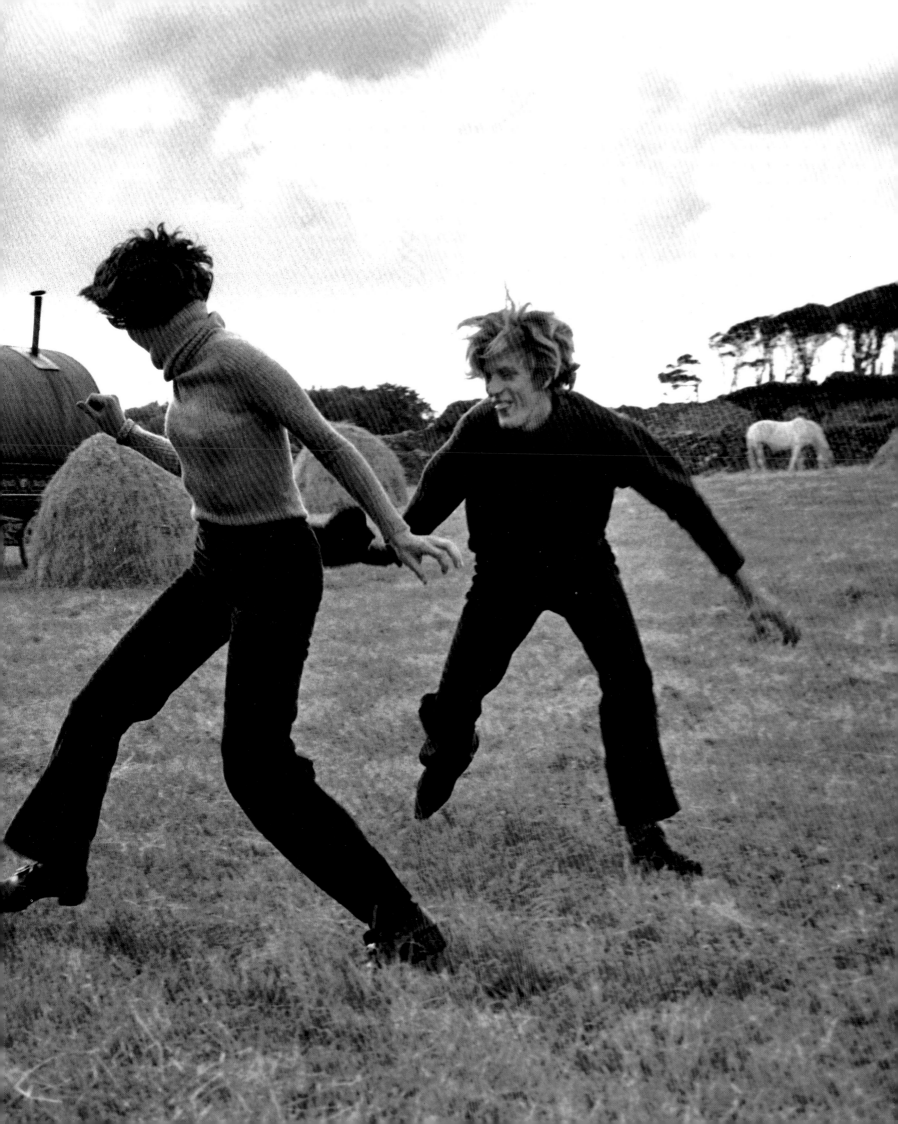

Richard Avedon
Veruschka in a suit by Antony Arland
May 1972

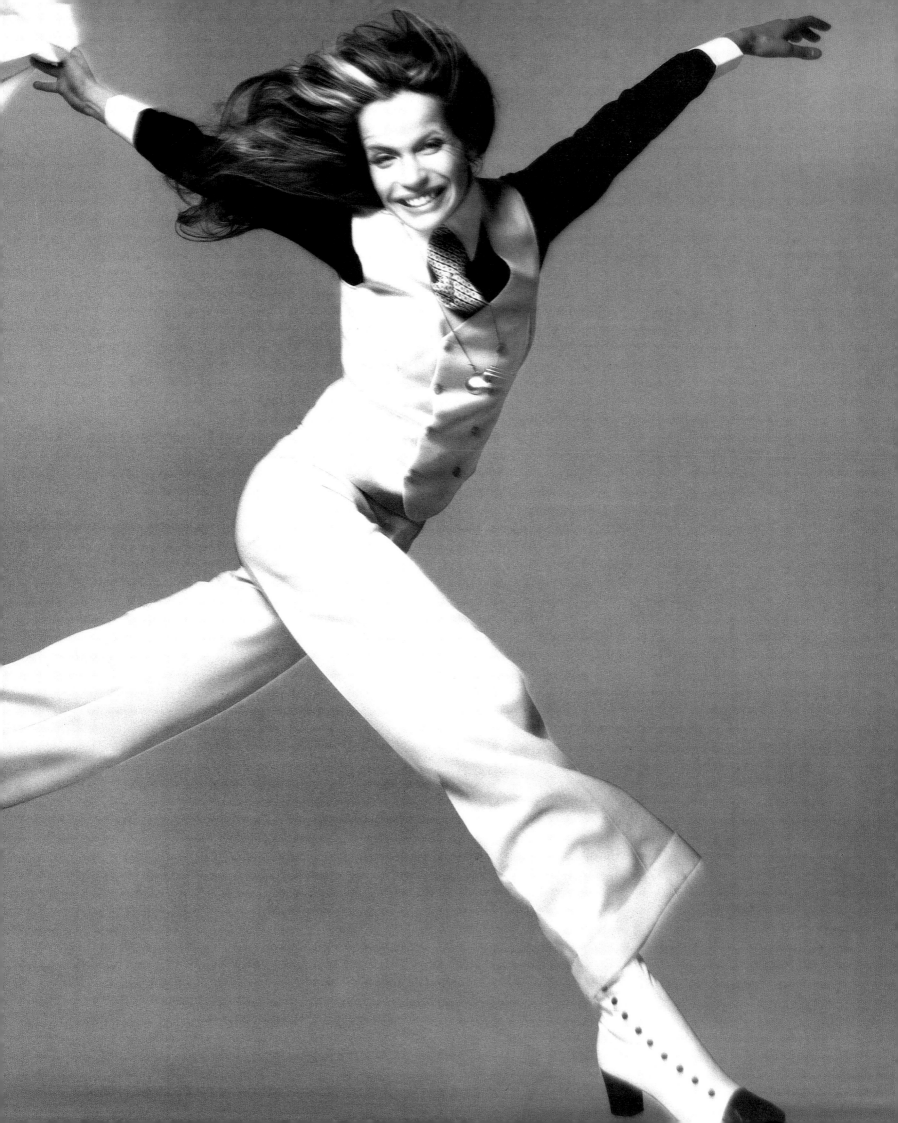

Richard Avedon
Twiggy
(unpublished)
1968

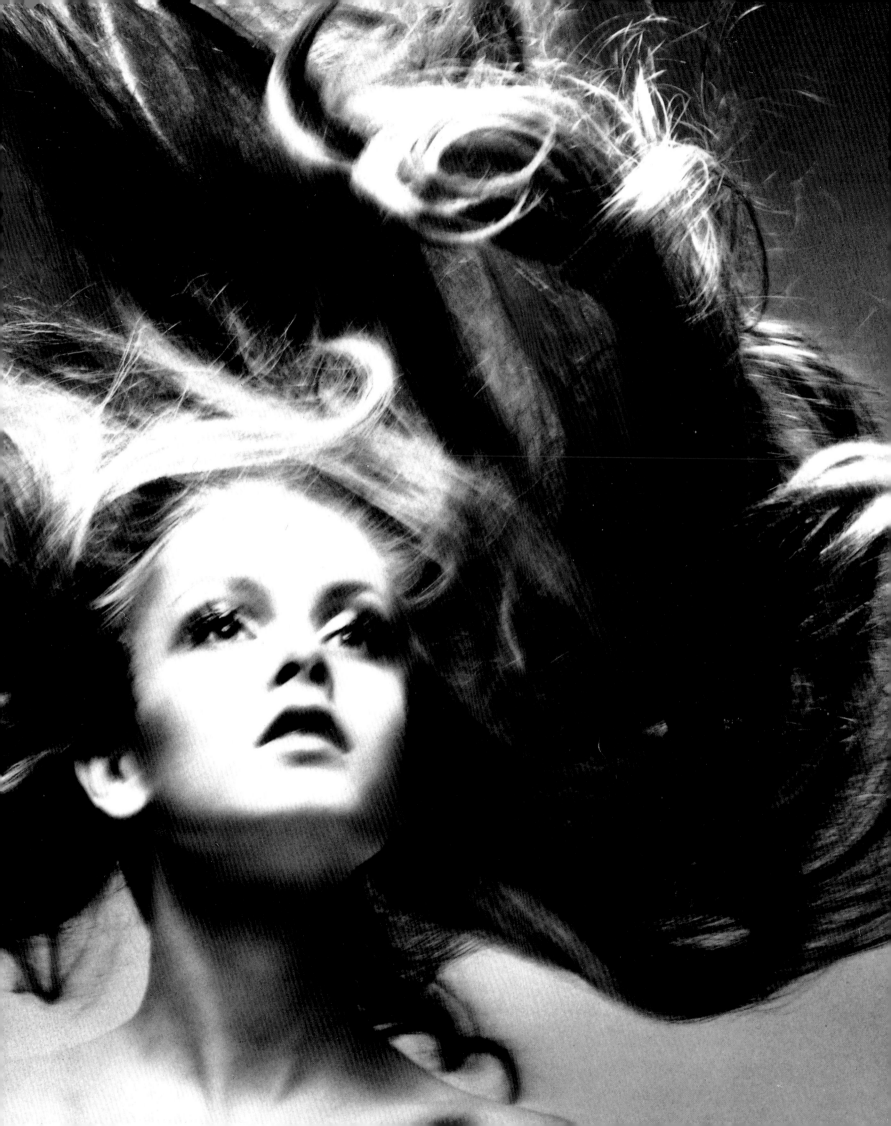

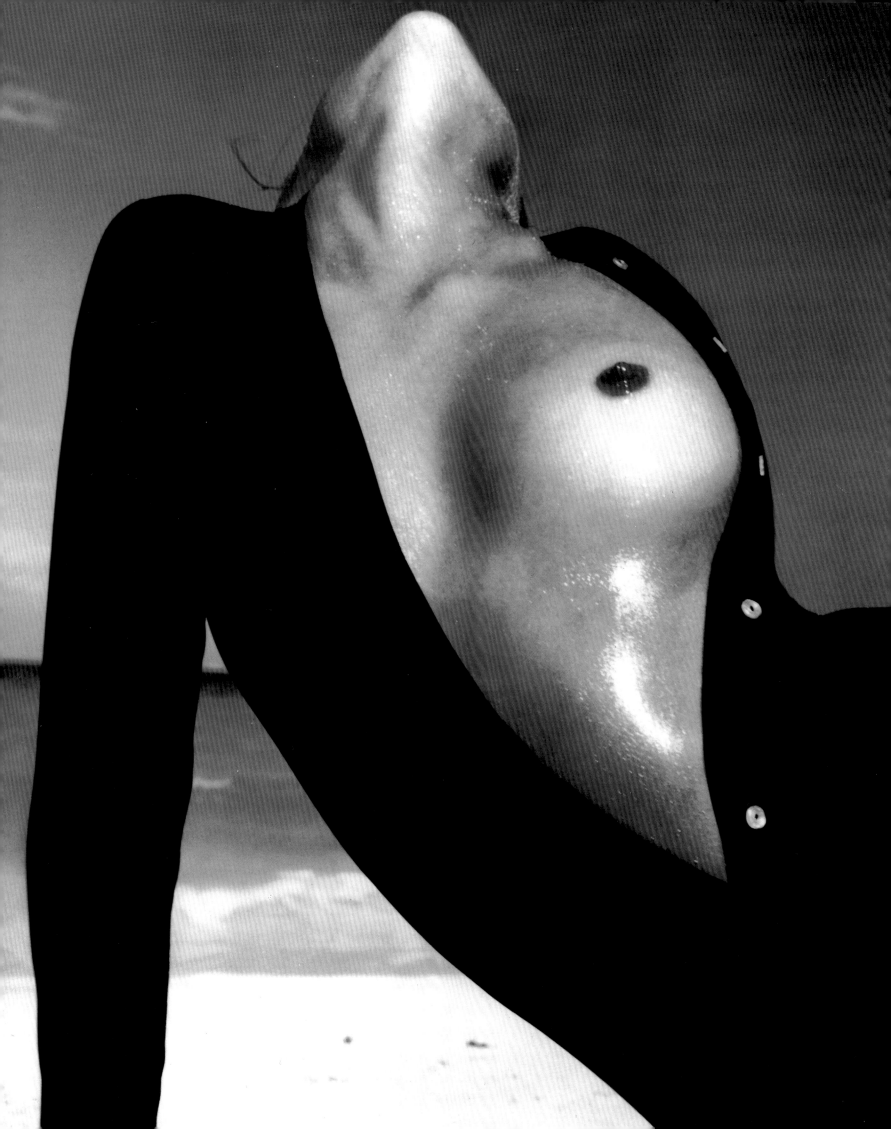

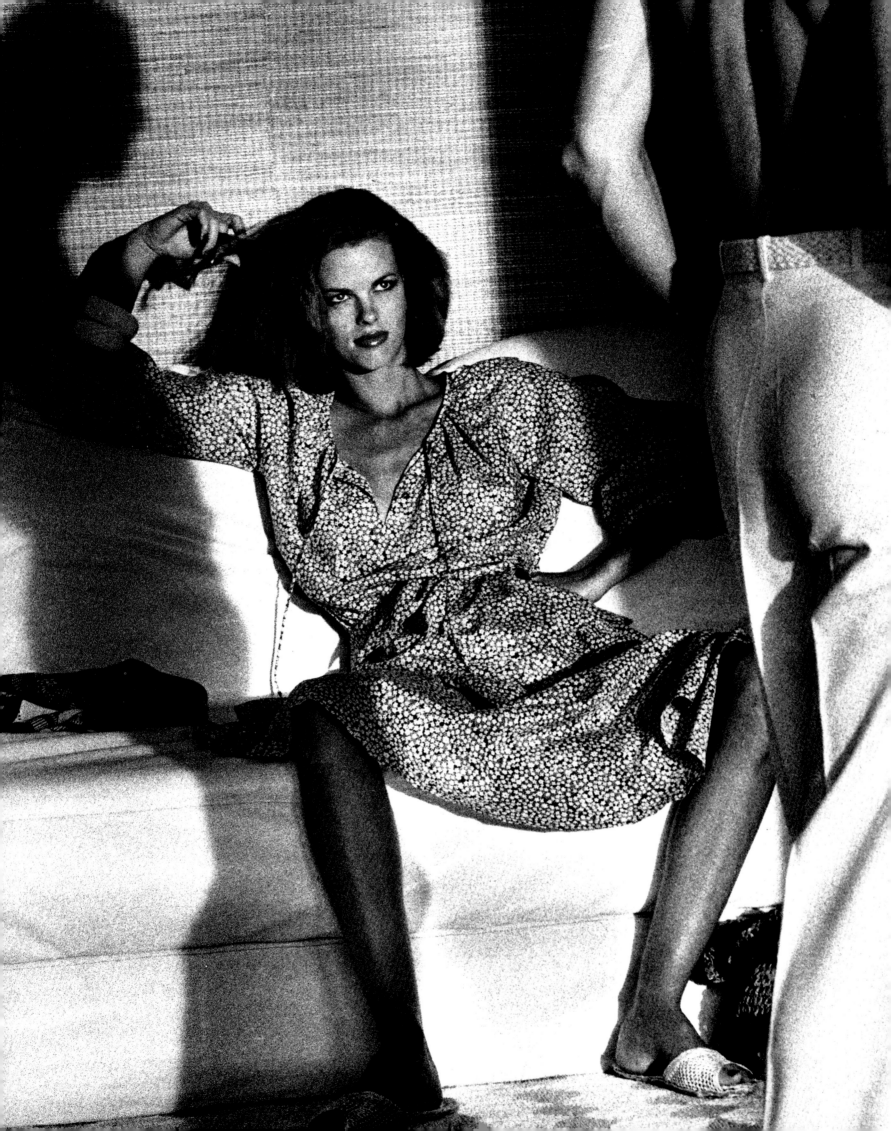

In the 70's

you began to see a new kind of

American *brashness.*

Why shouldn't a woman have the nerve to show a little abandon?

Isn't that reality?

— POLLY ALLEN MELLEN, *Vogue* Fashion Editor, 1966–1991

Helmut Newton
Lisa Taylor in Calvin Klein blouse and skirt
May 1975

In the spring of 1971, Grace Mirabella replaced Diana Vreeland as *Vogue*'s editor in chief. Mirabella had joined the staff in 1951, checking store credits for fashion captions. She had been the magazine's sportswear editor, and then Vreeland's deputy. Her ascendance to the top job marked a change in style at *Vogue*. "The red wallpaper and the leopard carpets were gone and everything was beige" is how one editor remembers it. In the July issue, Mirabella announced the return of "real-life fashion." The editorial voice was straightforward and practical. "What we want to say first about the clothes you're going to find in these pages is: just that. You-are-going-to-find-clothes!!!... The teeth-and-feathers thing is behind us; we are out of costume."

"The kind of woman that Grace wanted to build as a reader of *Vogue* was a young woman who was aware of who she was," says fashion editor Polly Mellen. "A woman who would take a good look at herself in the morning when she got dressed and then go out and forget what she had on and live her day. Grace didn't believe in too many bracelets. And she was conscious of how young women made decisions about buying expensive clothes."

Mellen was working closely with Richard Avedon, producing the close-ups of beautiful faces that the circulation department had determined were the most successful cover images. "The formula for our covers then was 'looking at you,'" she recalls. "Looking at the lens and staring out from the newsstand. We would prepare the girl to be the most beautiful girl in the world and then go in front of the camera and sell *Vogue*." Out of the studio, Avedon and Mellen were working with less conventional imagery. At *Harper's Bazaar* in the sixties, Avedon's fashion sittings on location had produced pages of photographs that had a narrative of sorts, with social commentary as a subtext. Photographs from a trip to Ibiza with two female models and one man, for instance, had evoked the boredom and sexual ambivalence of a certain kind of chic world. In December 1975, *Vogue* readers were startled by the scenario suggested in a fashion feature that was shot at Johnson and Burgee's new Fort Worth Water Garden. A fight takes shape on one of the pages, culminating in a violent slap *(page 164)*. The woman in the picture seems to be lifted off the ground by the force of the man's blow. Readers

protested, but Avedon's point had been made, and a serious social issue had been raised in the magazine's fashion section.

The model being slapped in the Water Garden was René Russo, who had appeared in the previous year's December issue in a photograph with a different kind of shock value. She and Cheryl Tiegs had been photographed by Helmut Newton, dancing together intently on the edge of the Haleakala Crater in Maui, Hawaii *(page 187)*. The picture was part of an eighteen-page feature on "sundressing" that portrayed two women and a man in various combinations—embracing, painting one another's toenails, brooding suggestively. It was the sort of thing that would continue to appear frequently in *Vogue*.

Helmut Newton was born in Berlin in 1920, and was a teenager there in the decadent thirties. "I was obsessed with photography," he recalls. "My mother was a subscriber to *Vogue*, and I was fascinated by the pictures in it. All I wanted to be was a fashion photographer, a *Vogue* photographer." When he was sixteen he apprenticed himself to a photographer named Yva, but two years later, in 1938, he left Germany for Singapore. Newton eventually ended up in Australia, where he lived until 1956. The Olympic Games were held in Melbourne that year, and Grace Mirabella, who was then *Vogue*'s sportswear editor, came to Australia to do a fashion feature. Newton worked with her on that project, and shortly afterward he moved to Paris and began publishing regularly in French *Vogue*. In the early seventies, he received a call from Alexander Liberman, who said, Newton recalls, "'We want you to come to New York. We want you to do forty-five pages.' Which is a lot. And so I went and I stayed for a long time."

Charlotte Rampling, "the sexiest woman in the world," according to *Vogue*, was one of Newton's favorite subjects during this period, and one of his most famous photographs of her is the nude shot taken in Arles, at "a fantastic hotel where all the bullfighters stay" *(page 190)*. The photographs that received the most comment, however, were part of a fourteen-page May 1975 feature that *Vogue* called "The Story of Ohhh" Shot in St. Tropez, the pictures evoke a steamy eroticism. A woman in a sundress crouches over a man at poolside, just about to kiss him,

while in the bushes another woman peers out, watching them and looking shocked behind large dark glasses. In other pictures the man touches the woman's breasts, nibbles her ear, ignores her while exchanging glances with woman number two. But the image that outraged people the most was one of model Lisa Taylor spread-legged on a couch, toying with a strand of her hair and gazing in a predatory way at a man in white pants and nothing else *(page 182)*. "The fact that her legs were open didn't seem very important to me," Newton says. "She had that big skirt on. But it caused a scandal. People canceled their subscriptions. And I was asked why I had photographed two women and one man together. What the sexual thought was behind that. I said, you know, I had absolutely no sexual thought. The magazine is just too chintzy to spring for two guys. They want to send one guy and two girls who can wear the dresses. It's very simple." Alexander Liberman included this photograph in his selection of exemplary fashion pictures for *American Photographer*. "Newton is one of the very important photographers of the seventies," he said. "He helped break conventions. . . . The frankly appraising glance of this liberated woman, of a woman who feels sure of herself toward men, makes this one of the most suggestive pictures I think *Vogue* has ever published."

Another fashion feature in the May 1975 issue added fuel to the flames. "My phone never stopped ringing," recalls Polly Mellen, who was the editor on both sittings. The other controversial series of photographs *(page xviii)* was a ten-page feature on bathing suits by Deborah Turbeville, an American photographer who had been a model and assistant to the designer Claire McCardell and then a fashion editor at *Harper's Bazaar* and *Mademoiselle*. She had become a serious photographer after taking a seminar given by Richard Avedon and the art director Marvin Israel. The bathing suit pictures were part of her first work for Alexander Liberman at *Vogue*.

"We were supposed to go to Peru for this," Turbeville recalls. "But then something happened and the trip got canceled. So Mr. Liberman called me and said, 'Listen, dear, would you mind doing the pictures on a set in New York, since this is a crisis?' His main stipulation was that there should be five figures across each spread. Groups of women. So I talked to a guy about building a set, but something bothered me about it. I prefer to work with real things rather than things that are contrived, and I was afraid that this wouldn't come off the way I wanted it to. I talked to someone I was working with, and I said that the atmosphere I was looking for was sort of a turn-of-the-century bathhouse, something very baroque and empty in daylight. And he started running around and finally called me from way downtown and said that he'd come across the most amazing empty bathhouse. It was unbelievable. It had available light, and the mood I needed, and there was never anyone there.

"So Polly did her usual brilliant job of casting and putting the suits on the right girl, and things started to take off. Of course Polly is very dramatic, and she started saying, 'Oh, my God, this is just incredible,' and calling Alex and giving him a blow-by-blow report. And someone else started talking in the background about it being like Auschwitz. But I didn't see it at all. I just thought that there were all these incredible-looking women dressed in black and white in this bathhouse and it was kind of gloomy, with strange light coming in. I always quiet everyone down during a sitting, and there was not even a breath. And everybody got very tense and was moving in this synchronized way. They knew what to do when I said yes or no, and they never looked at one another. They moved like puppets. And when it was over there was dead silence.

"When we made the prints I knew that they were spectacular, and then I heard that Mr. Liberman thought they were extraordinary and that they were getting these huge spreads. When the magazine came out there was an explosion, because of what Helmut had done too. People began talking about the pictures being immoral, and saying was it Auschwitz or a lesbian scene or an orgy. Or were they in an insane asylum. But if you start out trying to do an insane asylum or a lesbian scene or an orgy it looks fake. It is only when you don't set out to do it that things come off."

"At a time when health and energy were being stressed," Alexander Liberman said, Turbeville "brought a mysterious reminder that everything in life is not health and happiness."

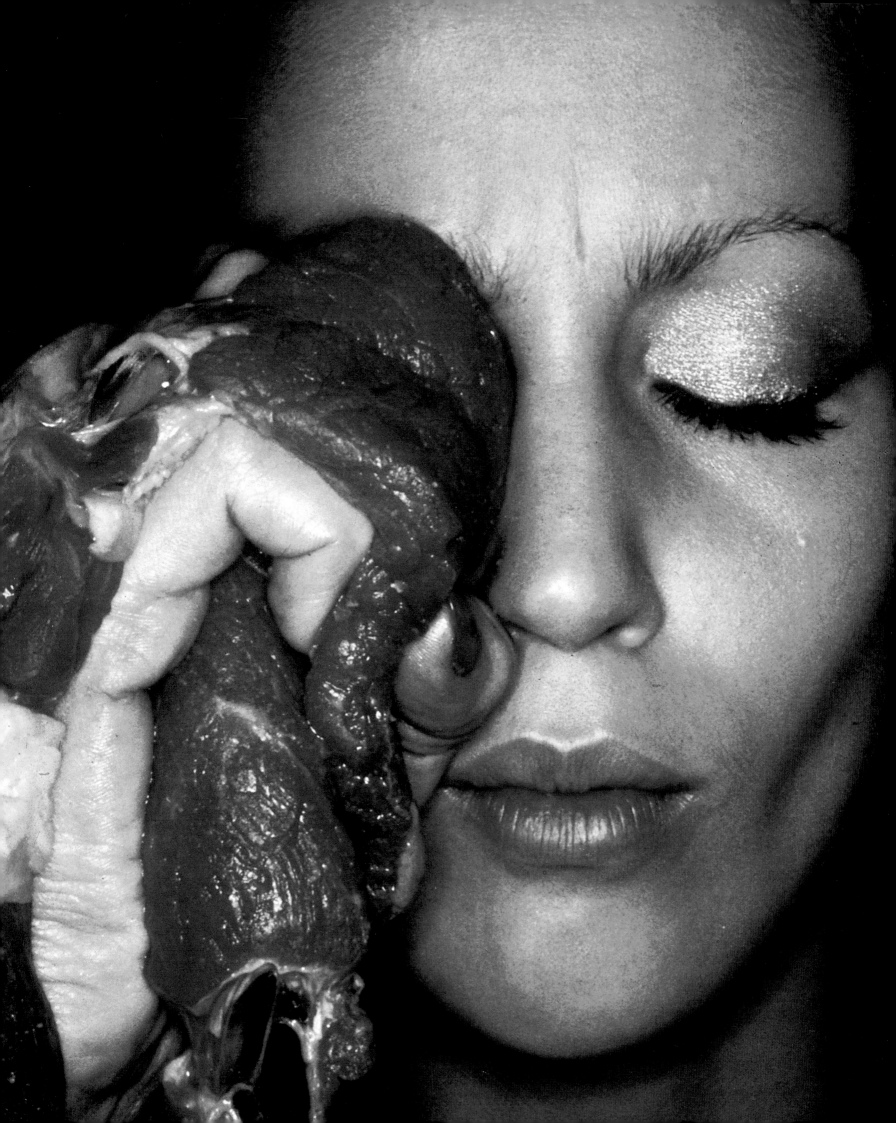

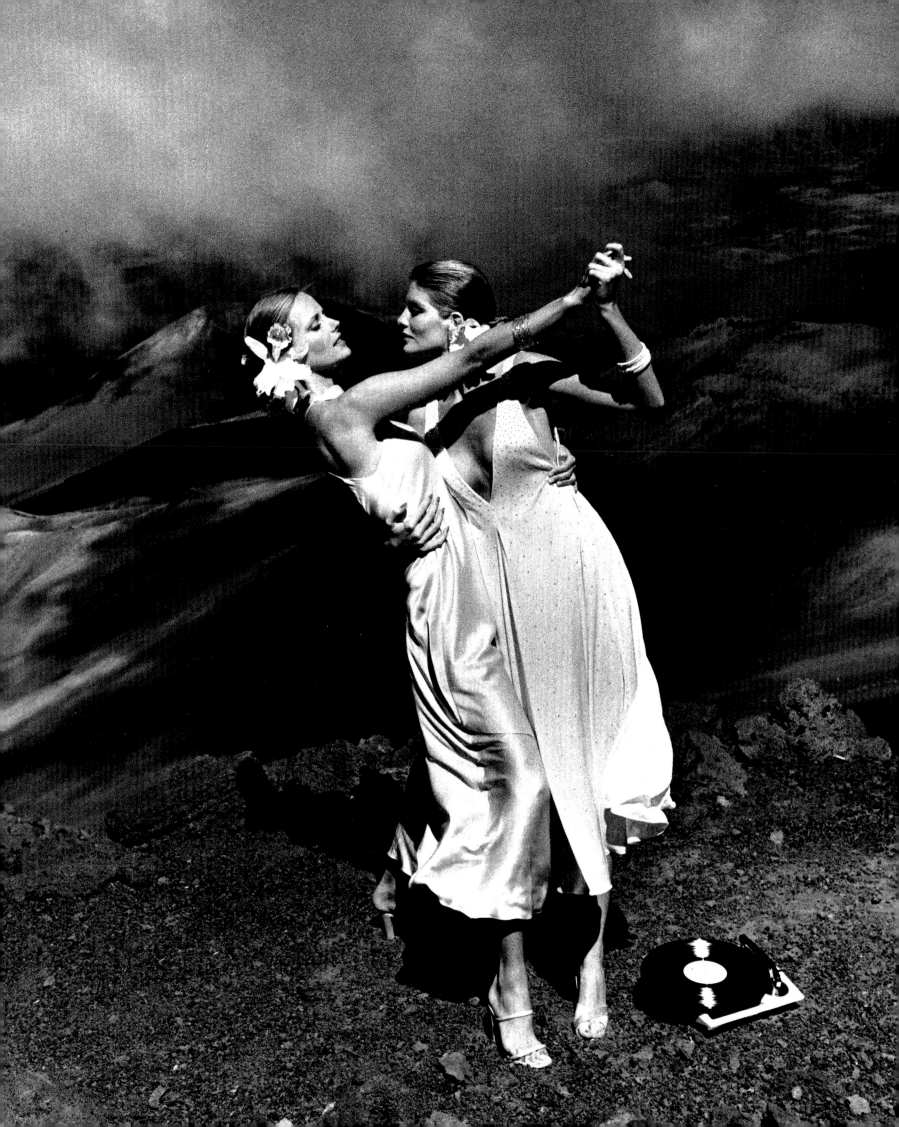

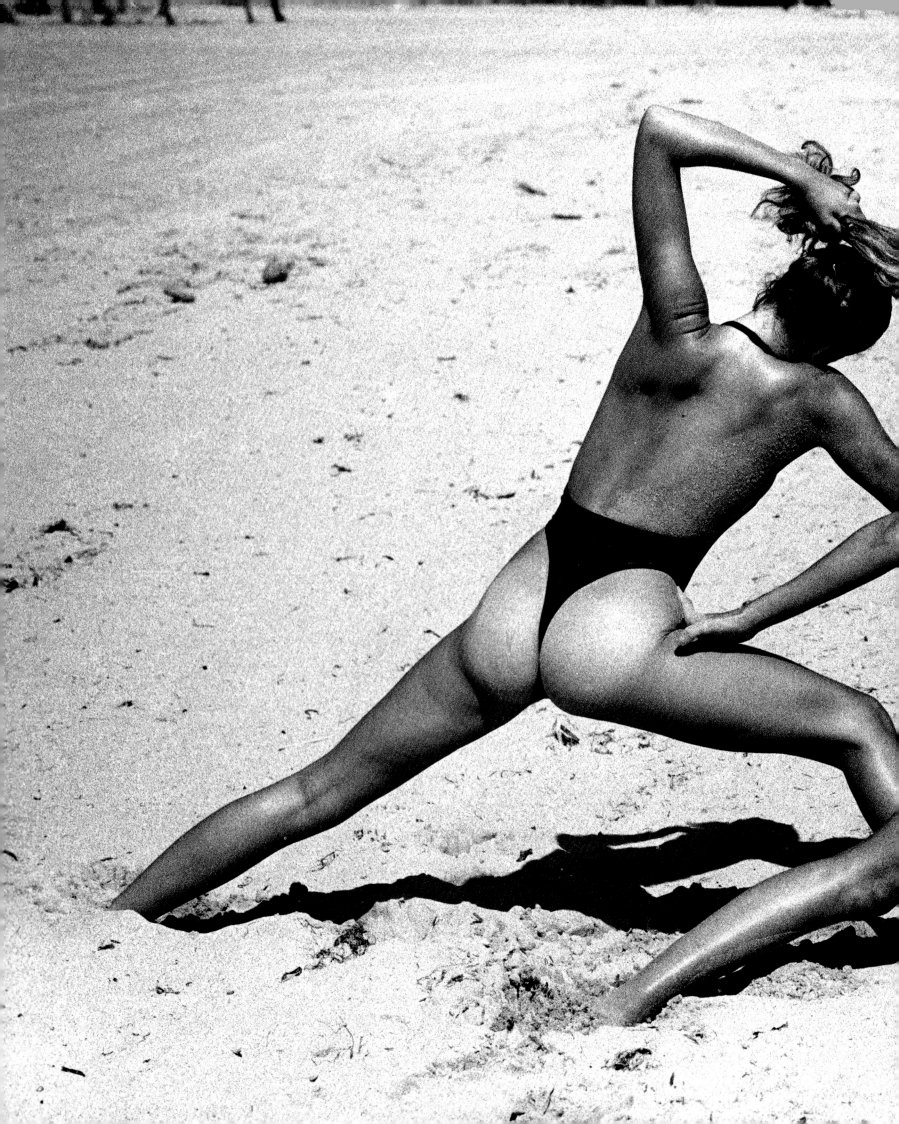

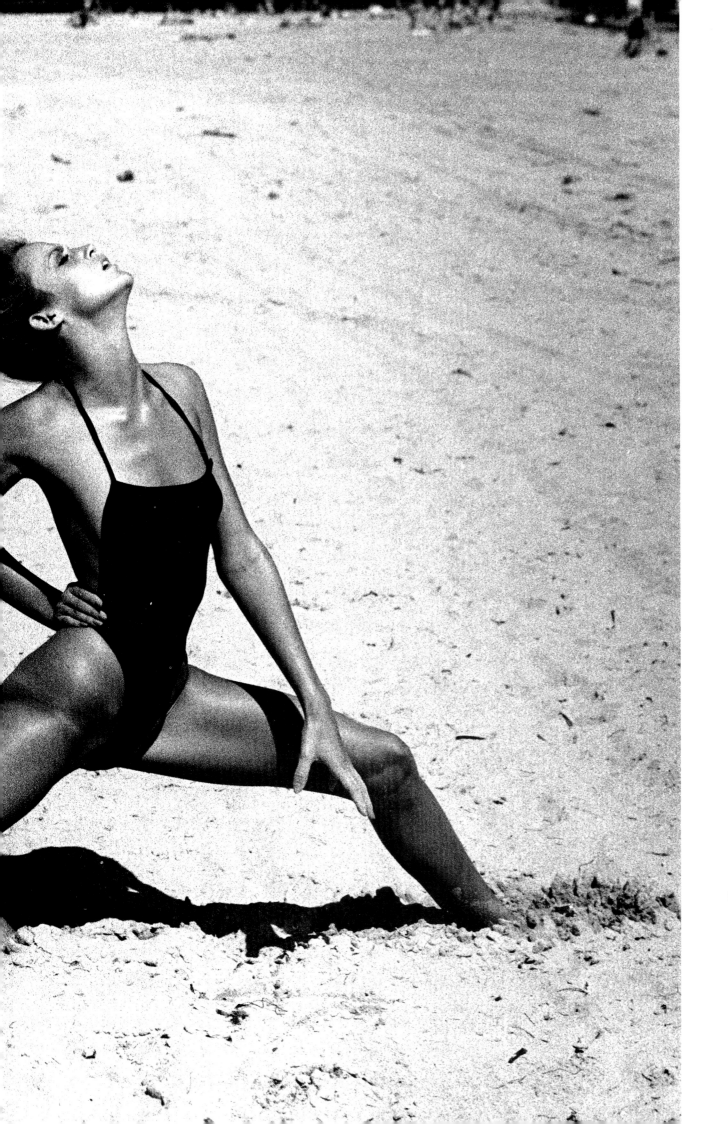

Helmut Newton
Lisa Taylor and Jerry Hall
in Rudi Gernreich bathing suits
January 1975

preceding pages

Helmut Newton
Jerry Hall
(unpublished version)
October 1974

Helmut Newton
Cheryl Tiegs and René Russo
in white evening dresses,
Maui, Hawaii
December 1974

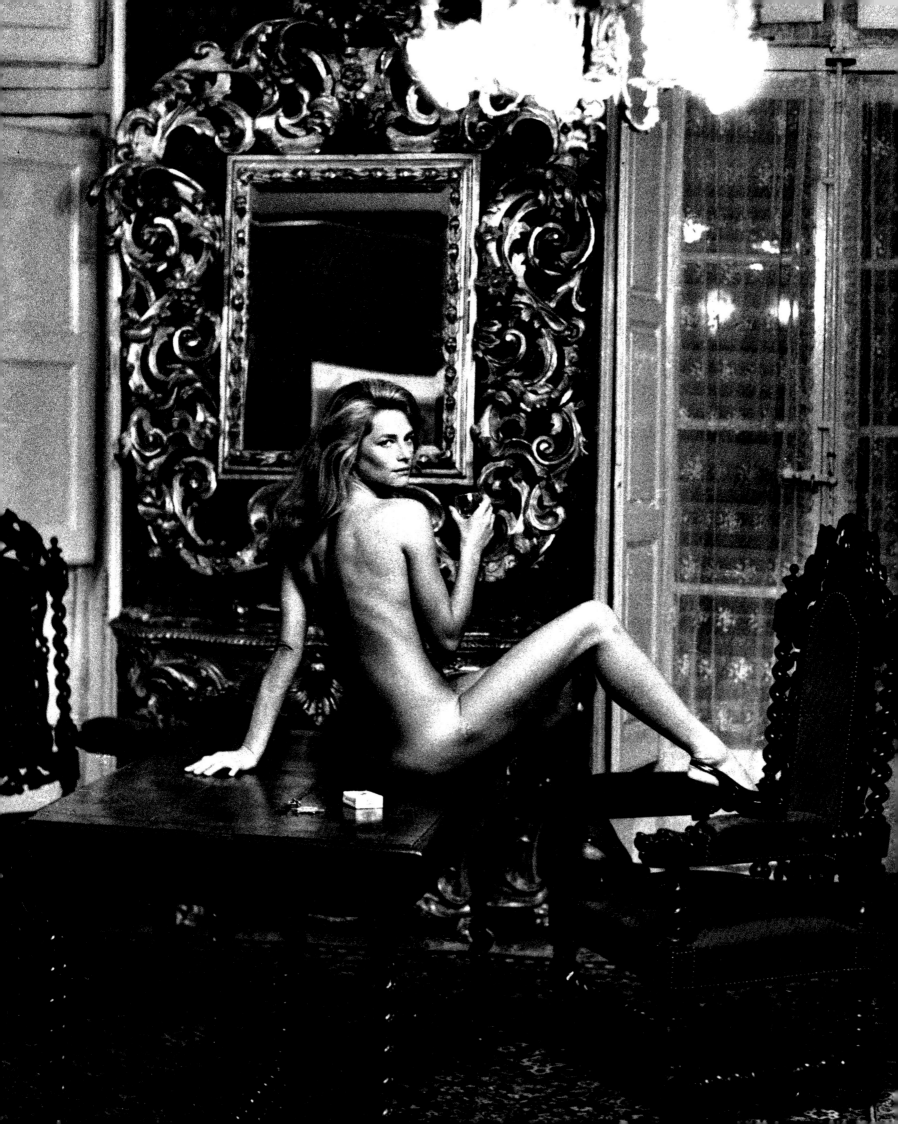

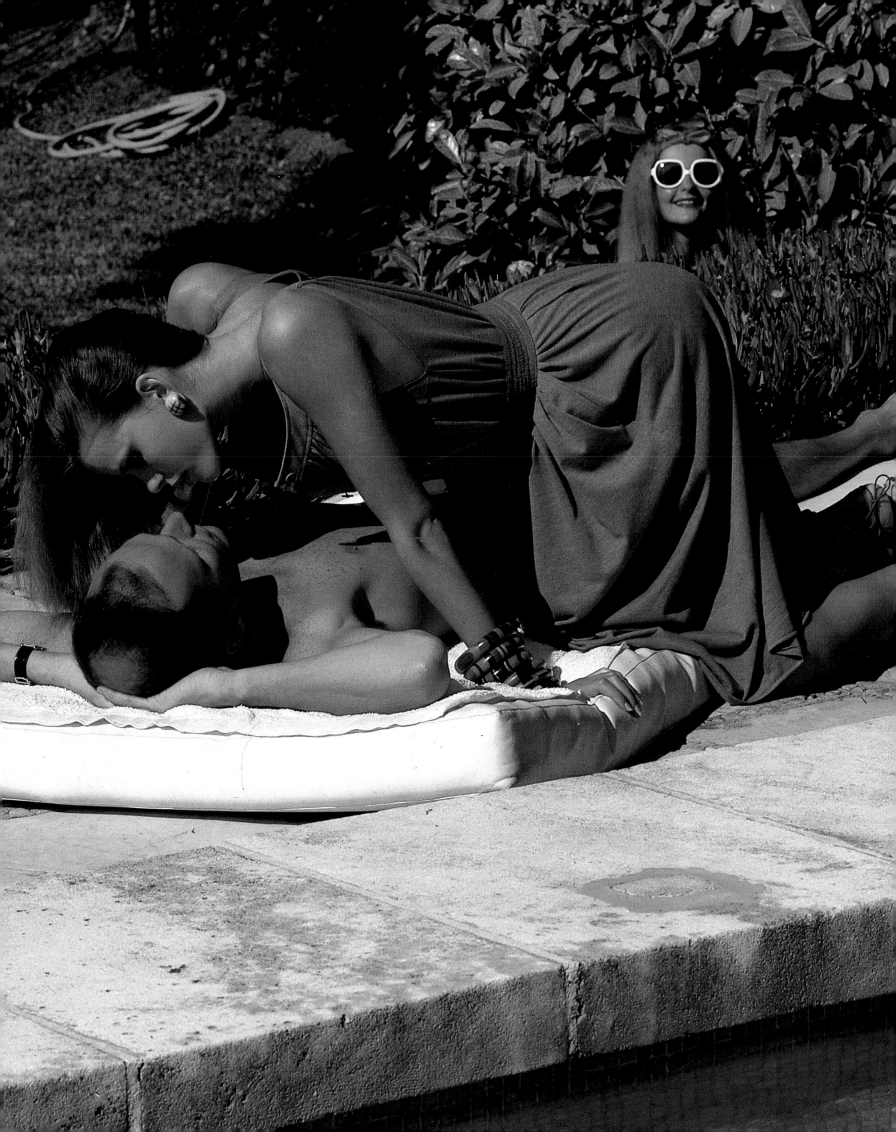

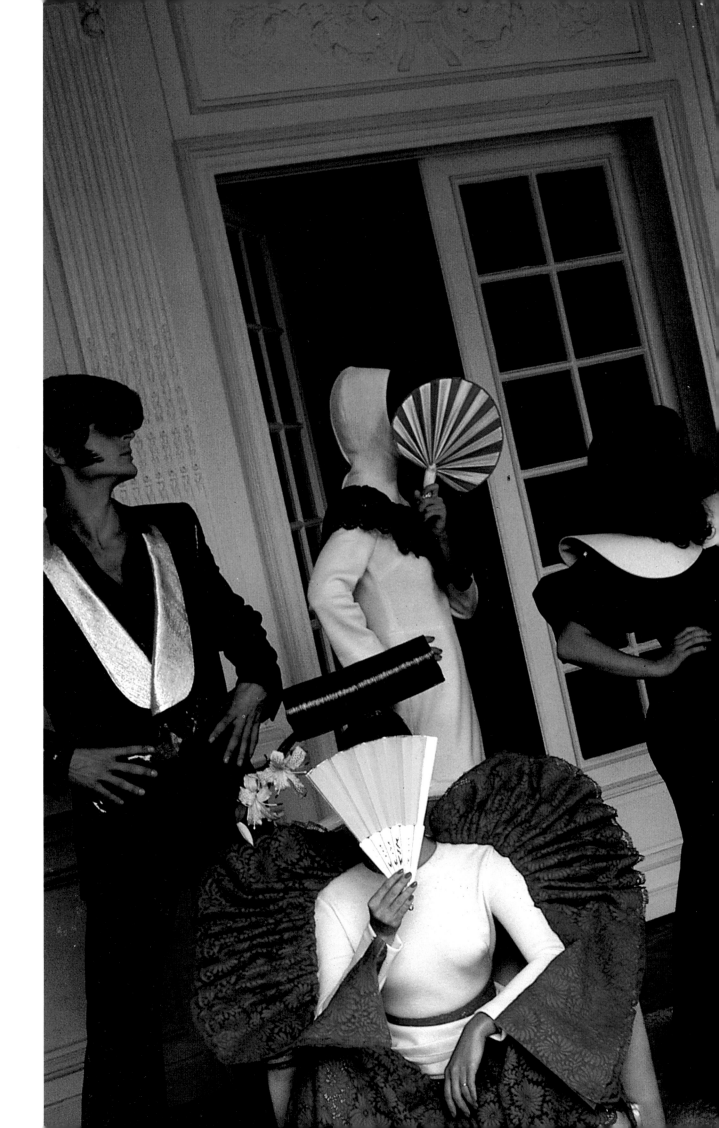

preceding pages
Helmut Newton
Charlotte Rampling
December 1974

Helmut Newton
Lisa Taylor in
Oscar de la Renta halter-smock,
St. Tropez
May 1975

Helmut Newton
Paloma Picasso and
her costumes for the play *Succès*,
by Rafael Lopez Sanchez
and Javier Arroyuelo
December 1978

following pages

Helmut Newton
Herbal wrap
July 1979

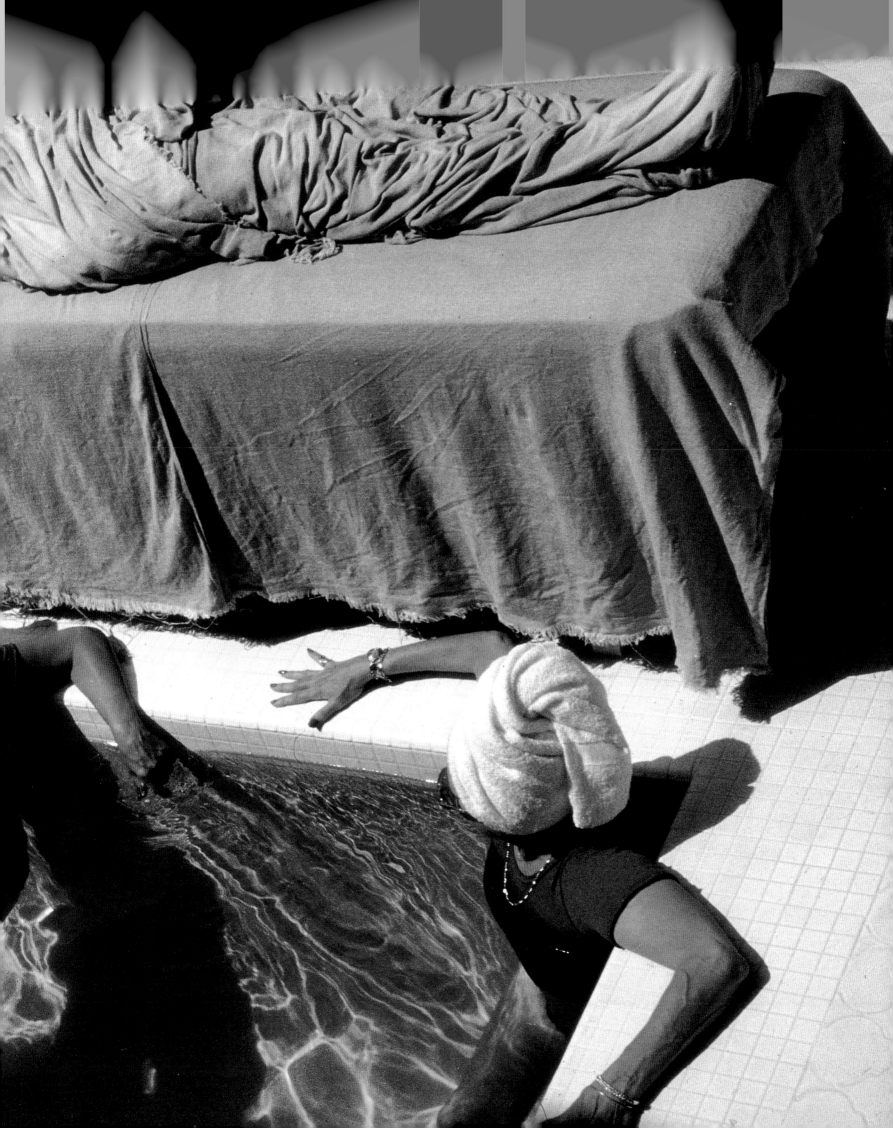

"Exquisite trash? Precious dreck?" wondered Thomas B. Hess in the August 1975 *Vogue*, in a text accompanying Irving Penn's photograph of two smashed cigarette butts *(opposite)*. The photograph was part of a series of platinum prints being shown at New York's Museum of Modern Art. Penn had "harvested" the butts "in the street near his New York studio some three years ago. He posed them as carefully and as sympathetically as he has posed celebrities, fashion models, and New Guinea mud men, in solo, duo, and trio arrangements. He took photographs of them. Enlarged the negatives. Spent two years making the prints." The New Guinea mud men mentioned by Hess had appeared in *Vogue* a few years earlier *(page 206)*. "In 1970 I went to the New Guinea highlands for *Vogue* with our portable studio," Penn wrote in *Worlds in a Small Room*. "I wanted to get past the purely costume part of the tribal dressing-up and see what I could of the people underneath." All but one of the ten trips represented in *Worlds in a Small Room* were undertaken for *Vogue*, and an editor from the magazine was often sent along to help out. "There were weeks of research and intense planning," Penn explained, "a program of visa arrangements, preparing presents (Chanel No. 5) for ministers' wives, gathering past copies of *Vogue* to explain our work"

A great deal of material not directly related to fashion was appearing in *Vogue*. Leo Lerman presided over a sort of "magazine within a magazine." "We believed that women are interested in every aspect of life," he says. "So we gave them everything we could. We would tell them what to look for in movies, in books, in jazz. We were never afraid of saying 'this is the greatest.'" Lerman brought Woody Allen and Irving Penn together to create portraits of great comedians. "The idea here," Allen said in the accompanying article by Lerman, "was to make quick impressions of Groucho *[page 199]*, Chaplin, Buster Keaton *[page 198]*, Harpo, . . . rough impersonations with no big attempt actually to make myself look like them . . . done in one or two minutes. Smear on some pencil, cut a mustache from felt, a hat or two" Lerman was particularly interested in the theater, and that world was well represented in *Vogue*, but the magazine was also full of dancers and artists and movie directors. Avedon photographed Monty Python's Flying Circus *(page 158)*

and Rudolf Nureyev *(page 160)* and Tina Turner *(page 165)* and The Ridiculous Theatrical Company *(page 167)*. Irving Penn's portrait of Ingmar Bergman *(page 200)* appeared next to an excerpt from the script of his newest film. Forays into topical journalism were made with an article on Vietnam in the form of diary entries by Gloria Emerson, the *New York Times* correspondent in Saigon *(page 201)*, and a piece about Watergate investigators Bob Woodward and Carl Bernstein *(page 202)*.

Features on fashion and beauty of course filled most of the magazine's pages, and the philosophy of the editor in chief, Grace Mirabella, was perfectly exemplified in a photograph of model Lisa Taylor driving a car for an article on makeup *(page 210)*. The photographer was Arthur Elgort, who had started taking pictures when he was an art history student at Hunter College in New York. He had trained himself as a "street" photographer in the tradition of Cartier-Bresson, and had then made pictures of the ballerinas in a dance school at Carnegie Hall, where he worked as an usher. He had jobs at *McCall's* and *Mademoiselle* before Alexander Liberman asked him to do some sittings for *Vogue*. For the picture of Lisa Taylor, the editors wanted a double-page shot that would demonstrate a kind of healthy American look, and since Taylor liked to drive, Elgort and the fashion editor, Polly Mellen, put her in a Mercedes convertible. "We're going to follow you over the George Washington Bridge and then back," Elgort told her. "We'll do that over and over." They put a hairdresser behind the driver's seat to adjust her hair. "This was before we knew about walkie-talkies," Elgort recalls, so an elaborate system of signals was worked out for speeding up and stopping and whatnot. Coping with all this gave Taylor the look Elgort was after. "When models have nothing to do but stand there, they look like they're asking a question," he says. "When you give them something to do, they become a beautiful girl and not just someone wearing an outfit."

"The casual, I might even say unprofessional, quality of the photograph makes it wonderfully accessible," Alexander Liberman said later. "If you look carefully, you see it's really a so-called 'bad' picture Elgort was not afraid to throw everything away and take a risk."

Irving Penn
Old cigarette butts
August 1975

196

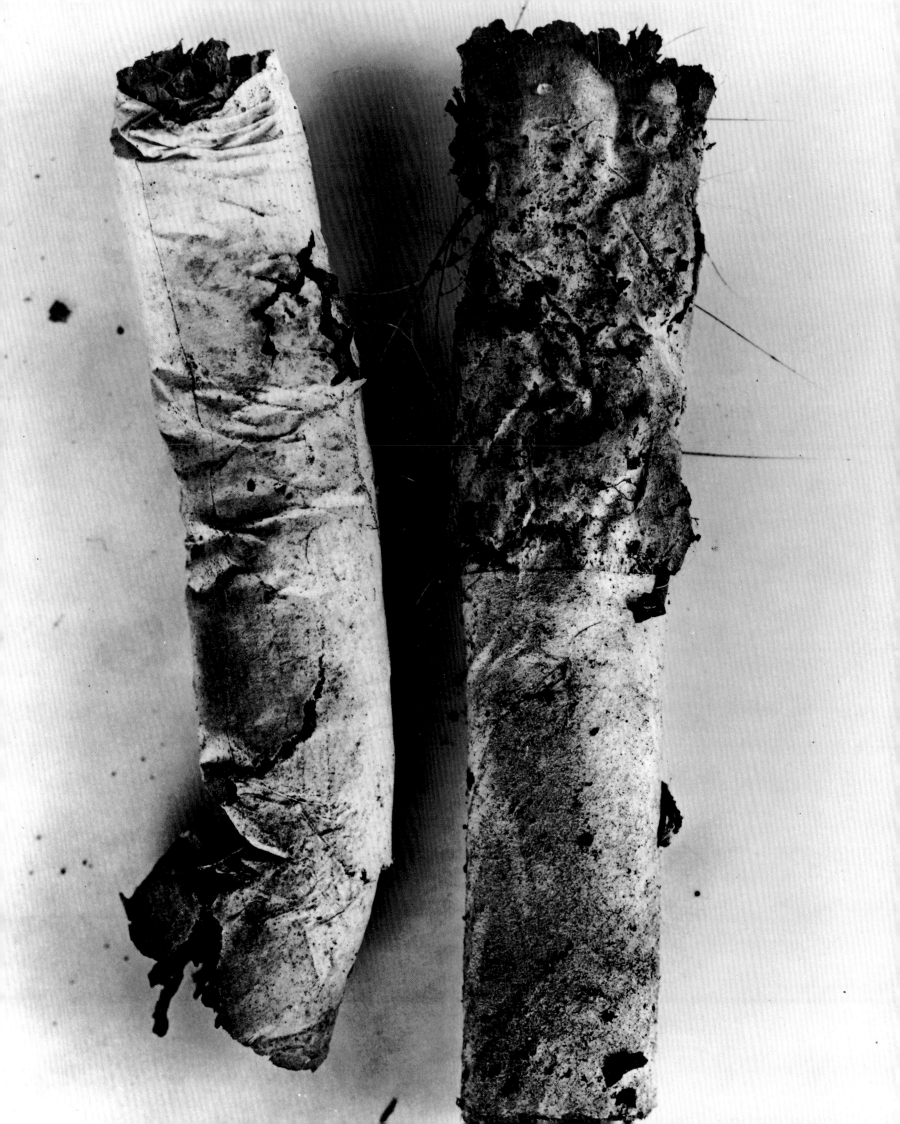

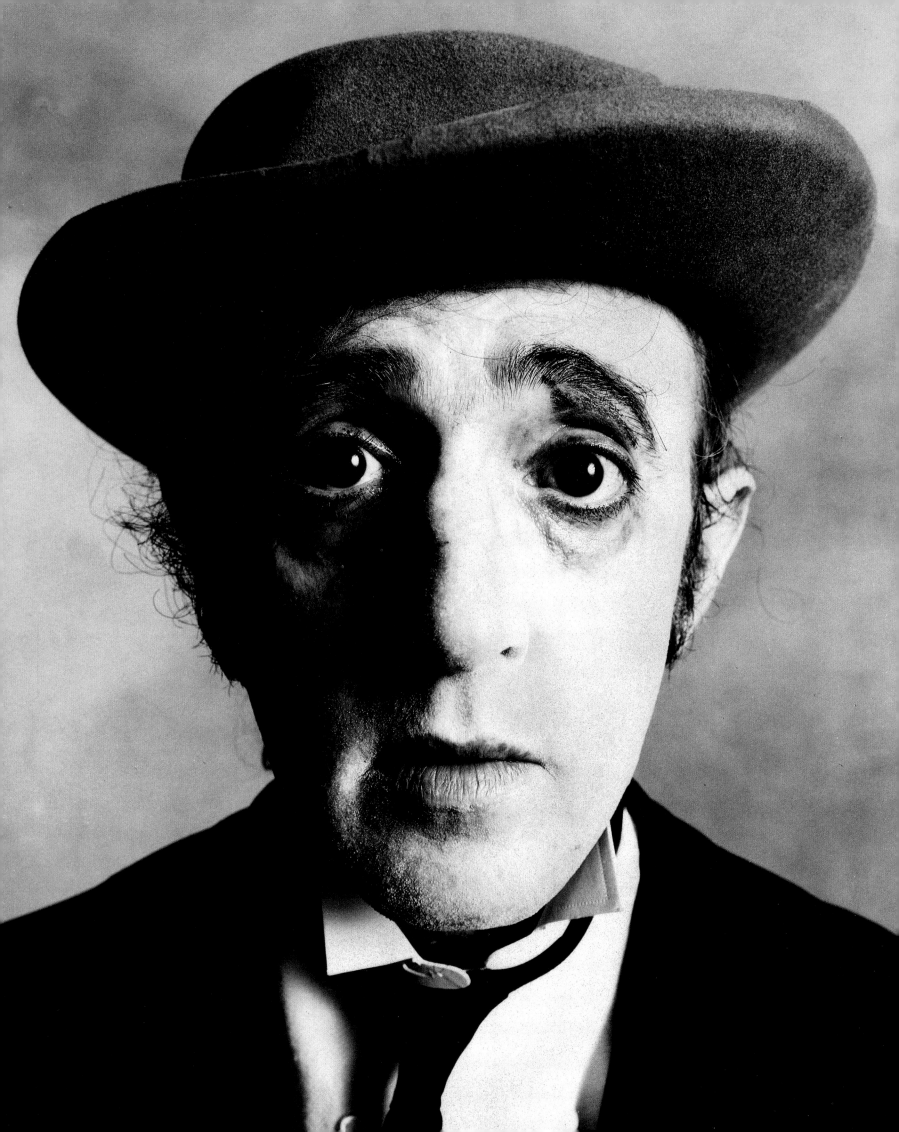

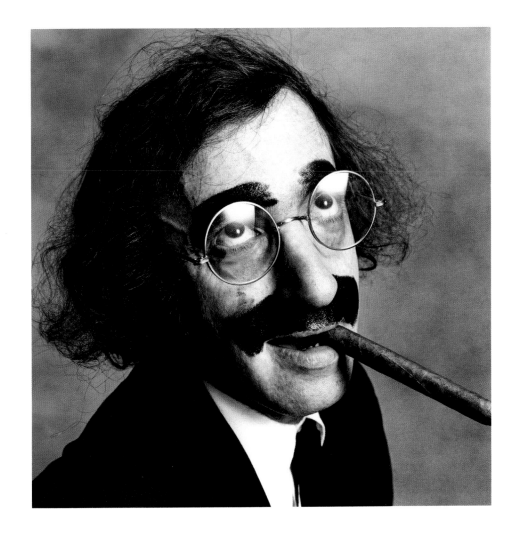

Irving Penn
Woody Allen as Groucho Marx
December 1972

opposite page

Irving Penn
Woody Allen as Buster Keaton
December 1972

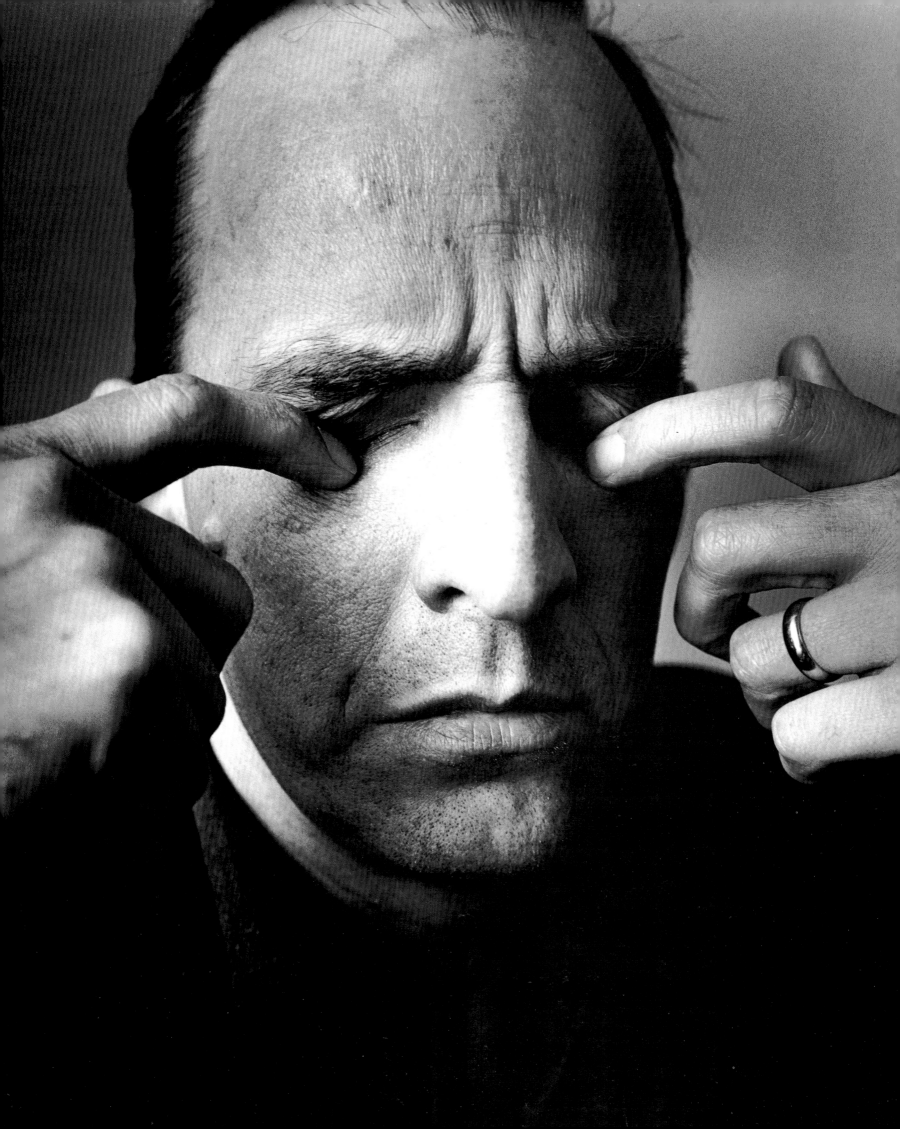

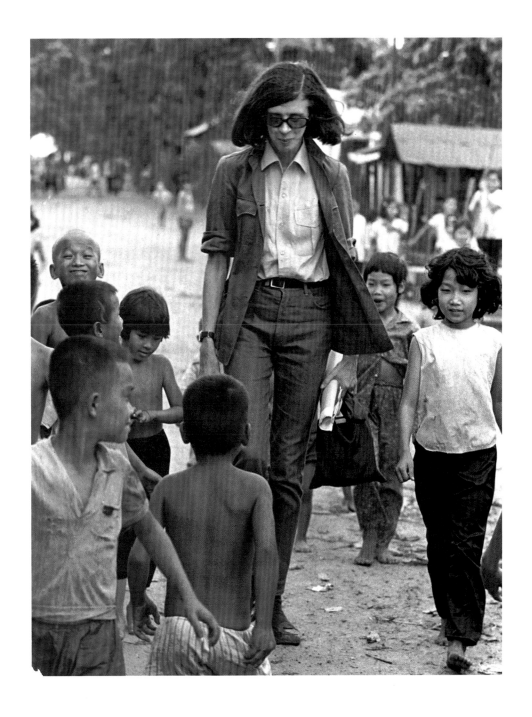

Nancy Moran
Gloria Emerson in Vietnam
January 1972

opposite page

Irving Penn
Ingmar Bergman
August 1974

following pages

Harry Benson
Bob Woodward and Carl Bernstein, Watergate investigators
August 1973

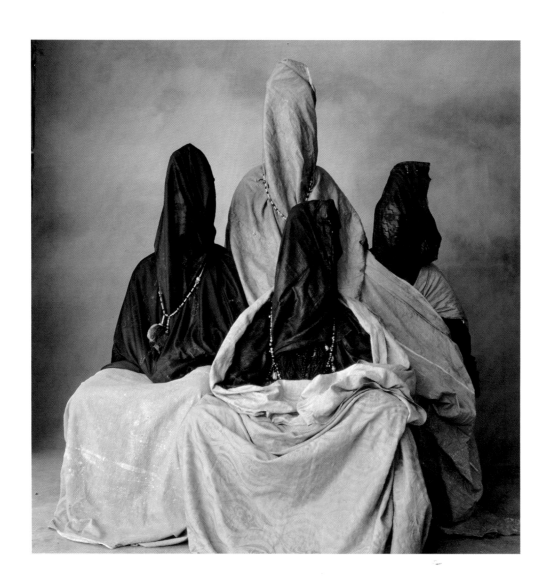

Irving Penn
Saharan women
December 1971

opposite page

Irving Penn
Moroccan women's hands decorated with henna
December 1971

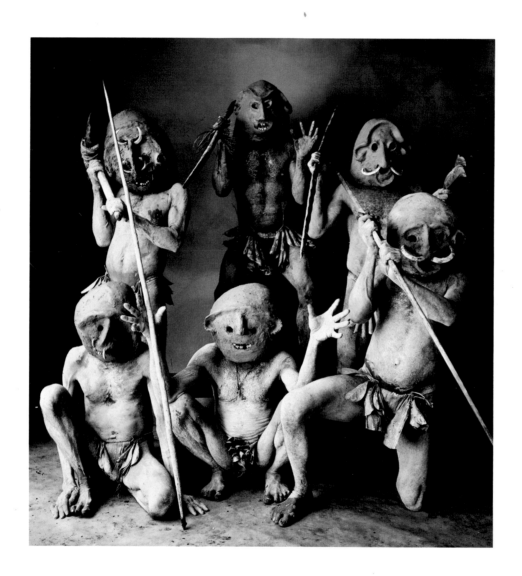

Irving Penn
New Guinean mud men
December 1970

opposite page

Irving Penn
Prospective brides in New Guinea
December 1970

following pages

Irving Penn
Vivienne and Naomi Sims in
Giorgio di Sant'Angelo's American Indian clothes
August 1970

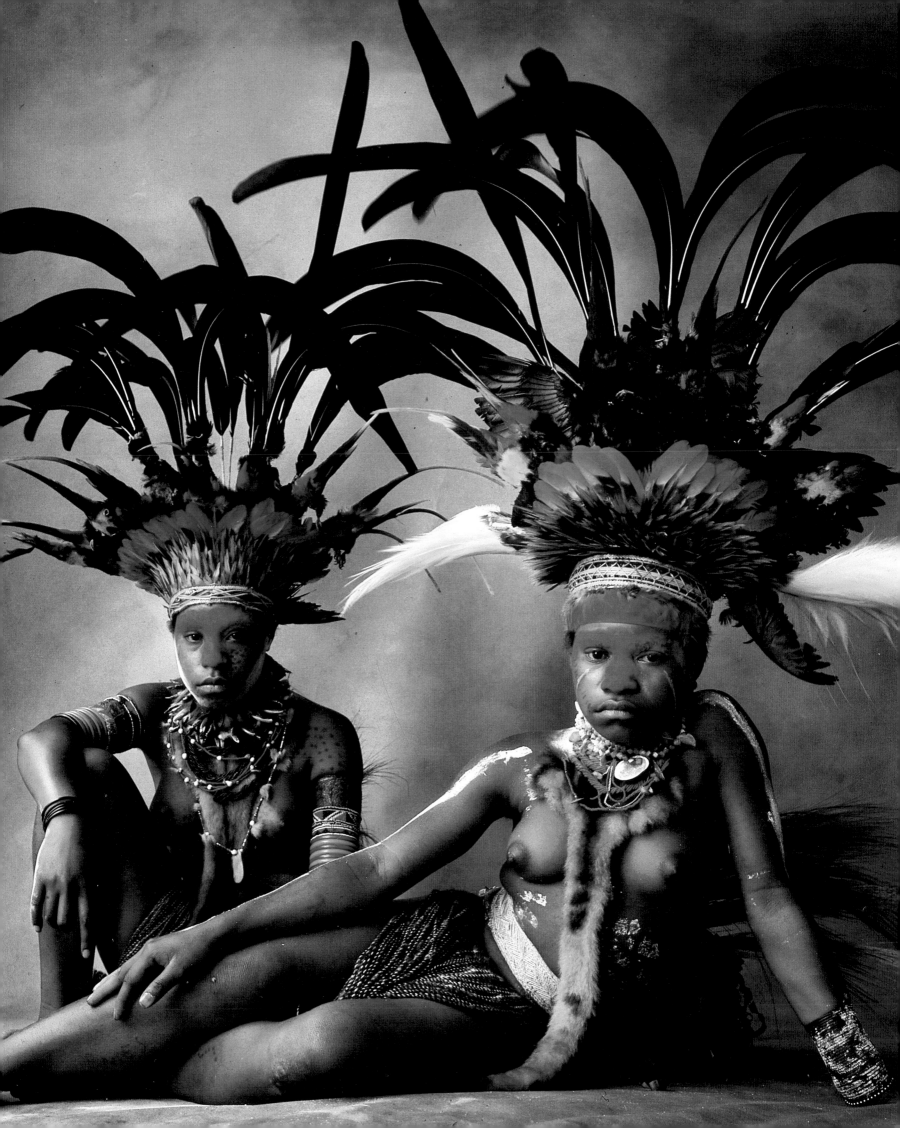

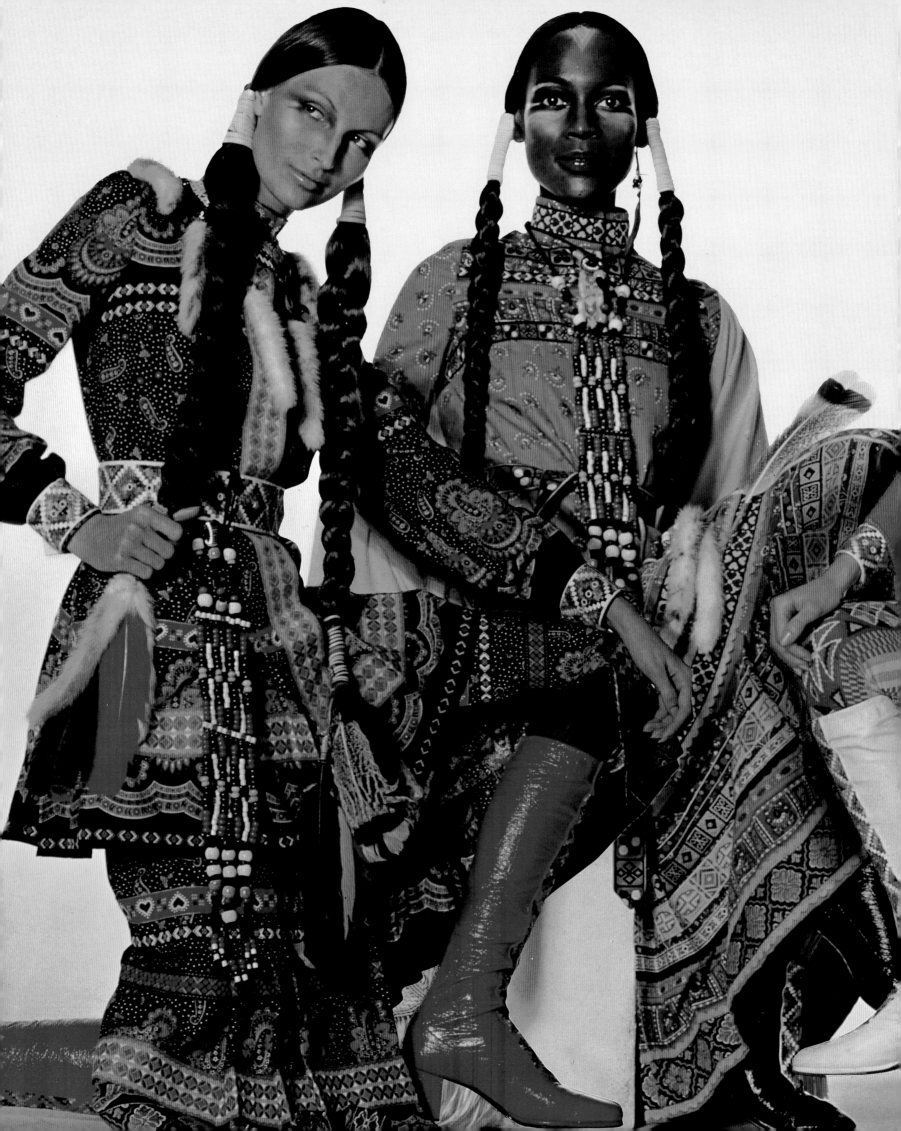

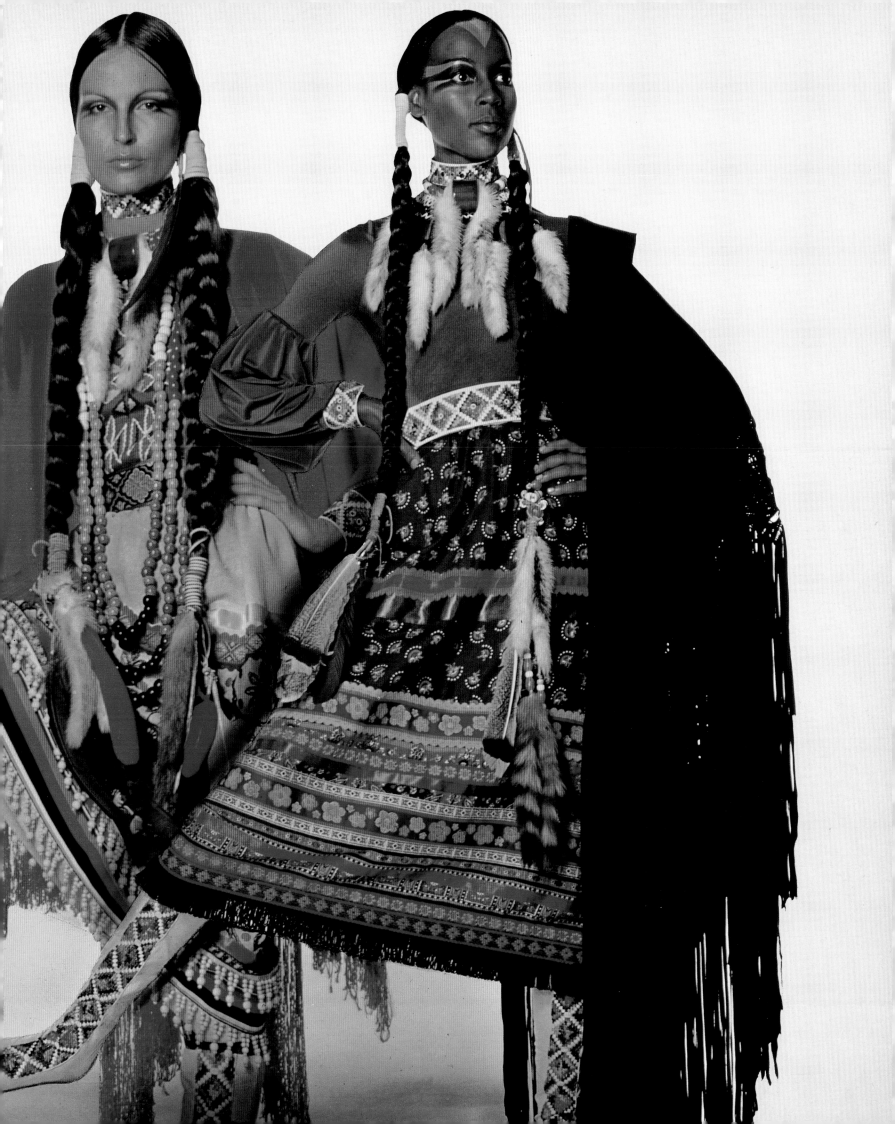

Arthur Elgort
Lisa Taylor
October 1976

opposite page

Arthur Elgort
Patti Hansen in Calvin Klein swimsuit
January 1976

following pages

Kourken Pakchanian
Emmanuelle and Susan Schoenborn in Anne Klein sportswear
May 1972

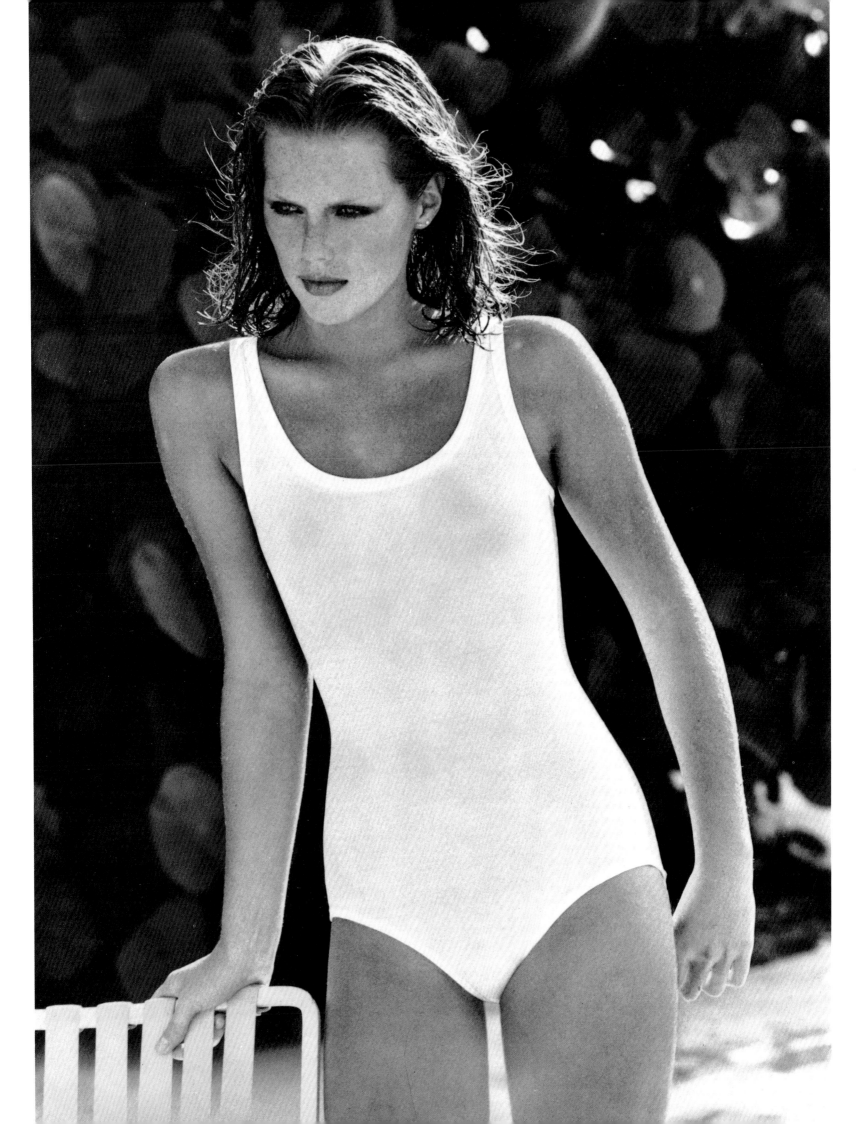

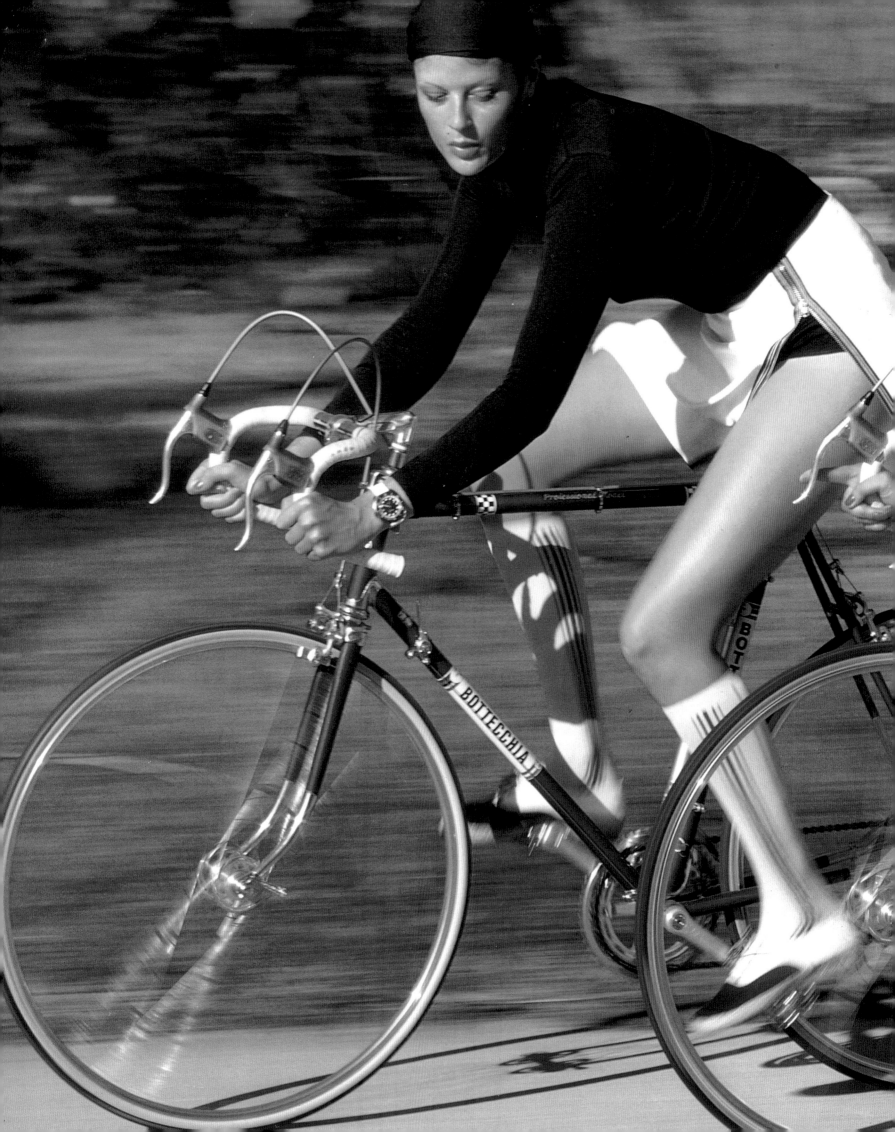

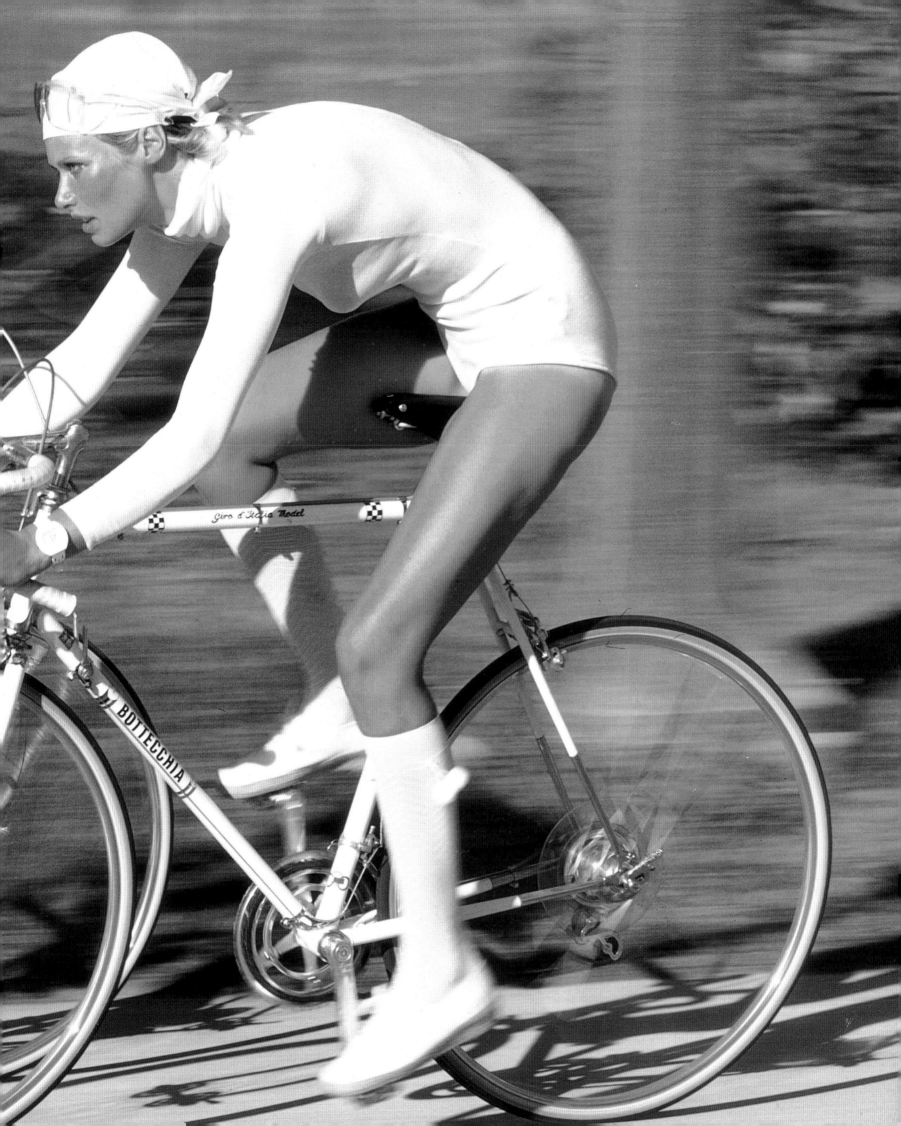

If you are too far ahead it can backfire and if you are too boring it can backfire

— ANNA WINTOUR, *Vogue* Editor in Chief, 1988–

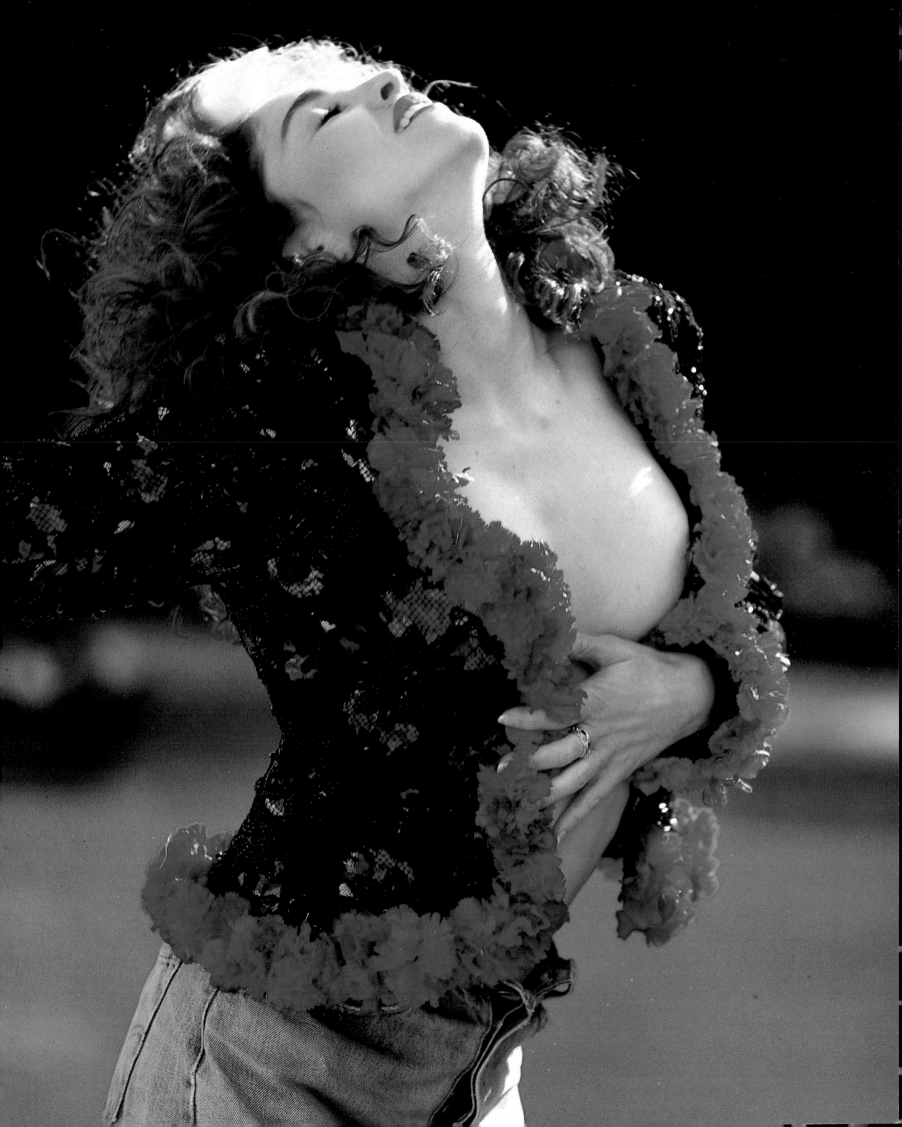

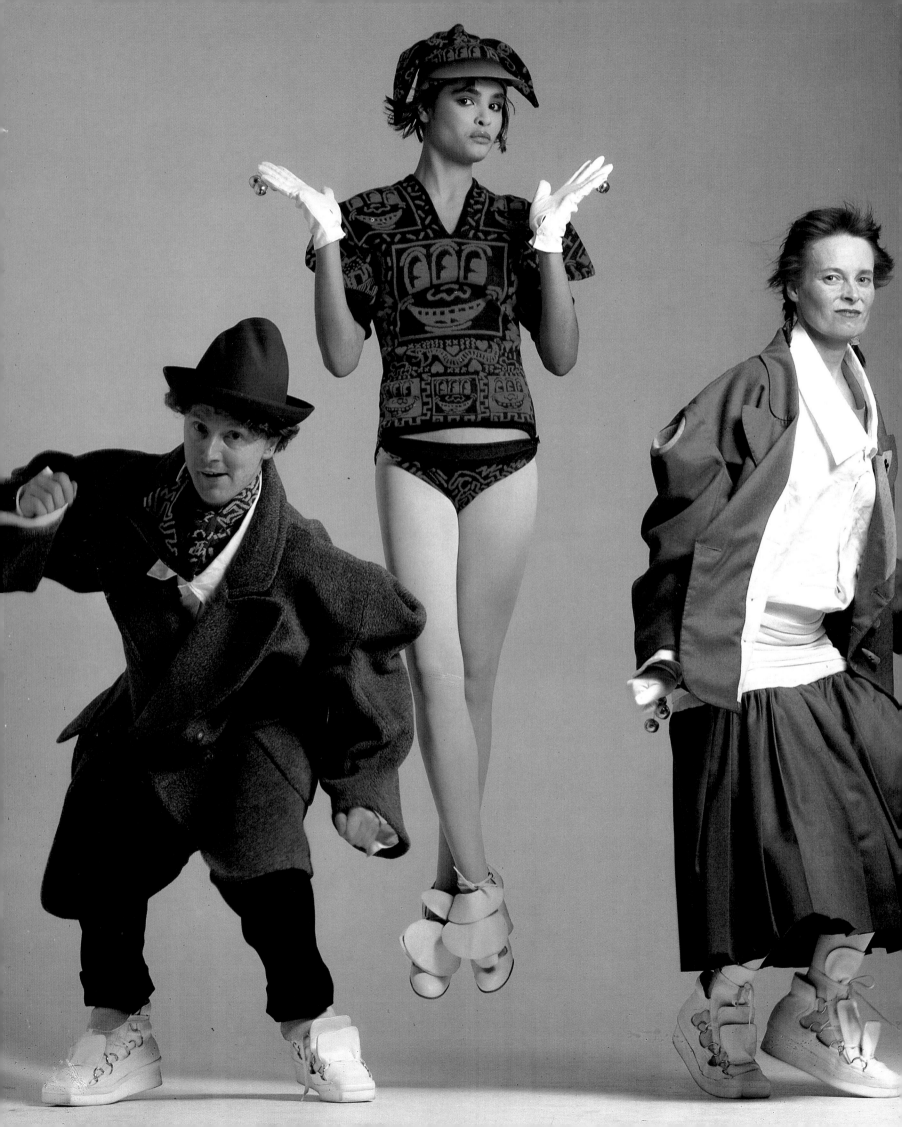

"The early eighties were very different from the late eighties," says Andrea Robinson, who was *Vogue*'s beauty editor. "In the early eighties there was multicolored eye makeup, very structured, big hair. And then later everything became more natural and played-down." For a story about the 1983 fall collections, Robinson worked with Irving Penn on a close-up of a colorfully made-up eye in which a contact lens designed to look like a bull's-eye had been inserted *(page 228)*. It expressed "a different way of looking...at fashion," *Vogue* explained. "A different way of looking, period."

"This picture with the contact lens has shock value," Alexander Liberman explains. "It's a graphic device to attract attention. In a sense it's a poster that dramatizes the subject matter of the magazine. A magazine is a very transitory thing. People flip through it, and there should be images that make a quick imprint on the mind of the reader as this happens. The 'poster' pictures do that, but also the photographs that have a more legendary quality. Sheila Metzner's photograph of Kim Basinger in Africa, for instance *[page 224]*, is one of these. There's a cultural depth to it. This is an eternal picture of romance in the park, beauty and the bird. She could be Athena. And then of course there is something like Helmut Newton's picture of Daryl Hannah in Malibu with the baby *[page 222]*. This is very modern in its shocking qualities. It creates its own legend, if you like." Hiro's photograph of a foot stepping on an octopus *(page 230)*, which accompanied an article on the care of feet, has an almost viscerally shocking quality. Hiro, who moved to New York from Tokyo in the mid-fifties to study photography, and who worked with Alexey Brodovitch and Richard Avedon, was trying, he says, to "photographically show how the foot can feel like the hand."

The legend that Helmut Newton was creating in the photograph of Daryl Hannah in Malibu is a European's view of America. For Newton it is a "very California story. It is my romantic notion of what America is, or should be, like. It's about this rich young woman whose husband goes off to play polo. And this young beach boy, who is good-looking like they all are in California, is having an affair with her. Everything is spelled out in the picture." In the photograph, the woman lies on a couch dressed in a bikini. Behind her is a television set, and a mirror in which the polo-playing husband is reflected as he enters the room. The beach boy wears only jeans. Most disturbingly, the woman's hand rests on a basket in which there is a crying baby. "It was a beautiful baby and terribly well behaved," Newton recalls. "The only thing was that the moment it laid its eyes on Daryl Hannah it started screaming. I had it in my arms and it was laughing. It was laughing with everybody, and then the moment it saw Daryl it was like an air-raid siren going off."

Newton was telling a different, more European, story in the fashion sitting photographed at the Montecatini spa in Tuscany. Women wearing spike heels and black dresses, or sometimes just a couple of towels or pantyhose and a bra, go about some mysterious business on the spa grounds and in old-fashioned rooms. The naked Amazon standing on a pedestal in a hedge *(page 220)* is Brigitte Nielsen.

It was hoped that putting the right photographer together with a subject and a setting would produce pictures that were unexpected—"time bombs," as Alexander Liberman says. "The interesting thing is to have hunches about what might happen. I don't like to preplan sittings in general. You set the mood." For Sheila Metzner's trip to Kenya, however, the photograph of Kim Basinger and the falcon was planned in New York. "Mr. Liberman and I talked about the entire story," Metzner recalls. "We actually made a sketch of the road and Kim walking down the road with the bird. Then of course when we got to Kenya we had to scout for the right road—one that wasn't tarmac and had the sun setting in the right place and wasn't too rutted. It was a really difficult road to find." Polly Mellen, who was the editor on the trip, recalls that they experimented with more than one bird for the shot. "The first one we tried was too nervous," she recalls. "But Kim talked to this one. She has a thing about animals. Not unlike Bardot. At certain moments the bird would open its wings and flutter and she would simply hold out her arm and let it stretch."

"Alex wanted the pictures to be glorious," Metzner recalls. And he was not disappointed. "To me the excitement comes when you get the sitting in," Liberman says. "And she came back with extraordinary, poetic pictures."

Steven Meisel
Vivienne Westwood and Malcolm McLaren
in their gray flannel suits
June 1983

preceding page

Patrick Demarchelier
Madonna in Christian Lacroix jacket
May 1989

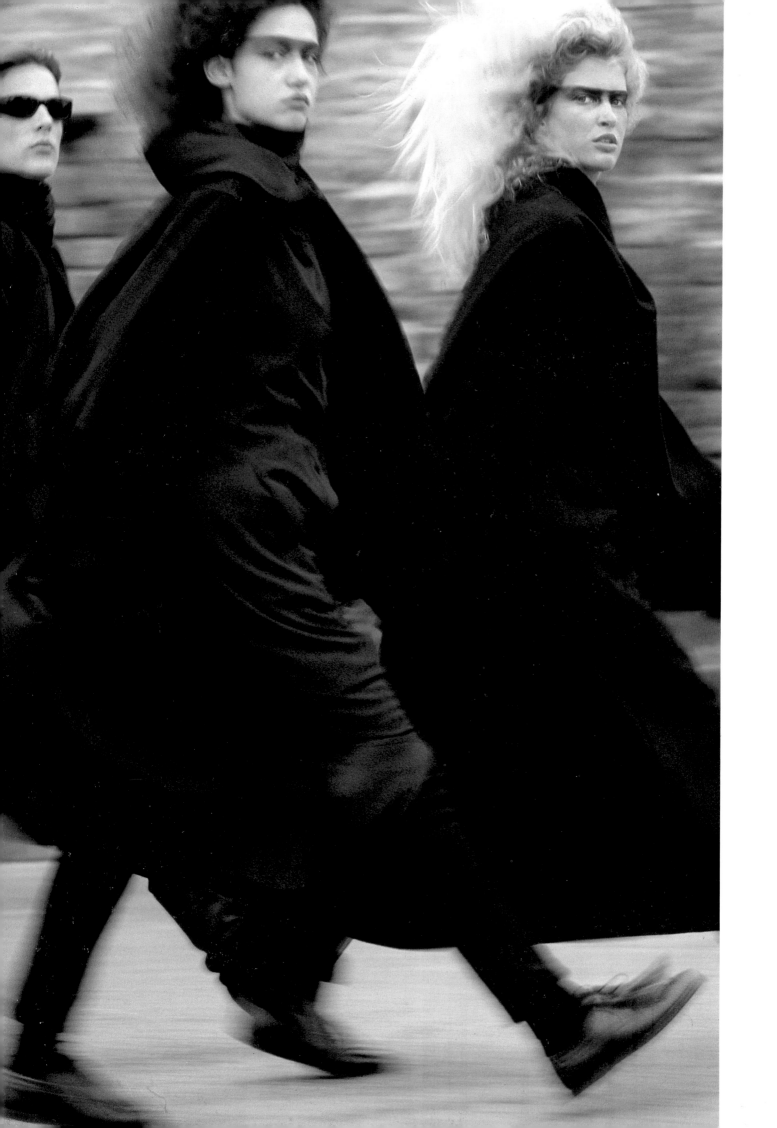

Hans Feurer
Yohji Yamamoto coats
July 1983

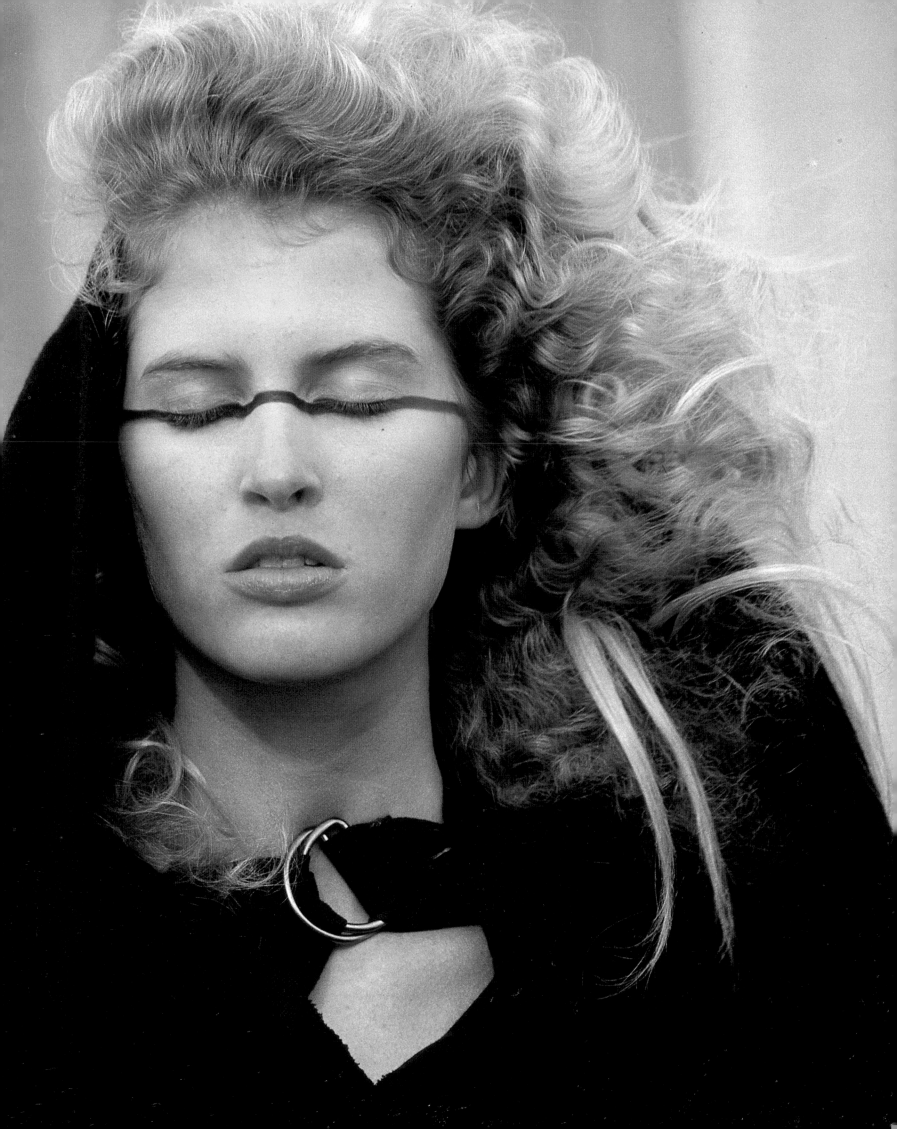

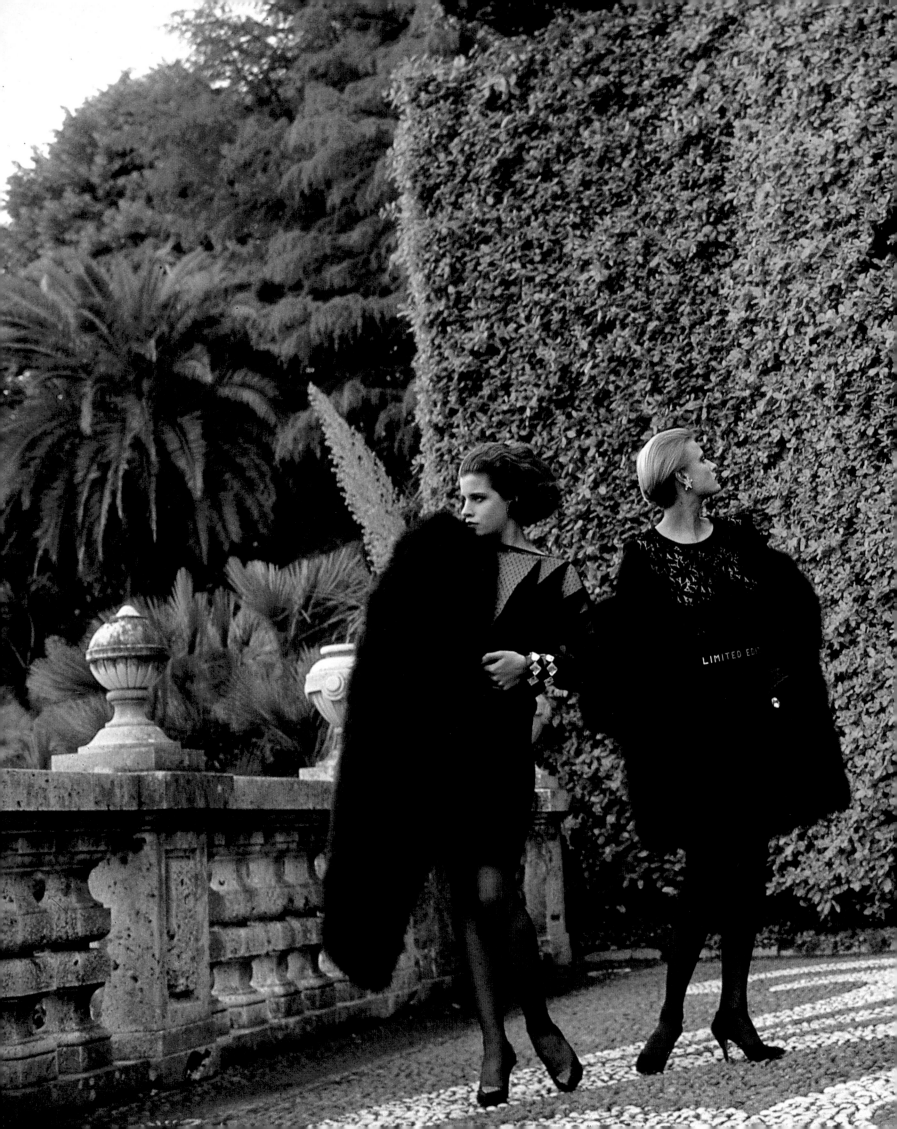

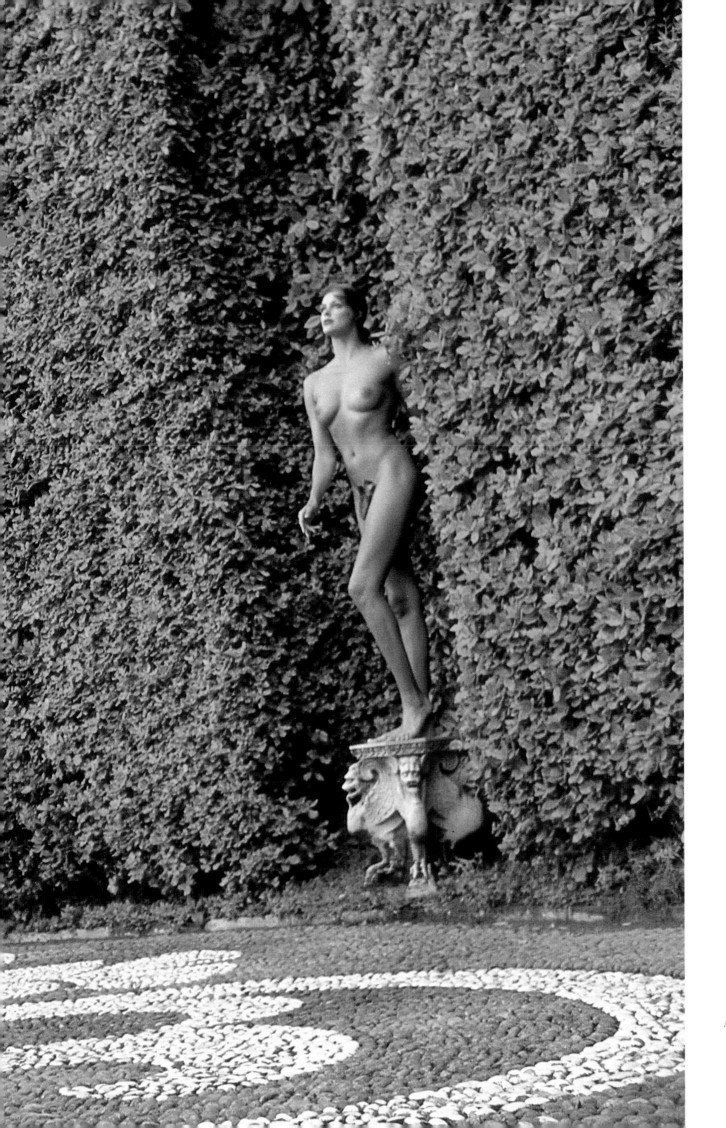

Helmut Newton
Daryl Hannah in Fiorucci bikini, Malibu
May 1984

222

Sheila Metzner
Kim Basinger in Kenya
April 1988

opposite page

Deborah Turbeville
Evening dress by Ungaro
December 1985

Irving Penn
Colored contact lenses
December 1985

following pages

Irving Penn
Bull's-eye contact lens
September 1983

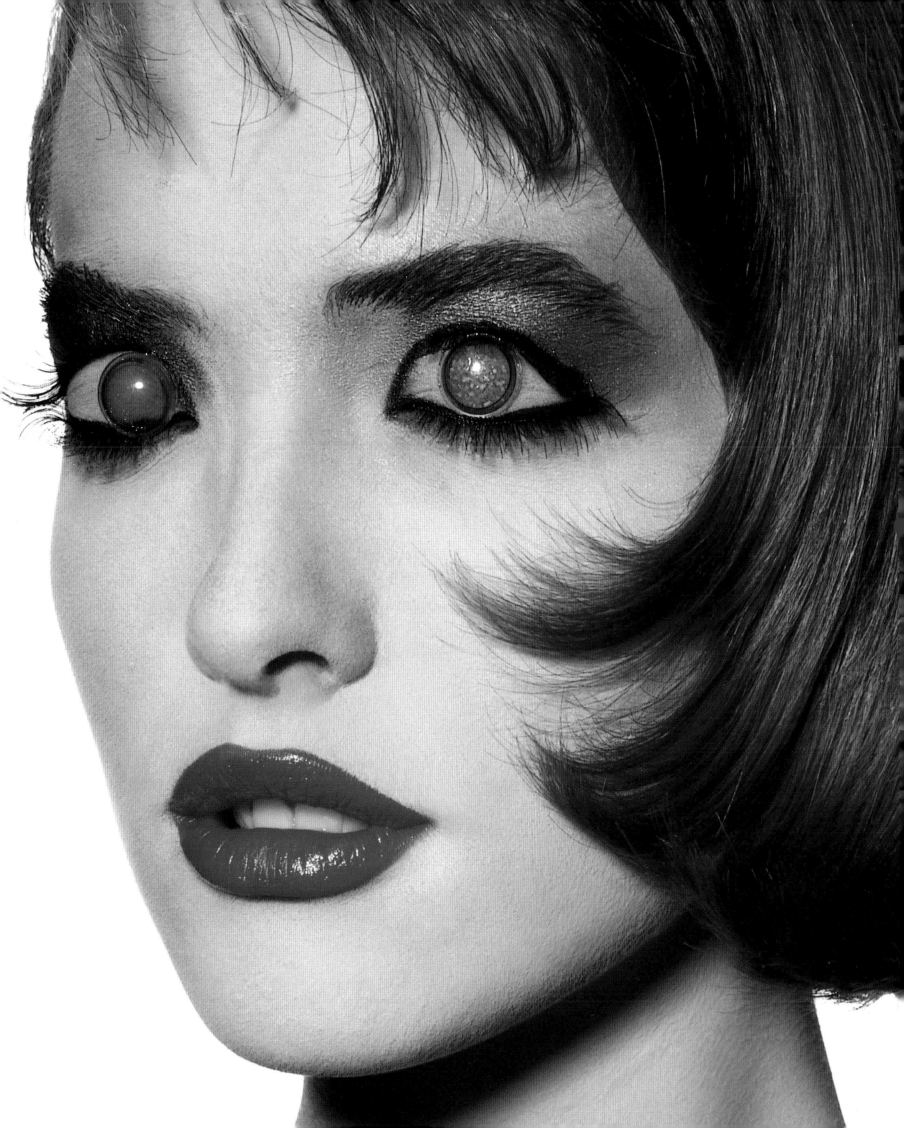

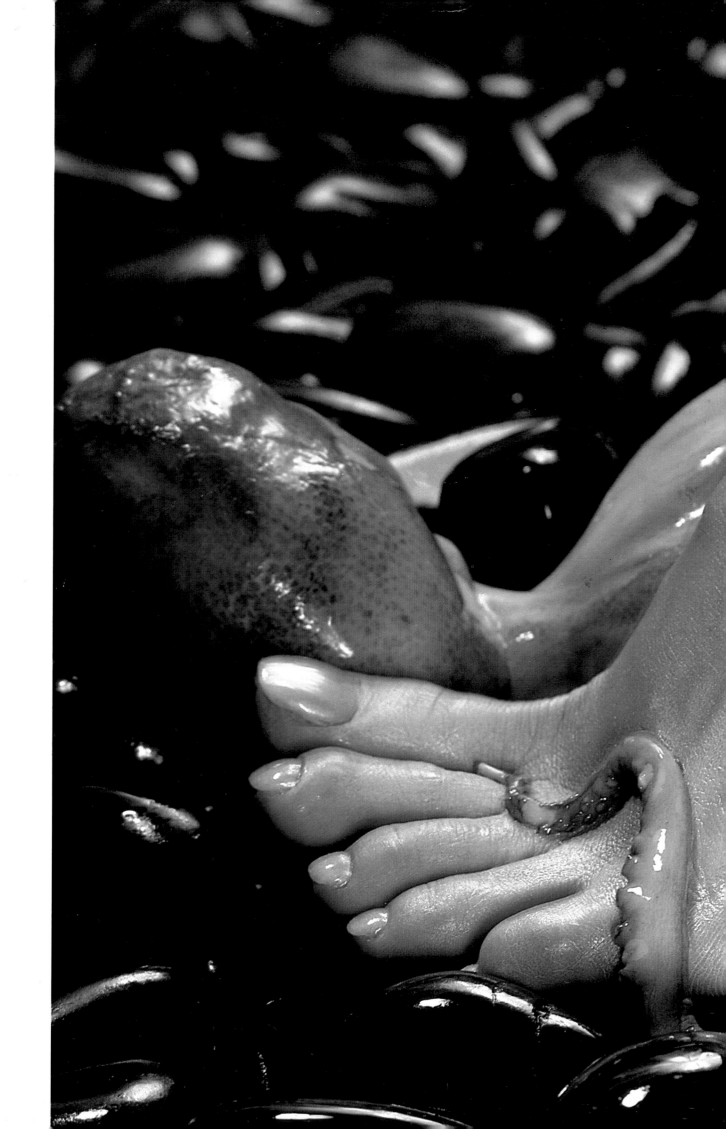

Hiro
Foot
April 1982

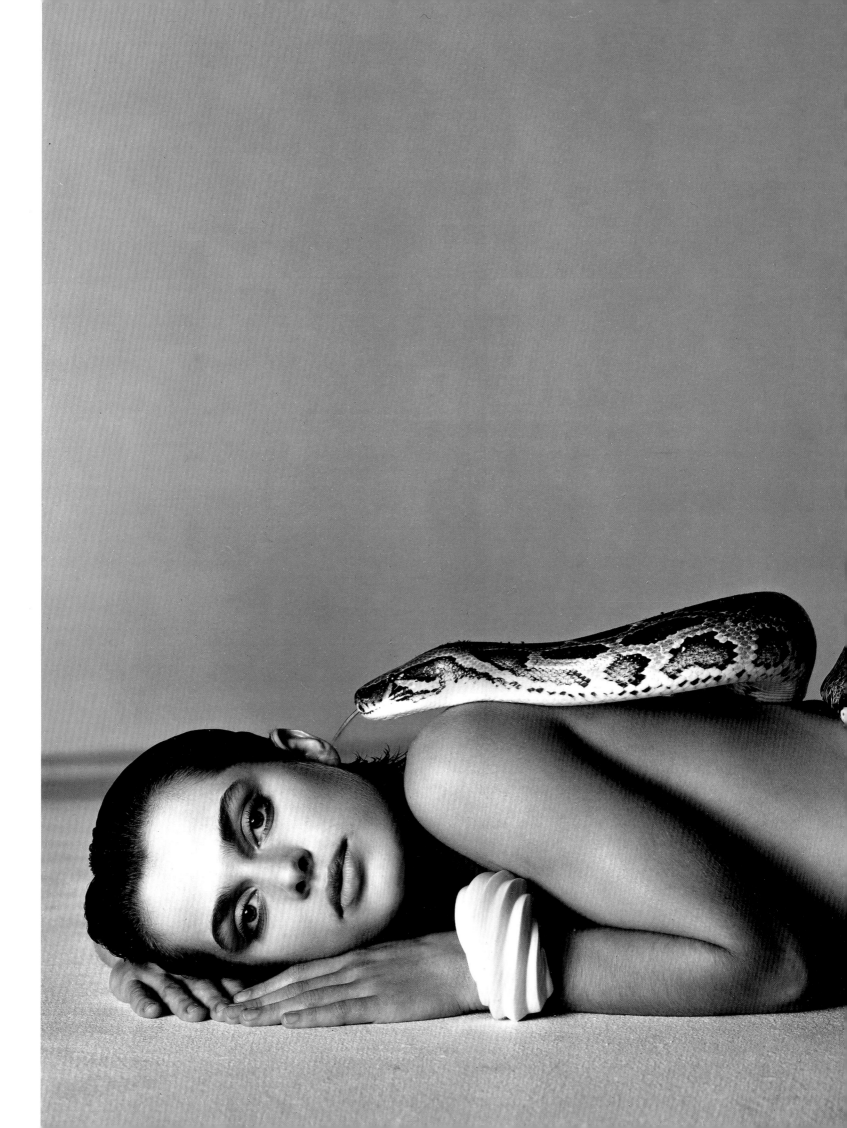

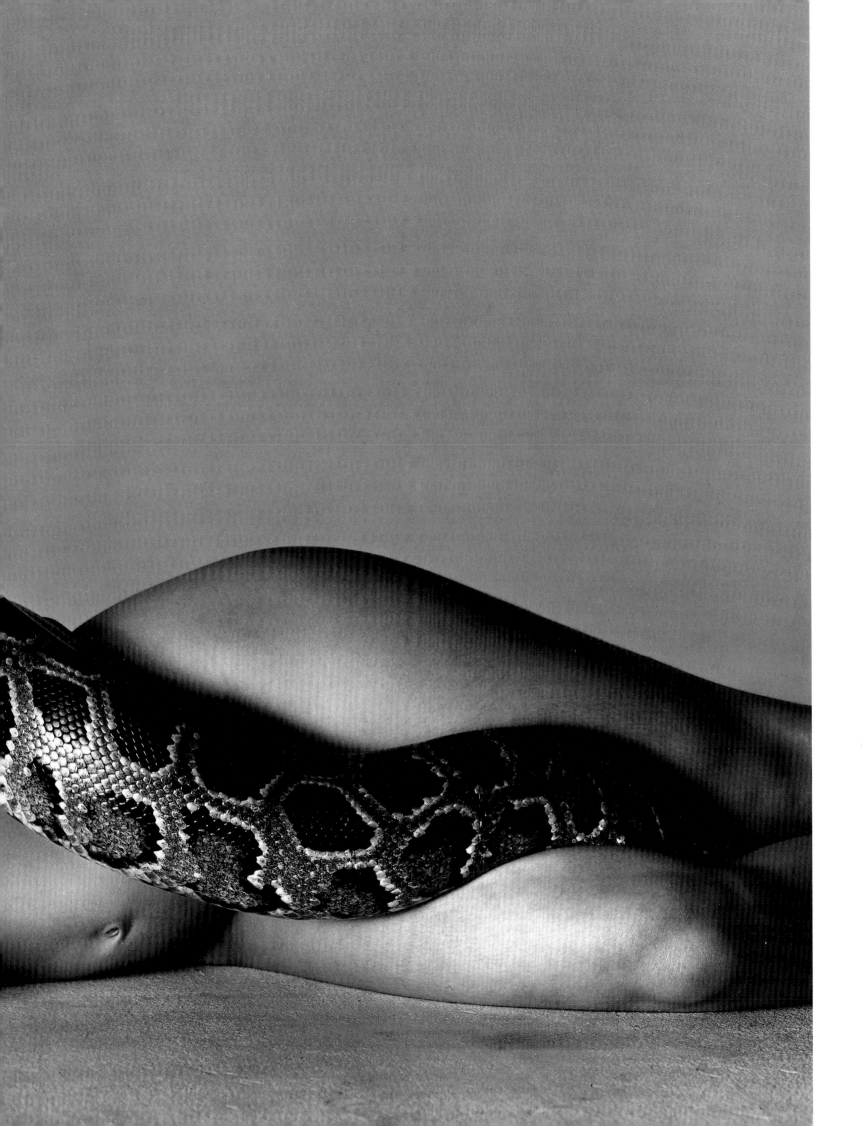

Richard Avedon
Wallace Shawn, Louis Malle, André Gregory
November 1981

preceding pages

Richard Avedon
Nastassja Kinski and the serpent
October 1981

following pages

Richard Avedon
Isabella Rossellini
November 1982

Richard Avedon
Amanda Plummer
May 1982

Richard Avedon
Nastassja Kinski
May 1982

Richard Avedon
John Malkovich
March 1983

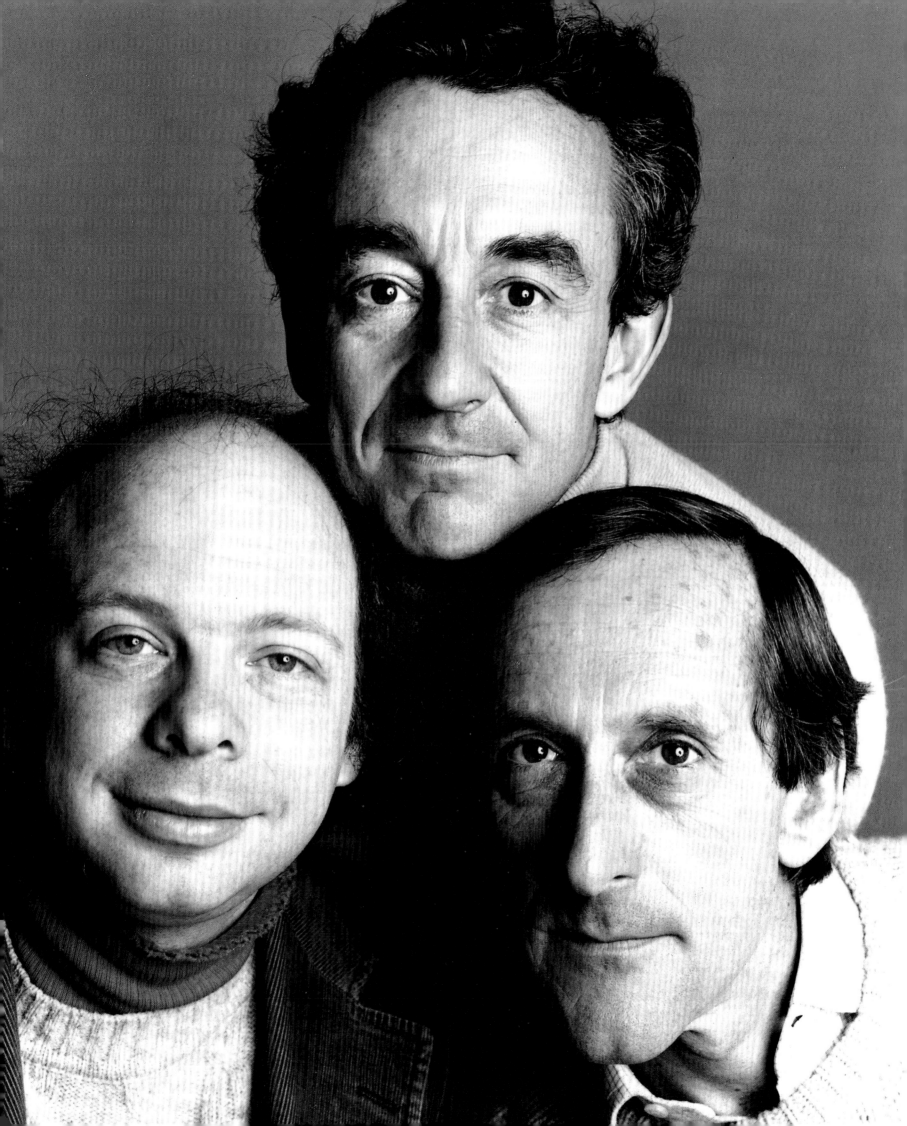

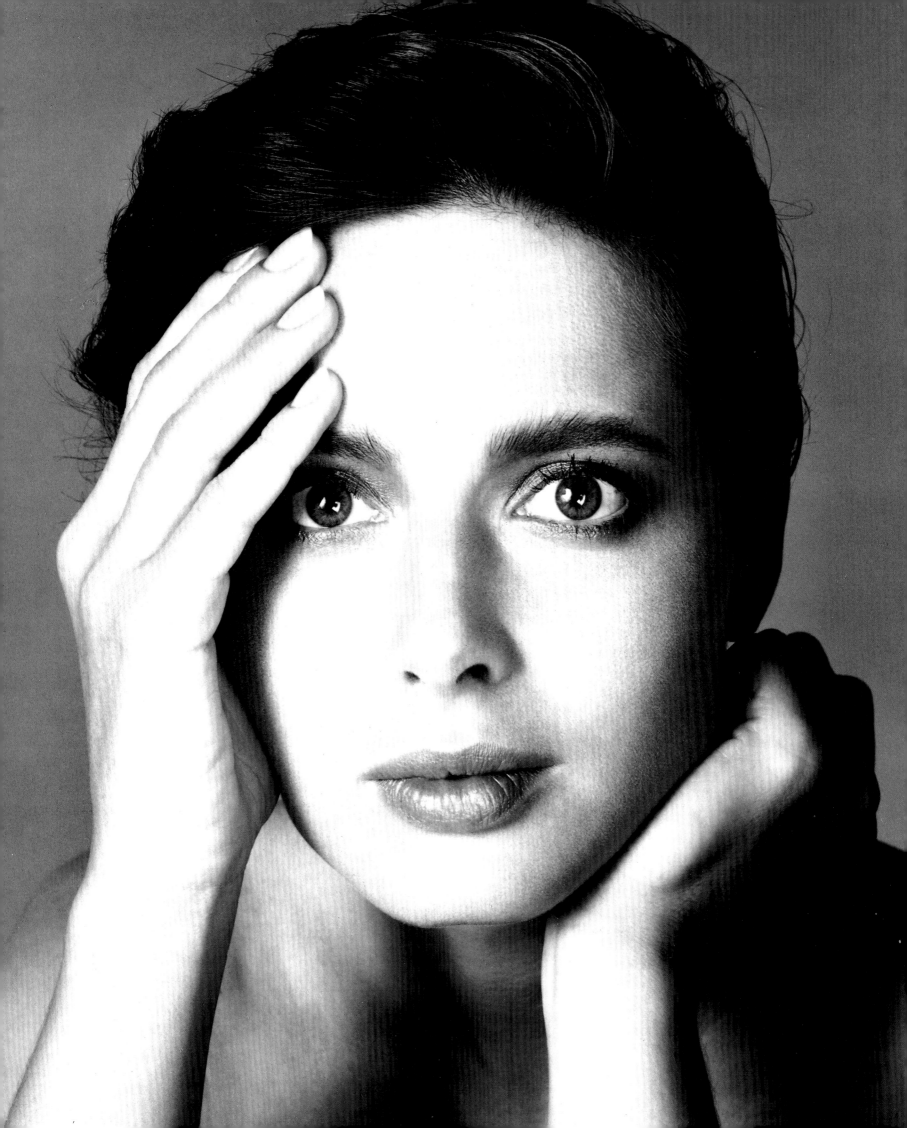

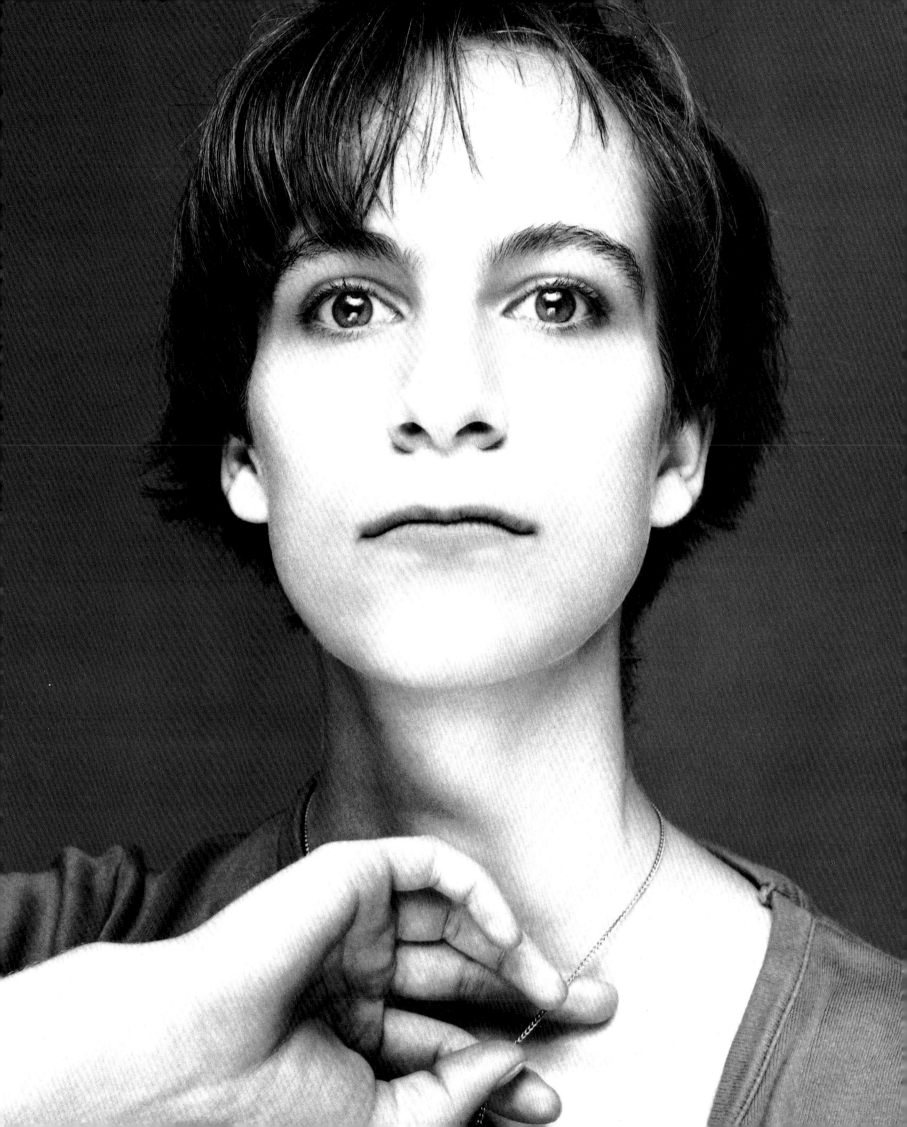

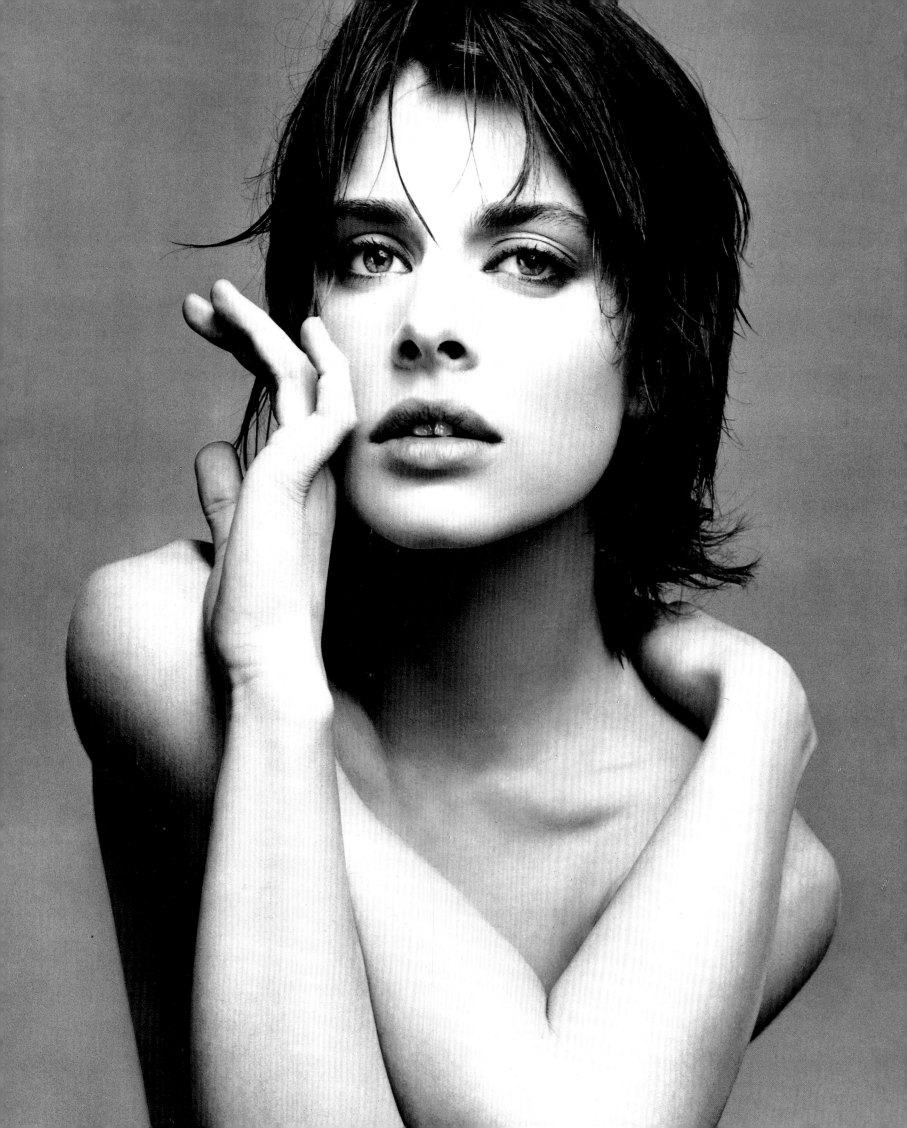

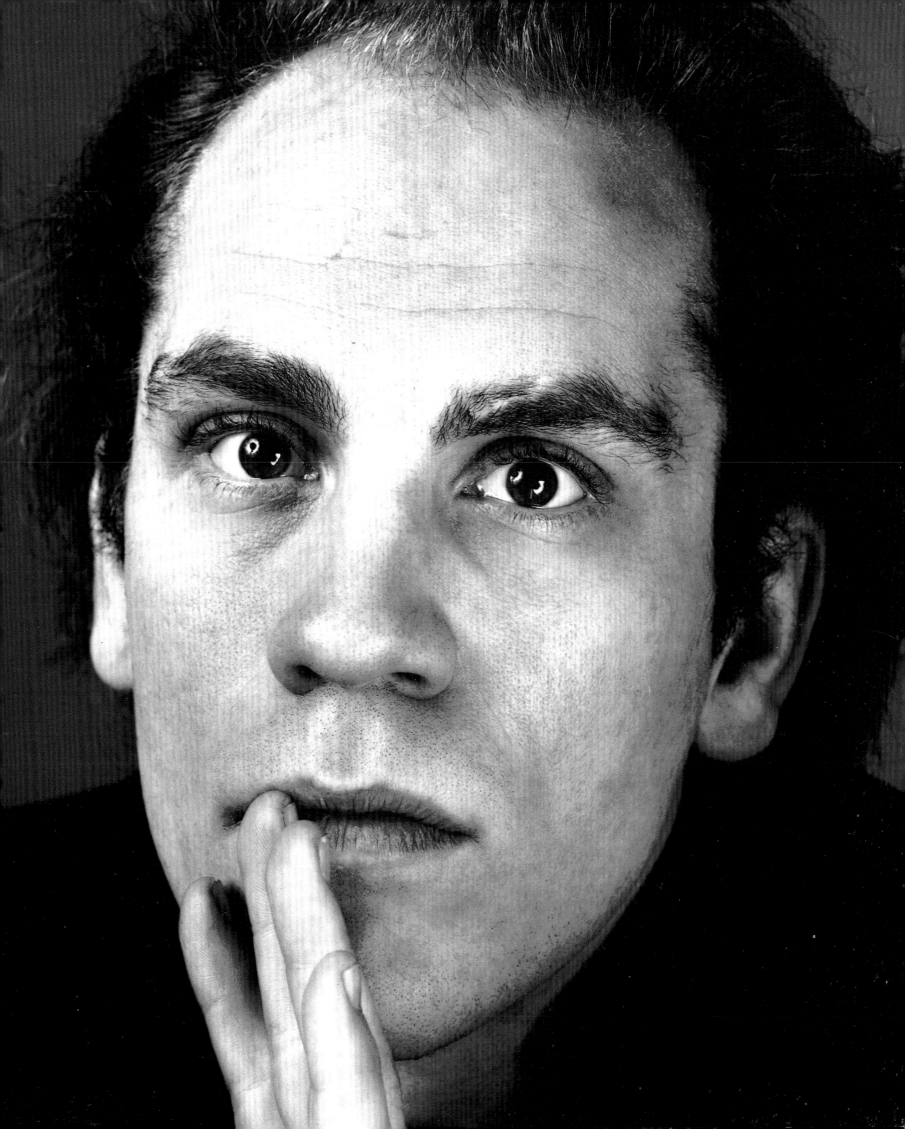

Kristine Larsen
Homeless man
March 1988

Kristine Larsen
Homeless woman
March 1988

Deborah Turbeville
Cy Twombly
December 1982

following pages

Irving Penn
Tom Stoppard
March 1984

Irving Penn
Yves Saint Laurent
December 1983

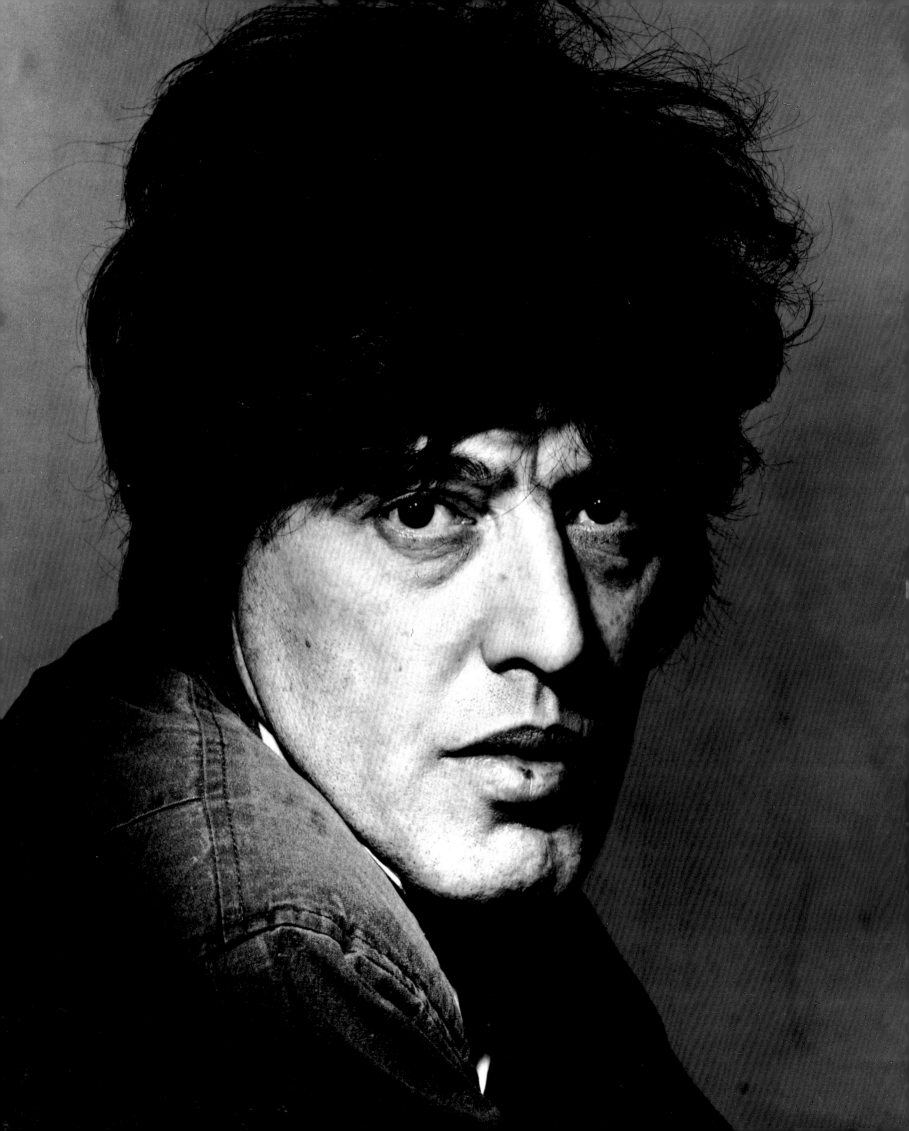

Irving Penn
Mikhail Baryshnikov as Gregor in *Metamorphosis*
March 1989

preceding pages

Irving Penn
Food phobias still life
May 1989

Helmut Newton
Diamond bracelets and emerald ring by Fred Leighton,
dresses by Claude Montana and Valentino
November 1989

following pages

Bruce Weber
Talisa Soto in Azzedine Alaïa stretch dress
June 1989

Bruce Weber
Talisa Soto in frayed Eric Javits hat
June 1989

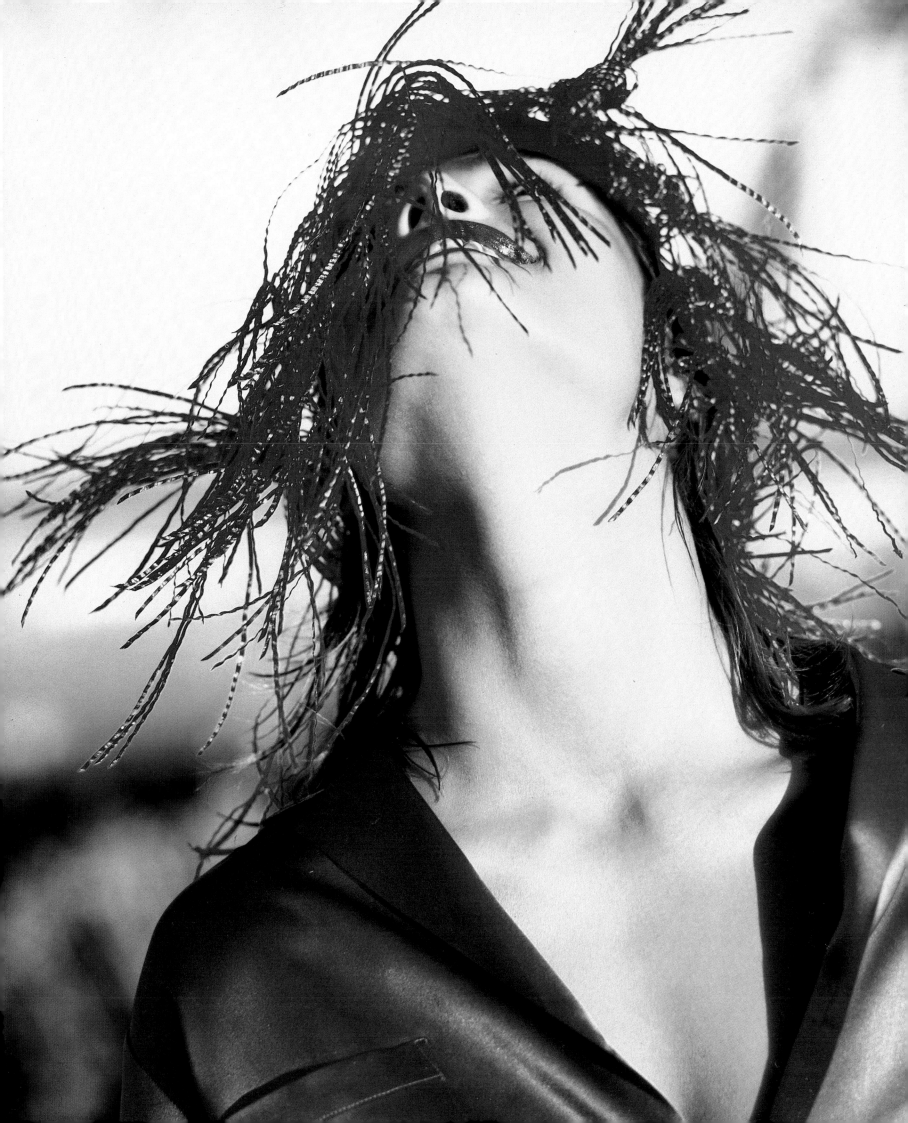

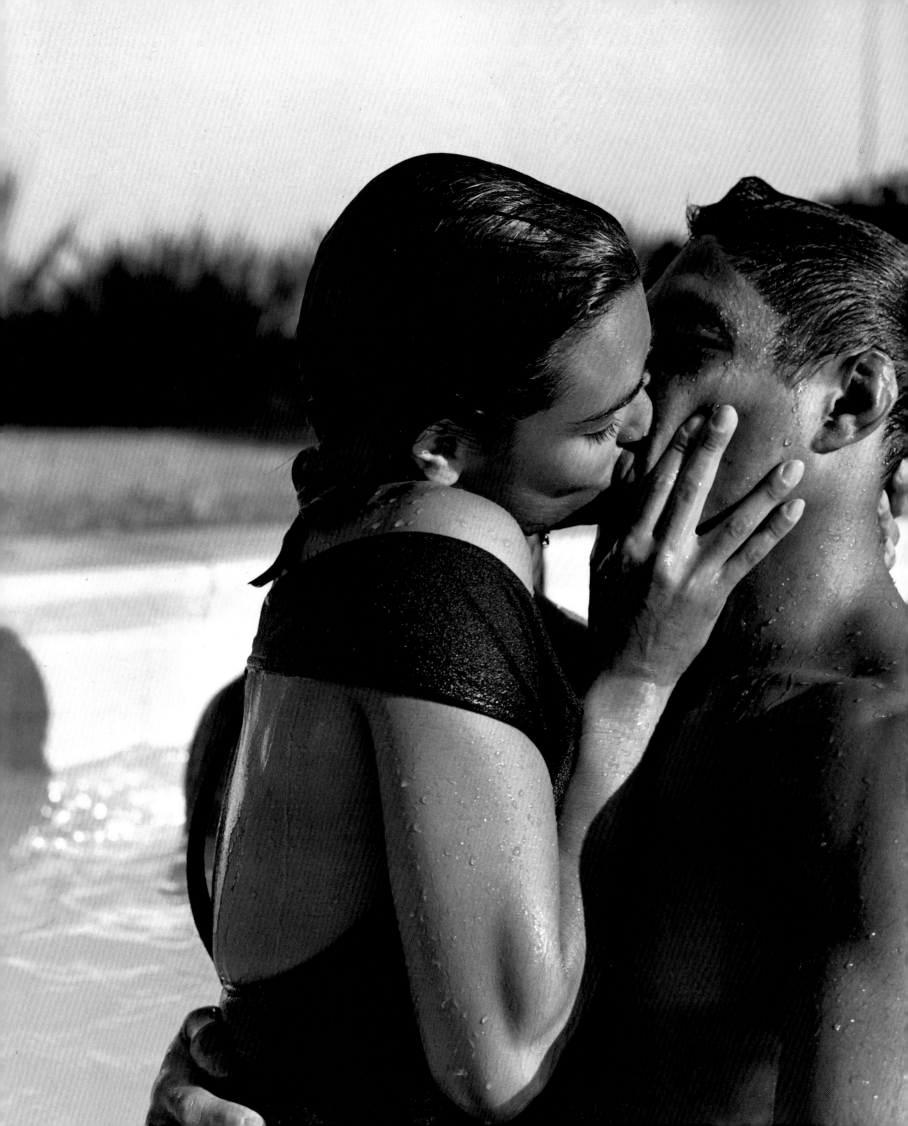

Bruce Weber
Talisa Soto and Hickson Gracie in Miami
June 1989

following pages

Bruce Weber
Mike Tyson in Gianni Versace,
Naomi Campbell in Azzedine Alaïa
December 1989

Bruce Weber
Naomi Campbell in Giorgio di Sant'Angelo,
with Mike Tyson and Don King
December 1989

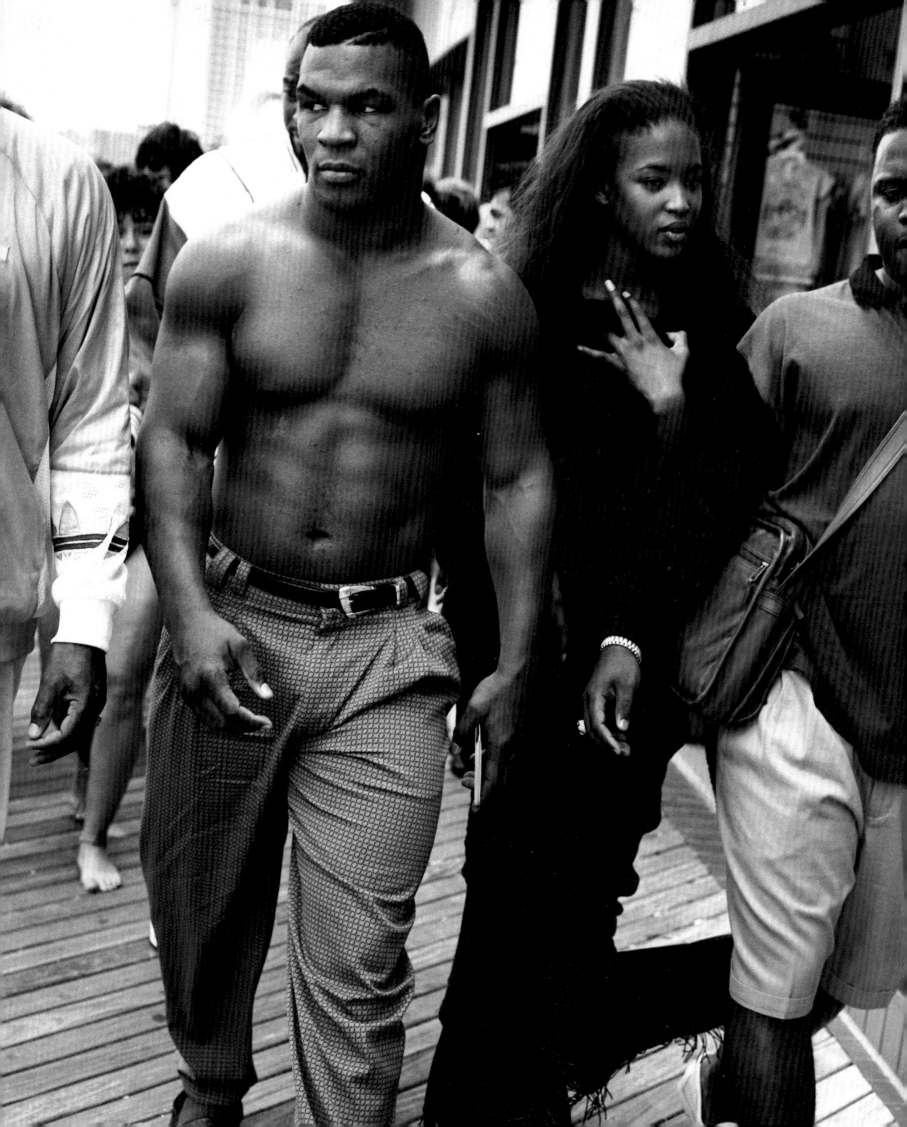

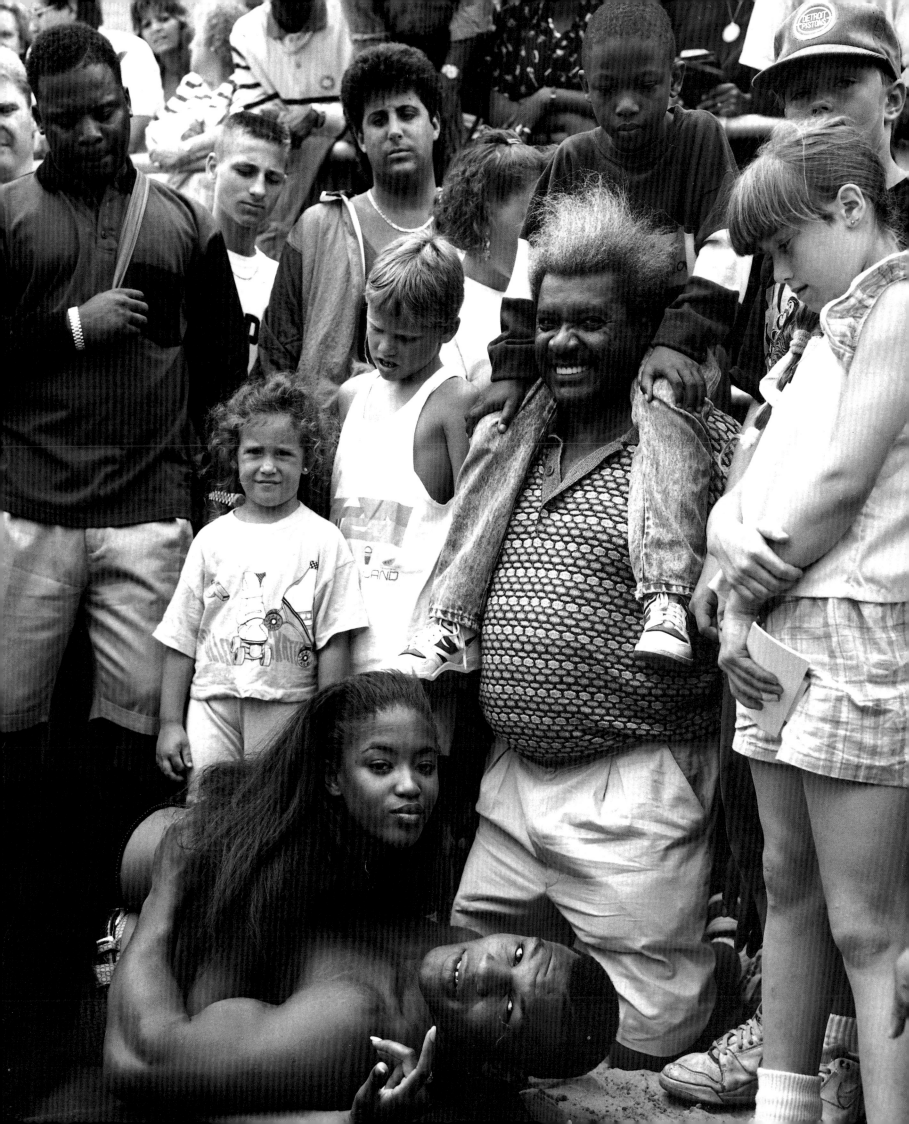

"Peter Lindbergh has a gift for catching light on a woman's face that is revelatory," Alexander Liberman says. "Those two women in the motorcycle jackets [opposite page] are unforgettable, beyond reality in the way that people on a movie screen are." Lindbergh is a German photographer who lives in Paris. His sitting with the Chanel dresses and the motorcycle jackets (opposite page and page xxii) was done under the Brooklyn Bridge. "We had in mind the battle between the two gangs in The Wild One," explains Grace Coddington, who was the editor of the feature. "We had booked the top models three months in advance for this sitting, which was to take four days. Then when the time came, one girl missed her plane from L.A. and arrived about six in the evening, and somebody else was working on another sitting that day and didn't show up until seven. And nobody wanted to be the first one to be made up and then wait around for the other girls, especially since they could only sort of lean in those big taffeta dresses. They couldn't sit down. Then just as the last girl arrived, these huge black clouds came over. And it was almost dark, and we arranged everyone with the motorcycles, and after Peter had shot about a roll and a half of film it started to pour. We went back later, but everything was wet and terrible. Peter got the big picture on the first roll of film, I guess." "That motorcycle picture is important to me," Anna Wintour says. "It expresses the idea of the street coming to couture. Rap music and very chic evening gowns converging."

The idea of fashion photographs as scenes from a fictional story or a real-life documentary has become more common since the fifties. "I'm more aware of the background than I used to be," says Arthur Elgort. "Before, the idea was just to show the clothes in all their glory and put a little blue in behind to indicate that there was sky. Now, editors seem interested in the whole picture, especially at Vogue. And this can be very entertaining for a photographer. On the trip to Russia, for instance, we were set up with the young cognoscenti of Leningrad, who gave us a good time, showed us around. It wasn't a case of going from your hotel to some famous monument to take a picture so that everyone could see you went to Russia, which is what most magazines ended up doing." The picture of Christy Turlington in a Yamamoto dress (page 262) was taken on a couch in the apartment of the artist Afrika, who was helping the Vogue crew and had invited them over for drinks. Afrika's wife and a friend of theirs share the couch. "Of course we also had an official guide," Elgort recalls, "and she thought we were crazy. She thought that all we would want is pictures of the Hermitage."

Helmut Newton's photograph of the model in a clinic (page 275) ad as its inspiration the photographer's own medical situation. Anna Wintour recalls that Newton called her and said, " 'I've just been having a check up, and I think we should take some dresses to the clinic and have this girl going through tests.' And I said great. And then when we published them we must have gotten five hundred letters from doctors. They were horrified."

For the December 1991 issue, Vogue did something more whimsical, "updating" classic fairy tales—Bette Midler did a version of "Little Red Riding Hood" (page 268), and Aretha Franklin (page 284) and the rap group Another Bad Creation recreated the story of Snow White and the Seven Dwarfs with model Beverly Peele (pages 283 and 285). "We need something for our fantasies to work on," says Grace Coddington, "and so we sometimes go back to old stories, or to the movies, the glamorous ones"—like Breathless, Godard's story of a girl who sleeps with and betrays a thief, which Coddington used in a sitting with the photographer Ellen von Unwerth (page 280). Unwerth is a German photographer who lives in Paris, and was a model herself for ten years. "Ellen pulls something out of the girls that you don't see anywhere else," Coddington says. "She finds something in them that's beautiful, and she works around that." Von Unwerth says that she is very influenced by films—"especially old movies, with all that glamour—the Marilyn Monroe movies, and Hitchcock, and Vittorio de Sica. I like to transfer little stories into pictures." The photograph of the two models sitting on a bench in Chanel dresses and hats (page 282) is about "chic ladies watching guys playing football in the park—chic people doing something which is not so chic. I don't like to see people posing. I like to capture a moment when they forget the camera and show something of themselves. The woman is always more important than the clothes she is wearing."

Peter Lindbergh
Helena Christensen and Tatjana Patitz in leather
September 1991

preceding pages

Herb Ritts
Waterproof makeup
June 1989

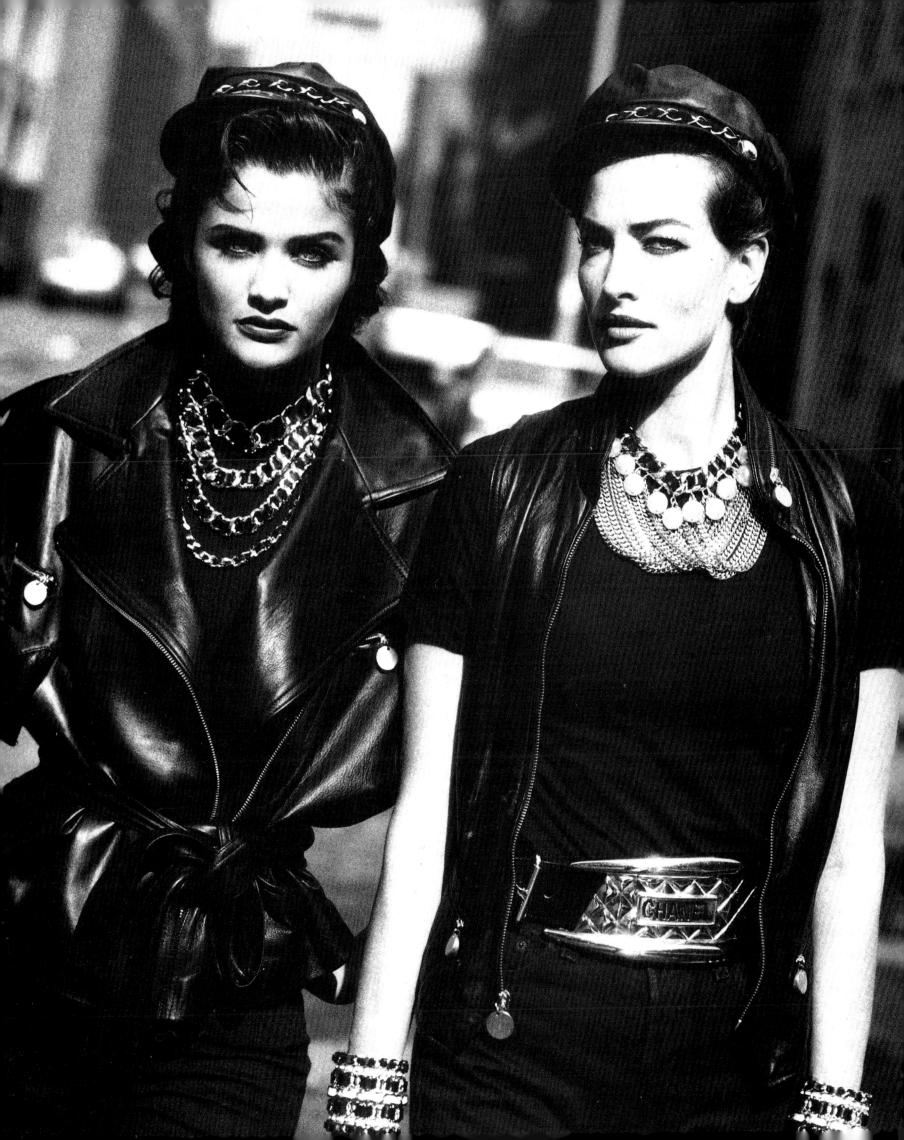

Peter Lindbergh
Sly Stallone in California
December 1991

preceding pages

Arthur Elgort
Konstantin Goncharov, Irina Kuksenaite,
and Christy Turlington in Leningrad
September 1990

Herb Ritts
Michelle Pfeiffer in a Giorgio Armani tuxedo
as Elyot Chase in Noël Coward's *Private Lives*,
October 1991

opposite page

Karl Lagerfeld
Jeff Koons and Cicciolina
August 1990

Herb Ritts
Bette Midler as Little Red Riding Hood
December 1991

Max Vadukul
Gérard Depardieu
December 1990

following pages

Herb Ritts
Elizabeth Taylor
with her Krupp diamond
June 1991

Helmut Newton
Julia Roberts
in Yves Saint Laurent dress
April 1990

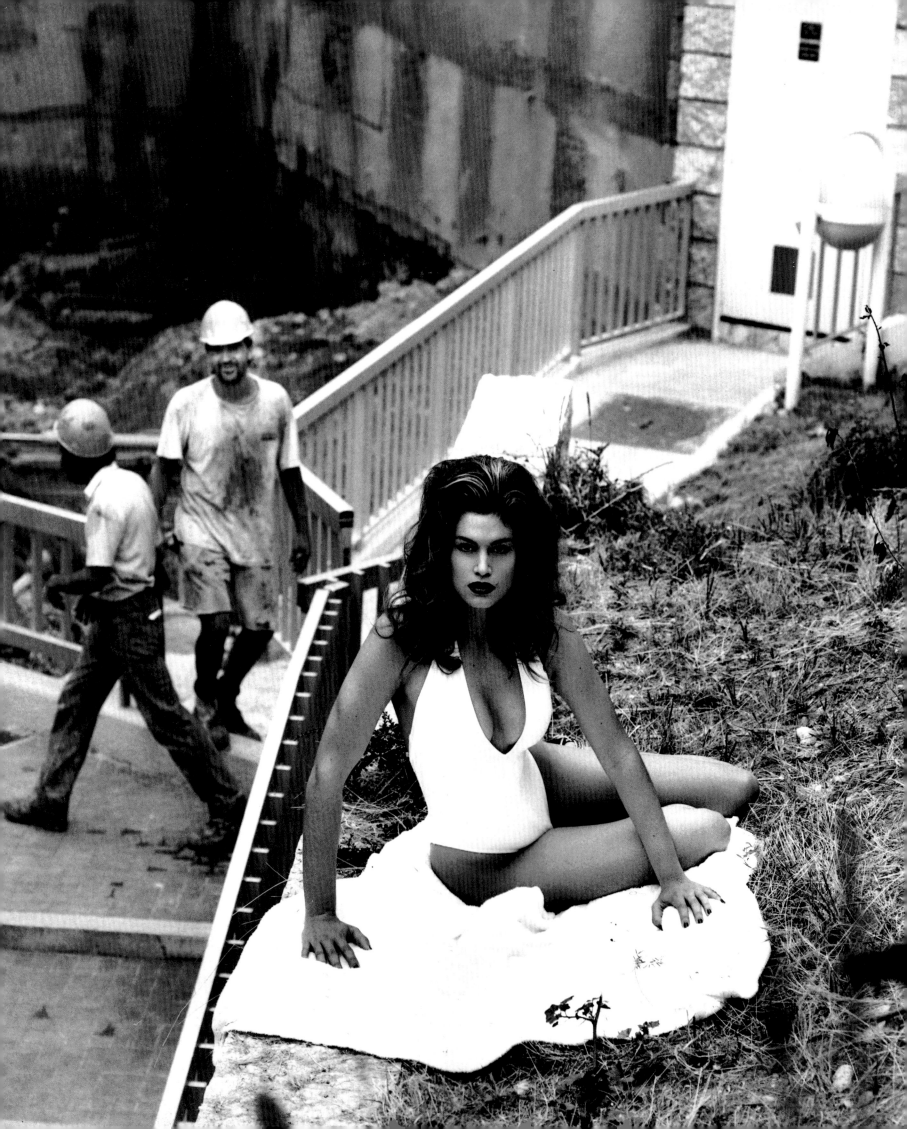

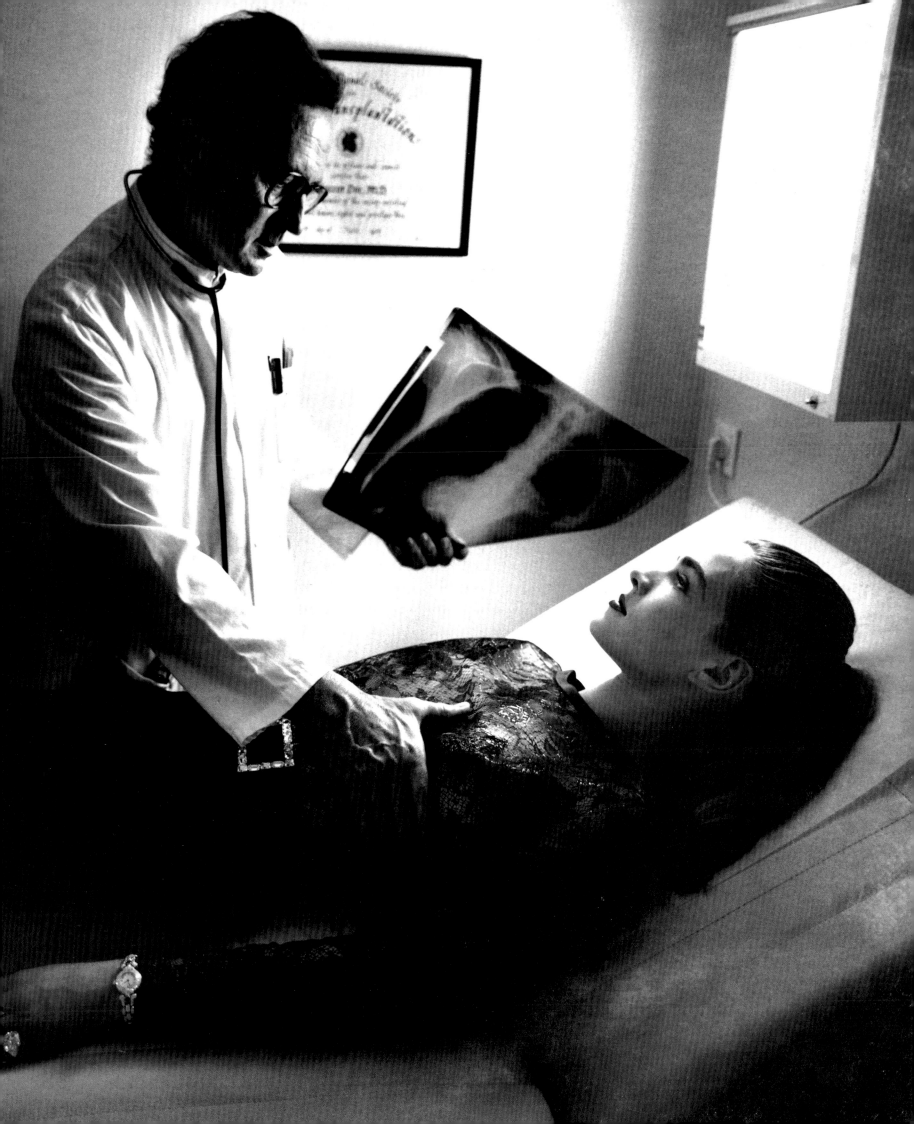

Helmut Newton
Cindy Crawford in Norma Kamali bathing suit
November 1991

preceding pages

Helmut Newton
Cindy Crawford in Ralph Lauren bathing suit
November 1991

Helmut Newton
Givenchy Couture blouse and satin skirt
November 1990

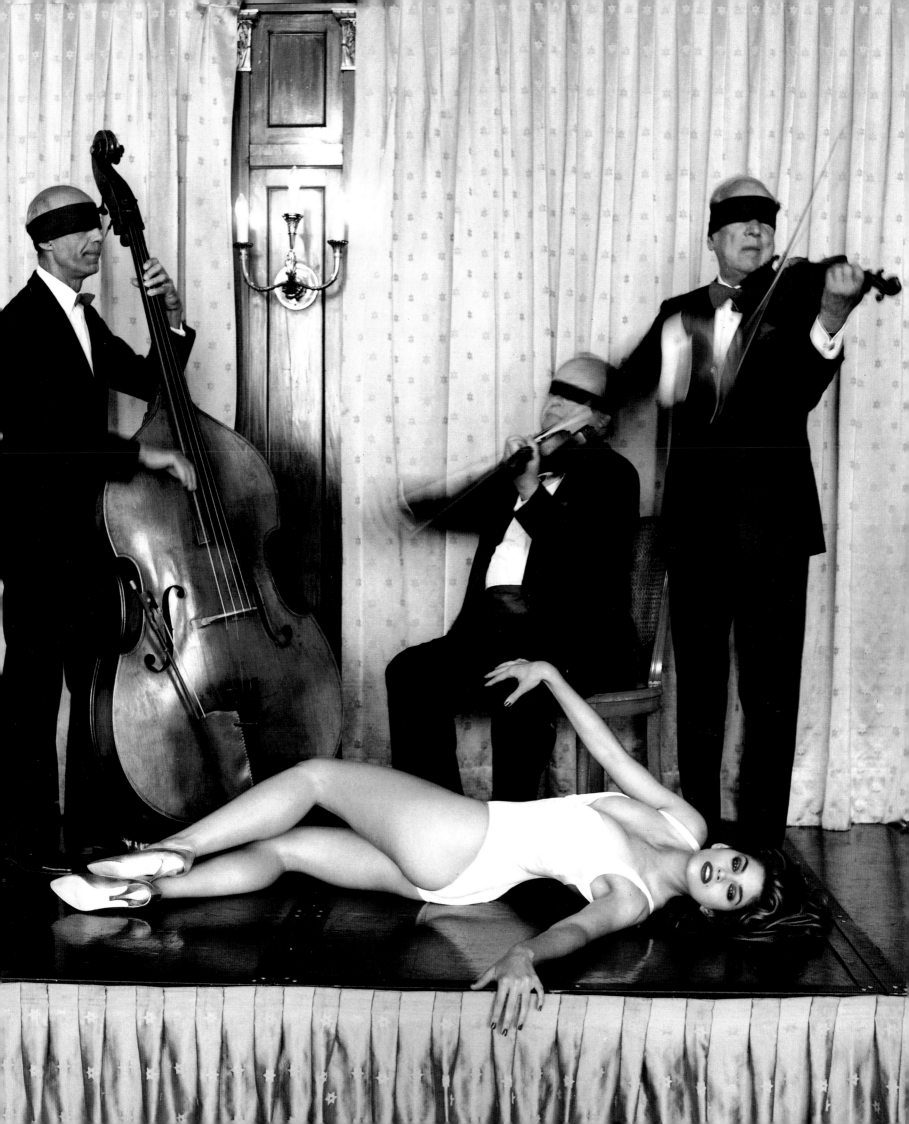

Irving Penn
Rhino mouse
June 1991

opposite page

Irving Penn
Eye makeup
August 1990

Ellen von Unwerth
Christy Turlington
and Stéphane Ferrara as
Jean Seberg and Jean-Paul Belmondo
in *Breathless*
October 1990

following pages

Ellen von Unwerth
Deon and Karen Mulder
in silk-tulle and
silk-chiffon dresses from Chanel
October 1991

Bruce Weber
Beverly Peele and
Another Bad Creation as
Snow White and the Seven Dwarfs
December 1991

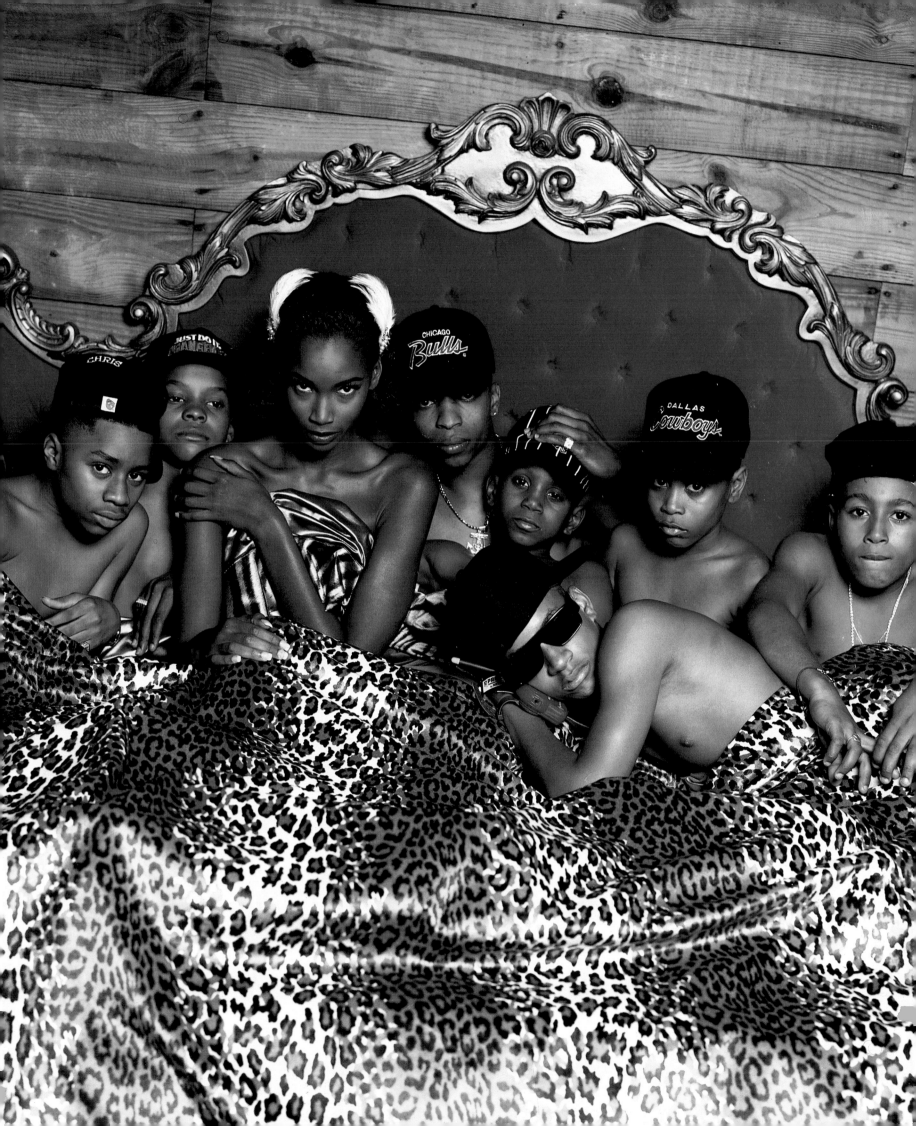

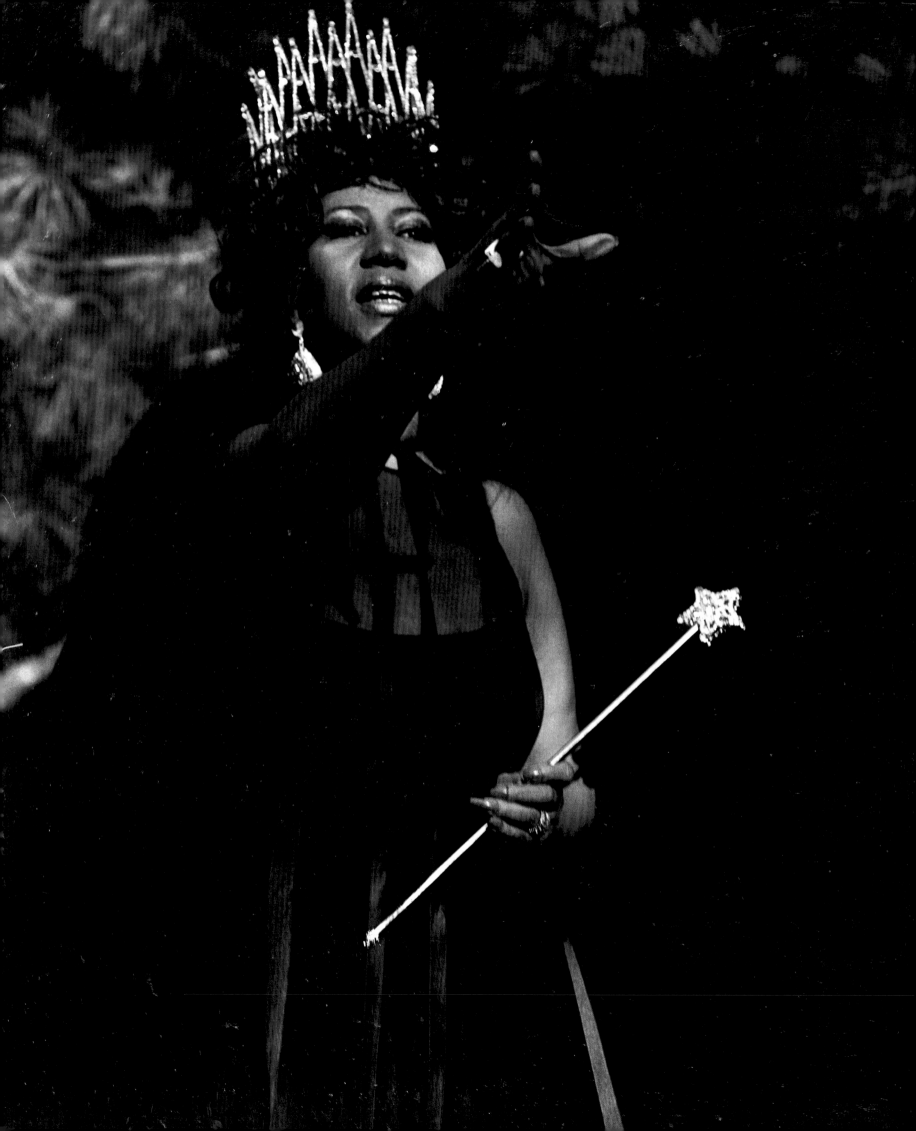

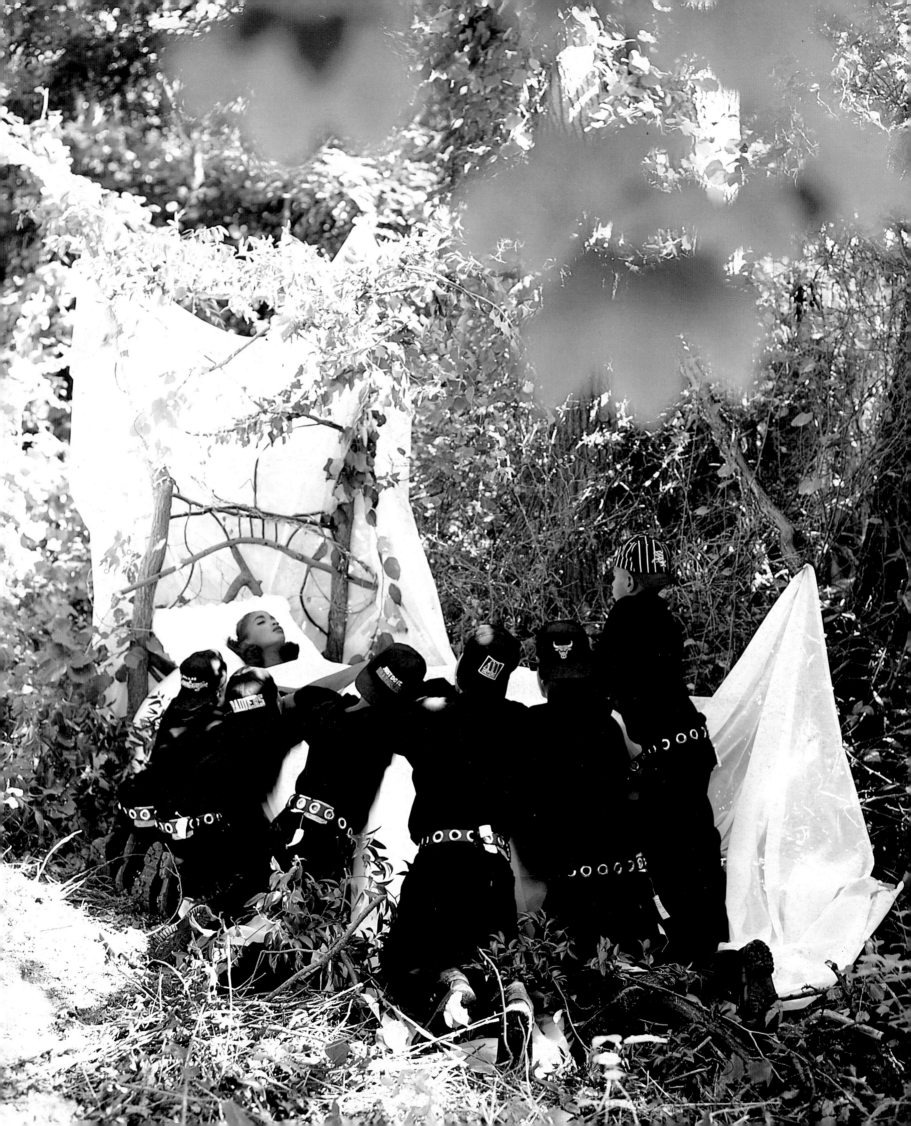

preceding pages

Bruce Weber
Harry Connick, Jr.
and Jill Goodacre
September 1991

Bruce Weber
Aretha Franklin as
the wicked Queen in Snow White,
in a Chanel Haute Couture "cage" dress
and feathered cape
December 1991

Bruce Weber
Beverly Peele and
Another Bad Creation
December 1991

287

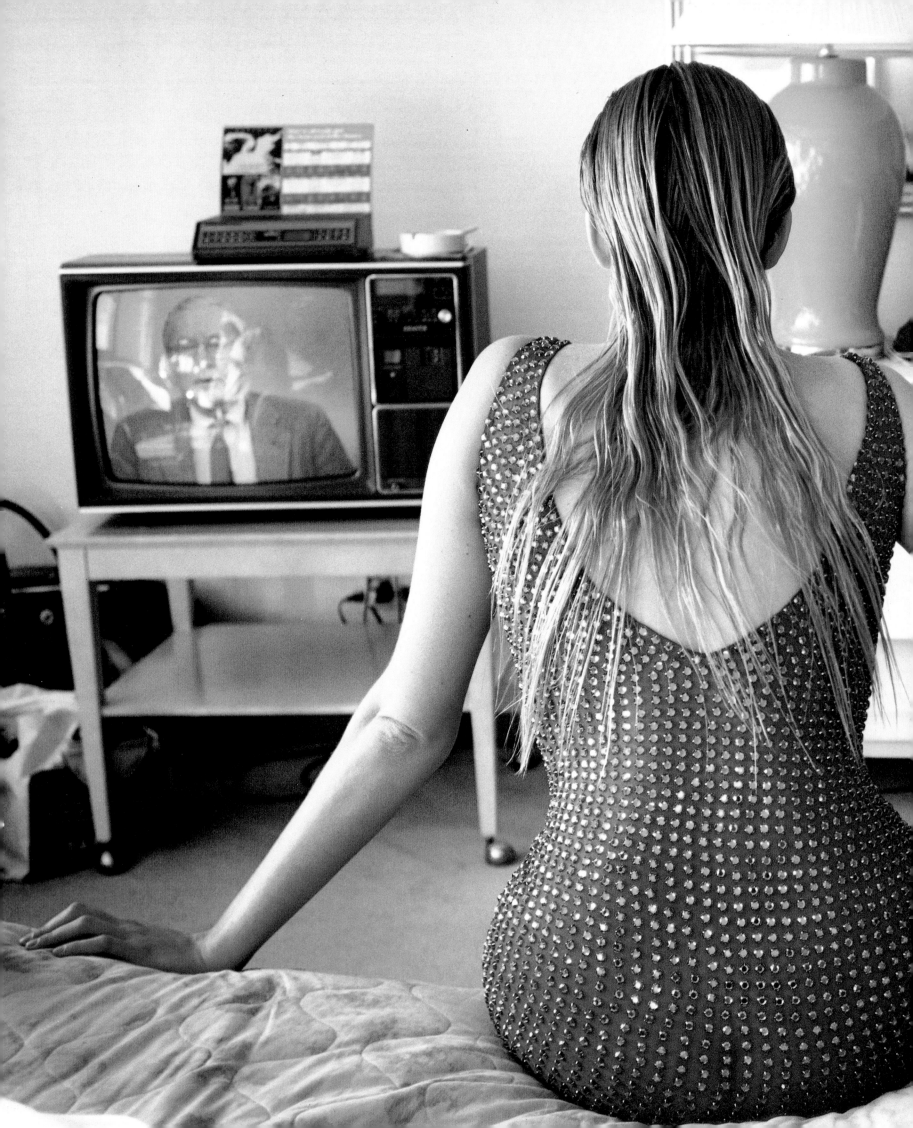

Helmut Newton
Giorgio di Sant'Angelo dress
April 1991

preceding pages

Jean-Baptiste Mondino
Azzedine Alaïa models
November 1991

291

INDEX TO PHOTOGRAPHERS

293

BIBLIOGRAPHY

Ballard, Bettina, *In My Fashion* (David McKay, 1960)

Beaton, Cecil, *The Glass of Fashion* (Doubleday, 1954)

Beaton, Cecil, *Photobiography* (Doubleday, 1951)

Chase, Edna Woolman, with Ilka Chase, *Always in Vogue* (Doubleday, 1954)

Ewing, William A., *Eye for Elegance: George Hoyningen-Huene* (International Center for Photography and Congreve Publishing Co., 1980)

Ewing, William A., *The Photographic Art of Hoyningen-Huene* (Rizzoli, 1986)

Filler, Martin, "Sharp Penn," *Vanity Fair*, March 1990, p. 180

Hall-Duncan, Nancy, *The History of Fashion Photography* (International Museum of Photography and Alpine Book Company, 1979)

Harrison, Martin, *Appearances: Fashion Photography Since 1945* (Rizzoli, 1991)

Horst, Horst P., *Salute to the Thirties* (Viking, 1971)

Jullian, Philippe, *De Meyer* (Knopf, 1976)

Kazmaier, Martin, *Horst: Sixty Years of Photography* (Rizzoli, 1991)

Klein, William, *William Klein: Photographs* (Aperture, 1981)

Lawford, Valentine, *Horst: His Work and His World* (Knopf, 1984)

Liberman, Alexander, *The Artist in His Studio* (Random House, revised edition, 1988)

Liberman, Alexander, "Liberman's Choice," *American Photographer*, May 1980, p. 40

Penn, Irving, *Moments Preserved: Eight Essays in Photographs and Words*, with an introduction by Alexander Liberman (Simon and Schuster, 1960)

Penn, Irving, *Passage: A Work Record*, with an introduction by Alexander Liberman (Knopf, 1991)

Penn, Irving, *Worlds in a Small Room* (Viking, 1974)

Penrose, Antony, *The Lives of Lee Miller* (Holt, Rinehart and Winston, 1985)

Ross, Josephine, *Beaton in Vogue* (Clarkson Potter, 1986)

Seebohm, Caroline, *The Man Who Was Vogue: The Life and Times of Condé Nast* (Viking, 1982)

Snow, Carmel, with Mary Louise Aswell, *The World of Carmel Snow* (McGraw-Hill, 1962)

Steichen, Edward, *A Life in Photography* (Doubleday, 1963)

Stern, Bert, *The Last Sitting* (William Morrow, 1982)

Szarkowski, John, *Irving Penn* (Museum of Modern Art, 1984)

Teicher, Hendel, *Erwin Blumenfeld: My One Hundred Best Photos* (Rizzoli, 1981)

Vallarino, Vincent, "Bert Stern," *Interview*, February 1987, p. 53

Vickers, Hugo, *Cecil Beaton: A Biography* (Little, Brown, 1985)

Vreeland, Diana, with Christopher Hemphill, *Allure* (Doubleday, 1980)

Vreeland, Diana, edited by George Plimpton and Christopher Hemphill, *D.V.* (Knopf, 1984)

Weymouth, Lally, "A Question of Style: A Conversation with Diana Vreeland," *Rolling Stone*, August 11, 1977, p. 38

ACKNOWLEDGMENTS

This book would not have been possible without the great generosity of the photographers.

For commentary on the photographs, we relied on reminiscences and advice from many people who are or have been associated with *Vogue*. Grateful thanks to Grace Coddington, Catherine di Montezemolo, Gloria Emerson, Anne Sutherland Fuchs, Amy Gross, Jade Hobson Charnin, Lauren Hutton, Leo Lerman, Kate Lloyd, Kathleen McFadden, Despina Messinesi, Susan Oberstein, I.S.V. Patcévitch, Jean Patchett Auer, Carol Phillips, Phyllis Posnick, Andrea Robinson, Babs Simpson, Sidney Stafford, André Leon Talley, and Susan Train.

For retrieval of the images, we are especially grateful for the assistance given by Susan Train and Amelia Austin (American *Vogue*, Paris), Lillie Davies and Robin Muir (British *Vogue*), Julian Bach, Gigi Benson, Kathleen Blumenfeld, Boda (Art and Commerce), Beverly Brannon (The Library of Congress, Washington, D.C.), Nan Bush (Bruce Weber Studio), Catherine Johnson (The Harvard Theatre Collection), Lydia Cresswell-Jones (Sotheby's, London), Nicola Majocchi (Irving Penn Studio), Antony Penrose (Lee Miller Archives), Rhea Rachevsky (Visages), Sidney Stafford, Joanna Steichen, Michael Stratton (Steven Meisel Studio), and Richard J. Tardiff (Horst Studio).

Thanks to Sharon DeLano and Linda Kaye at Random House, and to Paul Kramer, Suzanne Eagle, Linda Rice, Sarah Slavin, Shirley Connell, Karen Richardson, Elise Marton, Sherrié Liu, John McCue, Olga Wills, Fred Keith, Annette Ohnikian, Sydne Bolden, Laura Kronenberg, Lina Mak, Christiane Mack, and Richard Villani at Condé Nast. Cynthia Cathcart at the Condé Nast Library was our skilled and resourceful arbiter of the facts.

We gratefully acknowledge the following lenders: Joanna Steichen, page x; Frederick R. Koch Collection, The Harvard Theatre Collection, page 23; The Library of Congress, Washington, D.C., page 37; Sotheby's, London, pages 52, 53, and 139; The Edward C. Blum Design Lab, F.I.T., page 65; Magnum Photos, Inc., page 116. Richard Avedon's photographs are copyrighted by the photographer, and all rights are reserved.